Also by Frederick Fried

A PICTORIAL HISTORY
 OF THE CAROUSEL

ARTISTS IN WOOD

FRAGMENTARY LANDMARKS

NEW YORK CIVIC SCULPTURE

PANTHEON BOOKS NEW YORK

AMERICA'S FORGOTTEN FOLK ARTS

FRED & MARY FRIED

GRAPHIC CREDITS

GRAPHIC DIRECTOR: R.D. SCUDELLARI
ART DIRECTOR: JANET ODGIS
CHAPTER TITLING: GERARD HUERTA
PRODUCTION DIRECTOR: CONSTANCE MELLON
TYPE SETTING: SUPERIOR PRINTING
PRINTING: THE MURRAY PRINTING COMPANY
BINDING: THE BOOK PRESS

Library of Congress Cataloging in Publication Data
Fried, Frederick.
America's Forgotten Folk Arts.
Bibliography: pp. 198–200 Includes index.
1. Folk art—United States. 2. Primitivism in art—United States.
I. Fried, Mary, 1913- , joint author. II. Title.
NK805.F74 745'.0973 78-51790 ISBN 0-394-40714-8

Manufactured in the United States of America

First Edition

AMERICA'S FORGOTTEN
FOLK ARTS

ACKNOWLEDGMENTS

While this book was an adventure in discovery, our biggest find was the people who came forward to offer assistance and advice and to show their interest in our project. Through this book we made friends and found that other persons in remote areas, seemingly standoffish, gave unselfishly of themselves and their knowledge when they became aware of what we were after. To them and to the following we acknowledge their assistance, without which this book would not have been complete.

We are especially indebted to Richard W. Flint, Assistant Curator, and to the entire staff of the Margaret Woodbury Strong Museum in Rochester, New York, for their tireless assistance and guidance. Also to Marie Hewett, Director of Education, for her permission to use parts of her research on "Elephant Joe" Josephs. To the Buffalo and Erie County Historical Society, for their generous exceptions in allowing us to use the Joseph Josephs photographs. To Grace Henry Hanna, for the use of her scrapbook and photographs of the Henry Family. To Edwin H. Mosler, Jr., for his generous permission to use his rare collection of mechanical-bank artifacts. To Elaine Eff, for her research on painted window screens. To Anthony Spagnola, for his memories of his brother's work as a sand sculptor and for the use of his photographs. To James Shawn, for his patience and his account of his foundry experiences. And very special thanks to our editor, Barbara Plumb, without whose initiative, enthusiasm, confidence, and patience this book could not have been. And to those individuals and organizations listed below, for their measure of assistance.

Eva Salazar Ahlborn
Richard E. Ahlborn
Atlantic City Free
 Public Library
Mary Black
Vahe E. Boyajian
Michael T. Bucci
Tracey Cameron
Cecelia Caneschi
Susan Caruso-
 Green
Cedar Point, Inc.
Barbara Fahs
 Charles
Kenneth C. Cramer
William H. Dentzel
Robert Eckhardt

Enoch Pratt Free
 Library of Baltimore
Violet Felicio
Howard M. Fitch
Charles P. Fox
Henry B. Fried
Rachel Fried
Courtney Fry
Mary Germond
James W. Gibbs
Phyllis and William
 Gilmore
Julie and Michael D.
 Hall
Olga M. Hallock
Bertha Hanson
Clyde E. Helfter

Heritage Plantation
 of Sandwich
Louis Hertz
Betty M. Ivey
Fred G. Johnson
Lee Landon
Thomas C. Layton
William Wistar McKean
Meriden Public Library
Mel Miller
Minnesota Historical
 Society
Nancy C. Muller
Museum of International
 Folk Art, Santa Fe
O. Henry Tent &
 Awning Co.

Richard Oktavec
Ruth and C. F. Pearson
Mary-Ellen Earl Perry
Max Petersen
Mrs. C. Riebold
James Scott
Judith S. Sellers
Shelburne Museum
Dale H. Smith
H. R. Bradley Smith
Robert W. Swank
H. J. Swinney
Peter Tomasi
Tommy White
Robert F. Wicks
Barbara Williams
James Wilson

INTRODUCTION

Art is sometimes where we least expect it. The talents of the American people are boundless, but in a society where the tastemakers cater to the rich, art is supposed to come encased in a gold frame or placed on a marble pedestal. That kind of art is not what this book is about.

It is about art in spite of itself, art that exploited the quirks of man and nature, and art that passed with the seasons leaving memories that, like a time capsule, were later to be rediscovered, telling how we were.

There is art in these pages that served as the whipping boy for man's frustrations and his prejudices. There is art that was shot at, thrown at, slung at, and laughed at. There is people's art that struck back at their oppressors. And there is accidental art, made because it cried out for being, captured in a tree trunk or in a group of found objects.

It is all art that begs for recognition. We have recorded it to be enjoyed by all the people. It represents their skills and talents, their materials and motifs, all put together, all reflecting their time and environment and the tastes of their period. In our search we have found art in many strange, amusing, and amazing forms, but most fascinating of all have been the people—the artists themselves—whose varied backgrounds ranged from farms and small towns to big cities and from carnivals and taboo tattoo parlors to young ladies' seminaries.

We found that there is no clear dividing line where what has begun simply as a craft becomes art. Above all else, we found that the coming of the machine age by no means stilled the urge to create individual works of art—that today, in this electronic age of instant communications, that urge is perhaps greater than ever, at least in our area of graphic and three-dimensional art.

The hand-carved carousel figure gave way first to the Lochman carving machine, which copied one original into multiples. This was followed by copies in aluminum and finally in fiberglass, all cast from the old originals. But the art of wood carving is now attracting younger persons, who have picked up the mallet and chisel with great promise.

Fretwork has again become popular, to the point where one tool supplier is listing vises, clamps, and patterns in a current catalogue. And wall paintings with anti-drug and other social messages are showing up on the sides of buildings where once Castoria and stove polish were advertised.

With the arrival of warm weather, the painted window screens of Baltimore, some new, others washed and back in place, add a surreal effect to the street scene, proclaiming once more the art of the screen painter. The warm weather also attracts young and old to the beach, where more torsos, male and female, are revealing the art of the tattooer. Sand sculpture in many forms comes and goes on the beaches, giving evidence that individual expression is very much alive in America.

In recent years there has been a revival of interest in ladies' fancywork: needlepoint and other stitchery for pillows, rugs, wall hangings. Quilts have been rediscovered, not just as fancy needlework but as an important art form; in fact, they are now far too familiar for us to include them here. Weaving has also received its due share of attention. But there were many other arts that were important to the women of the nineteenth century who eagerly scanned the women's magazines for instructions in home decorating. With the renewed interest in Victorian furnishings, the decorative accessories of the period may also stage a comeback, though in modified form. Shellwork is already seen in many shops; twig, acorn, and moss work may be about to appear again.

But if some of the women's crafts we describe have vanished and been forgotten, the ephemeral, the seasonal arts recur year after year. The urge to make a snowman or a sand castle, a scarecrow or a jack-o'-lantern, seems never to die out. What appeals to us particularly is the way in which, in some places, these creations have reached a higher stage of development, becoming elaborate art forms: ice palaces and sculptures, for instance, and the fabulous palaces built of corn that celebrated the harvest.

There has been a tendency among those who admire, study, collect, or write about Americana to dismiss those things made after the magic cutoff date of 1830 as being mass-produced by machine and therefore in bad taste or of little interest. It is after that magic date that our story begins. For one thing, the Industrial Revolution did not happen at the same time everywhere. New settlers in the West were still painstakingly making their furniture and other necessities by hand at a time when Easterners were able to order these things ready-made from factories and suppliers. Often even mass-produced objects were still being finished by hand. Long after the invention of photography, the itinerant limner was making likenesses of people on farms and in remote areas. The newspapers and journals that came from the giant presses were illustrated with engravings painstakingly drawn by artists, and today even the reproductions in journals of the period are sought as prize examples of art. But our interest is always in the artist or designer who produced the original, the prototype of the mass-produced object.

We are interested, in short, in the urge that led people with no training as artists to paint, model, carve, or otherwise create art works that served to enrich not only their own lives but those of all who came in contact with them. Where it was possible, we interviewed the artists themselves, or people who had known them. The search for Dog Man had the excitement and mystery of a detective story, leading us, strangely enough, always nearer to home. Sometimes we found artists whose work earned them a place in more than one chapter. Marcus Charles Illions, famous as a carver of magnificent carousel animals, also tried his hand at sand sculpture on the beach at Coney Island. Johnny Eck, the screen painter, was also a carnival performer and the subject of his twin brother Rob Eckhardt's carnival banners. Banner painter Bobby Wicks was once a tattoo artist and later a show-front painter, as was Jack Cripe. We also learned that sometimes the creative urge extended into other areas, as with Charles Henry, scene painter, playwright, actor, and troupe organizer. And we learned that those who discovered this urge later in life found it a blessing: "Considering that I did not attend art school and had no formal art training, I consider my talent truly a gift." Modesty and appreciation for education, especially among those artists denied that luxury, are reflected in one old carousel carver's appraisal of another: "He's an artist...me, I'm wood carver." And in what one screen painter said of another's work: "Her backgrounds were cream color, and her trees looked like lace."

We keep thinking back to the little garden in San Francisco where a large corner hedge of cypress was trimmed into a mysterious face with long, flowing locks, and especially to the fallen eucalyptus tree on Divisadero South, carved into the image of a tortured soul, and wishing we had been able to find the artists.

A few words about the genesis of our book are in order. A number of years ago we were delighted to make the acquaintance of Barbara Jones's book *The Unsophisticated Arts*, which deals with a variety of popular arts in Britain. Some of these arts are typically British; many others, with national variations, are familiar to most Americans, though for the most part unrecognized as art. So when Barbara Plumb, our editor, first spoke to us about the possibility of doing a book on heretofore unrecognized American arts, the idea appealed to us immediately. Our research and photograph archives were bulging with candidates for such a volume. Selection was one of the problems. But the most difficult thing about writing this book has been ending it; obviously, we could have continued our search and selection, enjoying it all too much to come to grips with our deadline, which was twice extended for our convenience.

This book has been for us a real adventure in discovery, and we hope it will be the same for our readers.

Frederick and Mary Fried

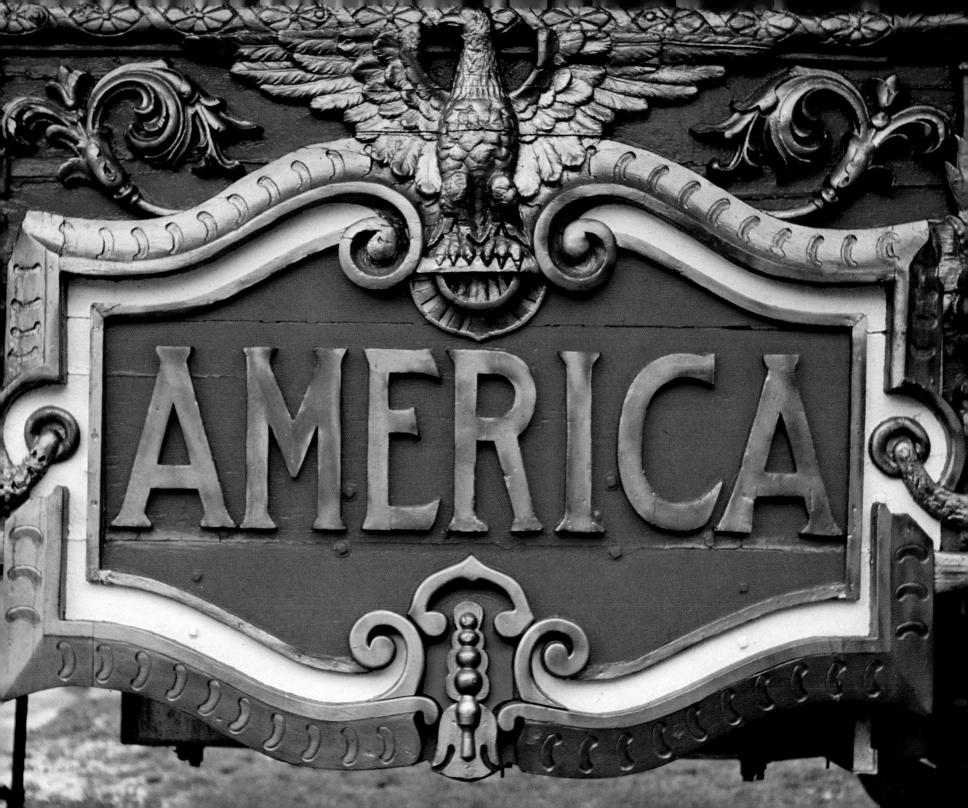

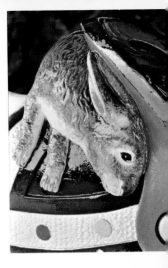

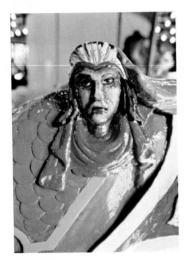
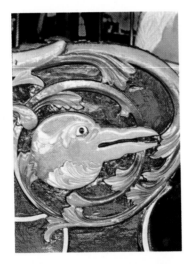
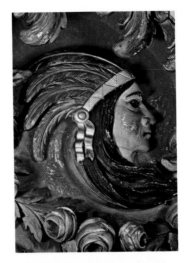
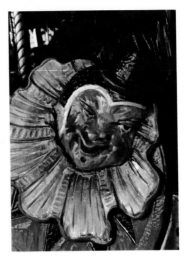
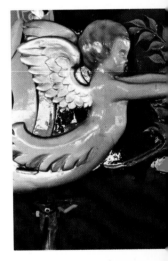

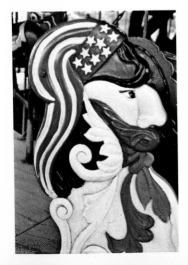
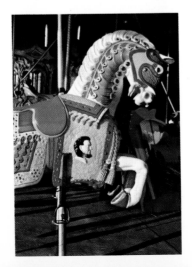
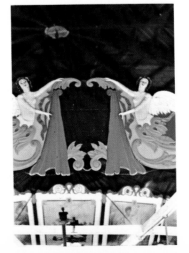

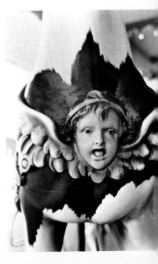

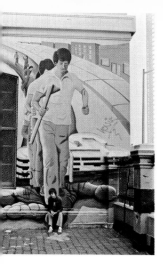
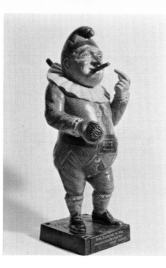
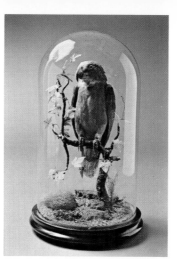
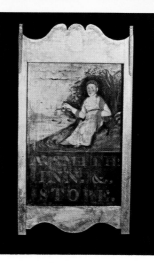
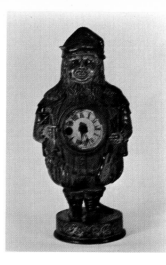
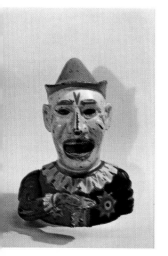

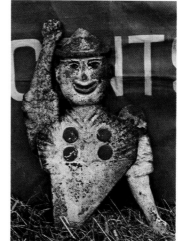
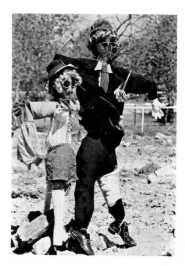
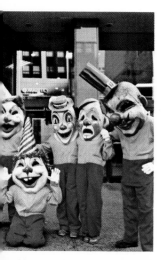
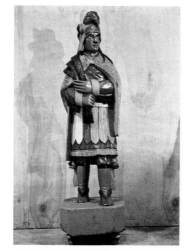
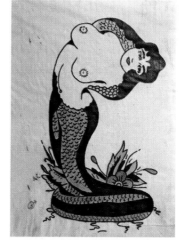
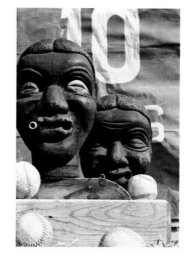
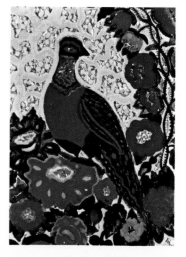

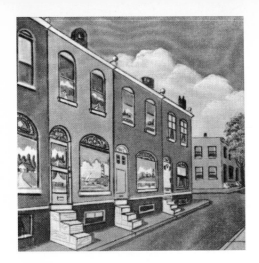

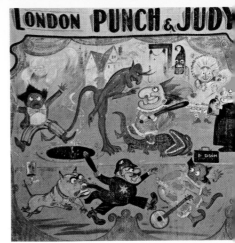

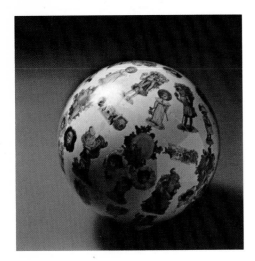

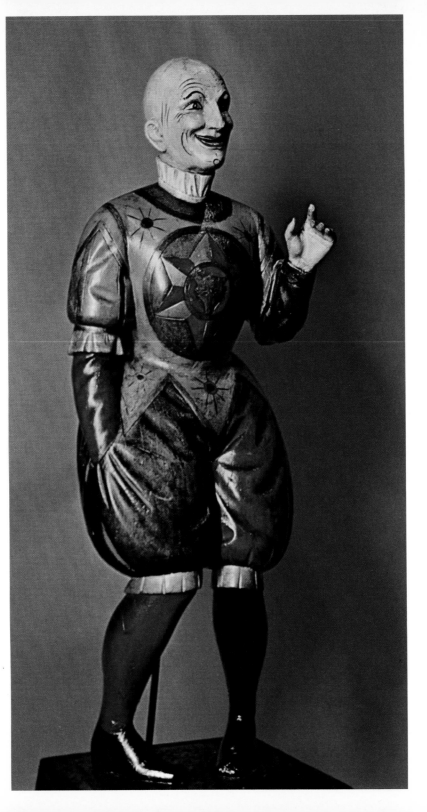

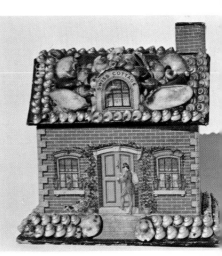

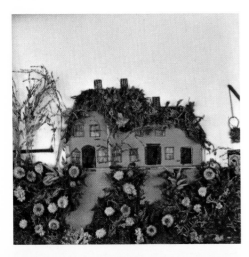

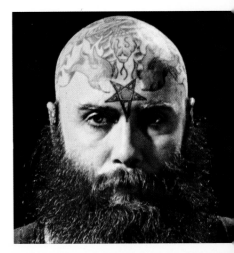

Page 9 Side panel of Barnum & Bailey AMERICA wagon. Carved in the shop of Samuel A. Robb, New York, 1902. Circus World Museum, Baraboo, Wisc.

Page 10 Top row, left to right
Self-portrait carved on side of carousel horse by Alfred H. Muller, 1910. Cedar Point, Sandusky, Ohio.

Euterpe, carousel chariot carving. By Philadelphia Toboggan Co. for Asbury Park, Casino, N.J., 1912.

Stork with baby and bouquet. By Herschell-Spillman Co., North Tonawanda, N.Y., 1914.

Girl and dog, carousel chariot side. By Herschell-Spillman Co., 1915. Jim Wells, Smithsonian Mall, Washington, D.C.

Rabbit, saddle decoration on carved-wood carousel horse. By Philadelphia Toboggan Co., 1918. Marriott's Great America, Santa Clara, Calif.

2nd row, left to right Indian, saddle decoration, carved and painted wood. By Charles Carmel, Brooklyn, ca. 1910. Prospect Park.

Bird with acanthus leaves. Chariot board section, carved and painted wood. By Charles I. D. Looff, Brooklyn, 1910.

Indian, carousel chariot, carved and painted wood. By Stein & Goldstein, Artistic Caroussel Mfg. Co., Brooklyn, 1914.

Jester, pommel decoration on carousel horse. By Philadelphia Toboggan Co. for Cincinnati Zoo, 1918.

Amorino and acanthus leaf, detail on carousel horse. Carved by Daniel Carl Muller, Philadelphia, 1910.

3rd row, left to right Uncle Sam carousel chariot side, carved and painted wood. By Herschell-Spillman Co., ca. 1914.

Armored carousel horse with carved portrait of Lincoln. By Charles Carmel for the B&B carousel, Coney Island.

Carved and painted wood panel of upper-outer carousel rim. By Herschell-Spillman Co., ca. 1914.

Dog on side of carousel horse. By Philadelphia Toboggan Co. for Cincinnati Zoo, 1918. Marriott's Great America.

Amorino on front of carousel horse. Carved by Marcus C. Illions, Brooklyn, ca. 1925. Ringling Bros. and Barnum & Bailey Circus World.

Page 11
Top row, left to right Outdoor mural, "Let Our People Grow." 17' x 180'. J.H.S. 65, Forsyth Street, New York. Cityarts Workshop, 1976.

Punch, tobacconist's sign. Cast and painted zinc, 24" h. By M.J. Seelig for William Demuth, New York, 1875. Smoke was blown through cigar.

Stuffed parrot on branch under glass dome, or "shade." Ca. 1880. Margaret Woodbury Strong Museum, Rochester, N.Y.

Inn and store sign of A. Smith, Addison, Vt. Shaped and painted wood. 1826. Collection Frederick & Martha Lapham. Photo James Barker.

Saint Nicholas blinking-eye clock. Cast and painted iron, 17" h. Designed and patented by Pietro Cinquinni, 1857. Made by Bradley & Hubbard Co., Meriden, Conn.

2nd row, left to right Humpty Dumpty mechanical toy bank. Cast and painted iron, 7" h. Made by Shepard Hardware Co., Buffalo, N.Y., 1882.

Indian and cowboy panels from Barnum & Bailey AMERICA wagon. Carved and painted wood. By Samuel A. Robb, New York, 1902.

"Giant of the Avenue," in front of Saw Blade Tavern & Museum, Phillipsville, Calif. Chain-saw carving, 18' h., by Mel Byrd.

Clown, shooting-gallery figure. Cast iron, painted, 18" h. By William F. Mangels Co., Brooklyn, 1912. Designed by William F. Mangels, Jr.

Two urban scarecrows guard a community garden in New Haven, Conn., 1977. A CETA grant–New Haven Arts Council Project.

3rd row, left to right Group of masked marchers in R. H. Macy Thanksgiving Day Parade, Seventh Avenue at 34th Street, New York, 1976.

Indian scout, tobacconist's figure, life-size. Carved and painted wood. Maker identified, c. 1870.

Ball-toss heads, life-size. Carved and painted wood, holes in mouth for clay pipes. By C. W. F. Dare Co., New York, 1878.

Tattoo artist's design. Tattoo inks and dyes on paper. Artist unidentified, c. 1912.

Tinsel painting of wreath and birds (detail). 15 3/8" x 19". Ca. 1850. Margaret Woodbury Strong Museum.

Left, top to bottom Baltimore street scene with painted window screens. Oil paint on wire-mesh screen, 30" h x 27" w. Artist, Richard Oktavec, 1976.

Potichomanie, glass ball lined with paper cutouts and painted. 10 1/2" d. Margaret Woodbury Strong Museum.

Rustic scene worked in moss, grasses, and dried flowers. 9 1/2" x 11 5/8". Ca. 1865. Margaret Woodbury Strong Museum.

Center Clown tobacconist's figure. Carved and painted wood, 54" h. By Samuel A. Robb, New York, 1886–1895. Heritage Plantation of Sandwich, Mass.

Right, top to bottom Side-show banner, oil on canvas. Painted by Millard & Bulsterbaum, Coney Island, ca. 1928. Margaret Woodbury Strong Museum.

Red brick cottage, printed on cardboard, decorated with shells. Ca. 1900. Frank and Frances Whitson Collection.

Lord Balkan, tattooed by Spider Webb, Mt. Vernon, N. Y., 1974. Courtesy Spider Webb.

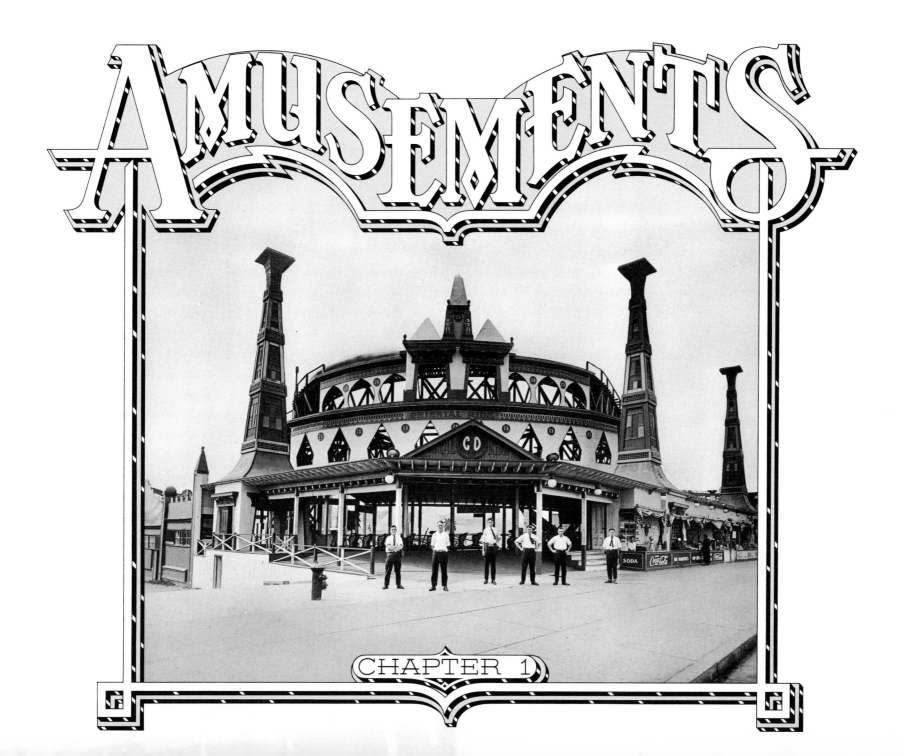

AMUSEMENTS

CHAPTER 1

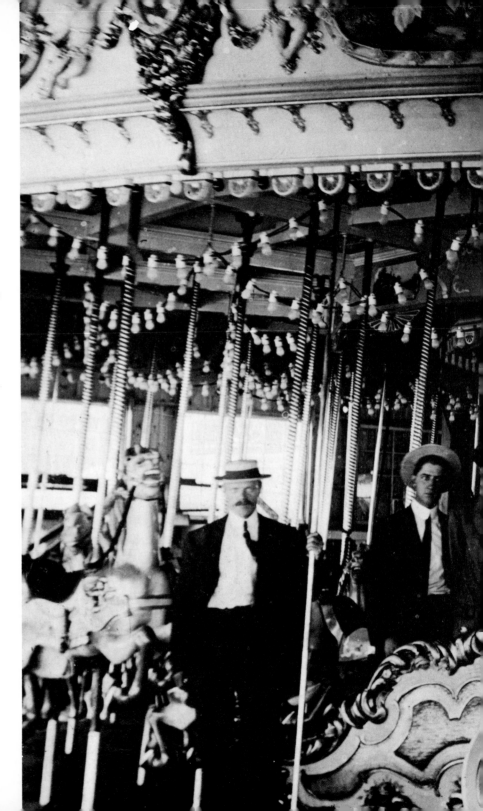

CAROUSELS

If to attract the Eye, to charm the Ear,
And touch the Heart . . . thou'lt charm the Age
When Art with delicate Experience joined
Shall form thy action and improve thy Mind.
—To Mrs. Pritchard on her playing Loveit in *A Cure for Covetousness*
at Henry Fielding's booth at Saint Bartholomew Fair, 1733

The midway, with its mass of moving configurations, a confusion of
sights and sounds, seems hardly the place where art would be found
in abundance. But there it is, waiting to be discovered, if with a little
patience and a lot of time we search it out, to be rewarded with the
unexpected.

Of all the rides on the midway, the carousel, which is the ancestor of
them all, is the most interesting. It is a forerunner of all the audio-
visual effects as it turns in circles, creating kaleidoscopic patterns
with each go-round as the organ beats out the rhythm from behind
its rococo façade. Who would dare say that it is not the first mobile
art form?

The first impression of this circular art gallery is confusion, with
mirrors reflecting the lights, the background, and the riders. It stops
briefly, and the riders are discharged for another group, who dash
madly about seeking a favorite steed. Then, just as we glimpse a
strange figure or a design we would like to examine, it starts up again.
And so the pattern is repeated, never stopping long enough to let us
seek out that first attraction, now forgotten as others take our eye.

When at last we can with leisure investigate the merry-go-round and
its hidden art treasures, we first see the horses and other animals and
the chariots as silhouettes. Then, as we look more closely, we realize
that no horse's mane was ever such a mass of movement as the
manes of these wooden steeds. It is never suspected that the carver
had studied the movement of a horse's mane before placing a pocket
where the hand could grasp it to help swing the rider into the saddle.
Nor was any circus or tournament horse ever embellished with such
trappings. It is here that the imagination of the carver went wild. It is

16

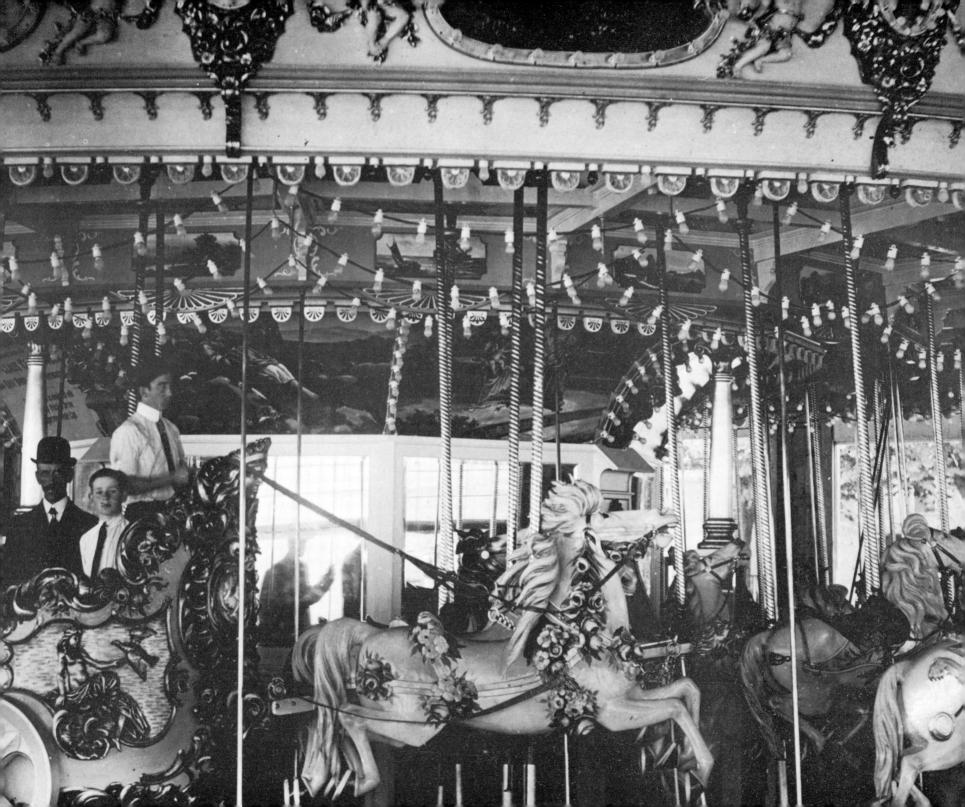

doubtful that he was familiar with the illustration of the Escadron des Turcs, a group of four mounted riders dressed in costumes for Le Grand Carrousel de 1662, a fancy daytime ball on horseback commanded by the Prince de Condé. This costly affair was given by Louis XIV of France to impress his teen-age mistress, Louise de la Vallière, and was staged in the square between the Tuileries and the Louvre, now called the Place du Carrousel. The horses had marcelled and curled manes and tails and were caparisoned with braids, tassels, and chains of golden rings. Yet the splendor of many carousel horses surpasses even that of the famous Escadron, for the chisel in the hands of the artist could fashion any extravagance he wished. "I made armored horse—idea all mine—out of my head": the words are those of Frank Carretta, then eighty-four, recalling his work for the Philadelphia Toboggan Company in Germantown, Philadelphia, in the 1920s. "Then the painter put liquid silver all over the horse."—"On the horse, too?"—"Sure, the armor, the horse, all over, it was the silver anniversary of the Philadelphia Toboggan Company." What the carver did not embellish with his chisel, the painter did with oils and brushes.

Another area of embellishment is the machinery enclosure. Hiding the driving mechanism, the center pole, the **A**-frame supports, and the gears are carved wooden panels, each framing a painted canvas. The scenes vary from a buffalo hunt by Indians, copied from or influenced by the paintings of the nineteenth century, to placid lakes and wild mountain views such as were popularized by Albert Bierstadt. The rim above and outside the platform, supported by rods to the top of the center pole, can be compared to a diamond bracelet with its reflecting mirrors set in carved wooden frames. Connecting the sections and hiding the separations are wooden shields carved with either an animal or a human head, gold-leafed, and gaily painted. At times the outer rim is a *tour de force* by a carver who employed all clichés and devices of the baroque. One such carver was Marcus Charles Illions of Coney Island, whose winged amorini peeking out from behind masses of acanthus leaves brought the atmosphere of art into the midway.

Some carousel carvers had received instruction in the arts. One such was John Zalar, listed as a "sculptor" in 1903, whose background in the fine arts was the deciding factor in his selection as head carver for the Philadelphia Toboggan Company. Zalar set the patterns that others were to follow for the next two decades. Another was Daniel Carl Muller, who studied sculpture with Charles Grafly at the Pennsylvania Academy of Fine Arts in Philadelphia while heading his own carousel manufactory and carving shop. But there were others, like Frank Carretta, who began as furniture carvers and cabinet-makers with no formal art training and yet produced excellent examples of the carousel carver's art.

There were still others whose work falls into the catchall category of American folk art. Among these were the carvers of the Armitage Herschell Company and later the Herschell-Spillman Company, both of North Tonawanda, New York. Many of these carvers worked their way up to the carving department of these carousel factories. Some of their early productions were made to be pushed or pulled around by a man or a horse; many had no platforms and were called "hanging carousels," and had a minimum of carving on their primitive horses. The larger of those with platforms, propelled by a steam boiler, are among the most charming ever made, with cats, dogs, goats, and all kinds of creatures of the wild alternating with the horses. A stork has its little bundle of life tucked safely on a scarf beneath the saddle seat, a neat way to keep it out of its beak. One can almost sense the carver's delight in this device; to top it off, he placed a bouquet of flowers in the baby's hands, no doubt to present to its new parents.

The imagination of the Herschell-Spillman carvers was given free rein in making variations from the original pattern. An angel and a harp are part of a chariot side that appears with variations on numerous carousels made by these carvers. In one, which could be a part of the "Peaceable Kingdom," all the units, each unrelated to the others, fall into place to form an amusing if not a pleasing composition. The angels of the upper outer rim, when dismantled, look like girls of the chorus line, but when arranged in place with the mirrors added, they

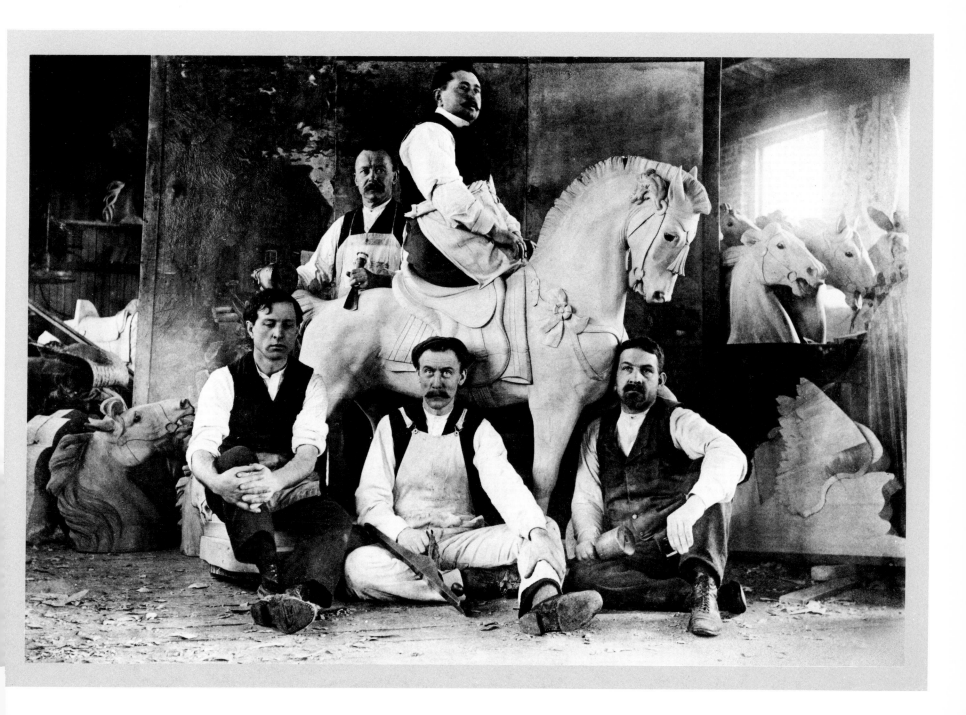

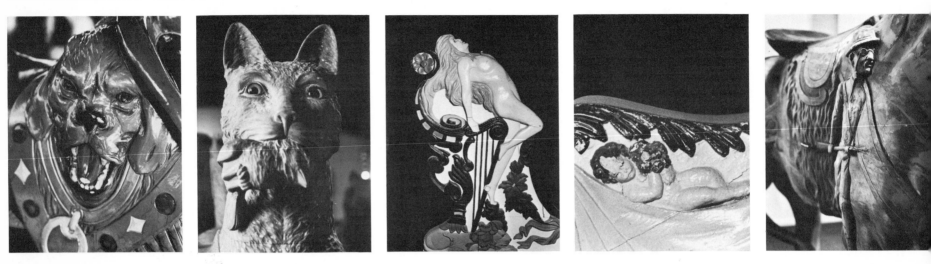

seem quite natural flying around (counterclockwise) in their heavenly circles.

Artistic license is a very broad term used to cover a multitude of lapses. Sometimes when the carver drew back to look at his work, he expressed amazement: "When we spoiled the work, if it looked good we left it alone." In painting this is known as the "accident," and it accounts for some startling new effects. But in carousel carving, if the "accident" did not look good to the carver or his foreman, it was cut away and replaced with a section of the wood, usually basswood, of which the entire animal was made.

In carving carousel figures, a cardboard form was traced on two planks of wood and the two sides cut out in silhouette. From these a box shape with a hollow center was constructed. The head, legs, and tail were made separately. "They had a form to cut two planks out, both sides, and on the middle they built block by block. They used to build the neck, they put the head on the neck with dowels, and when they finished the carving they put on the legs and tails. There were three or four patterns and we made them all different, we made the bridle different and the ornament different, very few were equal

[the same]." Frank Carretta also remembered: "I got paid good wages, union shop, I was compelled to join union—from Italy I just came, first carousel head I made took eighteen hours. Boss said, 'Nice work, but too long.' But I learned soon. Usually first [outside] row head take two days work, second row take day-and-half, and inside row take one day work." The figures were also graduated in size, the outside row having the largest with the best and most numerous carvings.

Another carver, Salvatore Cernigliaro, started with Gustav A. Dentzel in Philadelphia in 1903. "I made the cat with the fish in his mouth, sometimes a bird, whatever came to my mind. I made them fancy with ribbons and bells, all kinds." During the lifetime of Gustav A. Dentzel very few extravagancies were allowed. When his son William H. took over the business after his father's death, more liberties were permitted with the embellishments. Teddy Roosevelt as a big-game hunter, gun in hand, pince-nez, and pith helmet, all in high relief on the right flank of a tiger, would have been unthinkable anywhere in 1911 except on a carousel figure. This accidental surrealism was quite acceptable on the midway, where the unexpected

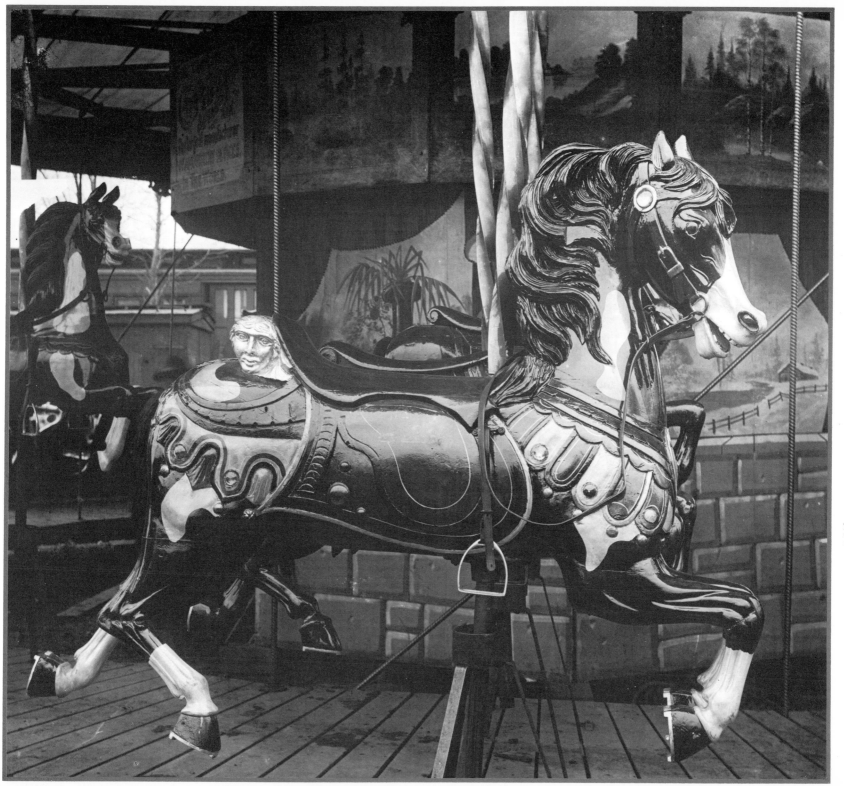

Opposite page Allan Herschell Co.
carving shop, North Tonawanda,
N.Y., 1922. **Left to right:** Joe
Waible, chariots; carvers William
Goeltz, Bert Bloomstine, William
Sprenger, Jake (Gerhard) Wurl,
Peter Flach, Harry Nightingale, Fred
Roth, Herman Jagow.

was commonplace and to be hoped for.

When saddle decorations were needed, the client's wishes were considered. In 1918 the Cincinnati Zoo had the Philadelphia Toboggan Company build them a carousel. Since animals, both domestic and wild, could be seen at the zoo, the huntsman, his hound, and his catch became the theme for the carousel. The carver had to devise ways and designs to frame them. It would not have done to conceal the catch in a gamebag, so it was placed behind the saddle. The huntsman, Indian or plainsman, was carved in deep relief along the neck or side of his steed, giving the young, adventure-minded rider his choice of mount. Man's best friend was placed wherever it pleased the carver. "Mr. Carretta, why did you put an Indian head on the horse?" — "We put an Indian head on for decoration, babies, angels, all kinds, according to the genius of the carver."

Humor was often in evidence; more than one carver admitted to having placed his wife's portrait in a most unlikely spot on the rump of a horse. Pets too found their way onto carousel figures. "We used to look at the animal and make his picture." The surprised look of the puppy on the seat back, a look that seems to question his being placed there, was a whim of the carver. The dog staring into the eyes of the horse behind was probably never noticed by its rider as it guarded the rear, sometimes with a pistol carved at its side.

The carver was never permitted to sign his name, except where he himself was the manufacturer, as was Daniel Carl Muller, who with his brother Alfred H. constructed and operated their own carousels. The manufacturer's name was often found on the painted panels surrounding the center pole and machinery. His trademark or initials were carved into the decoration of the lead or "king" horse. Occasionally, a carver would put his portrait on this horse, as did Marcus Charles Illions. Others would work their initials into a trapping, disguised sufficiently to avoid detection. Alfred Muller did it more openly; in one instance he carved his portrait wearing a jockey cap, but whatever significance that may have had will never be learned.

Sex was never represented on the carousel. Horses and other animals were asexual, for it was feared that it would offend the young and the female patrons if the stallion were distinguished from the mare, the lion from the lioness, or the stag from the doe. In a few well-known instances realism won out, but these were rare indeed.

At first glance into the carousel, it would seem that the art of the cathedral had overflowed into this profane pleasure vehicle. The glistening golden organ pipes are surrounded by spiraling columns that support an elaborate rococo frame, painted in delicate shades of blue and pink. On either side are half-life-size wooden figures in tights, one beating a tambourine, the other twirling to the cadence of the music and the beating of the snare and bass drums. The figures are animated by attachments to the instrument, and the whole is programmed by a paper roll, very much the way player pianos were operated.

At one time it was thought that all American carousels were of European make: it was the organ that was to blame. Early in this century, before America established its own organ factories, these instruments were purchased from France and Germany. The organ maker's name would be emblazoned in large letters on its façade, along with the address in Berlin or Paris. During World War I, most of the German names were painted over, but the impression remained for many years. Actually, at no time were there more than five carousels in America of foreign make — competition among American makers was too keen. America had five carousel factories in Brooklyn, three in Philadelphia, three in North Tonawanda and its environs in upper New York State, one in Kansas, and one in California.

Carnivals, road shows, and one or two circuses carried their own carousels with them, as well as their organs. C. W. Parker of Abilene and Leavenworth, Kansas, provided many of the carousels and organs for these shows. His own carnivals, called the Con T. Kennedy Shows for his brother-in-law who operated them, employed Parker-made carousels, which he called "Carry-Us-Alls." Parker's factory specialized in portable carousels of small to medium size, easily taken down and put up in a matter of hours. The figures were small and

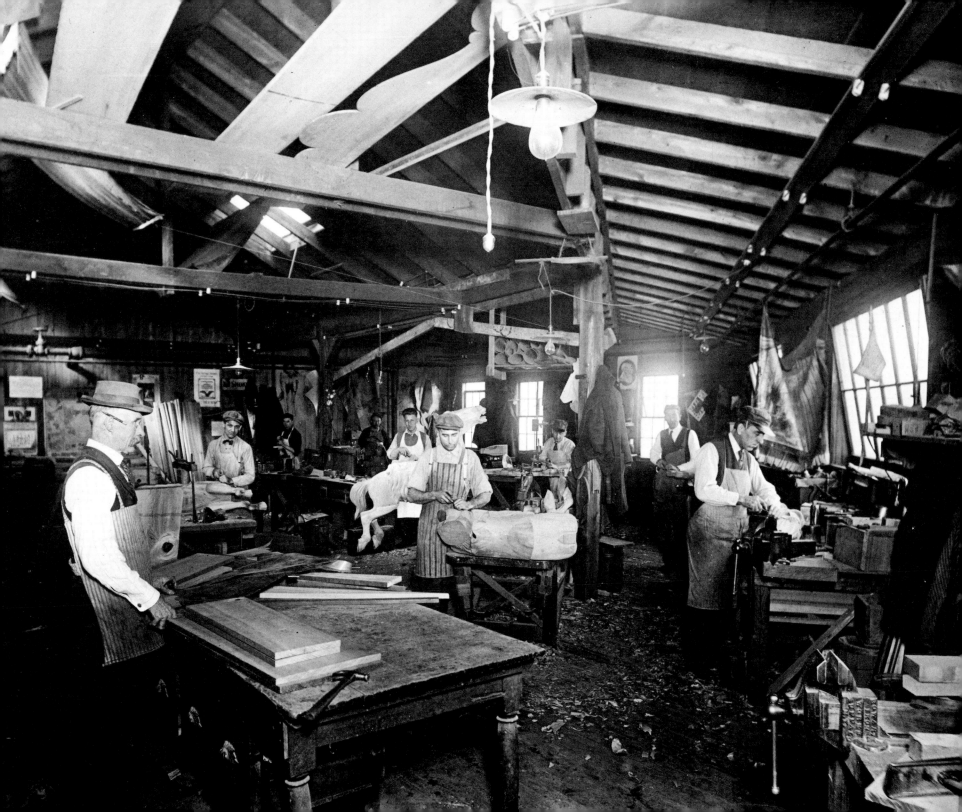

easily stacked in a van or a freight car. The organ was also portable and was provided with its own wagon. In the tradition of the show world, the carvings were most elaborate, decorated with gold and silver leaf on a background painted in pastel colors. The wheels of the wagon were embellished with horns as mud-cutters, faced with twirling trumpets. They were spared the torture of rutted roads by being transported on railroad flatcars with the rest of the equipment. The design of the organ fronts was not too different from that of the Parker "Carry-Us-Alls" made for parks or resorts, especially the outer rim and mirror sections. A category has yet to be decided on for this kind of art, but for want of a better one, it has fallen into the area of folk art. The grotesques of architectural ornament coupled with the studied cuteness of the wingless cherubs, who look more like brats suspended in air or swinging from the draperies, are a far cry from the traditional baroque.

In contrast to the carvings by the Parker factory are the fanciful and delicate rococo creations of Marcus Charles Illions, whose training in England was in the tradition of the guild standards. Illions came to America in the 1890s and established himself on Coney Island, where he helped to embellish the several seaside amusement parks being created there. His sense of design was superb, and he was gifted with a rare ability to execute it in chiseled wood. He carved carousel horses, rims, and mirror frames and beautiful chariot boards and sides. LaMarcus A. Thompson, roller-coaster inventor and builder, engaged Illions to embellish his coaster cars, which looked more like church pews than fun rides. These were not plaster casts but carved wood, each carefully made as if to fill an order for a museum rather than an amusement park. For the entrances to Thompson and Dundy's Luna Park, Illions devised extraordinary ticket booths in the form of Roman chariots, studded with colored-glass gems. Only one of these booths survives to this day, rescued from the great fire in 1946 that destroyed Luna Park forever.

Illions always maintained very high standards, which brought him little money but high regard. Even his competitors admired and copied his work; Charles I. D. Looff, also of Brooklyn, paid him the compliment of remarking to a client, "Of the horse carvers, Mike Illions is kingpin."

There were carousels before there were midways, but there is hardly ever a midway without a carousel. Some have more than one: Cedar Point Amusement Land in Sandusky, Ohio, whose architecture maintains the turn-of-the-century look though surrounded by modern rides, has three carousels, still the timeless favorite.

SHOW FRONTS

The show front was to the common man, woman, and child what the great proscenium of the stage with its music and shifting scenery was to the opera goer. The suspense of anticipating what went on behind the show front was similar to that of waiting until the overture ended to hear the first notes of the prima donna. The purpose of the front was to stimulate such excitement that to resist paying the entrance fee would be unbearable. What one actually saw did not always match one's fantasies or the depictions up front. But at least to the show owner, the show front served its purpose well.

Show fronts came in all sizes, shapes, and materials: painted canvas; carved wood combined with mirrors and scenic panels painted in oils; framed sections of tin painted with legends and scenes; and fronts made of composition materials and fixed in place.

Fronts as well as banners have been used as an attraction at fairs for centuries. The English caricaturist and illustrator Thomas Rowlandson (1756–1827) depicts such fronts in his scenes from Saint Bartholomew Fair. Miles's Menagerie, exhibiting elephants, apes, and other rare beasts, has a barker exhorting the multitudes. Then there is Saunder's Tragic Theatre, with buxom women, masked marauders, and an organ grinder and drummer to attract attention. A mammoth head, into which are fed Punch, clowns, and other human fodder, proclaims "Gyngles' Grand Medley," while a knight in armor addresses the crowds assisted by a dancer with a tambourine. Styles

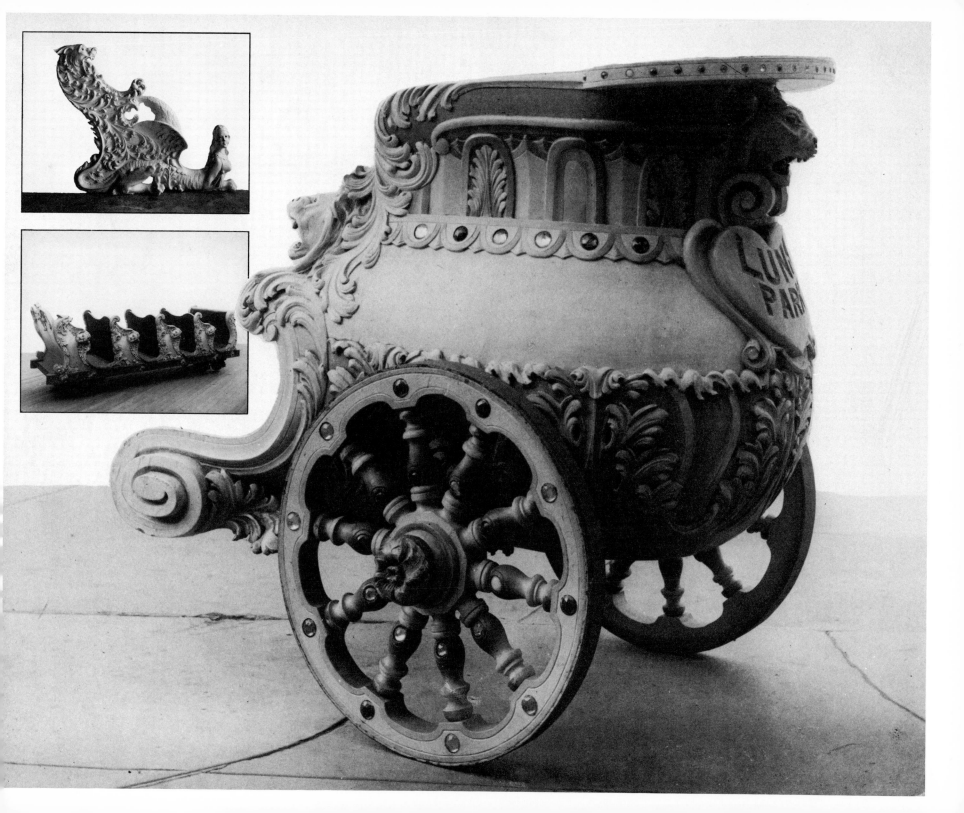

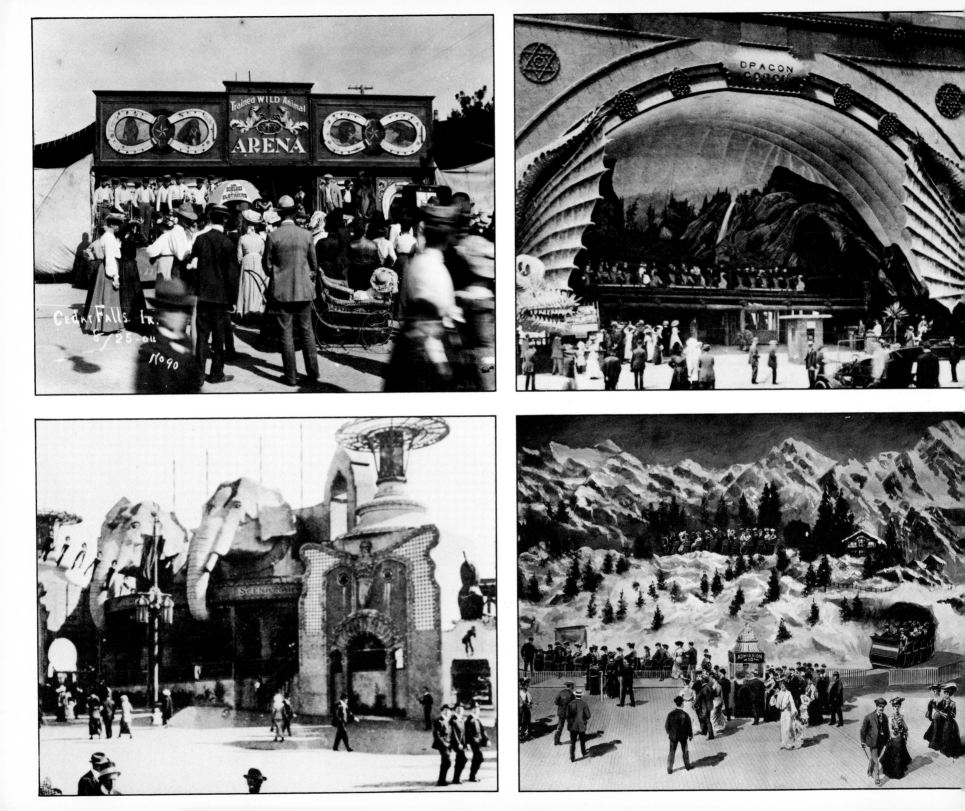

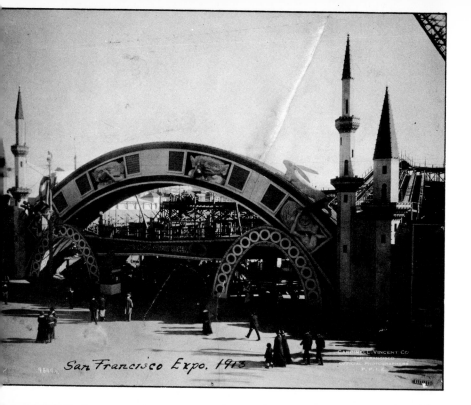

San Francisco Expo. 1913

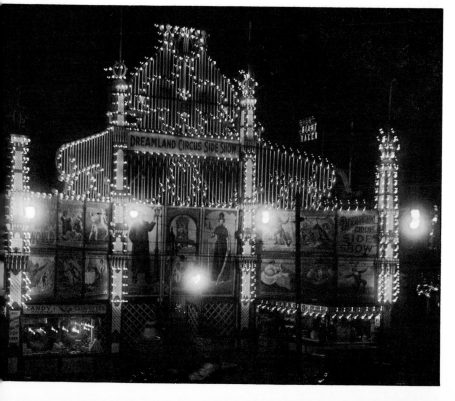

have changed over the centuries, but the pitch is still the same.

A new impetus to the show and carnival and their employment of the front was given by the invention and manufacture of amusement devices at the turn of the twentieth century. The fairs and expositions that attracted thousands were an inspiration to the designers and inventors of these devices. The success of the giant Ferris wheel at the Columbian Exposition in Chicago in 1893 provided a new turn in the design and manufacture of amusements. In 1885 LaMarcus A. Thompson had patented his roller coaster, a very primitive device which became steeper, faster, and safer in the following years. For many such devices the show front was unnecessary, as the visible motion of the ride and excitement of its passengers were advertisement enough. But for those where a mystery had to be created, the show front was the best salesman. At the Pan-American Exposition held at Buffalo, New York, from May to November 1901, one of the great attractions was "A Trip to the Moon via the Airship *Luna*." Its creator and concessionaire was Frederick Thompson, a designer with an extraordinary imagination. His moon trip was an "illusion" with grottos, Lilliputians, electrical effects, and moon monsters. The show front was so successful that on Buffalo Day, October 19, more than 19,000 tourists were carried on the *Luna*. The illusion show was thus established.

The success of this novelty led Frederick Thompson and his backer, Elmer S. Dundy, to other enterprises, culminating in the opening on May 16, 1903, of Luna Park on Coney Island, the greatest amusement park of its day. This inspired other developers, and the result was Dreamland Park, which opened one year later almost to the day

27

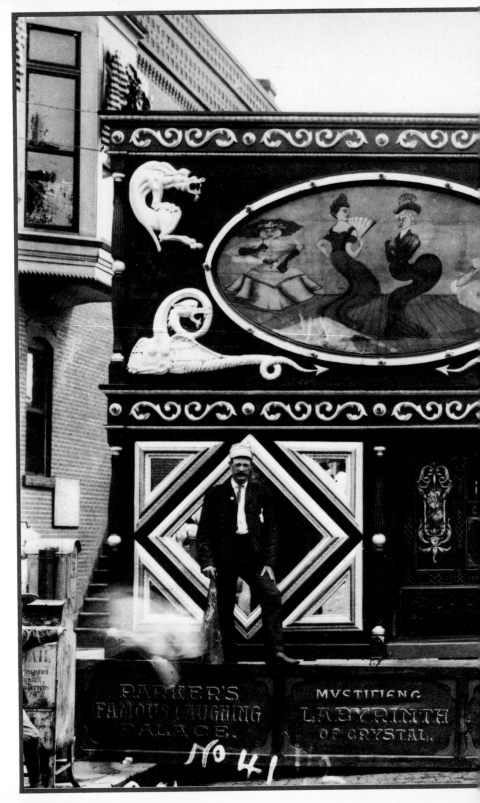

Right Carved and painted façade on C.W. Parker's "Laughing Palace," one of several attractions, Oskaloosa, Iowa, 1904.

a few blocks from Luna Park. For Dreamland, no expense was spared. Gaudy façades fronted on broad promenades with thousands of incandescent lamps strung along the structures. In the center of the lagoon a magnificent tower rose to a height of 300 feet, a fine facsimile of the Giralda tower of Seville. Scenic artists and designers were engaged, some among the very best. For the façade of the scenic railway "Coasting Through Switzerland," a huge show front in the style of an operatic stage was designed by Richard Rummel, a well-known stage designer, and constructed in the spring of 1904.

Other scenic railways and coasters were constructed throughout the country. Some had permanent housing, with entrances and show fronts made of burlap, wire, and plaster, materials similar to those used at the great fairs and expositions. For the Panama-Pacific Expositions held at San Diego and San Francisco in 1915, LaMarcus A. Thompson erected two great scenic railways with equally exciting show fronts. "The Dragon's Gorge" in San Diego and "The Safety Racer Scenic" in San Francisco both were eventually destroyed by fire and replaced by newer devices.

Carnivals and road shows carried their fronts, some of which had been to the Louisiana Purchase Exposition at St. Louis in 1904. Others were inspired by a feature such as "Little Egypt," a hootchie-kootchie show barred and frowned upon by bluenose town officials. C. W. Parker made a great point of emphasizing the purity and wholesomeness of his shows. He also made many of the best show fronts ever to grace an American midway.

Like all show fronts, Parker's were made in sections that could be taken apart for easy transport. For ballyhoo there was a band organ to draw the crowds closer, giving the "talker" the opportunity to enchant them into paying the entrance fee. The show front had carved figures, scrolls, illustrated panels, and lettered signs to lure the patron through its portals. The "Laughing Palace" was nothing more than a set of curved mirrors which elongated, shortened, widened, and thinned the image of the viewer. Such mirrors are now found in most amusement parks, but were a novelty in 1904 and were

28

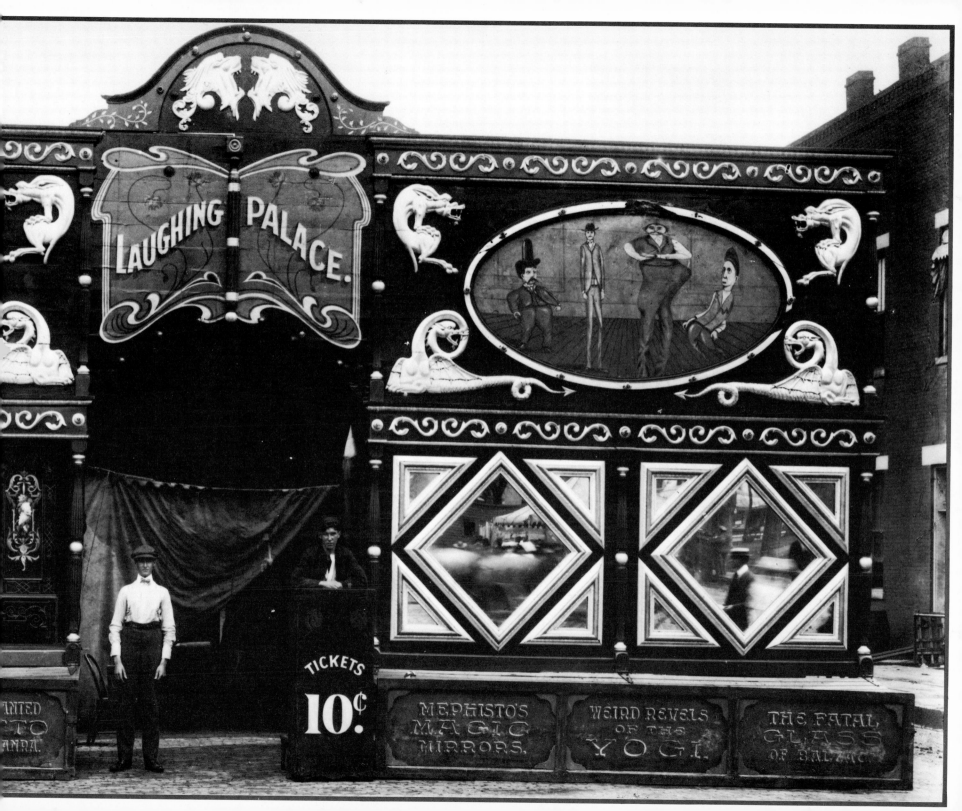

Opposite page Show front, for amusement designed by Hyla F. Maynes, North Tonawanda, N.Y. Oils on canvas. By E. J. Hayden & Co., Brooklyn, 1910.

alliteratively described as "Mephistopheles' Magic Mirrors." Exotic animals were always an attraction in areas where there were neither zoos nor wilderness. Some shows used various stunts so that the roars and shrieks of the creatures would draw the crowds inside the enclosed arena. The C. W. Parker shows had several such acts, with a uniformed band drawing the crowd to the show front.

In 1904 the movies, then in their infancy, were a great novelty. The films were of very short duration and were usually shown between vaudeville acts or in nickelodeons. The inhabitants of small towns or villages without access to theaters had to depend on traveling carnivals to bring before their eyes the great illusion of lifelike creatures moving on a flat screen. To heighten the illusion and the attraction, show fronts proclaiming the wonders of these phantoms of the films were placed in front of the tentlike enclosures in which the films were shown. These tent shows were called "electric theaters" in America, where movies had originated ten years earlier. In England, traveling movie shows were called "bioscopes," and had magnificently carved fronts as prosceniums. The C. W. Parker show fronts were smaller but scarcely less magnificent in their carvings. A program note for the Capitol Theatre in 1921 could well have served as a sign on one of these fronts: "When you enter these portals you stray magically from the dull world of confusion and cares into a fairy palace whose presiding genius entertains you royally."

Some of Parker's carved show fronts contained elements from his carousels adapted and grouped so as to appear different. Carousel mirrors and rim sections placed on a straight line composed an interesting front which served its purpose well in a traveling carnival. These fronts were also made for sale to other shows and carnivals.

The inconvenience of carrying about and setting up the heavily carved wooden front which it took several strong men to handle, as well as the time and expense required for making it, were reasons for its decline. It was replaced by the large canvas front supported on a telescoping pipe frame or on one of wood hinged with drop bolts. The canvas fronts were painted by scenic artists, who also did stage drops

and backgrounds for vaudeville shows, operas, and theaters. One such firm was E. J. Hayden and Company. Edward J. Hayden started his business at 108 Broadway in Brooklyn in 1896 and continued at this location for over twenty years, supplying shows, vaudeville houses, theaters, and merchants with scenery, stage drops banners, and signs.

Niagara Falls was not simply an attraction for honeymooners and for tightrope walkers and daredevils who went over the falls in barrels. It was also an inspiration for the developers who devised flume or water rides. The most famous of all such rides was Paul Boyton's "Shoot-the Chutes" at Coney Island. Another developer was Hyla F. Maynes of North Tonawanda, New York, whose proximity to Niagara Falls inspired him to design two "wet" rides, "Over the Falls" and "Witching Waves." "Over the Falls" was constructed about 1910 with parts or ideas borrowed from Frederick Thompson's version of Jules Verne's *Twenty Thousand Leagues Under the Sea*. The show front, measuring more than 30 feet wide and 20 feet high, depicts a rocket flight into the waves while a Buck Rogers type snatches a mermaid from the waves in lustful embrace. On the other side are lovers in a canoe and a daredevil caught in the current going over the falls. The crowd outside offers an interesting commentary on the times: the discarded Cracker Jack box at extreme right, the boy scouts with their merit badges, the clothing and hair styles of the men and women, and the concessionaires and ticket taker. Time passes, the attraction is no longer the same, the front fades or wears out, and another is substituted. The ticket taker is the same but older; the concessionaire and his assistant, though still on the platform, have aged and grayed. But the front is new: the name is now "Witching Waves" and the rocket ship and its captain are more in the style of Flash Gordon. The scenic artist, however, is the very same: E. J. Hayden and Company of Brooklyn.

Lighting was no great problem for the stationary front, so long as electric current could be supplied. The small shows had a large supply of naphtha lamps, which emitted an unpleasant odor. Some

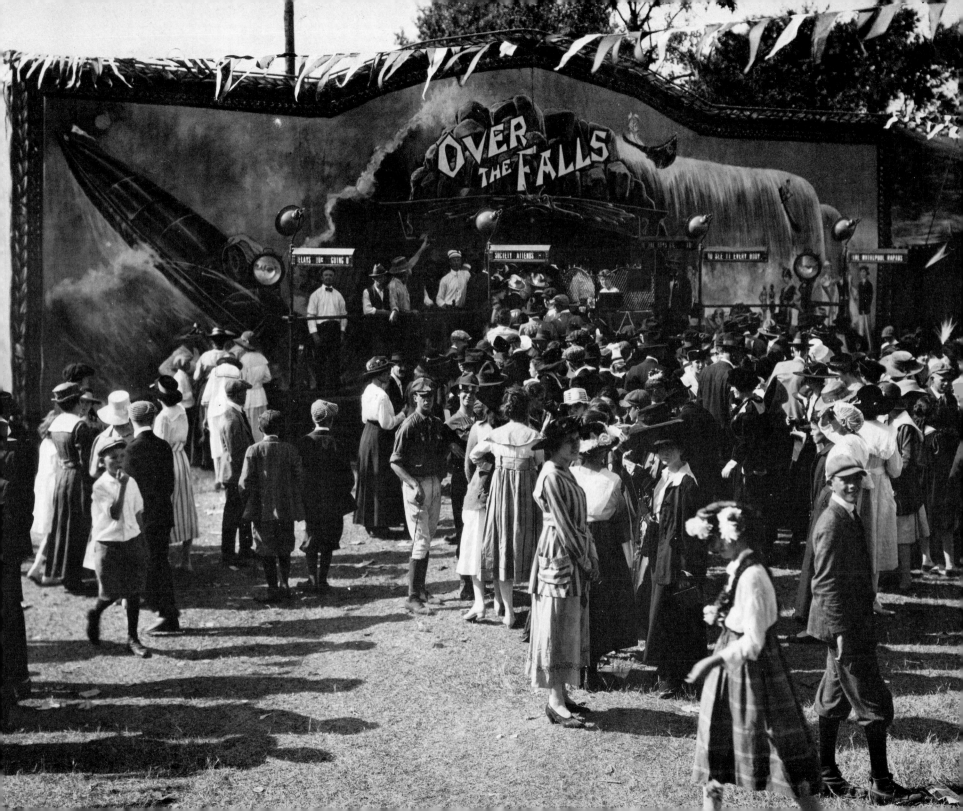

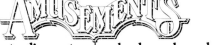

Opposite page
Inset Lucy, the "preposterous pachyderm" at Margate, N.J. An "architectural folly" when erected in 1882, it is now a national landmark.

Large photo Roller coaster, tower, and ticket booth to "Gulliver's Travels," with 100-foot-long Gulliver waiting to be explored. Revere Beach, Mass., 1918.

shows carried small generators, but these had a tendency to dim out the lamps or to fail completely. The brilliance of the Mazda lamps was an asset for any show, changing darkness into daylight; many shows that installed them took the name of "White City." The Dreamland Circus side show at Coney Island had General Electric install 1,000-watt Mazda lamps in their front, which "shone like a million fireflies in the dark" and gave brilliance to their double row of banners.

AMUSEMENT-PARK ARCHITECTURE

There are hardly any amusement parks in America today where the architecture of the turn of the century still remains. At one time the seashores of the Atlantic and Pacific were dotted with towers and turrets, piers and playland palaces, inspired by the tales of *The Thousand and One Nights* and whatever came to the minds of the designers sitting at their drafting tables. The architecture they created had no name; for want of a better one it has become known as "Seaside Baroque" or "Brooklyn Baroque," inspired by the many amusement parks along that two-mile strip of land called Coney Island. But the fantasy of fun is as ephemeral as its architecture; what fire and storm do not destroy, man does. The Astroturf of the sports arena has replaced the family park and its grassy knolls at the end of the trolley line, and instead of the movie palace the office building now dominates the city, dimming its lights after five and closed on Saturdays and Sundays.

Phineas T. Barnum's influence on the various aspects of amusements was enormous. His own home, Iranistan, referred to by critics as a "hodgepodge of domes, minarets, spires, piazzas, and lattices," may have been a source of ideas for later amusement edifices. However, it was not this Oriental villa in Bridgeport, Connecticut, that inspired one real-estate promoter to build one of the most unusual hotels in the world; it was the announcement in 1882 that Barnum

had purchased the mammoth elephant Jumbo. The elephant arrived at the New York docks on April 9, 1882, and on June 3 James V. Lafferty of South Atlantic City, New Jersey, filed a patent application for a hotel in the shape of the fabled Jumbo. Patent No. 268,503 was granted the following December 5, but construction of the elephant began before the patent was issued. Its over-all length was 75 feet; over-all height, 85 feet; height to floor of the howdah, 65 feet; its total weight was 90 tons, and it cost $38,000 to build.

The patent papers showed drawings of circular stairwells in the elephant's hind legs that led to the main hall in its body; other stairwells led to the howdah. The trunk led into a feeding trough, concealing the supports that held up the forward section of the elephant. This also had pipes leading to a sewer below for the elimination of "slops, ashes &c." The outer construction was of tin sheathing on a wooden frame. There were twenty windows, plus the two 18-inch portholes that served as eyes. The success of this "preposterous pachyderm" was so immediate that Lafferty built a second and larger one at Coney Island, advertised as the "Elephantine Colossus." It was constructed at West Brighton Beach in 1884 and reached a height of 122 feet. When it opened for business as a hotel in 1885, *Scientific American* compared it—somewhat tongue-in-cheek—to two contemporary monuments, the Statue of Liberty and the Washington Monument, as one of the Eight Wonders of the World. A third and the smallest elephant was built at Cape May, New Jersey, and was known as "The Light of Asia." This was razed in 1900; the "Elephantine Colossus" at Coney Island, surrounded by a roller coaster that seemed to imprison the elephant in a stockade, burned to the ground in 1896; while our first elephant, at South Atlantic City, now renamed Margate, is still intact and affectionately known as "Lucy."

In 1967, Lucy was offered for sale. It had deteriorated so badly that it was condemned and closed to the public several years before. A committee of local citizens was formed, who had the structure recognized as a historic landmark and official Bicentennial site. In 1970, when Lucy was scheduled for demolition, the newly organized Mar-

Right Architectural fantasies for LaMarcus A. Thompson's "Safety Racer" and William H. Dentzel's carousel, San Diego Exposition, 1913.

gate Civic Association persuaded Lucy's owners to present it as a gift to the City of Margate. Funds were raised to remove Lucy to its new site, two blocks away, where restoration has been taking place.

The 1893 Columbian Exposition in Chicago, with the Ferris wheel astride the midway, had its effect on the architectural design of the amusement parks that were to follow. Its pools, fountains, canals, and moats in various forms were used in many ways, sometimes as the splashdown for the shoot-the-chutes. Its monumental sculptures also influenced fun-park designs. But the structures of Luna Park, erected in 1903 on the site of Sea Lion Park in Coney Island, were the inspired creation of Frederick Thompson. His towers and temples of fun may have had their origin in the Byzantine and Moorish forms so much in fashion at the time. The effect was sufficiently astonishing at its opening to evoke editorials comparing Luna Park to the Taj Mahal! The nighttime brilliance of Luna's lights can be gauged by its impact on the Russian author Maxim Gorky on his visit to Thompson and Dundy's park: "With the advent of night a fantastic city all of fire suddenly rises from the ocean into the sky. Thousands of ruddy sparks glimmer in the darkness, limning in fine, sensitive outline on the black background of the sky shapely towers of miraculous castles, palaces, and temples. Golden gossamer threads tremble in the air. They intertwine in transparent flaming patterns, which flutter and melt away, in love with their own beauty mirrored in the waters. Fabulous beyond conceiving, ineffably beautiful, is this fiery scintillation."

On a cold, wintry day in December 1911, to paraphrase Gorky's description, the ruddy sparks set fire to the fantastic city, limning on the black background of the sky flaming patterns which fluttered and melted away in this fiery scintillation. Luna Park burned to the ground. It was built up again, and then had several more fires. Finally

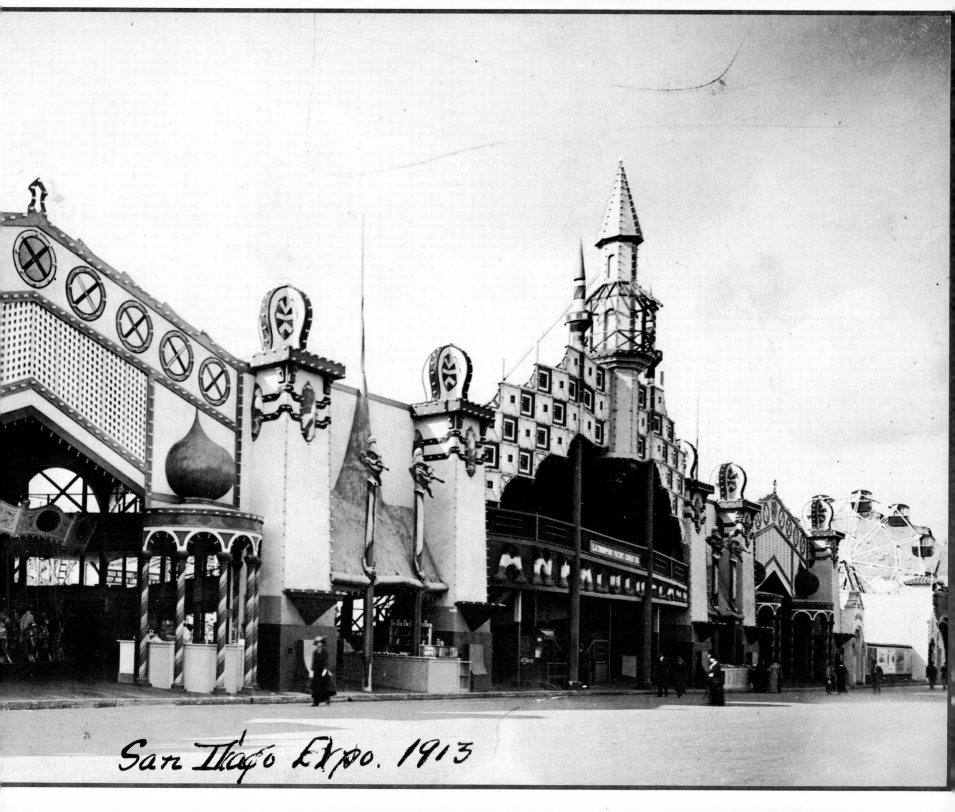

San Diago Expo. 1913

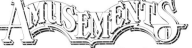

in 1946, a fire destroyed the park forever.

The construction of amusement parks was not like that of the present-day theme park, where an entire area is planned at once and carried out in a matter of two or three years. The early parks were built one or two rides or attractions at a time, others being added according to growth and fiscal stability. Wood was the material generally used, as it was abundant and cheap and could be shaped into whatever design was desired. The exceptions were those devices that were to be shaped into mountains for scenic railways, caves with stalagmites and stalactites, and other uneven surfaces. The scenic rides designed by LaMarcus A. Thompson, James J. Griffith, and S. E. Jackman were housed in pavilion-type structures. Those scenic railways devised by Thompson had the most fanciful of all structures in parks throughout the United States and Europe. The interiors were nearly all alike, with gallery-type accommodations for the passengers. A huge soda fountain, faced in marble with silver faucets and shaped like a doll house, was at one end, a lunch and souvenir enclosure midway, and a dance and beer hall at the other end, facing outward toward a lake or pond. On an upper level a brass band played for the riders and picnickers. As time went on, these rides gave way to newer, steeper, and much larger versions, and unfortunately none of these charming structures exist anywhere today.

LaMarcus Thompson's Pacific Coast Company erected pavilions at San Diego and San Francisco to house his Safety Coasters, each with a front derived from Aesop's fables or inspired by Hans Christian Andersen's fairy tales. There were also minarets, towers, arches, and bulbous Byzantine motifs. These 1913 creations were part of the developing phase of amusement-park architecture. World War I brought a halt to much of the construction. In late 1918 Thompson's "Oriental Ride" was built with a terminal incorporating vaguely Oriental and Egyptian elements and said to have been inspired by stage settings for the opera *Aida*. Constructed at Revere Beach near Boston, Massachussetts, this ride became very popular, encouraging the developers to expand and to install other attractions. One was a prone figure of Gulliver, 100 feet long, through which one adventured in semidarkness after first purchasing a ticket at the "Oriental" ticket booth—topped by an American eagle. A handy ladder inside Gulliver's jug enabled the intrepid ticket holder to pop his head up out of the cork to assure himself of the reality of the outside world.

The colossus at Revere Beach remained long enough to be imitated by LaMarcus Thompson at his resort at Rockaway Beach at the southern end of New York, with Coney Island just a few giant strides away. "Miss Rockaway," her head fashioned after that of the copper-coated symbol of liberty in New York Harbor a short swim away but retouched to represent a flapper of 1925, was a novel attraction. She was billed as "Miss Rockaway 1925 Realms of Joy." Who could resist her outstretched hands that drew toward her breast the ticket holder, who entered with expectations of getting his money's worth and who later exited through her left armpit? Miss Rockaway was later swept out to sea, along with the boardwalk and the Thompson roller coaster. Found floating nearby was the sign that had been to the right of Miss Rockaway: "Miss Rockaway 1925 Feast of Folly."

On May 21, 1965, Steeplechase Park, one of America's earliest and greatest amusement parks, closed down forever. Erected in 1897 by George C. Tilyou on the sands of Coney Island, it was named for its mechanical racecourse with large wooden horses coasting on a single track by the momentum of gravity from an inclined station. In 1907, fire broke out and consumed the entire park. Undaunted, Tilyou ordered that a mammoth steel and glass building be erected on the property. Tilyou died in 1914, but the park continued and prospered under his son Edward's direction. The architecture of Steeplechase Park was in the contemporary greenhouse, or conservatory, style. On its block-long glass façade was painted the most famous amusement-park logo of all time-the toothy, smiling gent with hair parted down the middle. Demolition ended the last great vestige of old Coney Island, and an era of nostalgia and haunting memories began.

Miss Rockaway

BANNER PAINTINGS & PAINTERS

CHAPTER ~2

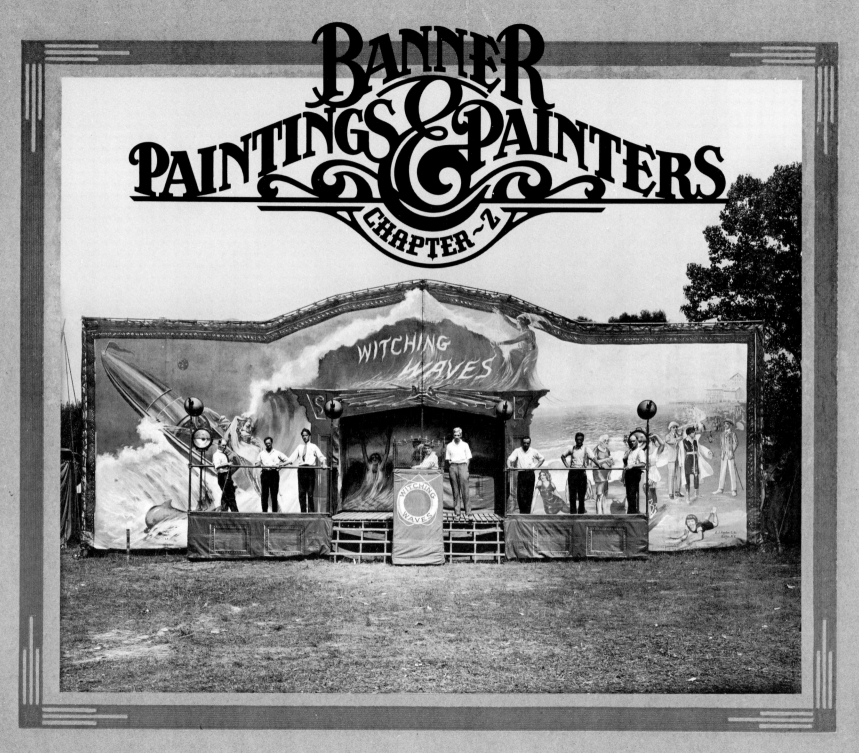

Preceding page Show front, for ride designed by Hyla F. Maynes, North Tonawanda, N.Y. Oils on canvas. By E. J. Hayden & Co., Brooklyn, ca. 1915.

Below "The Truants," showing banners on the circus lot. "The Old Time Circus," drawings by John Wolcott Adams, *Harper's Monthly*, 1910.

Opposite page Banner line of the Al G. Kelley & Miller Bros. Circus, Loveland, Tex., 1950.

Before you get into the circus tent, show ring, or stall and deposit your money with the ticket taker, your choice of entertainment is in front of you, bigger than life, although rarely lifelike. The huge painted canvas banners, usually strung on a line by the dozen, illustrate in vivid flesh tones the mammoth, 540-pound Baby Irene; Sealo—part man, part seal; Percilla the Monkey Girl; P. T. Barnum's Sensational Attractions; and many other oddities and rarities to entice the public inside. Hardly ever does the attraction approximate the art of the banner painter. Yet it is the banner that draws your attention and the change from your purse.

"The secret of the banner art is color, and never mind if you exaggerate the subject matter. The idea is to attract attention. We call it 'flash.'" This bit of confidence comes from Fred G. Johnson, at eighty-

four the oldest living banner painter, born in 1892 and until 1976 still actively painting bearded ladies, two-headed men, sword swallowers, snake charmers, and other side-show oddities all over the nation. "I can't climb the ladders or walk the plank any more to do the big jobs, but I can still do the smaller ones." Johnson still does an occasional job for the O. Henry Tent and Awning Company in Chicago, which also makes banners.

Banners made of canvas and fitted with grommets, rings, and pulls come in any size to order, 8 to 16 feet wide across the top and usually 8 feet in height. On special orders banners have been made to cover an entire show front. An early banner supplier, the United States Tent and Awning Company of Chicago, advertised in its 1911 catalogue: *Prize Fight Banner. One banner, 34 ft. wide across the top, 15 ft. high. Lettered, "Original Johnson-Jeffries Fight. Reno, Nevada, July 4th, 1910." Doorway in center, 8 ft. wide and 7 ft. high. On one side of the doorway is a picture of the arena, with Johnson and Jeffries in the ring, with their referee. Lettered underneath the picture, "The First Round." Picture on the other side of doorway represents the arena showing Jeffries knocked against the ropes, and the referee giving the count ten, to count him out. Lettered "Knock-Out Blow. The 15th Round." Over the doorway are the bust pictures of Johnson & Jeffries, with their names under each picture. Has been used two days.*

The price for this mass of art and history (in 1911) was $55. Other banners in the catalogue picture the wildest, weirdest, and most wonderful of human, superhuman, and supernatural phenomena on this earth and beyond. Their wild exaggerations are in tune with the American desire to live up to the Barnumanian concept of "the greatest, the biggest, the most wonderful and the best."

Banner paintings represent a true native expression embodying the character of the American people. They are the visible extension into our adulthood of the fairy tales of our childhood. They represent our dreams and our nightmares, the living proof of all the threats and fears fostered within us by fact and fiction. They represent our fascination with the macabre, the grim, the gruesome, the ghastly and horrible, as well as our admiration of strength, courage, and

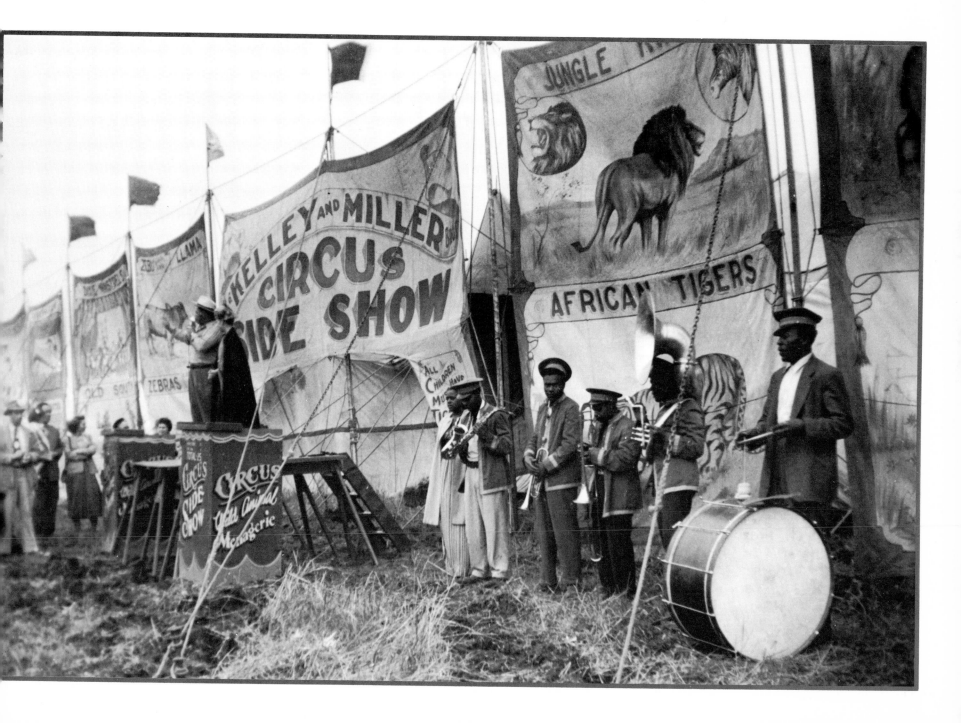

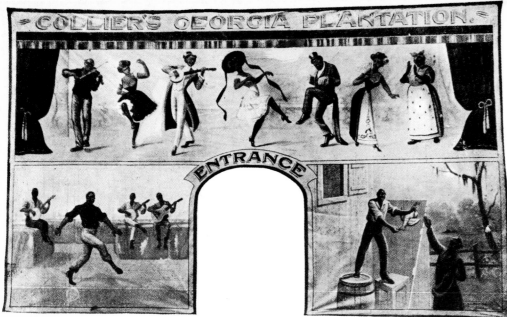

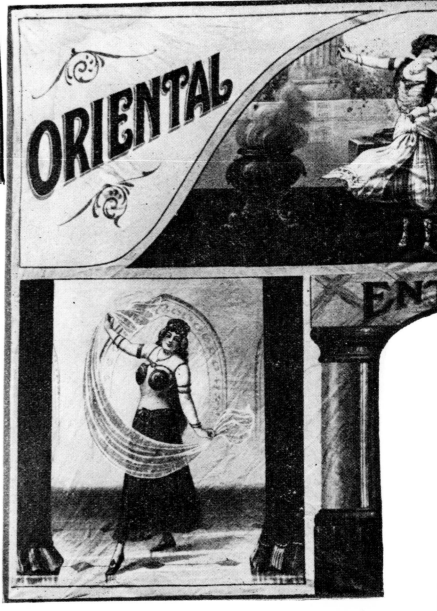

Above Banner paintings for "Collier's Georgia Plantation," minstrel show, cakewalk, and novelty acts. By H.C. Cummins, 1911.

Below Banner painting for vaudeville tent show. From 1911 catalogue of United States Tent & Awning Co., Chicago. F. Johnson Collection.

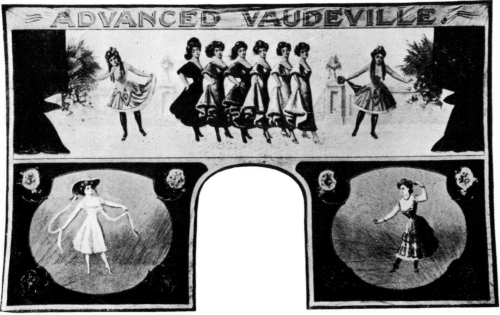

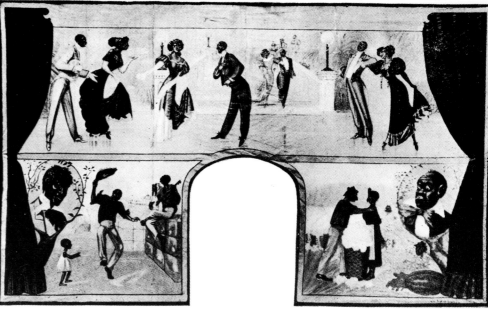

Center Banner painting for Little Egypt-type tent show. By Nieman Eisman for United States Tent & Awning Co., 1911.

Above "Plantation to Plenty" banner painting for Negro variety-acts tent show. Attributed to H. C. Cummins, Chicago, 1911.

Below Banner painting for vaudeville tent show. By H. C. Cummins for United States Tent & Awning Co., 1911.

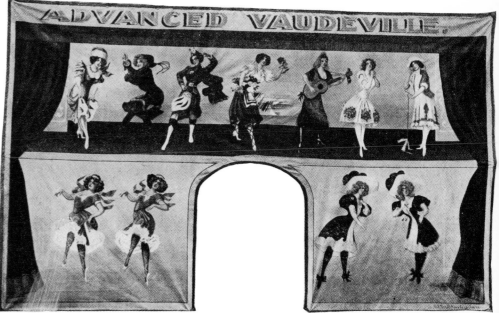

humor. The world of reality has limits; the world of imagination is boundless. The imagination of the banner painter makes him more than a storyteller in paint and canvas. He is, in a way, the poor man's Hieronymus Bosch in pieces and patches.

Banner painting is not an ignoble profession. Such illustrious persons as William Hogarth, Benjamin West, Matthew Pratt, and Edward Hicks at one time or another painted signs and political banners to supplement their earnings from their easel paintings.

Early engravings and photographs of P. T. Barnum's American Museum in lower Broadway show the art of the banner painter embellishing the façade with works of art two and three stories high and very much a part of the American scene. Banner paintings were a part of the medicine shows that toured the country offering the magical snake oil guaranteed to cure all known ailments. Banners were also carried by Chautauquas for educational and cultural purposes. Touring exhibits hung their banners outside the tents where curios, crafts, and minor works of art were on display for an entrance fee. Thompson's American Museum of Genuine Curiosities exhibited and sold a wind-up toy of two dancers. The banner for this exhibition is similar to two illustrations in the 1891 catalogue issued by the Ives, Blakeslee and Williams Company of New York, one named "The Famous Dancing Darkies," the other, "The Mechanical 'Cake Walk' Dancers." The canvas is unsigned.

Another type of exhibit was "The Herculean Task of Years," shown at its commencement in a banner painted by J. Bruce. This first of two banners shows Joseph Bergmann, the "Inventor," looking into the future as he sits at his workbench in his shop, with a sketch on the wall, blueprints on the bench, and tools scattered around. The second banner, "The Inventor Incessantly at Work for 17 Years to Complete the Cherished Labor of His Life," shows Bergmann still at work on his creation, a model or doll house three stories high with wings and porches. This banner too is signed "J. Bruce, 321 Court St., Brooklyn, N.Y." The paintings, though not dated, must have been done between 1878 and 1883, as Joseph Bruce was at this address only during these years. Bruce, an artist like his father before him, did much of his later work at 600 Broadway, where he continued painting scenery, stage drops, and portraits.

In 1883, "Elephant Joe" Josephs, banner, fresco, and sign painter, was forced to give up his shop in Buffalo, New York, to make room for another structure. The façade of his sign shop, which occupied the entire building, was probably the most highly decorated one of its kind and is recorded on a huge canvas he painted for the dedication of the building in 1869. (See Chapter 4, page 89)

Minstrel, medicine, and tent shows that traveled carried their own banners. Joseph Hallworth (1872–1958), known professionally as Karmi, had his own tent show with his wife and sons in which they performed various acts, live magic, and sword swallowing and showed early movies. Hallworth was a typical itinerant performer, playing dime museums, circuses, showboats, vaudeville, and, in 1900, the side show of Buffalo Bill's Wild West Show. He retired from the road when one of his sons became a soldier in World War I. His show carried three banners illustrating the various acts performed and two irresistible "thriller" movies of the early days of the flicks. "A Journey from This World to the Next—THE GREAT TRAIN WRECK" and "Automobile Dash for Death Down a Mountain One Thousand Miles an Hour," vividly depicted, prove that the current movie and television craze for havoc, murder, and gore is not a new fad. These banners date to about 1905 and were painted by E. J. Hayden and Company of Brooklyn.

Banner painting is one of the unrecognized American arts, but except for a handful of show people and a few circus, carnival, and show buffs, no one knows much about this art or who made it. Hardly any attention has been paid to the instances when the artist signed his work or to the firm's signature. Banner painting has never before been seriously considered as art. In view of the present flourishing interest in American folk art, the work of the banner painter, like the work of our unschooled and "naïve" artists, has taken on a new interest, although much of this work is labeled "artist unknown." Yet it has been said that this form of art has had more viewers than the fine art in museums and galleries.

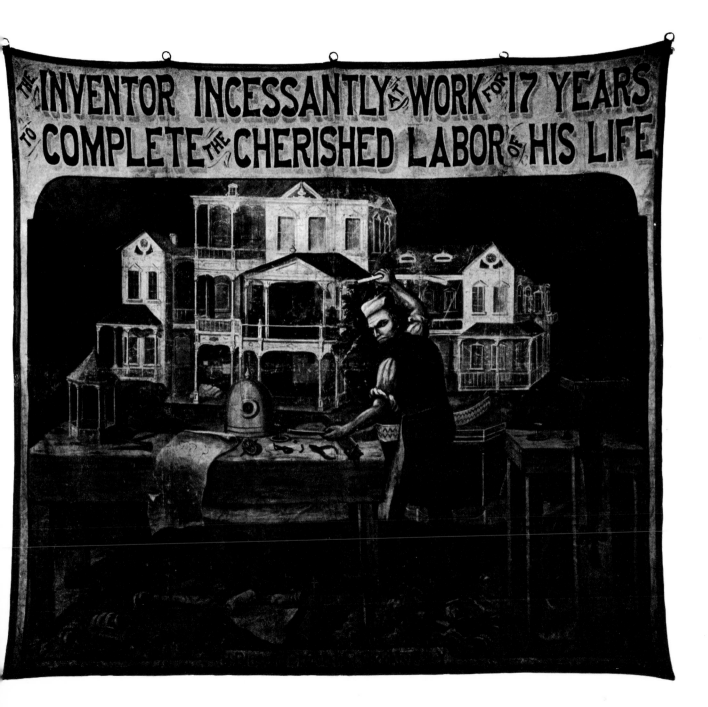

THE INVENTOR INCESSANTLY AT WORK FOR 17 YEARS TO COMPLETE THE CHERISHED LABOR OF HIS LIFE

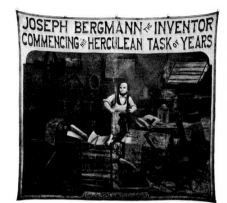

JOSEPH BERGMANN THE INVENTOR COMMENCING HIS HERCULEAN TASK OF YEARS

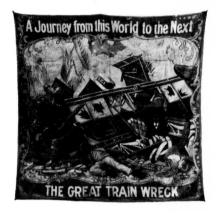

A Journey from this World to the Next

THE GREAT TRAIN WRECK

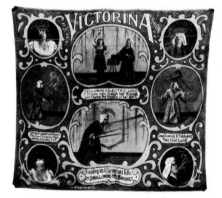

VICTORINA

BANNER PAINTINGS & PAINTERS

The art and techniques of banner painting varied with each of the painters. In general, banners painted for the circus were intended to deliver a rapid graphic message. As the visual effect was supposed to be immediate, the artist concentrated on the over-all effect rather than on detail. The gathering crowd need not be literate to know what the attraction was in the tent.

Painting the canvas for shows or show fronts required more flesh tones, a larger palette of colors, more blending, and greater detail. The artist spent more time taxing his skills to the maximum, and the crowds spent more time viewing his work, often getting a greater thrill from it than from the exhibit. The banner, however, was never intended as a work of art, but rather as a passing attraction. Because it was to be folded or rolled up and packed with the equipment to be strung up again in different locations and exposed to varying climates and weather, it was not expected to endure. The fact that many banners have survived is a tribute to their creators.

Fred G. Johnson describes his technique: "It took me five hours on a 10 by 12 foot banner (average). I work fast. Procedure—tacked up canvas on a frame or solid board (I had one 10 foot high by 40 feet wide and one 10 by 30 feet), tacks about 5 inches apart. I sketched in the subject with charcoal and then inked in the subject with a thin black paint to keep the outline. I *wet* the canvas and gave it a thin coat of white lead (I cannot get it any more) on top of water, oil, and benzine. Next I put in the background and figures . . . let it dry overnight, and the next day the finishing touches. For reference, I have all kinds of books, colored pictures of animals, freaks, etc." The finished banner was not given a coat of varnish, as this would make the canvas too stiff and cause it to crack.

Fred G. Johnson's colors were similar to those of his early coworkers in the first two decades of the century. His palette consisted of "light chrome yellow or lemon yellow, deep chrome yellow or orange chrome, bulletin red (bright), burnt sienna, burnt umber, ultramarine blue, Prussian blue, medium and light chrome, green, lampblack, aluminum." He used "japan dryers, boiled linseed oil, benzine, charcoal, white crayons, and of course, the main thing, Dutch Boy white lead, paste form. Red lead for borders. Brushes: chisel-edge bristle, flat 1½-inch, ¾-inch, ½-inch, ⅛-inch for finishing. For laying in, 2-, 3-, 4-, 5-inch bristle. No nylon! as they did not work on wet canvas."

In his notes to the author Johnson tells it like it was. "I was born on January 25, 1892, in Chicago, Illinois. My father, Louis Johnson, came from Norway; my mother, Cordelia, from Ohio. I was one of nine children, the seventh, and born with a special talent. Having graduated from grade school in 1906 I went to work as an errand boy for the United States Tent & Awning Co. in Chicago—7 A.M. to 5:30 P.M. at $4 per week. I was recommended by a neighbor, a sign painter who worked there. There I met a bearded artist by the name of Davenport who was painting banners—Wild West holdups.

"Worked there for about a year and got another job in a printing plant, was transferred to another department—advertising, under a commercial artist, Frederick A. Farrar, a cousin of Geraldine Farrar, the opera star. Jobs scarce until March 1909, the year Taft was inaugurated, the same neighbor, Maurice Healy, recommended me to a banner painter for the United States T & A Co. by the name of H. C. Cummins. Worked with him until fall, when show business was bad. Next, got a job with a decorating company which dealt in art also. In the spring of 1910 Mr. Cummins coaxed me to come back at much better wages, so I accepted. Got married in 1914. World War I broke out so show business was bad again, got a job painting ammunition trucks for the U.S. Army. 1918, war over, returned to the U.S. T & A Co. again and was given a studio all by myself; at that time they had three other artists—Cummins, Nieman Eisman, Anderson. Later there were three more—Davenport, Lee, and Tucker. Time marches on, then came Manuel and Chamberlain.

"1921, Walter F. Driver, part owner of the U.S. T & A, pulled out and with his brother Charles in charge of tent making formed the Driver Bros. Tent & Awning Co. They offered me a proposition and I accepted. 1926, Walter and Charles separated, he and I and a sailmaker

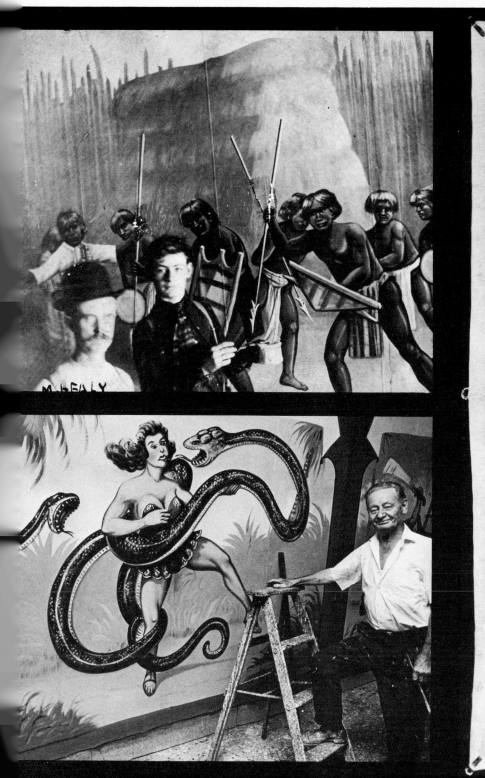

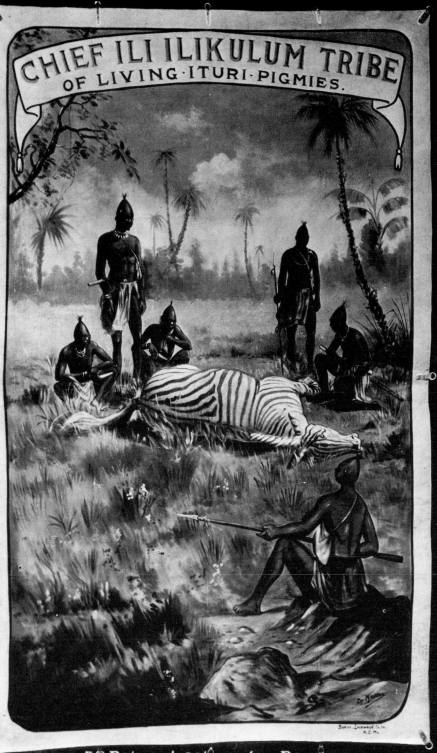

CHIEF ILI ILIKULUM TRIBE
OF LIVING·ITURI·PIGMIES.

A·Baker-Lockwood Banner

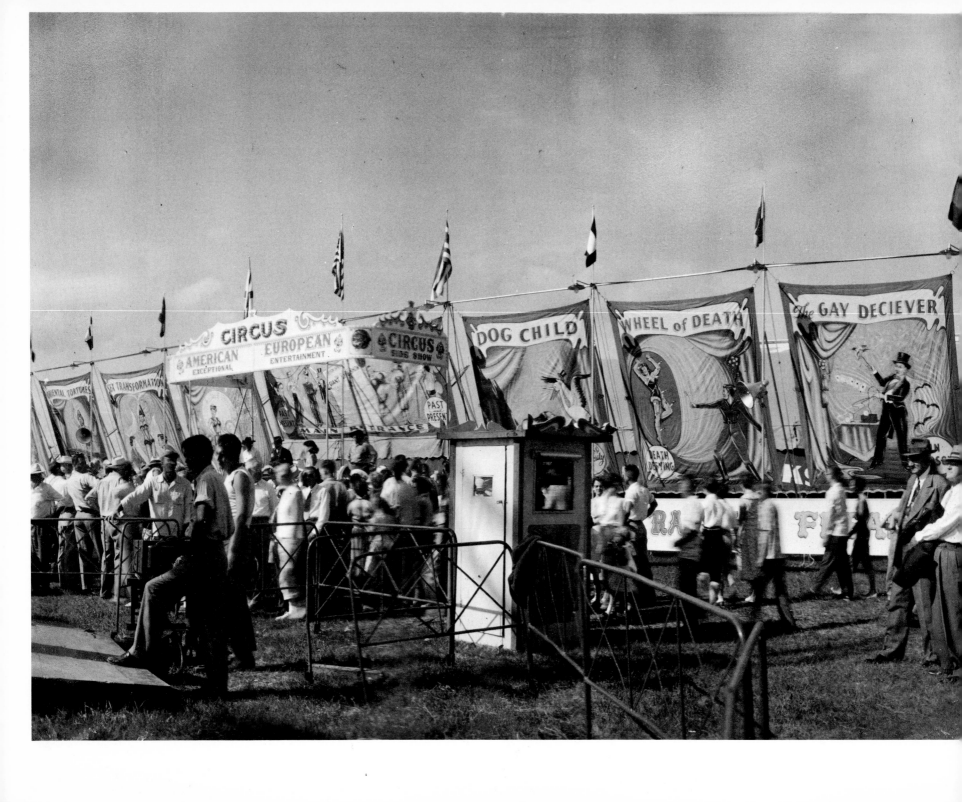

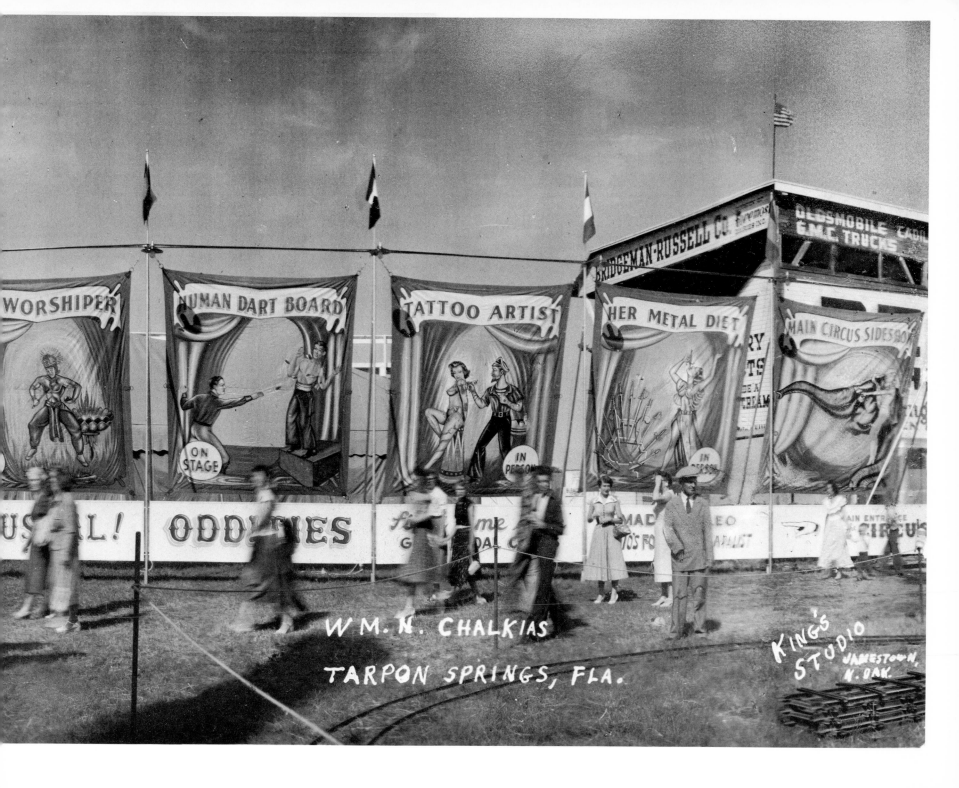

formed the Chas. G. Driver Tent & Awning Co. 1927, we went bankrupt—too much pressure from W. F. Driver, so back to W. F. Driver, business was good. 1930, W. F. Driver voluntarily went bankrupt, so out again. Nieman Eisman and a helper started for themselves. They offered me a chance to go with them, but W. F. Driver promised to open a studio. So then he made arrangements with Wm. A. Iden Canvas Products, but it didn't last long so out again, so I started my own shop in my garage. Chas. G. Driver got connected with the O. Henry as a partner, and as we were always good friends he got in touch with me in 1934. There I remained until December 31, 1974."

After sixty-five years in the banner business, Johnson is amply qualified to pass judgment on the work of contemporaries. "I rate the artists like–Millard—*good*; Bulsterbaum—average; Cad Hill —*very good*, much detail. I didn't know them but saw their work. H. C. Cummins—very good drawing, not so much flash. Davenport— free and easy. Manuel—very good for show business. Lee and Tucker —figures stiff, good coloring. Anderson—good on scenery. Chamberlain—no comment.

"Nieman Eisman was best—referring to side-show banner work for showmen who were well pleased with his type of work. Cad Hill, who I did not know—only saw his work—was very much in detail, too good for banner work.... The biggest banner I ever painted was for the Red Feather Drive in 1950, which hung 125 feet high by 25 feet wide from the roof to the entrance canopy of the Carson Pirie Scott store at Madison and State in Chicago. I also made banners for all the big ones and smaller as well:

Circuses	Sparks	*Carnivals*	Midget Twins
Ringling Bros.	Clyde Beatty	Rubin Gruberg	Mexico
Barnun & Bailey	Cole Bros.	Morris & Castle	Hawaii
John Robinson	Mills Bros.	Johnny Jones	Germany
Sells Floto	Haig & Haig etc.	Mike & Ike	South America etc.

And the Circus World Museum at Baraboo, Wisconsin."

During his years as a banner painter, Fred Johnson passed on many of his "tricks" to the younger men, but now he does only easel paint-

50

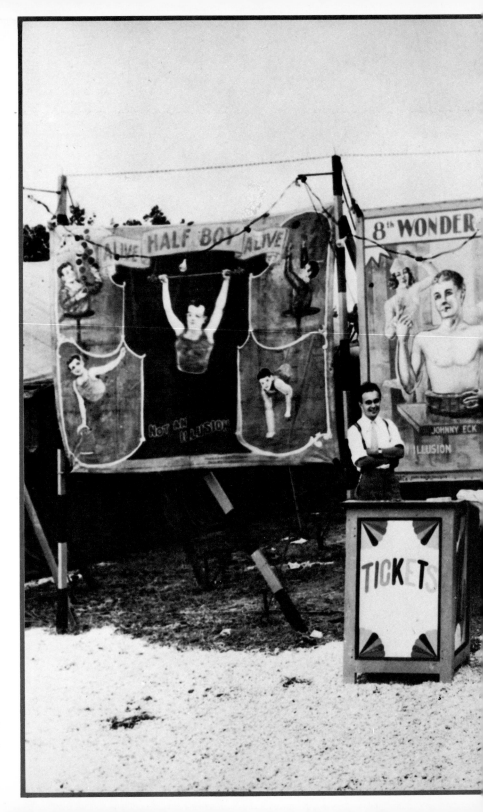

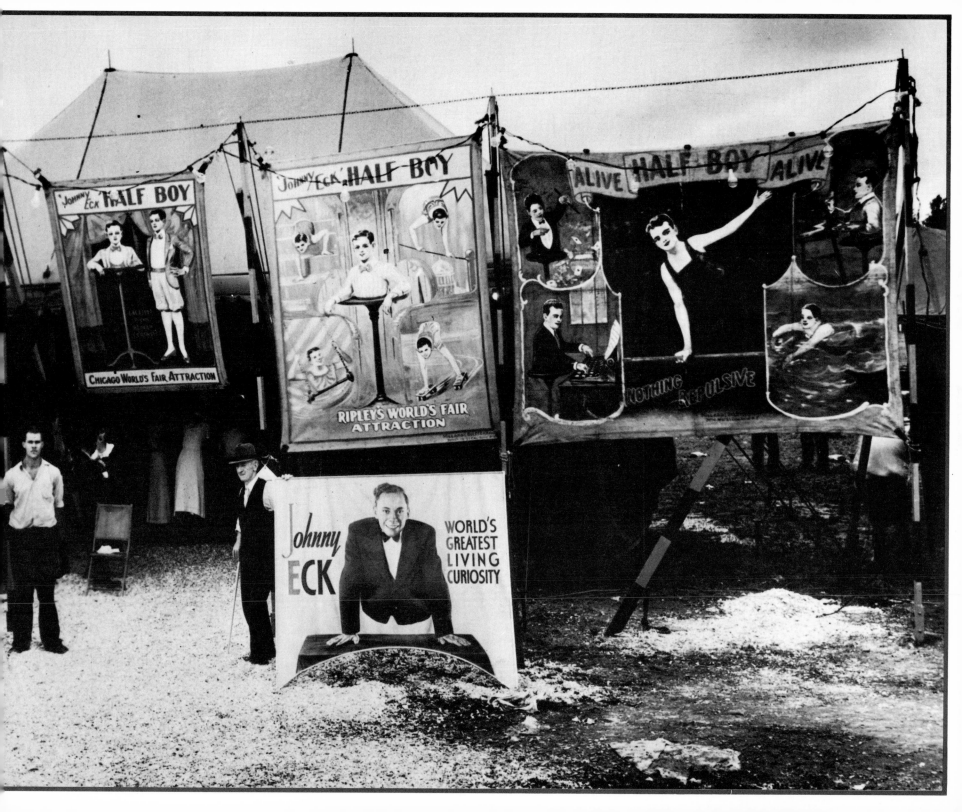

ings. "I only paint small pictures now, that I can sit down and do at an easel. Also . . . it takes about five hours on an 8-by-10 banner. Small paintings take much longer, as there is more detail and not particularly made for flash."

Robert F. Wicks, known everywhere as Bobby Wicks, is a former banner painter and tattoo artist and now a retired show-front painter. "I've put in close to sixty years of covering up nondescript objects with pretty pictures, flashy colors, and adding the eye appeal to entice the show-going public to spend their money. My start in outdoor show business came after my association with the 400 Group of artists who exhibited on the streets of Greenwich Village. The Depression played havoc with me—moneywise—so I took to the road."

Wicks was born in Brooklyn on April 30, 1902. His formal education ended upon his graduation from elementary school. He went to work for $3.65 a week and received his pay in silver coins. After a few jobs he eventually went to work for John and Frank McCullough in Coney Island, painting shooting galleries and loading tubes with 22-rifle shells. In 1915 he went to work for the Wildman Company, sign painters at Coney Island, where he rapidly adapted his talent to this work. "It was way back in 1916 that I painted the signs for Nathan Handwerker at Coney Island in New York. I think it was on the cor-

ner of Surf Avenue at Stauch's Walk. About then I became acquainted with Millard and Bulsterbaum, whose banners were the flashiest ever seen, with the orange mineral predominating. While the banners of Cad Hill (who was located in Providence or someplace in Rhode Island) were beautifully artistic but not quite as flashy as those glaring Millard and Bulsterbaum creations. I visited their shop on 8th Street and learned a few tricks. Just about that time Snap Wyatt worked with Millard and later became a banner painter, following that line since 1916 or 1917 until the present time.

"In 1931 I started painting scenery and show fronts, continuing this new endeavor for over forty years, a little over twenty of them with the Royal American Shows of Tampa. It has been twenty-five years since I was active in the banner-painting business, although on special occasions I would do them on short notice, like the last one I painted for the Lorow Brothers while the Royal American Shows played at Calgary about fifteen years ago. I painted banners for Betty Hartrick—two double-sized ones I painted for her Geek Show about 1947. Also for the Tracey Midgets, for whom I painted a set for the Midget Horse Show. . . . After retiring about four years ago (1972) I have produced many easel paintings with an occasional show front. But no banners.

"My easel painting yields a better income by far, and there is no deadline as with banners. Some of the paintings are of events and people or shows and life of my early years in outdoor show business. I could never live long enough to put on canvas the incidents, the people, or the times of long ago—Sig Sautell, Joe Ferrari, George L. Dobyns, Tex Austin, Major Gordon Lillie. I met Buffalo Bill on a subway train—IRT—I was delivering telegrams for the Postal Telegraph Company."

Bobby Wicks's paintings for the "Inquisition Show Front" have no comparison for three-dimensional effects, vivid color, and design. During the winter season he repaints carousel animals, chariots, and band-organ fronts. He is also in demand as a portrait and historic-scene artist. Bobby Wicks is full of memories of his youth in Brooklyn and may one day put it all together in a book of his own.

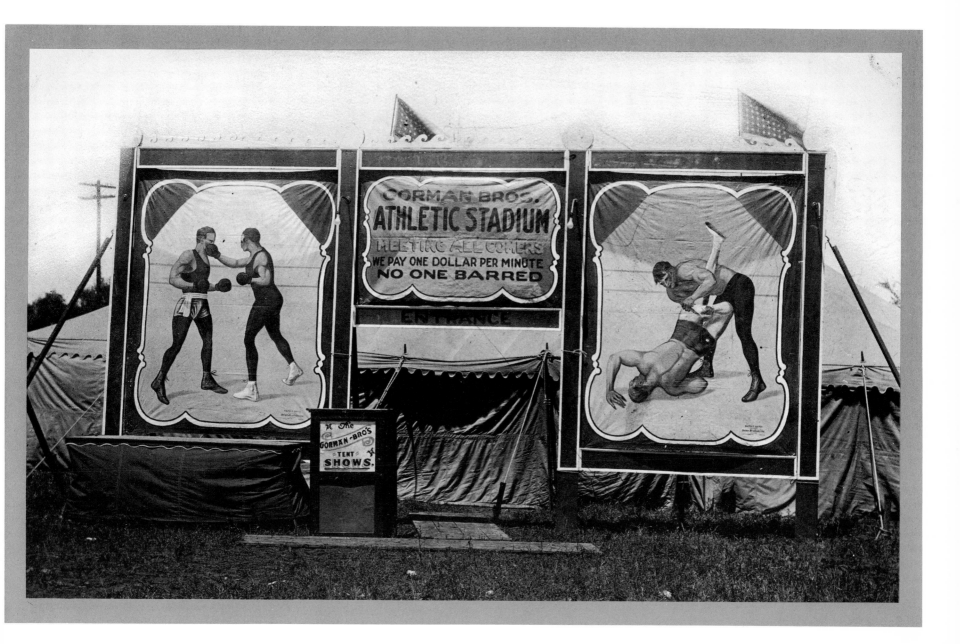

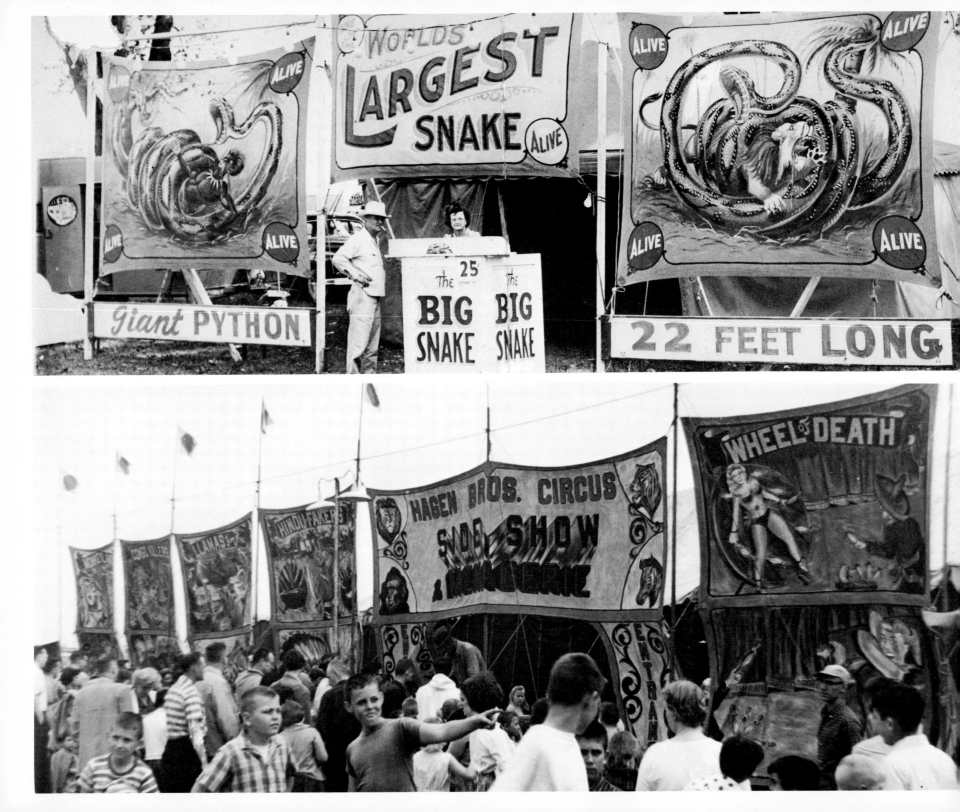

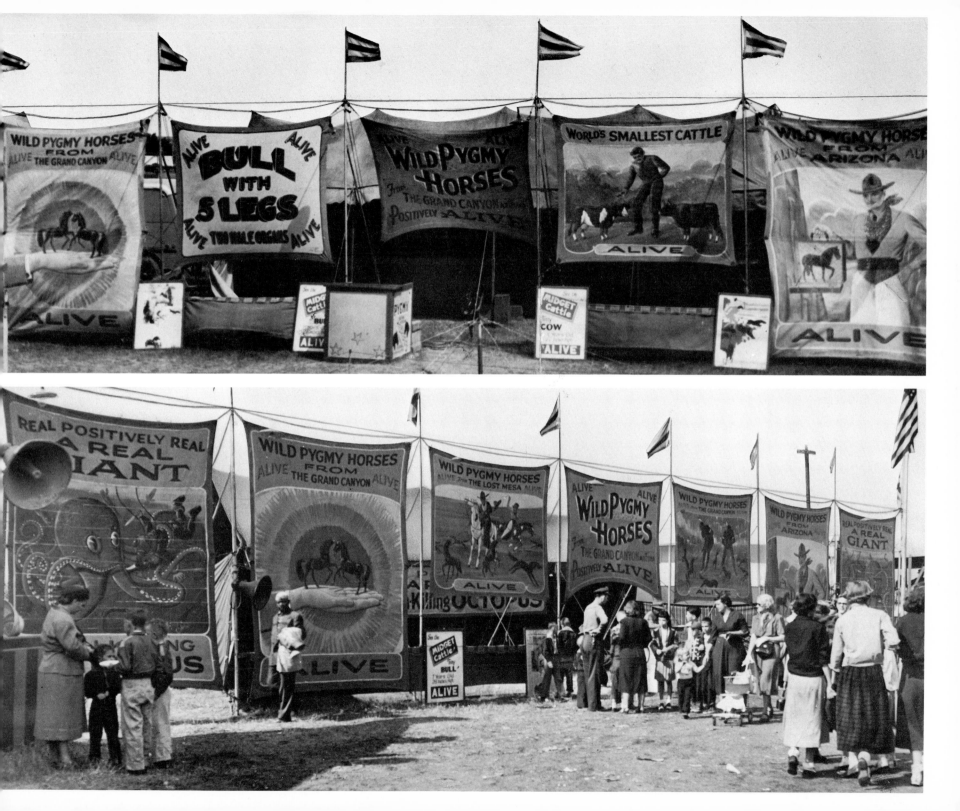

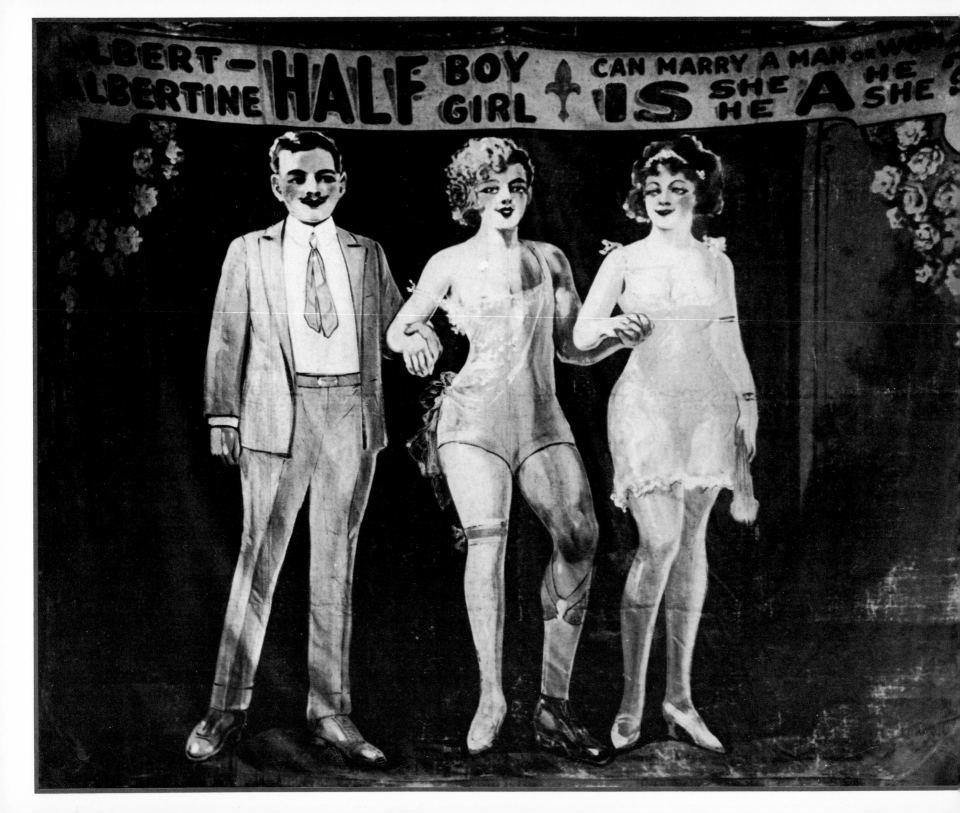

Left Banner painting of Albert-Albertine, half-boy, half-girl. Attributed to Snap Wyatt.

Algernon W. Millard opened his first shop in 1909 in Coney Island, and at times worked out of his home on 40th Street, Brooklyn. About 1912 he opened up a small shop on West 8th Street in Coney Island, and had as neighbors the William F. Mangels Company, makers of carousels, shooting galleries, and all types of amusement devices. His other neighbors were the police and fire departments, while across the street was Luna Park. His shop kept him busy enough to take on an assistant or two, one of whom, a young man named Dan Cassola, was adept at religious subjects and furnished the churches with banners painted on silk.

Millard is believed to have been related to a family who were ship carvers from the Revolutionary period and had their shops along the East River until the end of the last century. About 1915 Millard joined up with John Bulsterbaum, and the new firm of Millard and Bulsterbaum moved a few doors down the street to a larger shop. Coney Island was still the largest amusement area in the United States, and the various side shows, carnivals, and amusements kept the firm busy painting signs, banners, and show fronts and decorating amusement devices. In 1966 a large number of banners bearing the stenciled names of Millard and Bulsterbaum were discovered in a storage area over a Coney Island Dodgem ride. Nearly all had deteriorated badly—it seemed that all the pigeons of Coney Island had been nesting in them for decades—but enough was left to reveal the brilliant colors for which Millard was known. During the latter years of the Depression, the firm disbanded.

"Ask Any Showman" was the slogan and trademark of Snap Wyatt, one of the very few banner painters with a formal art education. David Clarence Wyatt had studied with John Bianchi, a theatrical and banner artist in Asheville, North Carolina. Wyatt, born in Asheville on October 12, 1905, had also studied and worked with a local artist, Mrs. Ida Crawley. When he was fifteen, itchy feet got him moving across the country, with a preference for the Southern states. That year he painted a ticket-box banner: "I added war tax and showed an iguana in oil for the Hagenbeck Wallace Circus side show in Asheville, and I think that was my first banner." Then, working for John

Bianchi, he did a theater backdrop showing the Statue of Liberty with a background of the American flag. The name "Snap" has stuck with him since his early days when he traveled from carnival to carnival, circus to circus, "hopping quite a few freight trains in doing so."

During the great Florida real-estate boom in the 1920s, Wyatt worked for Louis Francis, making real-estate panoramas. "Sometimes I painted in fire plugs, paved streets, lakes, trees, and houses that were not there as yet. Real-estate companies sold property and lots from these painted scenes."

Snap Wyatt settled next in Coney Island and applied for an art scholarship at Cooper Union in Manhattan. During the next four years he kept at his art studies there with but one interruption: he was called to Sarasota, Florida, to do a special job for the Ringling Brothers and Barnum and Bailey Circus, but then returned to Cooper Union. Upon graduation he went to work for Messmore and Damon at the "dragon" factory, creating sculptural animated figures and painting scenery, banners, and show fronts. "This was the largest firm of its kind in the world at that time. I worked on 'The World of a Million Years Ago,' a show of life-size prehistoric animals which was displayed in many of the world's fairs." In 1937 Snap and Cortez Lorow designed and built an "Animated Torture Show" depicting the many tortures used during the Middle Ages. It traveled across the United States and Canada with the Great Royal American Shows, who had winter quarters in Tampa, Florida.

"I painted all kinds of banners and related subjects and also did scenery. After creating, designing, and executing several of my own shows such as 'Fantasma'—a show of zombies, werewolves, and monsters, these were all animated figures, they talked, screamed, and made various weird sounds—I created a special monster with a pinhead and a single horn in the center of his head and named it 'Arrango.'" He went on to make "Nightmare Alley," with monsters, spiders, duck men, and others. The giant spider with a human head was 5 feet wide. Wyatt also did a "Whale Show": the whale was 30 feet long and had helped guide a submarine through the Northwest Passage under the ice. "It was a dilly of a tale they told about this

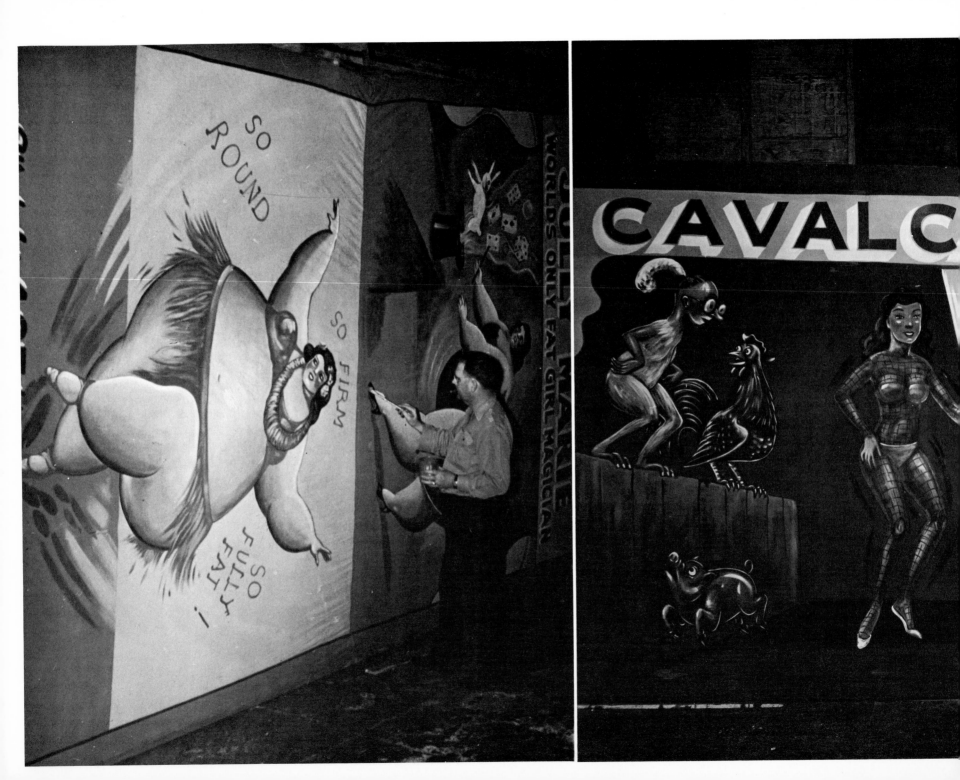

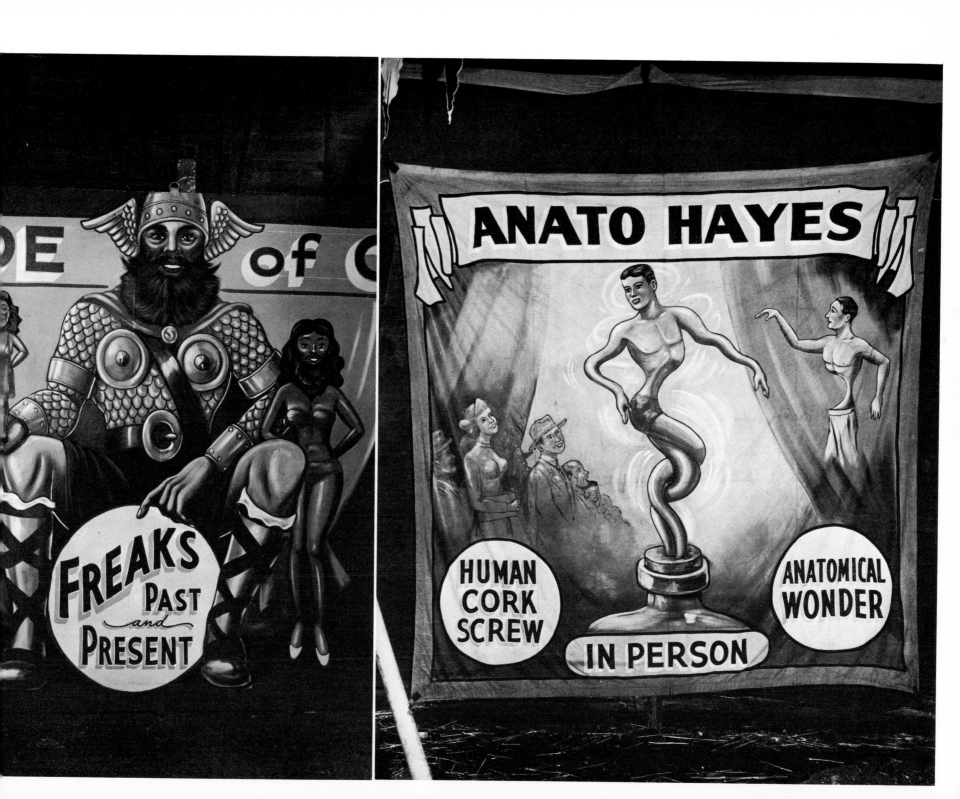

Preceding pages, left to right
Snap Wyatt banner of "Jolly Marie, World's Only Fat Girl Magician."

Freak show banner painting by Snap Wyatt, Gibsonton, Fla., Undated.

"Anato Hayes, Human Corkscrew and Anatomical Wonder." Banner by Snap Wyatt, Gibsonton, Fla.

Below left August Wolfinger painting the banners for the Times Square Flea Circus in the Schork & Schaefer penny arcade. Oils on sign painter's cloth, mounted on plaster boards.

Below right Two banner painters admiring section of large show front they have just completed for Sigler Sign Service. Jack B. Sigler, left; "Tattoo Jack" Cripe, right.

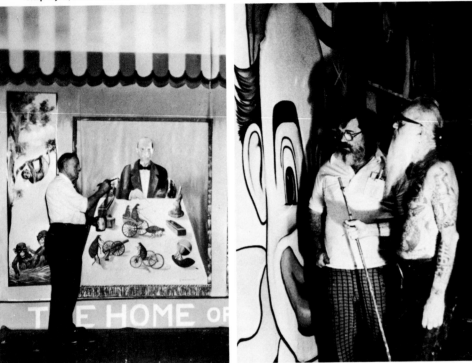

whale. These were my own shows, which traveled with the six largest carnivals in the country. I also dug up the Cardiff Giant again, which I made and sold to several showmen."

From time to time Wyatt did banners and scenery. "I also wrote and had published two books on papier-mâché. I think I painted banners for nearly every show or carnival in the U.S. and maybe more than any of the banner painters—this covers a period of forty years. The type of painting was oil on canvas, using orange and red backgrounds. I even once made an ocean red on a gaff banner. Millard, some called him Al, he was with Merrifield before Bulsterbaum came into the picture, we called him John—Merrifield, Bulsterbaum, and

Cad Hill were the three top banner painters of their time. All these men were good friends with me, and Merrifield was at one time partners with me. I was younger by far and learned from all three."

August Wolfinger, who was known up and down the shores of Long Island and Brooklyn in the 1920s, was one banner artist who considered his fine-arts background a justification for signing his decorations, signs, and banners. A reporter for the *Brooklyn Eagle* went so far as to call him "the Michelangelo of the Midway." Wolfinger had studied fine arts in Mainz, Germany, where he was born on November 4, 1879. One of his early major assignments was the decoration of the immense lobby of the Hotel Victoria in Wiesbaden. He then specialized in stained-glass-window murals, many of which are said to still adorn churches in Switzerland and Germany. In 1906, at the age of twenty-nine, he came to the United States with his wife and two-year-old son and settled in the Yorkville section of Manhattan. His artistic efforts took him to several areas in the United States. In Hickory, North Carolina, he did a mural for the First National Bank. He painted a portrait of Washington in the Oddfellows hall in Albany, New York, and did ornamental work in Saint Joseph's Church in Newark, New Jersey.

Wolfinger eventually moved to Brooklyn and drifted into amusement-park decoration and banner painting. When asked what led him to this change—cathedrals to carnivals and carousels—he replied, "An artist relies on his imagination, and the imagination is quite an unpredictable force." This same force drew him into painting those sideshow banners that decorated the fronts and drew the curious into the hot, dark interiors to view the Crocodile Girl, the Lady Elephant, Dora the Bearded Woman, the Human Skeleton, and other wonders and whims of nature. To compensate, Wolfinger also painted the panels, horses, and rims of some of the great carousels for which Coney Island, Brighton Beach, and Rockaway were noted. He worked sometimes on his own and sometimes with his son-in-law, Charles Riebold. The William F. Mangels Company, Coney's biggest ride manufacturer, employed Wolfinger as a free-lance artist to decorate their new rides and the many carousels they built for parks,

beaches, and carnivals all over the United States. "I used to watch Wolfinger," recalled Bill Mangels, Jr., "doing the dappling on the dapple-gray horses. He'd take some old *Daily News* pages, crumple them up in a tight ball, and twist them in the wet gray paint over the white. Boy, you'd see that horse change color so fast you couldn't believe it was really happening. That man was an artist." Wolfinger also painted shooting galleries and did the decor for dance halls.

On December 1, 1950, August Wolfinger was struck down by an automobile while crossing the street.

In the changing world of the amusements, not much of Wolfinger's work remains. However, the B and B Carousel on Surf Avenue in Coney Island has some of his most romantic scenes on the backs of its chariots and on its rims. The walls of the building also are decorated with his paintings, which are signed. The carousel at Rye Beach, New York, has some lovely scenic paintings on its chariots. And almost unnoticed in the heart of Times Square, a set of banners, painted by Wolfinger for the Schaeffer and Schork Flea Circus, vividly show the attractions that once drew the crowds. The circus is long since gone, but the panels, dusty, torn, and brown with age, still testify to an era when the art of the banner painter outdrew the neon sign.

Approximately three miles south of Tampa, Florida, is Gibsonton, the "Carnival Capital" of the East Coast. The shows in the area depend on two Tampa residents, banner painters Jack B. Sigler and Jack Cripe, working as the Sigler Sign Service, to illustrate their attractions. Bobby Wicks and Snap Wyatt live in the same locality; Wicks is still active, but Wyatt's health has forced him into involuntary retirement.

Jack Sigler's father, Clarence Grant Sigler, settled in Tampa in 1945, after he developed a heart condition and was advised to move to a warmer climate. Mr. Sigler, born in Roseville, Ohio, in 1897, moved to Akron at fifteen and was employed by the Goodyear Tire and Rubber Company. It was during this period that he studied commercial art at the Chicago Art Institute. In 1928, he left Goodyear and started the Sigler Art Service. Among his clients were the vari-

ous theaters, especially the circuits such as Loew's and Orpheum.

Jack Sigler was born in 1925 and worked with his father part-time after school and on Saturdays until he entered the United States Navy in 1943. After serving until May 1946, Sigler joined his father in the banner-painting business and also took courses at the Peter Eikland School of Art on the GI Bill. In 1950 the firm name was changed to Sigler and Son. After Clarence Grant Sigler's death in 1959, the business was carried on by his son and by Jack Cripe, known as "Sailor Jack," a banner painter and tattoo artist. Cripe had joined the Sigler firm in 1947 with seventeen years' experience as a banner painter, having worked for Snap Wyatt and the Siglers off and on. Cripe had also been with the William Chalkis Gold Medal Side Show, where he "took to swallowing swords, bayonets, and stove pokers" while also exhibiting himself as the Tattooed Man. "I actually have done most of the tattoos myself—I couldn't afford someone else to do them." Not all were done by himself. "A blind guy named Sailor Katzy did this one for me," he said, pointing to his arm. "Funny thing, he was a snake handler, six years ago he was crushed to death by his own pet python."

Sigler and Cripe work harmoniously together but deplore the infrequent use of the canvas banners. "Now, they're all your panel fronts—aluminum." A normal 5-by-10-foot banner, according to Sigler, takes a day to complete from the first rough sketch to the last stroke of the brush; the huge ones require four or five days. "Generally you start to make a sketch, get a good idea in your mind, then you draw in your panels and fill them in." Asked how he gets his ideas, Sigler admitted, "You copy a little and use your imagination mostly. You put them together and that's what you wind up with." Sigler has added the airbrush to the artists' tools and has a system of changing the corners on his borders each year.

Sigler and Cripe are two of the few still-active banner painters in the United States. Neither worries about the art dying out when they retire: "I suppose someone will come around and start." With such confidence, perhaps the art will never die.

BALL-TOSS GAMES

"Knock down one, you have them all!" Such was the call on the fairgrounds in eighteenth-century England. Such was the claim from the owner of the stick-toss stall, who had on his racks snuff-boxes, tobacco boxes, and other trinkets of small value, or else halfpence or gingerbread placed upon low stands. Children were enticed to lay out their coins for permission to throw at apples and oranges set up in small heaps. A halfpenny was the usual price for one toss at a distance of about 10 or 12 yards.

This game was derived from a brutal game of ancient origin known as "throwing at cocks." Throwing at cocks was a very popular diversion, especially among young men. Thomas More wrote in the sixteenth century about his skill as a youth at throwing a stick or cudgel at a cock. It was universally practiced on Shrove Tuesday, the season of carnival, or Mardi Gras. Joseph Strutt's *Sports and Pastimes of the People of England,* first published in 1801 in London, notes: "If the poor bird by chance had its legs broken, or otherwise so lamed as not to be able to stand, the barbarous owners were wont to support it with sticks, in order to prolong the pleasure received from the reiteration of its torment." This cruel practice was forbidden by law at the turn of the eighteenth century. Benjamin Heath, writing about the Scilly Isles in 1750, notes of St. Mary's that "on Shrove-Tuesday each year, after the throwing at cocks is over, the boys of this island have a custom of throwing stones in the evening against the doors of the dwellers' houses; a privilege they claim from time immemorial, and put in practice without control, for finishing the day's sport; the terms demanded by the boys are pancakes or money, to capitulate. Some of the older sort, exceeding the bounds of this whimsical toleration, break the doors and window shutters, &c. sometimes making a job for the surgeon as well as for the smith, glazier, and carpenter." After the practice of throwing at live cocks was abolished, a variation of the game was practiced using forms or facsimiles of cocks made of wood, tin, or paper. The privilege of throwing at the cock for a small

64

sum was rewarded with the form itself if it was overturned. This version of the game was never popular, and eventually it disappeared from the fairgrounds.

In America as late as the 1920s, an equally brutal game was in practice at seashores, fairgrounds, and festivals. Also advertised as a game of skill, it was to be found in nearly all areas of the country, the North as well as the South, and was engaged in by all classes of people. It was called "Hit the Coon," "African Dodger," "Dump The Nigger," "African Dip," "Coon Dip," and many other derogatory variations of the foregoing. The usual device was a painted canvas of a scene, usually a cotton plantation, with a hole large enough for a human head. The target was a black man, who stuck his head out through the hole and tried to get out of the way of the ball. Small prizes were awarded for a direct hit.

In 1878 the C. W. F. Dare Company of New York offered these painted "Negro Head Canvases" at the price of $9.50 for a 6-by-8½-foot size. The catalogue noted: "This kind of Hand Ball Target is popular at all places of resort, Church Fairs, County Fairs, etc. They are ornamented with oil paintings, of various and appropriate designs, similar to the illustration. Grummet holes are worked in the border, so they are complete, ready to tie up or suspend, as circumstances require."

Along with the canvases the catalogue offered "Negro Heads" made of wood—live targets were not always eager or available, and up against a deadly pitcher the "dodger" often refused to continue. The catalogue stated: "We give the price of Heads separately, as live Heads are often used instead." The "Boy's Size" head sold for $5.00; "Adult Male Size," for $5.50; "Adult Female Size," for $6.00. On request the wooden heads were made to hold clay pipes, and in order to save time in replacing those broken, a hole for a pipe was made on each side of the mouth. The heads were mounted on a stick or iron rod and manipulated back and forth by an operator behind a curtain. Not many of these were made, as the live target was preferred. Today these wooden heads are rare, though some were in use until the 1930s at Steeplechase Park on Coney Island. The ball used was the

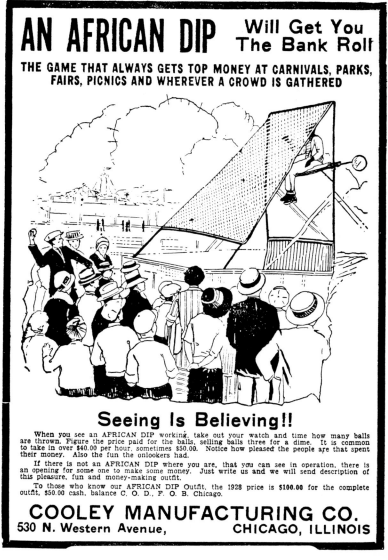

Top right Old-style big-head baby rack with stereotyped minority faces. Painted leather mounted on iron plates, 7″ x 7″; faces 7″. By H. C. Evans & Co., Chicago, 1932.

Bottom right Ball-toss figure. Lithographed paper on shaped wood, 16″ x 25″. From 1891 catalogue of Ives, Blakeslee & Williams Co., New York.

league ball made by S. W. Rice and Company, the same used in baseball games but with a softer cover, which put lots of "english" and spin on the ball, making it difficult for the thrower to win a prize and for the "dodger" to judge its ultimate direction.

Faced with the problem of finding enough "dodgers," operators of the game devised a helmet or wooden cap adorned with a mop of curly hair to protect the human target and thereby attract paid volunteers. Eventually, social consciousness in many areas was raised to the point where the game was forbidden by law.

The "African Dip" did not depend on a direct hit at the person but at the target device attached to the delicately balanced plank upon which the person sat, and which, if hit squarely, would dump the sitter into the tank of water below. Blacks were not the only ones subjected to this abuse; the Irish too were a disdained minority, and figures of Paddy, Mrs. O'Leary, and others were used as targets. One such figure, made of wood, leather, and cloth and painted, sits on a beam, hinged at the back and balanced so that a well-thrown ball would topple it backward, hitting the counter where an attendant would replace the figure for the next pitcher. There were several versions of Mrs. O'Leary, whose cow was popularly supposed to have started the Chicago fire of 1871. Ogden and Company of Chicago made a cutout figure in wood with a target in the lower midsection. If the ball hit the target in the middle, Mrs. O'Leary's apron would fly up and catch the ball. If it struck her head, that would fall back on its hinges and hit a bell, which would ring loudly. Then a rope up front would pull the head back up, and at the same time the apron would return to its original position. H. C. Evans and Company, also of Chicago, made a version called "Mrs. O'Leary's Wash Tub," a variation of the old game of "pop it in the bucket." If three baseballs were tossed into the tub in a certain and practiced manner, they would not pop out, and the tosser would be awarded some kind of prize.

Another ball-toss game that gave the intolerant the opportunity to express resentment against a particular minority, profession, or type

66

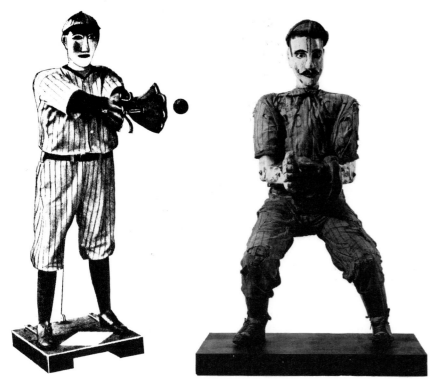

tion. . . . One of the popular kind consists of separately hinged or revolving figures, so that either will fall or turn over when hit without disturbing the others in the row." A rubber ball was used, so as not to injure the figures! In their 1932 catalogue H. C. Evans revived the old-style big-headed baby rack, which afforded the players the chance to pick a favorite peeve to vent their hostility upon. In dead center were the black and the Semite, with less distinguishable types all about.

A big hit in every way at the fairgrounds was the "Big Tom," which resembled the cartoonist's alley cat that sat on fences with a half-moon in the background and was the target of the awakened sleeper. The painted canvas cat, weighted, was mounted on a wood block. The game was operated at a dime for one ball and three balls for 25 cents. A box of candy went to the pitcher who knocked Big Tom to the ground.

Like the wooden Negro heads, the dolls from the doll rack and Big Tom have become objects of the folk-art collector's search and several have appeared in museum exhibitions.

The "Champion Base Ball Catcher," sold in 1891 by several firms, was a large figure made of wood covered with a colored lithograph of a professional baseball player behind the bat. The figure had four openings or pockets lined with canvas mesh into which balls were thrown. The pockets were numbered for scoring, and to make it difficult, rubber balls were used.

A ball-toss game with a sex angle was found in Alna, Maine, as part of an old carnival apparatus. The painted figure of a baseball player of the 1882 Boston team stood with his hands waiting to receive a thrown ball. In front of him, delicately balanced, was a female figure cut out in silhouette and painted to life. She was placed in front of a support to which her lower back was hinged. Her upper garments were painted on; the lower ones were real. A well-thrown ball would send her toppling backward, skirt, underskirt, and all flying up, which gave the pitcher and the crowd a vicarious thrill. If the ball missed the girl, the pitcher still had a chance of knocking back the hinged

was the "doll rack" or "baby rack," which is still found at some carnivals. The "dolls" were stereotypes of the black, the Semite, the Irish, the devil, the police, the military, and others. The C. W. F. Dare catalogue of 1882 stated: "There is a great variety of Hand-Ball Targets, varying according to custom and locality. Some have wooden heads with loose hats. The skill is to knock off the hat. Others are automatic with various figures that spring up when the target is hit. Others with figures of cats, women, &c., appearing at the windows of a house. Some are arranged to keep up a continuous clatter to attract atten-

Below Ball-toss game. Coney Island. Two competitors for the plush stuffed baby-doll prize. *Metropolitan Magazine*, Sept. 1897.

Opposite page, left "Flash," or the marksman's reward, given for a direct hit. Whimsies of the 1920s.

Opposite page, right Detail of "flash" given as prize for direct hit at shooting galleries and ball-toss racks. 1928.

head of the catcher.

"Evans' Atta Boy Art," whose uniform is a revelation of the impact of the missed ball, is a mechanical baseball catcher. The life-size wooden figure in a baseball uniform of the 1920s is a most imposing one, and as the manufacturer unintentionally indicated in its name, it is a work of art. It was described as follows in the H. C. Evans 1932 catalogue:

A new and novel ball throwing game that instantly commands the attention of the public. Atta Boy Art is a life size figure wearing a regulation baseball uniform. The figure is made of wood reinforced and braced with iron and mounted on a heavy wood base 24 x 24 inches square with metal braces. The head is of wood, hand-carved and handsomely painted in natural colors. The arms of the figure are extended in a catching position and fitted with gloves. Upon the payment of ten cents the player receives three baseballs which he pitches to the figure. A ball properly pitched will strike a small trigger between the hands and when this is accomplished the ball is caught and retained until released by the operator from the counter. Rewards are paid according to the number of balls caught on each play. It is purely a game of science and skill and without a gaff of any kind, fair and square . . . faster than Big Tom or Cat Racks.

Atta Boy Art sold, complete, for \$65.00; baseballs were \$1.00 per dozen.

The "gaff," or gimmick, referred to in the catalogue applies to the cat rack, another ball-toss affair with several Big Toms in a row. The cat rack does a big business. The targets are large and easy to hit, but since they are heavy, it is another matter to knock them completely off in order to score or win a prize. The player may not find it difficult to knock off two of the cats but will often fail on the third: here is where the gaff is employed. Each cat is backed by a heavy piece of wood with a hinge at the bottom. In the rear of the cats is a metal rod with four projecting rods, each of which fits into the open posts of the four hinges. At one end of the rod is a strong spring, which pulls the projecting rods in place. At the other end is a strong wire, which runs out at the side of the rack and into the railing surrounding the alley. The wire ends up beneath the counter, unseen, where it may be quickly reached by the operator, unnoticed by the player. Before the game the operator pulls the wire and hooks the end of it over a catch or a nail. This extends the spring and pulls the small projecting rods out of the hinges. If two cats are knocked off the rack, the operator reaches under the counter and releases the end of the wire. The spring snaps back, pulling the rods into the hinges of the two cats remaining upright. Those cats may now be knocked over, but they will turn on the hinge and will not be able to fall from the rack, the object of the game.

The largest and one of the most interesting of the ball-toss games was "Evans' Walking Charley." To quote the catalogue: "The Walking Charley is the greatest baseball-throwing game ever conceived and is a game that can be operated year after year in any Park, with undiminished popularity. The indestructible, life sized figures are very life-like as they move in and out of the scenic back stop and the Walking Charley is a concession that is legitimate everywhere." The game

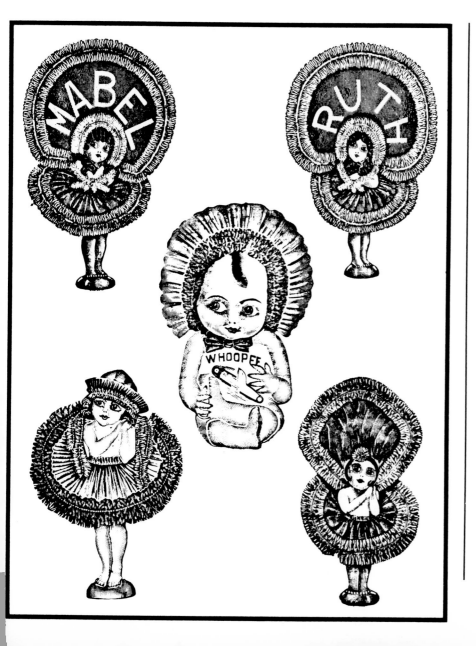

with six figures cost $350, and an eight-figure game cost $400 (in 1932). One had the choice of hitting Sambo, Jiggs and Maggie, Andy Gump, Barney Google and his horse Spark Plug, and many other figures, made to order, from the comic strips or real life.

Other ball-toss games were "The Bingo Family," "Automatic Dodging Dolls," "The Family Rack," and also "Our Boyhood Days," which was not a ball toss but a row of bean shooters that projected marbles at the target.

The largest and most violent of all the ball-toss games was the "Kicking Mule," made by the Philadelphia Toboggan Company in the 1930s. The game was derived from the mechanical toy bank "Always Did 'Spise a Mule," patented April 27, 1897. The bank's action was similar: a coin placed in the rider's lap was deposited below in the bank after a lever was pressed, sending the mule kicking backward. The ball-toss mule was a life-size figure carved in wood, and it was a lifelike, frightening experience when the ball hit the target and sent the mule kicking, accompanied by a great deal of clatter. The sign read "Hit the Ass and See the Action." The ball was pitched at fairly close range. The mule was not gaff-rigged.

There are a number of other ball-toss games where the target is not considered a collectable work of folk art: "Drop Them in the Squares," "Cone and Baseball," "Pop-Em-In." All are gaff-rigged, so let the would-be player beware.

Flash for the Fair, or the Marksman's Reward

Besides the satisfaction of making a direct hit with a baseball at a human or inanimate target, a further incentive was offered by the rows of dolls, dressed in cloth and tinsel trim. To quote one supplier's description: "Glorian Butterfly Doll . . . wonderful, flashy number has long curly wig, veil and painted features. Beautiful costume of crepe tissue in assorted colors and tinsel trim. Height 22 inches." These were sold by the dozen or gross lots, and were offered to the tosser as a prize for

69

three direct hits. The Sheba dolls—made to look like Theda Bara, the temptress of the twenties, with her big eyes and bare shoulders—were surrounded by halos of feathers and tempted the ball tossers to try and try again. Advertised as "the biggest flash of the season for Ball Games, Grind Stores and Pan Joints," Sheba dolls were sold to the operators of ball-toss games at $3.75 per dozen.

Other rewards were plaster dogs, cats, horses, chickens, fringed lamps, and other fragile and ephemeral attractions. One of these was the Kewpie doll, made in several types of material; like the carnival glass that was set up as a target to be smashed, these have become sought after by collectors. The plaster figures came advertised as "Novelty Ornament Assortment. The wonderful number for your ball-throwing game. These assorted subjects made of composition in natural colors. Average height about 6 inches. Packed 100 assorted to the barrel. . . . 100 pieces $10.00."

The variety of prizes was infinite. After Lindbergh's solo flight across the Atlantic in 1927, "Lindy" dolls and souvenirs were the rage. Each era had its hero or heroine replicated in cheap plaster, crepe paper, or plush, and as time passed on so did these fragile mementos of other eras and of deeds magnified in the retelling.

SHOOTING GALLERIES

Bang bang! They're dead! Not so if you're shooting lions, tigers, elephants, bears, domestic animals, and all kinds of birds on the wing, including the bald eagle. That is, if they are made of cast iron and racked up on a shooting gallery. What a splendid way to preserve our endangered species and to rid ourselves of aggressive tendencies! But then, this too, the cast-iron species, is endangered, giving way to the electronic and computerized plastic and composition shooting galleries with bulletless guns and targets projected on a screen. Those charming forms that appear to have come right out of cookie molds are being sent to the scrap-iron yards to be reincarnated, possibly into battle-

ships to be shot at again by larger-caliber guns. Those that got away are showing up in a folk-art museums and are now the target of collectors.

The art of shooting at a mark is quite ancient, whether it was the crusaders' catapults flinging boulders at the walls of Acre or the arrows from the legendary longbows in Sherwood Forest. We are told by Joseph Strutt that a favorite mark used in games was the popinjay, an artificial parrot. Other marks were "prickets" (pikes), hazel wands, and rose garlands. The most famous of all targets was the apple placed on the head of the son of William Tell, whose crossbow found its true mark. Marksmanship contests, whether as turkey shoots or rifle matches, have long been a feature of outings and festivals in America.

In 1868, a Grand National Shooting Festival was held in Manhattan, with the East River as a boundary, a little over a mile north of where the United Nations now stands. It took place in Jones's Wood, which had just lost out to Central Park as the location for the city's new park. Several hundred delegations from all parts of the country participated in the huge festival, which began with a grand procession through the streets of New York led by General Franz Sigel, a Civil War hero. The prize money came to $30,000, with watches, suits of clothing, and art objects as fringe rewards.

In 1871 the National Rifle Association was organized and was incorporated by the legislature, who gave as its primary reason the interests of national defense. This was in a period when the nation was still trying to heal the wounds of the Civil War. The Creedmore Range in Queens County was established by this organization and became one of the largest of its kind in the country. Annual contests were held each year, and following the International Exposition in Philadelphia in 1876, invitations were sent to the various countries to participate in an international rifle match at the Creedmore Range in 1877. The landscape was perfectly suited for this event, with acres of level ground sufficient for twenty ranges, each capable of handling distances from 100 to 1,000 yards, with 25-foot embankments behind

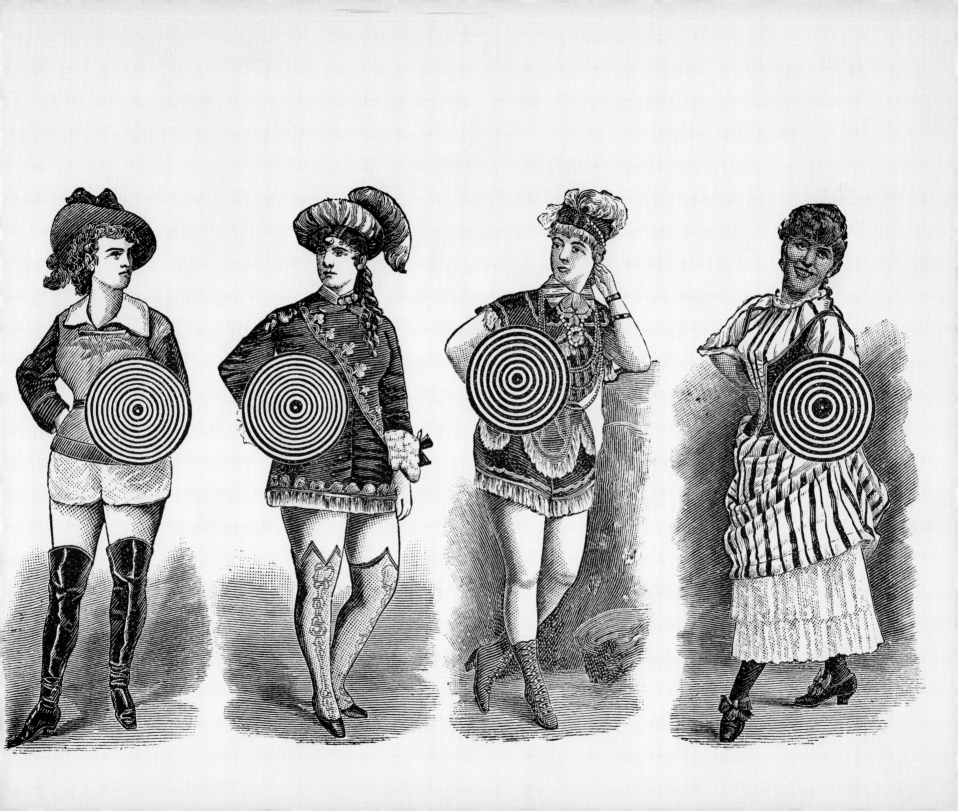

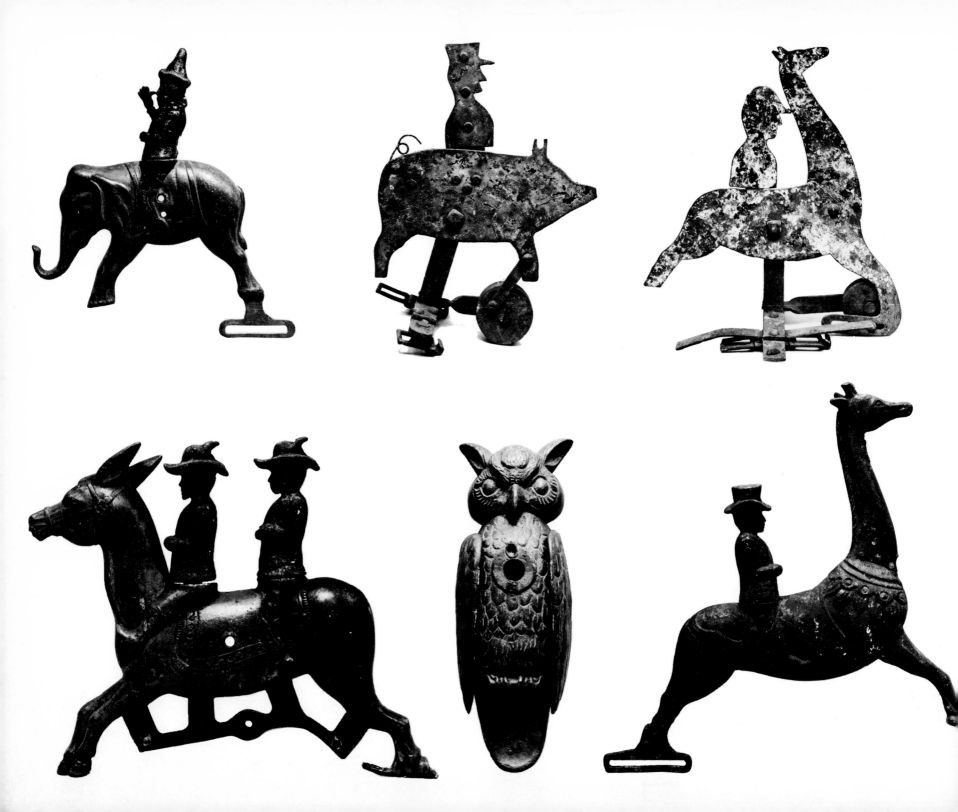

Preceding pages, left Cast-iron shooting gallery figure by H. C. Evans & Co., Chicago, 1932. James Gilmore Collection.

Preceding pages, right Life-size lithographs of actresses on shaped wood, used as target holders. By C. W. F. Dare Carousal Co., New York, 1882.

Left A group of mechanical shooting-gallery figures. Cast and sheet iron. By C. W. Parker, Abilene, Kan., 1904. Used in gallery on page 75. Patricia Anne Reed Collection.

Right Cast-iron shooting-gallery figure. By C. W. Parker, 1901. Patricia Anne Reed Collection.

Below Woodland scene shooting gallery with moving figures. By William F. Mangels Co., Coney Island, 1916. See clown in color section.

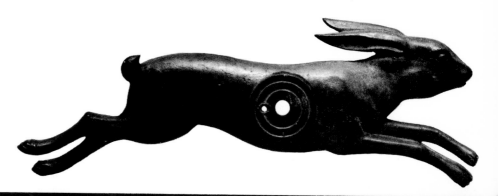

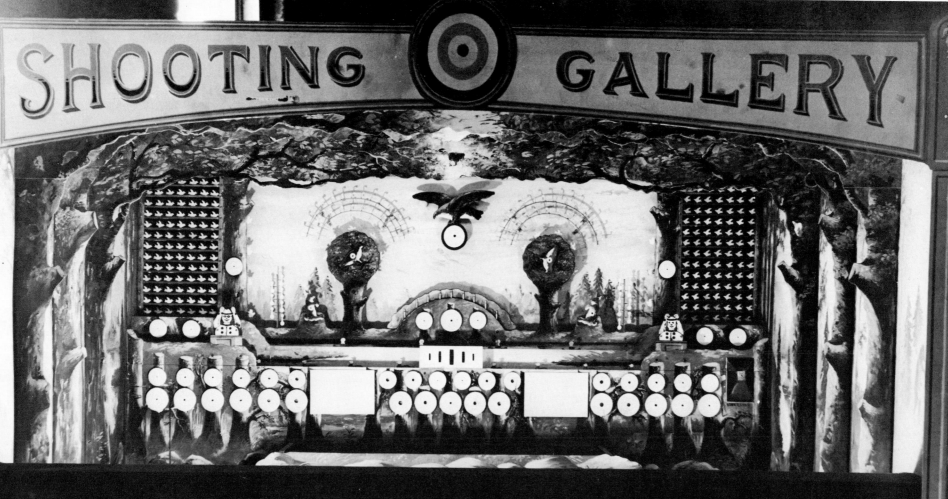

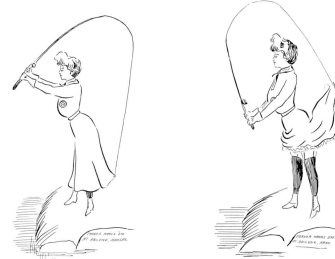

the target area. At a separate range visitors could enjoy firing with shotguns at glass balls thrown into the air. A weather vane indicating the direction of the wind, shown on a huge clock dial, was placed in the center of the field. Some newspapers at the time reported that it was nice to have John Bull shooting with us and not at us for a change.

Targets have changed down the centuries along with the type of arms used. After the air gun was invented in 1550 by Lobinger of Nuremberg, a large variety of mechanical targets came into use. The most popular was the target that when hit by a pellet would perform some mechanical action that amused the shooter. With the introduction of the small-caliber magazine rifle, these targets became obsolete.

Our early fairgrounds, seaside resorts, and festivals had very primitive shooting galleries consisting of a few iron or sheet-metal targets, some made in various animal or bird forms and others in the shape of soldiers with clay pipes stuck in a corner of their mouths. Many of these targets were portable and made to fold up and be moved about.

These were "well suited for Picnic Grounds, Fairs or Amusement Halls, where an alley is wanted temporarily," according to the 1882 C. W. F. Dare catalogue, which also showed life-size theatrical posters of acrobats, clowns, and actresses in short skirts and tights that were used as target holders. Other targets were bottles, crockery (now collectors' items), and clay pipes.

Toward the end of the nineteenth century, patents were filed with the United States Patent Office for moving targets. These were made of cast iron or sheet metal; evenly spaced and hinged on a chain with sprockets at either end, they were kept in continuous motion by a motor.

C. W. Parker of Abilene, Kansas, held two such patents, which started him on his way to success with his carnival and carousel businesses. Parker learned to copy ideas from his successful contemporaries and either improve on them or change them to suit his needs. "Sportsmen's Paradise" contains several figures taken directly from a contemporary German carousel catalogue which Parker adapted for his poster. The squirrel tree became a favorite, offering the marksman or markswoman a chance to wait until the last moment before the squirrel disappeared into the tree to press the trigger. It is still in use today, but slowly and surely giving way to the electronic fox that keeps disappearing and reappearing at one end of the plastic log in "Plinkers' Canyon."

Backgrounds were of plate steel with woodland and water scenes painted on them. After a period of time, the pock-marked background would require fresh paint, as did the target figures. The pond and its dunking ducks is still a favorite. After being hit squarely the duck would fall back into the water with a splash; the hollow back controlled the splash, and a track device pulled the duck back up again. These were called "Cast-Iron Dropping Birds." There were figures that did complete somersaults when the bull's-eye was hit and were automatically reset. These were made of gray iron cast in relief, mounted on steel plate, and operated by a weight that required rewinding after thirty turns. The American eagle, the owl, a moon-face, and a howling cat, when hit in dead center, would ring a bell, calling

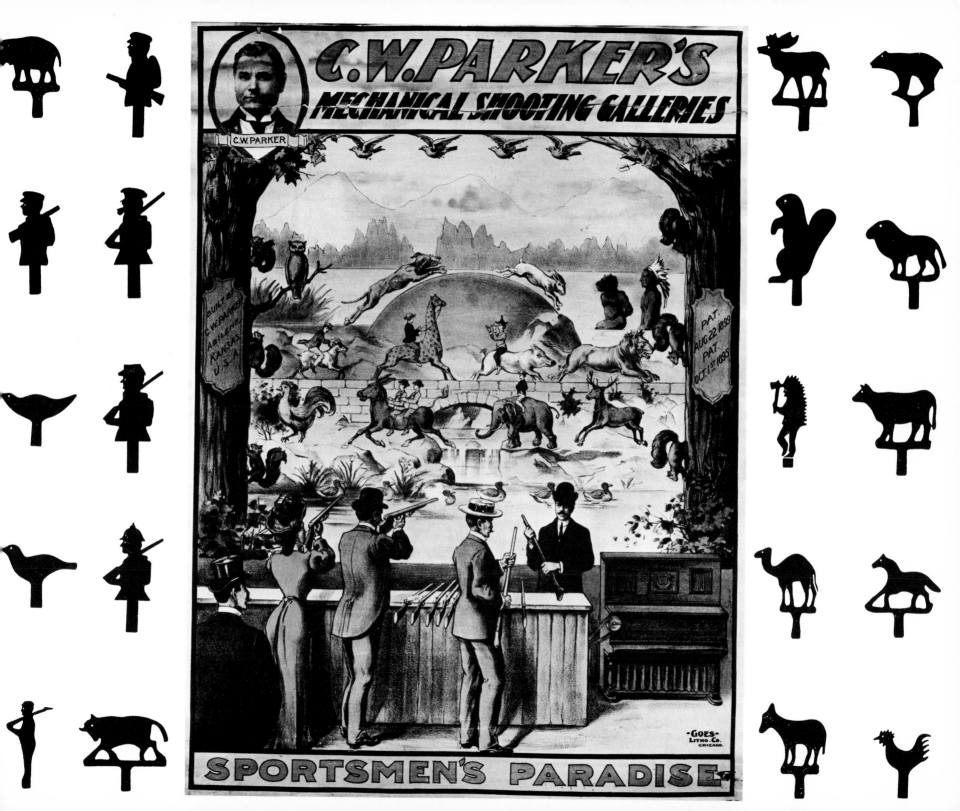

attention to the dead-eye marksman. The cat, called "Howling Tom," was also fitted with an electric siren voice and an automatic blinking eye that was a real "hit" in every sense of the word. Players endeavored to shoot out the eye, and if they succeeded, the other eye automatically lit up; a small pilot-type gas jet with a candle nearby did the trick. Malleable iron stationary and moving targets sold for 50 to 80 cents each or $5.00 per dozen. Clay pipes packed in barrels of 1,500 were $12.50 per barrel. If one wished to make one's own clay pipes, bronze molds could be purchased for $6.00 each.

Signs outside shooting galleries sometimes noted: "Ladies invited, no rough language or spitting allowed." After all, Annie Oakley was the best shot around, which nobody would dare deny. Coney Island had many such shooting galleries, with painted scenes of the American West where the buffalo roamed and discouraging words were not permitted. Coney Island also had one of the largest builders and designers of shooting galleries in the country, the William F. Mangels

Company on West 8th Street. Mangels carried the largest number of patents, dating to 1901, on shooting galleries in the United States, and was constantly coming up with more novel ideas. He was also able to illustrate his own designs and execute them as well.

When asked, "Who was your designer?" Fred Mangels, who had succeeded his father on the death of William F. Mangels, replied, "My father, but go see my kid brother." His brother was William F. Mangels, Jr., then sixty-two. "Bill, who designed the Indian in the canoe, the eagle, the clown that shifted the balloon from one hand to the other, and the rest of the targets?" "I did some," Bill said without looking up, as he worked away at the grinding wheel shaping a gear for a kiddie whip ride. "How did that happen?" "My father dumped a new job on me and told me to make him some interesting shapes that would make the customers to shoot at them. I looked around at books and old pictures. I was about to give up when going to the bank on Mermaid Avenue, I went by a cakeshop, saw some gingerbread boys, and bought a bagful of different kinds. I took them back to the shop, worked some ideas around the shapes, and that's how they came about." "What did your father say?" "Put them in production."

Putting the drawings into production entailed tracing the shapes on thin wood and cutting them out on the band saw. They were then sent to the foundry, where plaster molds were made and refined and then used for the sand molds, from which the iron figures were cast. Bronze molds for the larger figures were kept at the foundry, numbered and tagged for reorder.

C. W. Parker made shooting galleries until 1920, but the H. C. Evans Company of Chicago kept them in production to the mid-1930s, and the William F. Mangels Company was producing them until 1969. Two large Chicago manufacturers, the A. J. Smith Manufacturing Company and Emil R. Hoffman and Son, were taken over by H. C. Evans, who continued using their patterns, working them onto new galleries of their own make. The John T. Dickman Company of Los Angeles made novel shooting galleries from 1917 but went out of business about 1934, a victim of the Depression.

Other types of shooting galleries, using popguns—air rifles with

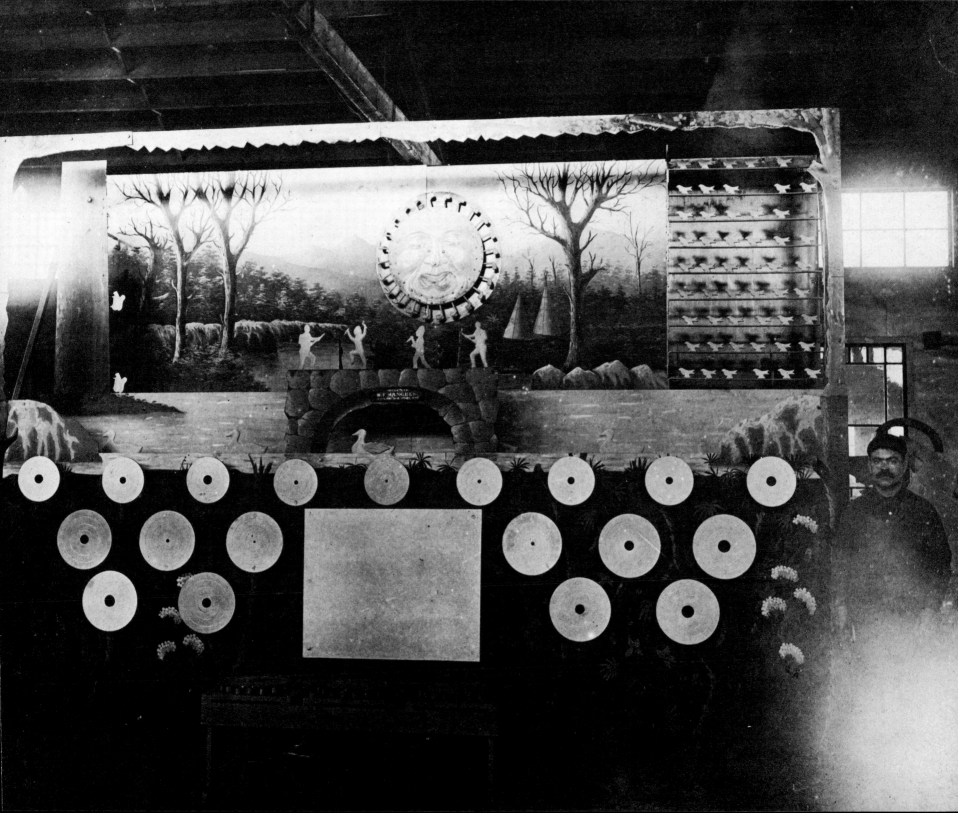

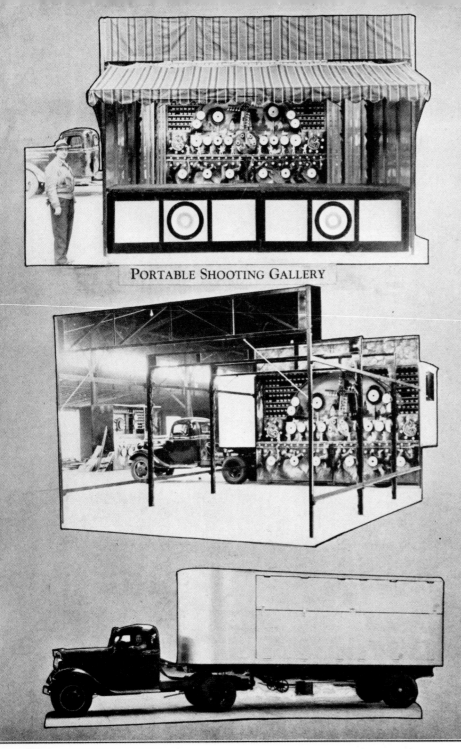

PORTABLE SHOOTING GALLERY

corks as ammunition—had targets known as "doll racks." "One baby down" was rewarded with one cigar or a package of chewing gum; two dolls, with two cigars or packages of gum; three hits was good for five cigars or five packs of gum. Getting one cigar was hard enough, five nearly impossible, as the rack was gaff-rigged.

In Europe at the beginning of the twentieth century the automated sheet-iron shooting gallery was very much in evidence, with a large variety of figures engaged in a humorous situation that was activated by a bullet hitting the bull's-eye. Most of these galleries were made by Oscar Will in Thuringen, Germany. Some of the targets had as many as twelve figures set in motion by a bull's-eye, such as the hopper into which old ladies were fed to emerge as maidens of great beauty. The "Ragamuffins' Ball" was described as follows: "Just to show the 'Upper Ten Thousand' what they can do, a nice bunch of good-for nothings gather to have their own dance. Some flags made of broomsticks and rags are easily found, as well as some street musicians, and the party begins, led by Mister Cobbler carrying the club flag. Old man Fillup, raised to the shoulders of the gang, joyously swings his bottle to the tune of the music. Everything is moving and gesticulating, greeted by Old Man Fatty and his spouse, and even an old beggar woman tries to get mixed up in the procession. The weaker sex is represented also, on the platform and busily drinking too." An organ was provided with a tune or two in the same spirit. Although most of the targets were of a rowdy character, there is a charming winter scene with youngsters on sleds that go downhill only to reappear at the top of the hill. The target is at the base of a pine tree.

The shooting galleries of Oscar Will were made for all European countries, some with patriotic national themes. Most interesting were the groups of musical figures, usually in the costume of the nation. These were equipped with drums and bells and were set in motion when a small target, off the figure, was hit dead center. The "Drummer Girl" had a good military drum, which her hands, holding drum-

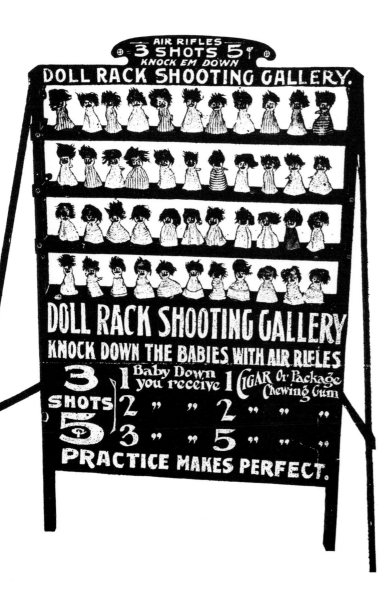

sticks, would beat when the target was hit. The "Dance Hall" would have a ball: "On a hit, the curtain rises and five pairs of dancers in bright dresses turn merrily around to the tune of the organ. The disk must be attached to an organ and will be set into motion by the organ itself." The "Tooth Puller" was a favorite: "After several unsuccessful attempts, the quack finally, at a hit of the target, pulls out the aching tooth, but with great effort, thereby losing his equilibrium and falling backward, exploding a cartridge. At the same time, the suffering patient puts out his tongue." This figural target recently appeared in a New York antique shop. Most of these painted sheet-iron figures were scrapped for the metal in World War I and World War II.

Some American shooting galleries established in recent years used motion pictures as animated targets. Realistic-looking animals running through the wilds gave the marksman just enough time to draw a bead. Birds flying through the air could be picked off, with the score registering on electronic boards. Several of these motion-picture targets were on the market. One had an endless sheet of white paper mounted on rollers like a roller towel. Objects were projected on the screen, and behind the screen was a bright light. When the paper was hit, leaving a hole, a sharp point of light appeared. A sound-gear device with electric connections caused the picture to stop briefly each time the rifle was fired to enable the hit to be seen. The bullet hole would disappear as the screen moved on, shutting off the light points and presenting an unbroken surface. This gave way to the completely electronic gallery where the electric gun is used, and this in turn has been feeling the competition of the computerized shooting gallery.

The crack of the gun and the clink of the bullet hitting a cast-iron rabbit or duck are hardly heard any more. The muted electronic plink of the wired gun now dominates at "Plinkers' Canyon." In a few more years, the cast-iron duck will be as rare as the whooping crane.

SIGN & SYMBOLS

J.E. CALLANS CIGAR STORE COLD DRINKS

CHAPTER · 4

A significant change took place in Times Square, New York, when a huge derrick mounted on a truck lifted off the gold-leafed bronze letters, each 3 feet wide and 20 inches high, from the F. W. Woolworth sign and replaced them with interior-lighted plastic letters. Although the neon and plastic age had arrived long before 1954, the removal of these beautifully designed and formed letters was the *coup de grace* to an age when even stores that offered articles that sold for only a nickel or a dime had their names majestically emblazoned in 14-karat gold leaf. The sign was a remnant of a time within living memory when merchants proclaimed their wares with works of art, the remains of which now repose in folk-art museums and historical societies. It was also a time when as one rode the trolley car down a street or avenue, the journey was not unlike a trip on a scenic railway or a ride through a picture gallery. Four-, five-, and six-story buildings with brick walls at corners, or topping smaller structures beneath, advertised household products in brilliant colors, and those signs no longer in use flaked away like sunburned skin.

Two black boys, arms around each other's shoulders, sitting in a gold-painted tub full of suds were a familiar sight on walls throughout the East. Known as the Gold Dust twins, they advertised a washing powder. Old Dutch Cleanser was another familiar sign, with a Dutch woman in cap, apron, and wooden shoes, stick raised, chasing away the dirt. The slogan of yet another cleanser was Bon Ami's "Hasn't scratched yet!" with chicks breaking out of their shells. The Dutch Boy sitting on a scaffold, a can of paint beside him, brush raised with the sign unfinished, was greatly admired for the realistic three-dimensional effect created by the sign painter—who might have been seen as he, on a real scaffold, was being lowered to the ground. Ward's TIP-TOP bread, painted in red, white, and blue, was a kite high on the wall with painted children below pointing upward. The sight of "Castoria" in script across the brick siding brought a response of abhorrence, recalling times of illness and detention from street play. Stove polish was advertised in smaller spaces, and Koester's bread, on the sides of Baltimore's buildings, had a huge head of a baby girl in curls wearing a pink bonnet, all crudely painted.

A road sign most often seen on billboards showed a huge bull standing before a rail fence, gazing into a field where perhaps a herd of cows would be grazing. Often the butt of barroom jokes, it advertised Bull Durham's Cut Plug chewing tobacco. Barn sides were fine places for advertising Purina feeds, and an occasional faded remnant can still be found on protected barns. When auto speeds were much lower than now, the Burma Shave signs, each with a brief part of a catchy slogan, were spaced out along the sides of roads.

One of the headquarters in New York for painted wall signs and bill posting in 1890 was the firm of Van Beuren and Munson at the corner of Rose and Duane streets. In a contemporary photograph the firm, owned by Alfred Van Beuren and Henry Munson and Son, demonstrates its wall-painting talent with four-story comic figures and painted fool-the-eye bill posters. A four-story lady in a bonnet holds in one hand the sign "40 Rose St." and in the other a three-story leash at the end of which is a pug dog. Around the corner, a billposter on a tall ladder is watched by children as he applies the paste over tatters of posters painted with humorous messages. At the other end of the building is a four-story dandy with cane, partly hidden by the hanging sign of Edward A. Dickinson. Around the corner to the left, a painted playbill poster announces "The Great Moral Drama" at the Empire Theatre—"Billy the Kid in *Rotan Tomatus*"—and the first appearance of "Prof. Whiskers" and the "Cannon Ball Tosser" at McFug's Garden. A black and a white goat nibble away at the bottom of the poster. One of the sign painters sits at the second-story open window.

The largest wooden sign in America in the 1890s was that of the Mechanico Therapeutic Zander Institute of N.Y.C.; it was 128 feet long and had raised gold letters on a ground of imitation copper. In 1897, the Singer Sewing Machine Company ordered a sign from Spanjer Brothers at Fourth and Ogden streets in Newark, New Jersey. The letters, made of wood, were 10 feet high and the W was 14 feet wide; all were gold-leafed on a white-lead base. But although its letters were taller, it was not as long as the sign of the Mechanico Therapeutic Zander Institute.

The best-known examples of the carved wooden sign were the show

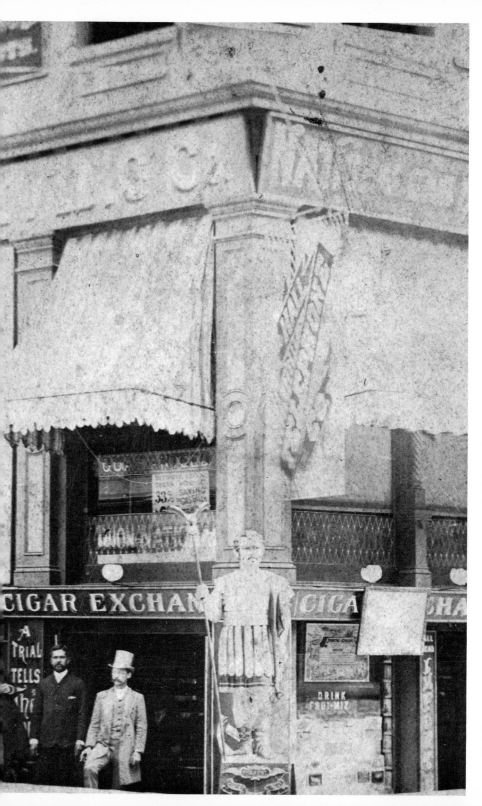

figures mounted on wheeled pedestals that stood in front of shops along the avenues and streets: a bear and her cubs at the door of a furrier's shop, a dandy in a checkered, double-breasted suit outside a men's clothier, and an Oriental holding a box of tea in front of a tea importer. But the most colorful and by far the most numerous were the cigar-store Indians, squaws, chiefs, and warriors holding a handful of cigars or brandishing a tomahawk. At nighttime, the figures were wheeled into the store for safekeeping against theft and weather.

In 1892 there were three shops in Manhattan and one or more scattered about the East where these primitive works of art were created. The largest and best known was the shop of Samuel A. Robb, located at 114 Centre Street in Manhattan; there many of the great carvings for the Barnum, Bailey and Hutchinson circus wagons originated. Robb's shop also made large wooden molars that hung from second-floor windows of offices advertising painless dentistry, and huge wooden feet with bunions, painted white and sawed off at the ankle, that hung from chiropodists' windows. For cutlery shops, Robb supplied huge wooden knives and forks that hung over the heads of pedestrians.

Figures made in the Robb shop appeared in cities throughout the country. Baltimore had several; one squaw in front of Joyce's Tobacco Shop on North Charles Street lost her spear, which was replaced on the Fourth of July by an American flag. One of the largest figures created for a tobacconist's shop stood at the corner of Broadway and Astor Place in Manhattan and was a representation of the actor Edwin Forrest in Roman garb, probably in the role of Spartacus in *The Gladiator*. The owner of the tobacco shop, Hamlet Edwin Forrest —not related to the actor but proud of the name—had this figure carved, probably in Robb's shop. It was sufficiently prominent to have a *New York Times* reporter take note of it in an article on August 3, 1890.

Not all show figures were made of carved wood. In 1869 Moritz J. Seeling, at his Art Establishment on Maujer Street in Greenpoint, Brooklyn, began to supply William Demuth, a wholesale smokers' article importer and distributor on Broadway, Manhattan, with cast-

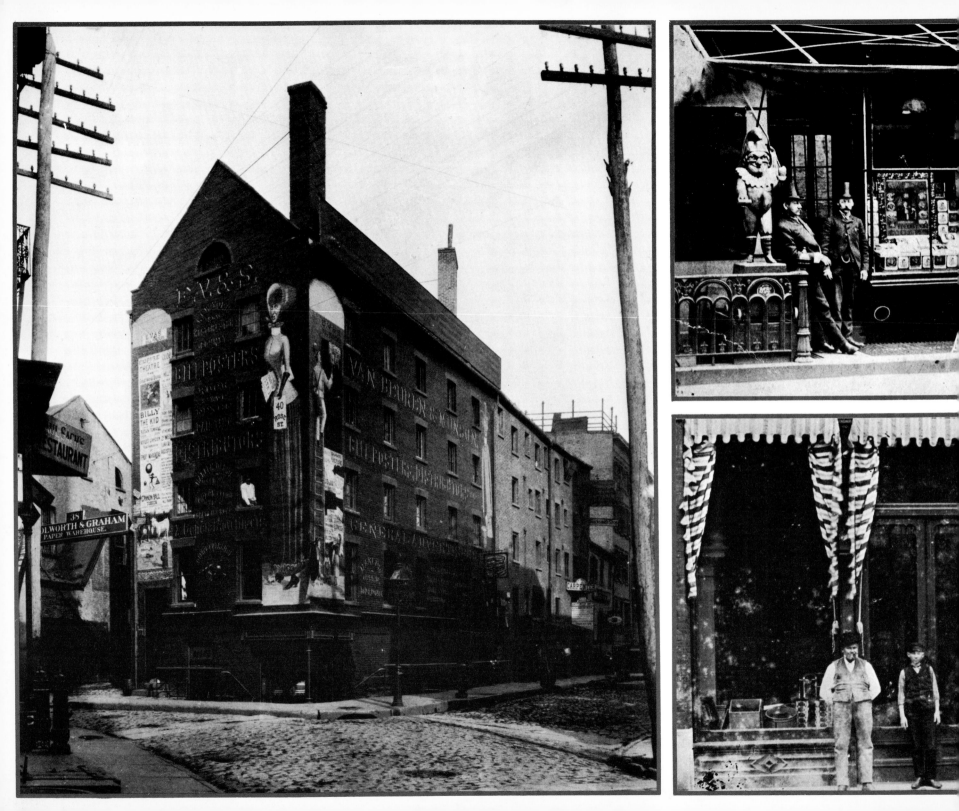

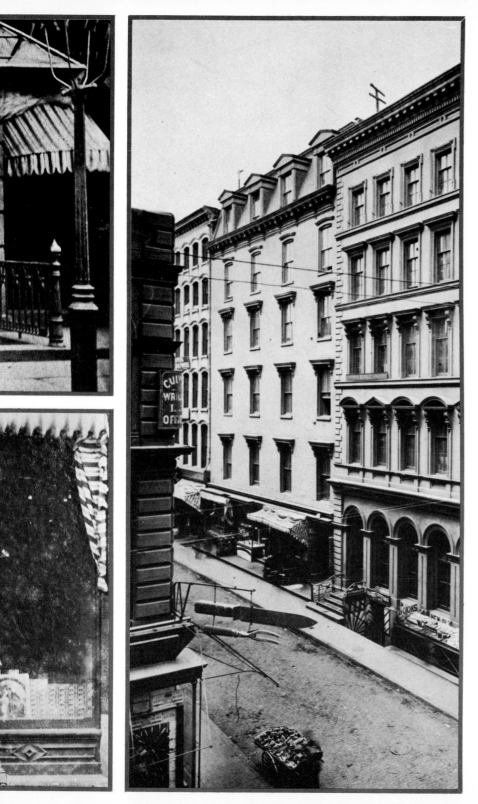

zinc Indians and other figures for shop fronts—Pucks, Punches, pages, theatrical figures, and Goddesses of Liberty. Some were used as architectural and garden ornaments, serving more than a single purpose. One such figure, made for a library, was changed in character by adding a handful of cigars. This was a figure of Johann Fust (1400?- ?1466), a German printer and partner of Gutenberg, whom he supplied with capital to carry out his inventions. This figure of cast and pressed zinc was used as a tobacconist's figure, and an identical one in the same medium, originally used on the Public Ledger Building, is in the Rare Book Department of the Free Library in Philadelphia—without the cigars.

One of the most curious, amusing, mystifying, and highly decorated buildings was the extraordinary sign shop of "Elephant Joe" Josephs at 46 Exchange Street in Buffalo, New York. Dedicated in 1869 with great pomp and ceremony, the entire structure was one gigantic advertising sign extolling the talents of the owner, his wit and humor, the esteem in which the community held him, and the types of businesses his art and talent could best serve. There was hardly an inch of space that did not exhibit some phase of the sign painter's and artist's skills and humor.

Joseph Josephs, a rabid Republican, earned his nickname from his custom of carrying little elephant symbols which he distributed as his personal trademark, anticipating the adoption of the elephant as the Republican Party symbol in the 1870s. Josephs' personality, like the front of his building, was most colorful. He had a huge ego as well as a large coterie of friends, who may also have been his customers, and his popularity in and beyond Buffalo established him as the most successful commercial artist in the entire area.

Josephs was born on Broadway in New York in 1826. After serving his terms as apprentice and journeyman commercial painter in New York, Baltimore, and Philadelphia, he chose Buffalo to establish his home and business, settling there in 1853 and opening his shop in 1855.

The sign shop on Exchange Street was converted by Josephs from an elegant mansion, one of the first buildings to be erected after the

85

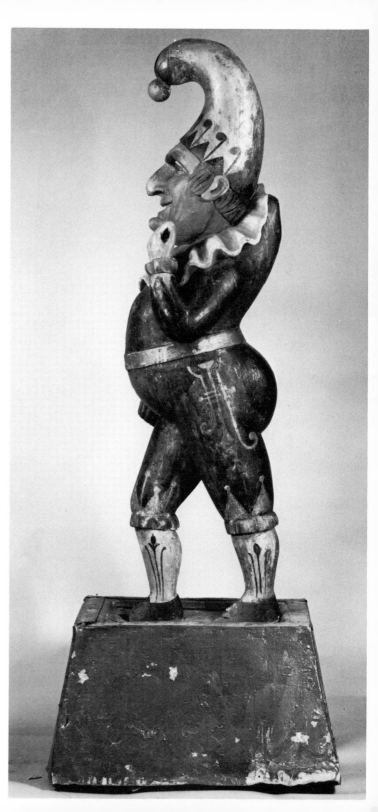

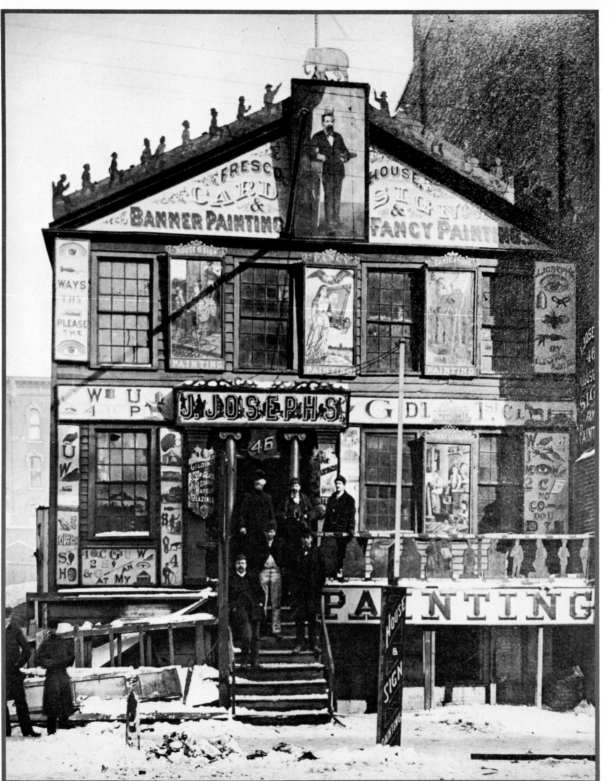

Preceding pages, left to right
Cigar-store Indian, 64″ h. Ca. 1875. Found in Springfield, Mass.

Indian squaw in front of Joyce's Tobacco Shop, North Charles Street, Baltimore. Carved in Samuel A. Robb shop, New York, ca. 1892.

Pressed-tin sign hung on sides of barns and walls. 6′ h. x 4″ d. Designed by Silas West, Haverhill, Mass., 1897. Heritage Plantation of Sandwich, Mass.

Cast-zinc tobacconist's figure of Johann Fust, German printer, partner of Gutenberg. Cast by M. J. Seelig, Brooklyn, ca. 1868.

Punch, carved and painted wood, 4′9″ h. Attributed to Samuel A. Robb shop, New York, ca. 1890. Smithsonian Institution.

This page, left Sign shop of Joseph Josephs, 46 Exchange Street, Buffalo, N.Y. Photo taken Feb. 10, 1883, day before the building was demolished. Buffalo and Erie County Historical Society.

Following pages
Left Gunsmith's sign at 6 Center Market Street, New York. Carved and shaped wood. Made by Frank Lava 1921. Destroyed 1952.

Top row, left to right "The Watch That Made the Dollar Famous," Ingersoll Dollar Watch sign. Pressed and painted metal, 33″ x 25″. Ca. 1912.

Pawnbroker's sign, Rochester, N.Y. Paint and gold leaf on tin, 20″ h. x 16″ w.

Paint supplier's sign from western Pennsylvania. Painted front and back, it rotates with wind. 52″ h. Sanford and Patricia Smith Collection.

"Greenback" sign, nailed on telegraph poles and buildings. Paint on shaped tin, 34″ h. Margaret Woodbury Strong Museum, Rochester, N.Y.

Bottom row, left to right
Clothier's sign from Maine, hung on barns and buildings. Pressed and painted tin, 62″ h. x 48″ w. Designed by Silas West, 1897.

Bicycle store sign, Greenpoint, Brooklyn. Carved wood and found metal and rubber, 40½″ h. Courtesy The Brooklyn Museum.

British burned Buffalo in the War of 1812. At first glance, it appeared to be a misplaced wall from an art and sculpture gallery. The entire front was an attention-getting device to amuse, excite, and puzzle the viewer, and it drew attention far and wide. At the peak of the roof was a painted cutout figure of an elephant, and along the edges of the slanting roof were tradesmen with the tools of their trade, all in painted silhouette, who seemed to be marching toward the elephant. A huge self-portrait of the artist holding his palette was centered on the top floor, while on the lower floors examples of his work covered every inch of space. At each side of the building front and surrounding one first-floor window were messages worked into rebuses.

A rebus is a puzzle consisting of pictures of objects, signs, and letters which by their names suggest words or phrases. Rebuses on advertising cards were a fad at the time, and one example of an old trademark still in use today is the red horse followed by "-ish" for "horseradish." One rebus on the Josephs shop front reads: "I always try to please the eye." The "I" is an actual painted eye, an awl stands for "al," "ways" is in letters, a painted toe stands for "to," and the "eye" is another painted one. The viewer could spend much time deciphering the meanings and be entertained and informed for his efforts. A contemporary reporter for the *Buffalo Advertiser* wrote that Josephs' works recorded "the strength and follies of the present day. . . . A historian, a century hence, without any other source of information could read aright the riddle of the times from the designs which Joe Josephs has spread out so voluminously to the gaze of an admiring community."

Over the years the sign shop remained an attraction, but like so many other landmarks and works of folk art, it was doomed to be replaced. The building was beginning to show wear, and the paintings had faded. In 1883 the sign shop was torn down and the site used for an addition to the J. N. Matthews Printing Company. Josephs and his son moved to a new location, but the impact of this move put an end to his once-colorful career. He died in 1893, after spending his last years as an invalid. But a visual record of happier days remains: Josephs painted a huge canvas that shows the building and the

officials who gathered on his steps for the dedication ceremony in June 1869. The canvas is now owned by the Buffalo and Erie County Historical Society, who purchased it in poor condition and sent it to the New York State Historical Association at Cooperstown, New York, for restoration. Conservation students there undertook the restoration as a class project. Another student, Miss Olive Marie Hewett, now director of education at the Margaret Woodbury Strong Museum in Rochester, researched the history and background of the painting and Joseph Josephs, using her findings as her thesis for a master's degree in museum work at Cooperstown.

Signs and figures hung from buildings as a symbol or indication of the wares or services to be found there. In Manhattan in 1892, photographer William Kurtz had a large female figure holding a lens as his trade sign, overlooking 23rd Street near Fifth Avenue. Farther south was the Puck Building, at the corner of Mulberry and East Houston streets; the figure of Puck, which represented the publication of the same name, is still there, admiring his reflection in a hand mirror. The *Brooklyn Daily Eagle* had a huge wooden eagle over its entranceway; with time and progress it was replaced by a metal bird and still later by one with electric lights. The newspaper is no more, but the illuminated eagle is in the care of the Long Island Historical Society in Brooklyn.

In Rhode Island in 1889, *the Pawtucket Record*, the local paper, had a wooden figure of a newsboy hung over its entrance, hawking an "extra" as he ran through the streets. The figure has been preserved and is now in a private collection.

The red light was known throughout the United States as the symbol of a bordello district. In New Orleans the symbols were more obvious; many houses were decorated with fretwork that had various phallic symbols carved into the designs. But in the French Quarter, The Cricket, an octoroon dance hall, had a 26-inch-long wooden cricket, with no obvious sexual significance, hung over its doorway. The dance hall is long since gone, and today the sign hangs over the doorway of an antique shop in Venice, California.

At the end of the last century, a traveler in Maine going up any main

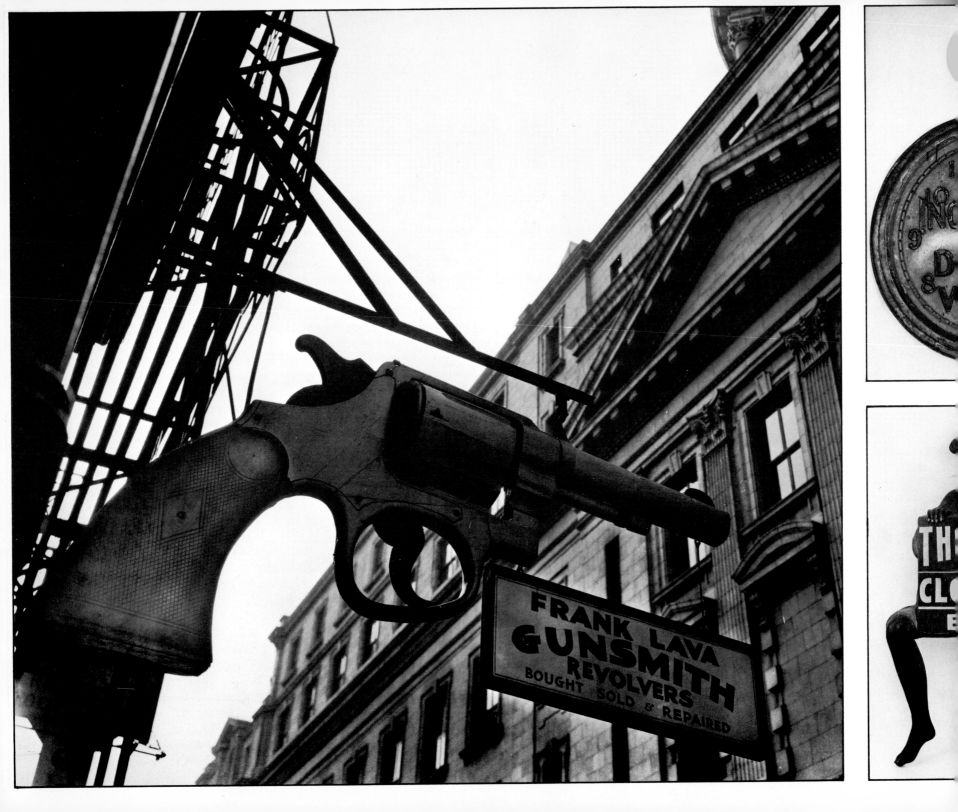

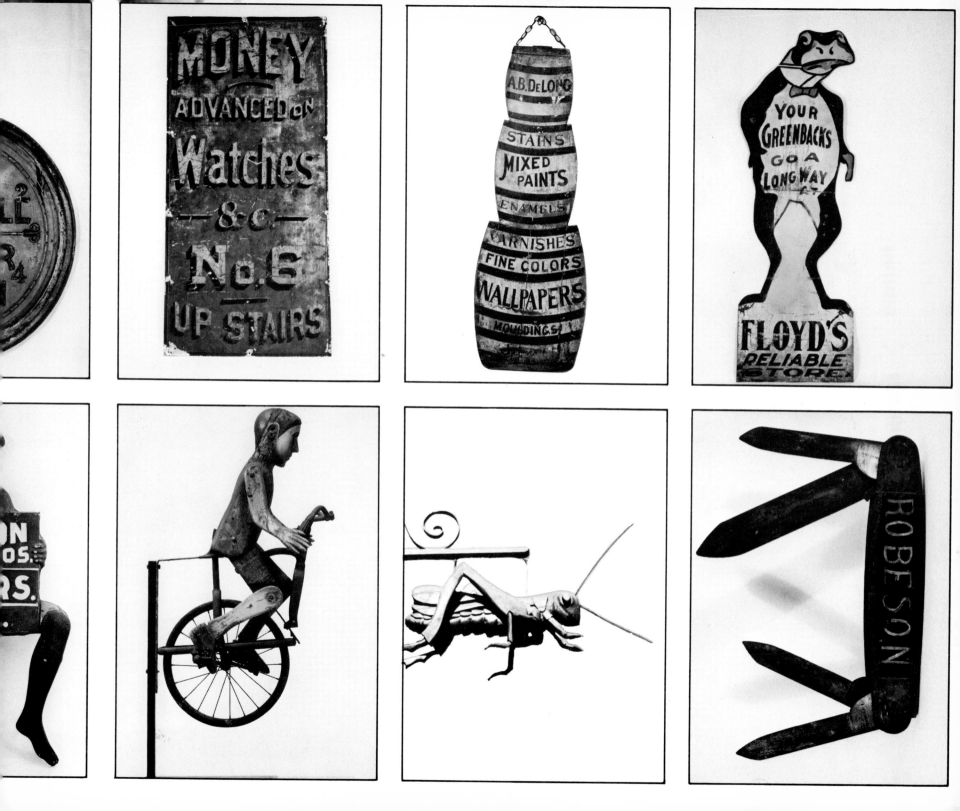

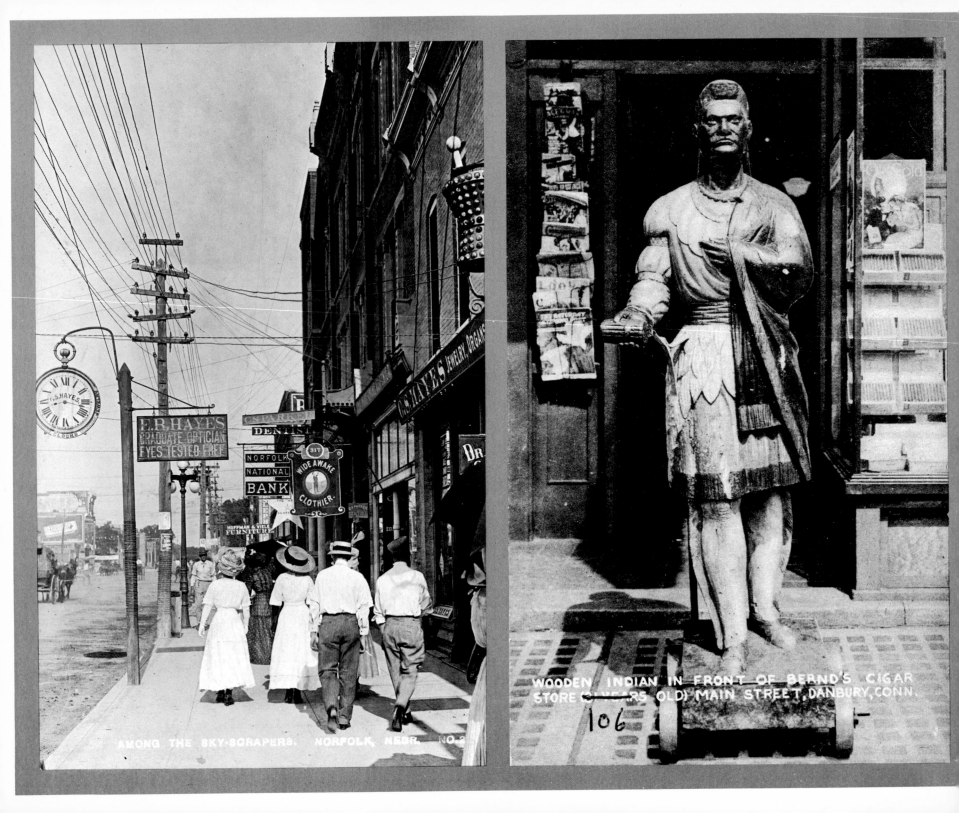

AMONG THE SKY-SCRAPERS. NORFOLK, NEBR. NO. 2

WOODEN INDIAN IN FRONT OF BERND'S CIGAR STORE (3 YEARS OLD) MAIN STREET, DANBURY, CONN.

106

Far left Street of signs, Norfolk, Neb., 1912. Apothecary sign, upper right, was illuminated; light shone through faceted glass gems.

Left Tobacconist's Indian. Carved and painted wood, 6′ h. Stood in front of Bernd's Shop, Danbury, Conn., from 1867 to 1949. Carver, Louis Jobin.

or country road leading to Brunswick, Bath, Wiscasset, and points north and west would be astonished by what appeared at a distance to be a man in a derby hat hanging from the side of a barn by his fingernails. As the traveler came closer, the man proved to be a pressed-metal figure of a billposter, bearing the sign of a clothing merchant in Bath. Thompson Brothers were quite aware of the value of advertising; their signs appeared for miles around and were even to be found in New Hampshire. One of them, the figure of a black boy in a seated position, was to be seen perched above a barn window with interesting effects. These figures of pressed tin, painted in bright and realistic colors, were riveted at the joints and would rattle in the wind. Most of the designs were created by Silas West of Haverhill, Massachusetts, who obtained design patents in 1897 for these and other shapes. The manufacturer is unknown, but some West figures have turned up on barn sides in Ohio, Pennsylvania, and upper New York State.

The workman who needed a watch but could not afford a gold-filled seventeen-jewel timepiece could go into a watchmaker's shop, attracted by the sign of "The Ingersoll Dollar Watch," and indeed purchase a watch for a dollar. Advertised as "the Watch that Made the Dollar Famous," the Ingersoll had no jewels, but did have a lever escapement and was worth the price. The sign was the same on both sides and was made of pressed tin in two parts, soldered together. It also came in cast iron for outdoor use.

The sidewalk clock sign with two or four dials on a tall column is still to be seen; two in Manhattan have been on the exact locations for over sixty years. Their original wind-up spring movement has been replaced by an illuminated electric mechanism, remote-controlled.

At Third Avenue and 11th Street in Manhattan, there hung until quite recently a sign that promised to outfit the obese who could not be fitted elsewhere. Anyone riding the Third Avenue El or the streetcar beneath would be amused at the sight of the paunchy man in his long underwear displayed above Sig Klein's Fat Men's Shop. This sign could be viewed from either north or south, as the portly figure, cut out of sheet metal and gold-leafed, was mounted on both sides of a wire screen. Today the El, the streetcars, and the Fat Man have all vanished from Third Avenue.

Farther down on the East Side of Manhattan, opposite the old police headquarters, hung a huge wooden revolver aiming directly across the street. The sign suspended below the gun noted that "revolvers" were "bought, sold & repaired" by Frank Lava, who with an assistant had designed, shaped, and carved the sign. The gunsmith's shop, founded in 1850 by Eli Parker, was closed during the Civil War and reopened in 1870 by the ancestors of Mr. Lava. The shop used to do repair work for the police, and still services weapons for the sheriff's staff. Mr. Lava was asked recently what had happened to the revolver sign: "It sort of fell apart, so we took it down and stored it in the basement—but it got worse and nothing is left of it now."

Less than twenty miles south of the Canadian border is the town of St. Albans, Vermont. Travelers passing through on Route 7 could not help noticing the sign on top of A. T. Thibault's Bicycle, Livery, Carriage, and Paint Shop. Mounted on a high-wheeled bike facing the road was what appeared to be a man all set to roll. The figure was actually made of wood by Mr. Thibault around 1902; mounted on a Columbia high-wheeler, it proved to be the most visible sign in town. The sign was purchased about 1948 by an antique dealer near Brattleboro, Vermont, and has since been sold to a collector. Thibault also made weather vanes, one of which is still in use and owned by a son in St. Albans.

In the Greenpoint section of Brooklyn at a much later date, another bicycle dealer laminated some boards together, shaped and carved them, and with spare tricycle parts constructed a sign that served his purpose for many years. The figure has great impact from all sides, and when viewed from left or right, its profile suggests a unicyclist in a concentrated balancing act. Deservedly, it has been rescued for the folk-art collection at the Brooklyn Museum.

Fish signs, now usually painted on shop windows, were once made in hollow copper and hung from a pipe with the word "FISH" across the obvious shape. Their manufacturers also made weather vanes, using the same form to serve a double purpose. But to use as a fish-

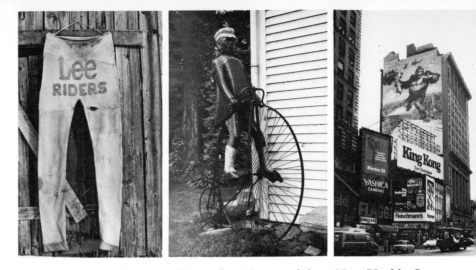

This page, left to right
Lee Rider dungaree sign from store near Manchester, Vt. Stencil on cloth, 8′ 7″ l. Ernst Beadle Collection.

Bicycle sign, St. Albans, Vt. Carved wood and high-wheel Columbia bike. Made by A.T. Thibault, 1905.

Wall painting for movie remake of *King Kong*, 47th Street east of Broadway, New York. Oil paint on brick wall, 85′ x 125′. Artist, Paul Chin, for Artkraft-Strauss, 1977.

Opposite page "Prisco" sign. Lithograph on ¼-inch cardboard, easel back, 60″ x 37 ¼″. Courtesy Calista Sterling.

store sign a fish that once went swimming around and around on a merry-go-round is really a fine example of recycling. The codfish in the straw hat with a Maurice Chevalier tilt served as a trade sign—where else but by a fish store on Cape Cod! It is possible that it may once have been on a French carousel. The base suggests waves but also has a step for mounting and angle irons as footrests. A leather or cloth seat—no longer there—was held in place by brads.

Wood and tin signs, considering their outdoor use and exposure to rain, sleet, snow, flying stones, and Halloween pranks, have held up very well, but had they not been rescued by museums and collectors, they would not have endured. From time to time, they are brought out of storage to be exhibited as folk art. Some of the larger collections are at the Shelburne Museum in Shelburne, Vermont; the Margaret Woodbury Strong Museum in Rochester, New York; the New-York Historical Society in Manhattan; the New York State Historical Association in Cooperstown; the Van Alstyne Collection at the Museum of History and Technology, Smithsonian Institution, Washington, D.C.; and at a few other museums that have pioneered in the saving of these graphic symbols of another era. Many trade emblems are to be found in these institutions, and additional ones may be seen at the Heritage Plantation of Sandwich in Sandwich, Massachusetts. Besides the tobacconist's Indian there are the oversized shears of the tailor, the mortar and pestle of the druggist, the jackknife of the cutlery shop, the gilt boots and hat of the shoemaker and hatter, and the giant eyeglasses of the optician. The three gilt balls of the pawnbroker are still to be seen in various cities, but the huge pipes, cigars, pens, and gloved hands have all disappeared. Large plastic keys have replaced the wooden ones, and one New York savings bank long ago retired its wooden beehive and had one cut in stone over its doorway.

In California, where everything is bigger and shinier, cleverness and humor are served in equal mixtures. A huge image of Frankenstein holding a mug of beer stands in front of fast-food shops with a sign in bright plastic that reads "Frank-in-Stein." A chain of hero shops in the East matches it with a two-story leaning tower bearing a sign

"The Leaning Tower of Pizza," while one deli in New York's Garment District has the obvious symbols for its sign "Lox, Stock & Bagel." Although these and others are meant to attract and amuse, by their nature they soon become outdated, making way for others that reflect the changing times. An old-time tin sign in the shape of a frog reads "Your Greenbacks Go a Long Way"; today the sign would be a large loaf, with the word "Bread" substituted for "Greenbacks."

Symbolism in signs is often obvious, like the hand holding a foaming stein of beer for the saloon. But a lion sitting on a barrel that bears a brewer's name has no association with the king of beasts, unless it is to suggest supremacy in the brewing of beer.[*] A stack of barrels once was the sign of the paint supplier, but today, with different wording, it could mean a cooper or a pickle vender. The sign of the hand painted black was once the dread symbol of the Black Hand, precursor of the Mafia. The hand and the crystal ball, used singly or together, were the signs of the palmist or fortune teller, and occasionally an eye was added to make it more obvious that the psychic could see into the future.

On Divisadero Street in San Francisco, between Golden Gate Avenue and McAllister Street, are several signs replete with symbolism where the eye and especially the key are dominant. On the sign for the Liberty Lady Locksmith at 918 Divisadero Street is a portrait of the locksmith centered with a sunburst behind her lighting up the lettering. In each hand she holds a key and an orb, and on all sides are locksmiths' symbols as well as those of the Masonic order. Even the name of the artist is preceded by the symbol for *om*, or energy. Above the doorway another sign, with the lettering "Divisadero South," shows a rainbow centered over an African tribesman looking upward. The sign of the Pisces Bootsmith Bootery has since been removed, but like the others it was a work of art filled with symbols.

[*]*Löwenbräu, translated from the German, is "lion brew."*

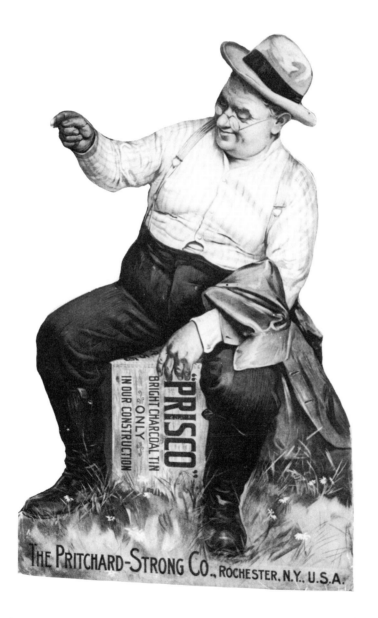

"PRISCO"
BRIGHT CHARCOAL TIN
ONLY
IN OUR CONSTRUCTION

THE PRITCHARD-STRONG CO., ROCHESTER, N.Y., U.S.A.

All are by the artist Doug Ogden of Berkeley, California.

The group of locksmiths, male and female, black and white, have more than a trade in common. The idea of keys to unlock not only actual doors but also the recesses of the mind, of being, is the dominant theme in the lives of these people, who are friendly, hospitable, and open in their attitude toward strangers. Genevieve Thibodeau, the Liberty Lady Locksmith, is an attractive young woman who practices the trade by going about the city opening doors for people who have lost their keys.

Doug Ogden, the artist who painted the signs, also decorated the interiors of Divisadero South. He has not had an easy life: "I was born on June 2, 1949, in Philadelphia, where I was raised. I attended Penn State for two years, a liberal arts major, until I was drafted into the marine corps in 1969. However, at the time I was married and had a young daughter and after completing seven months basic training, I applied for and was refused a hardship discharge. I deserted the service and with my family came to the Bay Area. It was at this time that I first began painting. In 1972, I was apprehended and given an undesirable discharge from the service and continued to pursue my art independently.

"Considering that I did not attend art school and had no formal art training, I consider my talent truly a gift. I feel that it is not from me as it is through me and my openness to it: thus the symbol [om], or energy, that precedes my signature on all my works. I try to reflect this energy in very centered moments that are timeless and spaceless, somewhere between dream and reality. For those who look to see, these moments and images are deep within us all and all around us." Doug Ogden's signs will endure in memory and thought long after they have served the purpose for which there were created.

The advertising signs made for the indoors came in pressed celluloid, tin, and pressed wood; some were lithographed or printed messages mounted on cardboard. A favorite, found in drugstores, candy shops, and ice-cream parlors, was the Moxie soda sign of a man mounted on a horse standing in an open touring car. On the sidewalk outside a drugstore would be a life-size sign of a Cape Cod

95

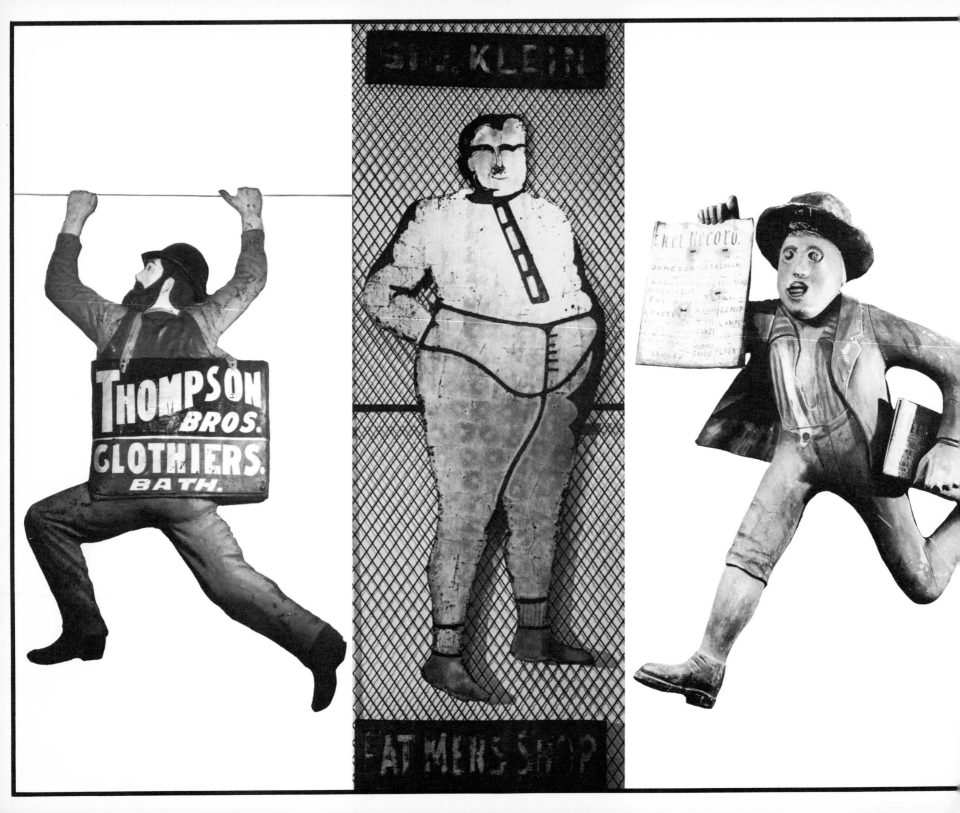

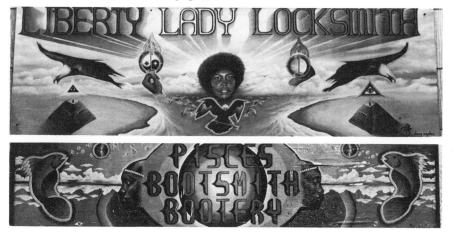

fisherman in oilskins hauling on his back a huge fish; the wording at the bottom read "Scott's Emulsion." The Pritchard-Strong Company had a most lifelike sign printed on glossy paper and mounted on ¼-inch cardboard with an easel in back to hold it up. The man seated on the Prisco box, shirt unbuttoned, coat draped over an arm pointing to a display of the product in the window, appears to have come from a *Saturday Evening Post* cover.

The antique cardboard display sign is making a comeback — but only in antique shops and flea markets. Most were discarded long ago, as they gathered dust and stains and peeled if they got damp, or had to be replaced by updated signs for newer merchandise. Some were put in warehouses, only to emerge many years later as decorations. One of America's most famous signs, painted by Benjamin Hicks of Newtown, hung for many years on the wooden bridge at Washington's Crossing at Taylorsville, Pennsylvania, on the Bucks County side. It was a copy of John Trumbull's painting of Washington crossing the Delaware. It was removed and thrown into the garret of a store at Taylorsville, and had it not been for Henry Chapman Mercer, who rescued it for the Bucks County Historical Society, one of America's folk-art treasures would have been lost forever.

The most ephemeral of all signs, and also the largest, are the painted billboards in Times Square, New York, heralding a new film or an occasional rock group, then painted over in a few weeks to announce the next major attraction. A signboard stretches from West 45th to West 46th Street, covering an entire city block and reaching up to the seventh-story level of an adjacent building. Unlike the other billboards, where the printed message comes from a factory in prepared strips ready to be pasted up, the entire area of 60 by 260 feet must be painted by hand under difficult and perilous conditions. The artist's studio is his scaffold; his model, a sketch, prepared by the advertising agency. Paul Chin is the artist and art director for Artkraft-Strauss, which has many billboards along Broadway. Chin and two others are the only artists who portray the movie and rock stars in gallons of paint on nearly a half-acre of signboard.

To herald the remake of the movie *King Kong*, Mr. Chin completed a wall mural one block north on Seventh Avenue. Painted on the side of a brick wall, the painting, identical to the movie poster, was fifteen stories high and done in brilliant colors. The huge ape stands poised, straddling the two towers of the World Trade Center, clutching the girl in one hand and a smoking jet fighter in the other. The detail is admirable. "I figure out a scale to work with for each particular billboard," Chin told a *New York Times* reporter. "I draw boxes on the sketch, and each one represents a larger area on the actual billboard. For example, one-eighth of an inch on the sketch will equal eighteen inches on the actual surface." Mr. Chin then traces an outline, doing one box at a time, referring to the sketch with the boxes, while drawing from the sketch with charcoal. "I block off a box, trace, and paint it. I follow this process until completion." Working with his assistants, who do only the lettering, it takes Chin five weeks to complete the job.

There is one great advantage to this location, according to Eugene Kornbert, vice-president of the Artkraft-Strauss Company: "We've never been defaced. We're simply up too high."

Mr. Chin is a realist: "I don't feel any sorrow when I cover one billboard to start another. . . . It's a job."

In a fast-moving and fast-changing America, there seems to be no time to stop or turn back to take another look at something that catches our eye—a painting on the side of a barn, a tree stump strangely carved, a village where for a century time has stood still. We are too intent on "getting there," wherever "there" may be. But we will be haunted by that fleeting glimpse, and soon it will be too late to return: a new shopping mall will have obliterated the entire area, with no vestige remaining of that which originally attracted our interest.

Yet wonders remain to be seen, along the highways, side streets, and back roads, if the traveler will but change his pace and head back in the direction of what first caught his eye.

PAINTED WINDOW SCREENS

A generation or so ago—in the pre-beltway era, that is—highways led straight into the heart of a city and then out the other side. This slowed traffic considerably, of course, and was most annoying to the traveler in a hurry as well as to the residents along the highway–become–city street. For instance, U.S. 40, entering Baltimore from the northeast, becomes Orleans Street. Here the traveler of that earlier time saw sights unglimpsed by today's Beltway driver. East Baltimore consists of row upon row of nearly identical little two-story red brick houses, each with three gleaming white marble steps leading to a narrow front door, with one wide window or two narrow ones beside it, and on the floor above, two more narrow windows. A monotonous scene, but suddenly it would turn surreal as you glanced at the windows of a house on a side street and saw through to a pond with swans, a red-roofed cottage, trees, clouds, and blue sky. It was the surrealism of the utterly commonplace, with something impossibly out of scale, misplaced, or askew, as in a painting by Magritte. And so, caught up in a spell, you might turn a corner, then another, time forgotten, looking for more of these scenes: a mountain peak, a forest glade with deer, a waterfall—some brightly colored, others

faded and scarcely visible—all framed in windows and doors.

The dreamlike quality of these window scenes, which can be found to this day in East Baltimore, is due to the wire-mesh screening upon which they are painted. The effect is like that of a theatrical scrim: when illuminated from the front, the painted scene is visible, but when the front lights are dimmed and the area behind it is lit, the painting on the scrim vanishes. The painted screens of the Baltimore houses work on the same principle; while admitting light and summer breezes, they effectively conceal the interior from the gaze of the passer-by. At night, of course, this no longer holds true, and for privacy the householders must draw the blinds or curtains. These screens are still in use; in fact, they seem to be increasing in number, for new ones are always being painted, old ones retouched.

Over the years, this working-class neighborhood, where the first of the row houses were built around 1830, has changed remarkably little. The streets appear cleaner, if anything; the steps are still well-scrubbed. However, there are a few additions: neat little trees have been planted at intervals along the narrow sidewalks, maples on some streets, cherry trees on others. Not yet tall enough to give much shade, they seem to be in perfect scale with the houses. And many of the old red brick fronts have been covered with formstone, a veneer of artificial stonework. This provides a less satisfactory background for the paintings, but it does reinforce the impression that the area has not let itself deteriorate. Blue-collar workers live here, people from Central Europe mostly—Poles, Czechs, Germans. These are people whose ancestors were given to decorating their stucco-walled houses with paintings. The tradition is being carried on in a different medium in Baltimore.

Wire-mesh screening appears to be of fairly recent origin, though a coarse wire netting is said to have been made in Germany in the seventeenth century, production by hand being necessarily slow and costly. This heavy-gauge material was later used in this country for cellar windows to keep out rodents. A finer-mesh screening to be used against insects was made of mosquito netting, a coarse cheesecloth. This was sometimes tacked to window frames, but was more often

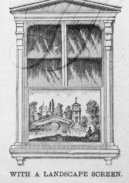

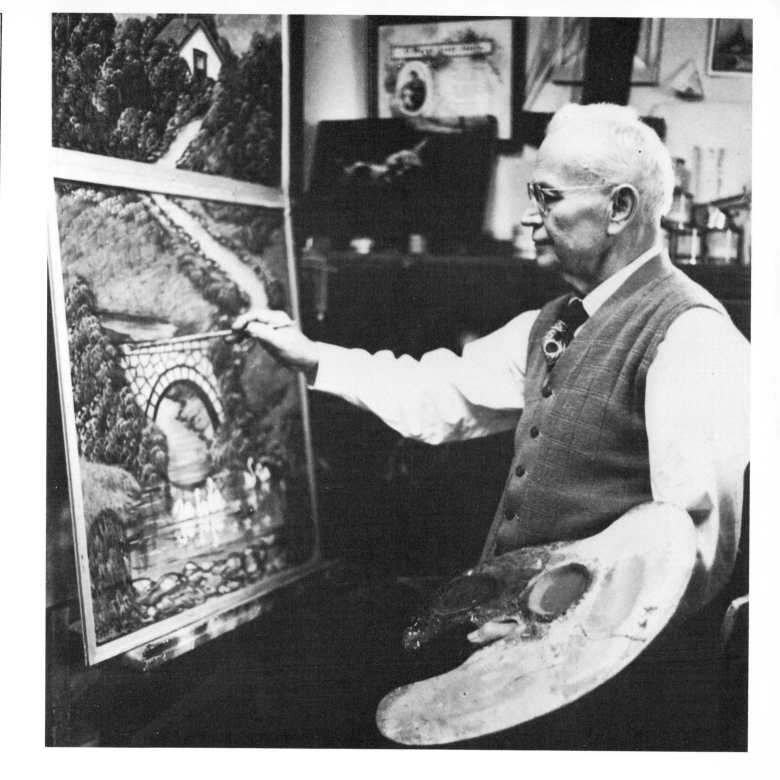

used to screen beds and particularly to cover children's cribs, while little tents of it, with wire frameworks, were made to cover food.

All that changed with the arrival of the fine wire-mesh window screen. Benjamin Gilbert, of Gilbert, Bennett and Company in Georgetown, Connecticut, was manufacturing wire-mesh sieves by 1834, having made his first wire cloth on a neighbor's carpet loom. In 1861, the Civil War shut off the Southern market for sieves, and the company, left with an oversupply of wire cloth, painted it gray and offered it as window screening. It was an immediate success.

Remarkably fast on the heels of this great invention came decorated screens. It was a period when ornamentation was lavished on everything; no surface could go unadorned. Window shades were being painted with bouquets of flowers or romantic ruins or sylvan scenes; it naturally followed that the same type of decoration should be used on wire window screens.

In 1874, the E. T. Barnum Company of Detroit, a manufacturer of wire cloth and ornamental wirework, advertised painted screens which were sold by the square foot: landscape screens, "coated with a ground of drab and afterwards beautifully decorated by an experienced French artist, in imitation of water, mountain, rustic and other natural scenery, making very handsome and useful screens." The advertisement continued: "A peculiarity of these screens, apart from their great beauty, is that persons inside of a room can look out without difficulty, while those from the street cannot look in, and you are thus secluded from the gaze of outsiders. This alone is of great importance to banking institutions where they have money or valuables exposed. If desired, any name or sign can be lettered upon them in rich gold letters, shaded. . . ."

The E. T. Barnum catalogue showed two scenes: the first, captioned "Misery," depicted a family seated at the dining table, beset by swarms of flies; in the second, entitled "Contentment," they were shown dining in peace, with a decorated screen in the dining-room window.

In a catalogue of the same period, Howard and Morse of 45 Fulton Street in New York City featured a similar advertisement. The illustrations showed a family in bed, slapping wildly at flying insects; then a good night's sleep assured by the installation of a window screen painted with a rustic scene, a boy fishing in the foreground. This company quoted a price of 24 cents per square foot for made-to-order landscapes. Special designs were 65 cents, screens with a simple geometric pattern were just 7 cents a square foot.

The screens of this period were painted in monochrome, usually in shades of gray, gray-green, or drab. Unless they were given a coat of varnish frequently, or repainted from time to time, the picture was soon lost. Many a fading design must have been covered with a coat of plain gray or drab paint. The recent discovery of a pair of badly faded nineteenth-century screens in a storeroom at the New York State Historical Association at Cooperstown proved to be a rare find.

Decorated screens were widely used during the last quarter of the nineteenth century. In 1939, William Sumner Appleton of the Society for the Preservation of New England Antiquities wrote to *The Magazine ANTIQUES* recalling their use on Beacon Hill in Boston when he was a boy. They were also a common sight in New Orleans, Charleston, South Carolina, Philadelphia, and, of course, Baltimore. However, they dropped out of fashion, were discarded, and vanished completely from the public memory.

In the mid-1920s, there was a revival of the fashion in Baltimore. A writer for the Baltimore *Sun* mentioned one or two Italianate stucco houses in Roland Park as having gray monochrome scenes from the Roman Forum, after the best Italian manner, and a house in Guilford, another enclave of the well-to-do, as having a pair "painted with Japanese garden scenes, the hues in the screens toning exactly with those to be found in the stone path and chimney." The custom-made screens must have been the creations of local interior decorators. However, the revival was of short duration. Meanwhile, though, a folk tradition had come into being and still flourishes in Baltimore. On Hanover Street in South Baltimore, and on many streets in East Baltimore, as far back as 1913, there were painted screens similar to those seen today. While they are for the most part unsigned, and some are painted by the homeowners themselves, a

great many over the years have come from the shop of the Oktavec Brothers, founded by their father, William Anton Oktavec, a draftsman and commercial artist.

William Oktavec arrived in America from Bohemia (now Czechoslovakia) in 1901 at the age of sixteen and settled on New York's East Side with his parents. He studied commercial art and mechanical drawing at night school while working during the day as a demonstrator for an airbrush company in Newark, New Jersey. He painted his first screen during this period, to keep passers-by from peeking in at his firm's secretary.

In 1913 Oktavec came to Baltimore, hoping to open an art-supply store. It failed, and he tried groceries instead. During the hot summer months he hit upon the idea of protecting the vegetables on display in front of his shop by keeping them inside instead and painting pictures of them on the shop's window screens. In no time he was filling orders for screens throughout the neighborhood and was soon able to set up once more in the art-supply business, this time with considerable success.

The Oktavec sons have always believed that their father invented painted screens, but as research has proved, they were in use long before his birth. However, credit is due him for introducing them to East Baltimore, and for setting the style that is still followed. Country scenes with cottages, mountains, lakes with swans, waterfalls, tree-lined winding roads, bridges over streams—these were the elements, in endless variations. It was customary for a set of screens for a house to be painted all alike, or with changes on the same theme.

As the screen-painting business flourished, so did the shop at 2407 East Monument Street, which stocked greeting cards, art supplies, stationery, and religious articles, and handled repair of religious figures and stained glass as well as framing pictures. It became the community art center, with William Oktavec as its instructor in drawing and painting.

Orders for screens were mainly local, but an occasional order came from out of state, such as the request from the lumber tycoon Frederick Weyerhaeuser in 1940 for woodland scenes and brooks on 4-by-7-foot screens in fine copper mesh. They were so much admired that Weyerhaeuser ordered a duplicate set to be framed and hung inside his house in the State of Washington.

Oktavec's three sons helped out when old enough, learned the business, and took over when their father died in 1956. Albert and Bernard handle repairs and framing; Richard paints screens. The rustic cottages with winding paths and lakes with swans so popular in his father's day are still in demand. Richard has expanded his portfolio of designs, favoring Baltimore landmarks. The Highlandtown Library Center of the Enoch Pratt Free Library purchased paintings of the Shot Tower, the Pagoda in Patterson Park, and the Washington Monument in Mount Vernon Place, all Baltimore scenes. All are displayed in the library's windows.

Every screen painter has his own method, but basically the technique is that used by Richard Oktavec. The screen to be painted is first cleaned, then coated with white paint, keeping the paint thin so the holes in the mesh are not clogged. The scene is then sketched in; for this purpose Oktavec uses black paint, and when it dries, fills in the colors with oil paints. "My colors are mixed with a special formula," Richard explained. "I work at an easel with a palette and use stiff artist's oil-paint brushes, and the screen is then finished with a thin coat of varnish. Given normal wear and weather, the screens should last for at least eight years. However, for best preservation, they should be brought inside during the winter months. Should the scene fade because of exposure to heavy sunlight, it can be touched up by the artist or by the customer himself."

Like his father before him, Richard Oktavec gives out work to other painters when he is overloaded. One such artist is John Eckhardt, a neighborhood friend who lives around the corner with his twin brother, Rob, also an artist, who does repairs on stained glass for the Oktavecs.

John Eckhardt, the screen-painting twin, is an extraordinary human being and a screen painter with "soul." Born severely handicapped, he started drawing at a very early age, encouraged by his mother, who supplied the twins with real artists' materials. When the boys

Opposite page Cellar window screen combines sentiment and patriotism with a vision of the Madonna showing through painted wire mesh. 407 North Streeper Street, Baltimore, 1976.

were six years old, they made greeting cards, which they displayed in their front windows and sold for spending money. At nine, John was painting in oils and taking lessons from William Oktavec. He painted on canvas and on screening; he sold his first screen for $2, and more commissions followed. In 1923, when they were twelve, the twins had their own carnival show. John Eckhardt became "Johnny Eck the Half Boy—the World's Greatest Living Curiosity." Indeed, physically he does appear to be a half person, finishing off at the waist. But his personality is whole; while life has been a struggle, he has squeezed enjoyment from it at every opportunity. John Eckhardt is keenly interested in people and takes pride in his art. His problems are those that might beset anyone: taxes, inflation, and crime in the area.

"I was a performer, walked a tight rope, worked on trapeze, juggled—I did everything. Rob, my twin, ran the show. . . . When we were sixteen, we signed on with the major railroad carnivals, a season at a time. Then it got rough—the 1929 crash broke us. We were eighteen years old then.

"Off seasons we painted screens. Our early screen work was not a success. During our travels an itinerant sign painter came to our tent hungry and tired, looking for work. We shared our food and he shared priceless information with us, and in return we secured a job in the show for him. And thanks to that sign man I broke into screen painting in a bold way.

"In 1932 I had a very good part in a feature film called *Freaks*, produced by Hi Browning for MGM. Today it is considered a classic. I was also in *Tarzan*—I was a bird—I played with Maureen O'Sullivan and Johnny Weismuller—Neil Hamilton was the leading man. I was also in an act called *Miracles of 1937*—the only time a man was sawed in half. When the upper half walked down the stage, it created a panic. The men were more frightened than the women—the women couldn't move because the men were walking across their laps, headed for the exit. Two ambulances were parked outside for those who passed out."

Johnny Eck remembers these as the high points in his career. But calls for this kind of work were very rare. Soon he was back on the

East Coast helping Rob as cashier in an arcade, and more recently, running a minitrain at carnivals, taking children as passengers.

When they weren't traveling, there was time for other kinds of work. Johnny Eck painted screens which are on view throughout the neighborhood. Four screens in two days is his capacity, working with japan colors on a white undercoating and protecting the finished screen with a coat of spar varnish. The screens he paints for Richard Oktavec are often snow scenes. But his favorite is the painting of Christ that he did for a family at 423 North Port Street. The customer had brought in a screen with a Christ figure for retouching; it was in too poor a condition for this, so Johnny simply coated it over with white and began anew. His Christ appears to be standing behind a table in the upper half of the doorway; the features are alive, the painting is vigorous, the colors bright but not garish. While he was at work on the painting, he says, "People would stop at my window and kneel in prayer, crossing themselves in front of it."

As the Catholic religion still plays a major role in the lives of the people in this part of Baltimore, it is surprising that screens with religious motifs should be almost unheard of here. In 1967, Ben Richardson, another screen painter, did four screens for a rabbi in West Baltimore: views of Jerusalem and of Bethlehem, the Wailing Wall ("with twenty-six people"), and "Mother Rachel's tomb"; these were to be used in the synagogue as a divider between the men and women of the congregation. Whether or not they were originally used for this purpose, they are now in the windows of a private house in the 5700th block of Park Heights Avenue.

Benjamin B. Richardson, born in Essex, England, grew up in the Highlandtown section of East Baltimore. His father, a contractor, had hoped to have his son study architecture. Ben was forced to give up this idea after losing all the fingers of his right hand in an accident; instead, he got a job as a salesman and collector for a clothing shop. But he began painting screens as a sideline and hobby and soon had enough work to keep him busy. Despite the loss of his fingers, he continued to use his right hand for writing and painting, controlling the pen or brush with his thumb. From East Baltimore,

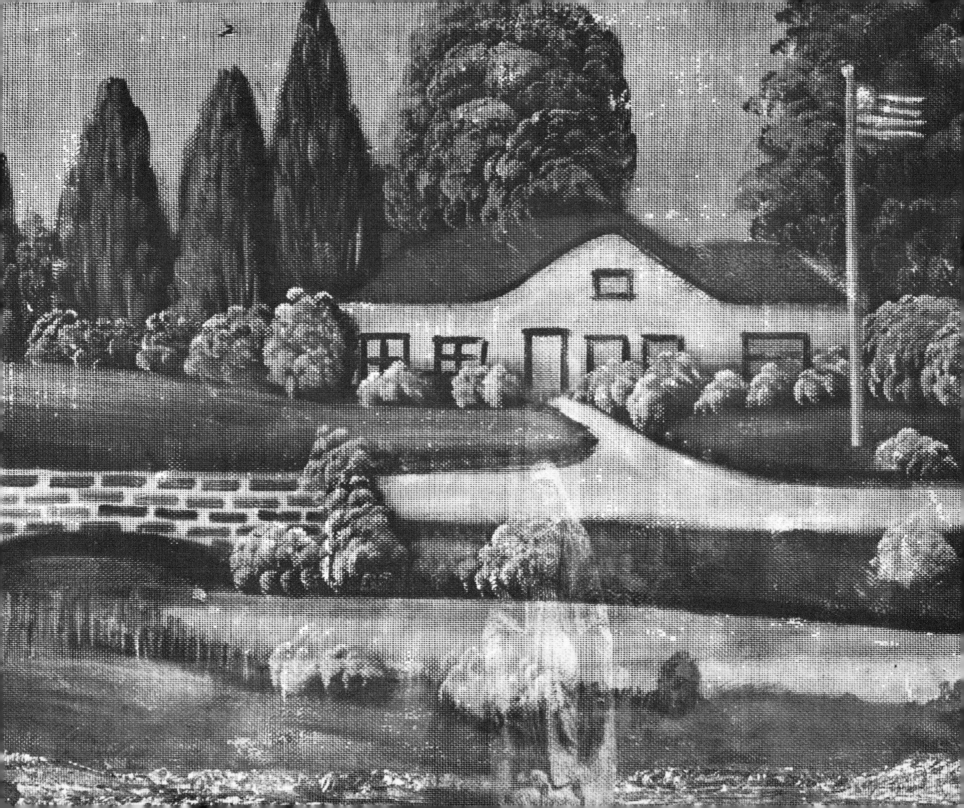

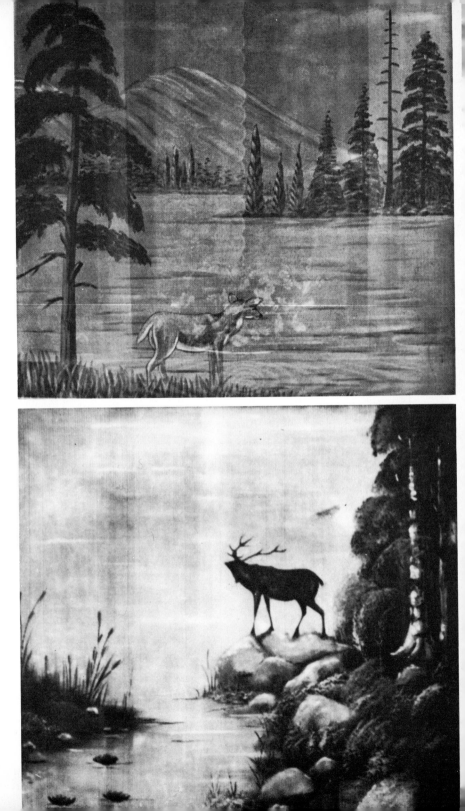

he moved to West Franklin Street, and then to Harman Avenue in Southwest Baltimore, where he has lived with his family for the past twenty or more years. His screens are to be found in many parts of the city and in surrounding counties; he has also filled orders from out-of-state customers who had heard about him from former Baltimoreans.

Not too long ago he was commissioned to paint six screens for the windows above the Midway Bar in the 400 block of East Baltimore Street, the notorious Block, where pornography was the prevalent theme. The screens, intended to counter this image, were of historical subjects: the Statue of Liberty, Baltimore's Washington Monument, the vessel *Constellation,* now a permanent feature of the Baltimore waterfront, two other sailing ships, and the Shot Tower. Three of these scenes covered the windows of Tattoo Charlie's second-floor apartment over the bar and drew compliments from the city solicitor.

Needing assistance, Ben instructed his older brother, Ted, in the art, but the results were below Ben's standards. Ted had a tendency to overload the screens with paint, clogging the holes. (The screens must be lightly painted to permit air to circulate freely.) Ted Richardson at a later time did some screen work on his own.

In the forty-three years or more that Ben Richardson has been painting screens, their number must have run into the thousands. Although he has retired, recommendations from other customers keep him active. Richardson credits the elder Oktavec with introducing the art to Baltimore, but he admires the work of Miss Ruth, who at one time worked for William Oktavec. "Her work was true to life and she never clogged the holes," he says. "Her backgrounds were cream color, and her trees looked like lace."

Ruth Chrysam grew up on North Montford Avenue in East Balti-

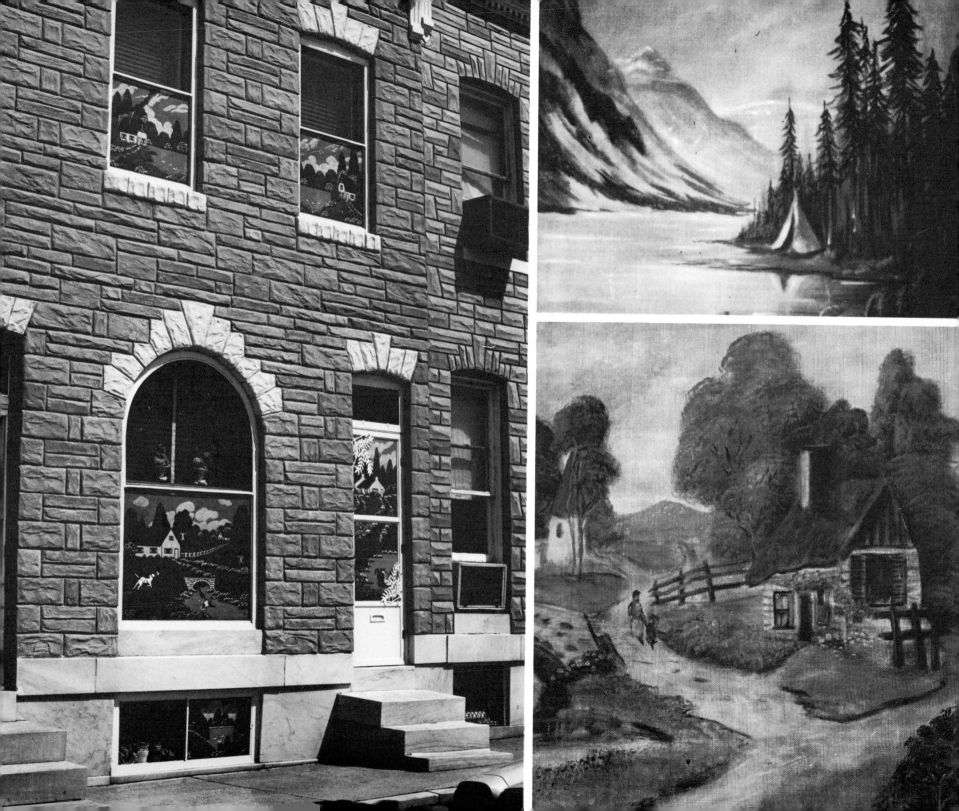

more, a short distance from William Oktavec's art store. Upon completing her high school studies at the Institute of Notre Dame, where she majored in art, she returned for two years of postgraduate study with Sister Mary Sabina. In 1930 she became an apprentice of William Oktavec and spent four years learning all aspects of the business: framing and the repair of statuary and stained glass as well as the art of painting screens. At that time the Oktavec boys were still at school, and the store, located where it is today, had a room roofed with glass that served as the studio for painting screens. Ruth Chrysam was paid $3 per week as an apprentice. When the NRA made $10 the minimum weekly wage, she quit, knowing that Mr. Oktavec could not afford to pay his assistant and her at that rate.

Miss Chrysam went into business for herself, establishing Ruth's Art Shop in the basement of her family's house at 141 North Montford Avenue. Employing her own talents and the skills she learned from Oktavec, she engrossed diplomas, repaired dolls, and, of course, painted screens, always giving instructions in their care: regular scrubbing with soap and water, hosing off, and putting away for the winter. Some of her screens are still to be seen on Montford Avenue, though she moved to New York in 1941, where she later married William Fahey. She can recall the itinerant screen painters who went from door to door picking up jobs, offering low prices but also poor-quality workmanship. The lasting quality of her screens is exemplified by one that she painted for her sister in Baltimore twenty years ago: it has had but one touching up.

Frank Cipolloni, an employee in the exhibit department of Baltimore's Enoch Pratt Free Library, where he does signs and posters, also paints screens occasionally, his first being done in 1946. His subjects are swans floating on lakes, street scenes with gaslights, and his version of Baltimore's famous Shot Tower. Examples of his work can be found throughout his own neighborhood, Baltimore's Little Italy, in the Albemarle Street area. As to technique, Mr. Cipolloni has discovered that by placing a black posterboard under the screen to be painted, he can obtain a monotype; the grid pattern from the

screen gives a pleasing effect, and two paintings can be had from the work for one.

It would seem that with the increased use of air conditioning there would be no need for screens, painted or otherwise. But the residents of East Baltimore continue to cherish their screens and to display them, sometimes behind closed windows. They are increasingly aware that they have something unique that gives their neighborhood a special distinction. And the painters of the screens are being recognized as practitioners of a traditional form of folk art, with roots in the past century and with its own beloved old master—William Oktavec.

ROADSIDE SCULPTURE

The traveler who gazes out the train window, or the driver who can afford the luxury of moving at a pace below the speed limit, is often rewarded with evidences of the creative spirit which appear along the highways and byways of America. The view may be fleeting, but the viewer may have glimpsed enough to perceive that here, too, individual expression

exists. Through necessity and sometimes by accident, the art of the people manifests itself in whatever medium is at hand. The rural mailbox can be an interesting form of roadside art. Usually supported by a post driven into the ground, it is intended to serve a practical purpose. Yet it presents an opportunity to do something more: to express the individuality of the boxholder. Boxes are painted and decorated; the post is often embedded in a concrete-filled milk can which is itself decorated. At times, the links in a length of heavy chain are welded into rigidity to act as a support—as one such welder remarked, "It's my link to the outside world." A miniature garden may be planted around the mailbox pillar for the delectation of the mail-man and passers-by. Morning-glories clambering up the post are a favorite flower.

Humor is evidenced in an amusing flower planter–*cum*–newspaper box located outside Walnut Hill, a community near Centralia, a big oil-producing town in southern Illinois. Its creator was an oilfield worker who used a welding torch and discarded oilfield materials. The strange bird (prehistoric, or perhaps Martian?) holds in its mouth a perfectly conventional *Centralia Sentinal* box. The cauldron that forms the body of the creature contains cheery geraniums.

Mailbox supports made of a flat board cut to the silhouette of Uncle Sam and painted in red, white, and blue were fairly common at one time and are still to be seen. One life-size figure of Uncle Sam, mod-eled in cement and plaster, has a sensitively rendered face that con-trasts surprisingly with the crudely realized hands. This figure, found in Hudson, New York, appears to have been made to hold something in its left hand, possibly the base of a mailbox or perhaps an American flag. A shiny new coat of paint has given the figure a dapper appearance and the whole front an air of respectability.

The Bicentennial year brought forth much opportunistic adver-tising, but also much valuable research into the history of small towns and villages all over the country. The resultant Bicentennial booklets contain a wealth of information and have created a new pride and interest in origins that will not be forgotten. On an entirely different level, there was an impulse to put on a good front—to dress up for the big occasion. Houses were repainted, parks and plantings spruced up, and, as a delightfully anachronistic touch with true folk-art flavor, fire hydrants were turned into quaint little patriotic figures in red, white, and blue, along with an occasional Smokey Bear, the national symbol of fire control. The decorating of the fire hydrants was done by schoolchildren under the guidance of their art instruc-tors.

The Bicentennial theme appears unexpectedly in the Pennsylvania oilfields, where pumps are to be seen on suburban lawns and in back-yards as well as in the fields; once painted bright green and looking like giant grasshoppers, often with eyes and mouth added, some pumps have been redone in red, white, and blue with stars. In Cali-fornia, too, oil pumps made to look like grasshoppers nod endlessly as they pump the oil from the ground along Route 101 between Salinas and Greenfield. One may yet appear as civic sculpture, repre-senting a new art trend.

Driving east or west, the traveler is bound to come upon wayside shrines, adorned with plaster saints and a Madonna in front of an upturned bathtub, half planted in the ground, that serves as a niche. All-weather plastic flowers are grouped along paths lined with painted rocks, which may converge at a birdbath fashioned by the owner of the garden. Some shrines are even more elaborate, with quotations from the Bible painted on boards, while others have large figures cut and shaped from cinder block and padded with cement, identifiable only by name tags. At night, spotlights create weird effects and strange shadows on the figures; they all seem to be rising as if on Judgment Day.

Coming off the Freeway in northern California just above Garber-ville is the Redwood Highway, the old road that leads into the "Ave-nue of the Giants," named for the huge redwoods that line both sides of the road. At Phillipsville, a short distance up the avenue, stands a 15-foot wooden figure labeled "The Giant of the Avenue." It is carved out of redwood, as a memorial to the loggers, woodsmen, and pioneers "who conquered this savage but peaceful land." The dedica-tion, like the figure, is the work of Melvin Byrd, a giant of a man, who

Opposite page
Large photo, center Uncle Sam, painted cement and plaster, life-size. Hudson, N.Y.

Top left inset Mel Byrd, timber feller and chain-saw sculptor, beside his "Giant of the Avenue," 15′ h. Phillipsville, Calif.

Bottom left inset Headless horse with rider carved with hand axe by

unidentified Indian ca. 1925. Mendocino County, Calif.

Top right inset Jeremy Perfect and Don Rivait carving tree stump into owl, Bristol, Vt., 1976.

Bottom right inset Figure carved from fallen eucalyptus trunk, Eddy and Divisadero streets, San Francisco. Artist unknown.

The Passing Scene

ought to know, having spent his youth and later life felling timber in "this savage but peaceful land."

The figure stands in front of the Saw Blade, Mel Byrd's tavern-museum, which inside and out is a tribute to the sweat and labors of the men of muscle who risk their lives and health in the woods of the giants. The tools of the woodsmen are all about. Hard liquor is not sold here, but the Saw Blade's drink list is in the spirit of the area: Crew Hangover, Whistle Punk, High Climber, Gut Wrapper, Donkey Puncher, Gear Jammer's Delight, and Cat Skinner's Cocktail! — the last a concoction of champagne, bitters, and sugar with as much kick as a jammed chain saw.

Mel's father, Leonard Byrd, was a native Tennesseean who moved around a good deal in the early days after his marriage, first to Nebraska, then to the wilderness of British Columbia, and on to Oregon, where Mel was born, the youngest by ten years in a family of six. After World War II, the family moved to Sebastopol, California, where Mel finished high school in 1949 while working weekends and holidays with his father, constructing wood shacks and splitting fencing, post rails, grape stakes, beanpoles, and railroad ties from redwood, in rain, snow, and blazing sun. In the early 1950s the family moved north into Humboldt County, where things were booming, and the Byrds were back in the woods hand-splitting timber year after year. They bought a piece of land in Phillipsville, and "Byrd's Lucky Stop," a general store, was born. Father and son built the store themselves. Then the men went back to lumbering, and Mrs. Byrd stayed behind to manage the store.

The great flood of 1955 set them back. Mel went into logging for himself and Pop, feeling his age, managed the store. Another flood, in 1964, put an end to the general store and sent Mel back into the woods for "gypo" loggers as a timber feller. Then in 1967 the Freeway bypassed the town, which made the idea of a tavern a reality. The store was remodeled into a rustic loggers' museum, tavern, café, and exhibition hall for Mel's chain-saw art. Sharon, Mel's wife, runs the tavern, as Mel is most times up in the woods felling timber. "I'm an artist too. I make two hundred pounds of hamburger patties in a month," says Sharon, and Mel agrees with her.

Mel Byrd's first carving was a chair chopped out with an axe from a 4-foot piece of redwood. When the small chain saws were introduced in the late 1960s, Mel bought one and with it carved "The Giant of the Avenue," now a landmark in northern California. He now fells trees in the summers and does sculpture as time permits. Mel says, "It's an art to fall these big trees in the layout, which is only the width of a cat's blade . . . a cat may spend the better part of a day pushing out the stumps, etc., to make a layout for the tree — that's a level space for the tree to fall. The art of falling a tree takes lots of preparation. In order to be a successful redwood faller, a person's got to be able to drive a stake at two hundred feet." The art of making a tree fall exactly on that stake is like the art of chain-saw sculpture. If too much is cut away, the shape you had in mind doesn't come out that way.

The headless horse and rider outside the Saw Blade Tavern was carved by hand axe "by an old Indian fellow — name unknown — about fifty years ago. It originally stood at the gate of Old Ranch in Mendocino County. I claimed it as right-of-way as the Freeway was going through and brought it home to rest in Phillipsville." If Mel had not saved it, the sculpture might have been bulldozed to splinters. Above the porch roof of the tavern is a huge painting that depicts the life of a logger. "The painting was done by our barmaid, Judy Fratti. She said it was a tough job as she had never done something so large — also she had three children, and the youngest was two then. Judy enjoyed working on the piece out in the sun, in the summer of 1972. Her husband is a logger."

Mel Byrd, time permitting, exhibits his chain-saw sculpture at the Sierra Cascade Logging Conference in Anderson, California, and at local Humboldt County fairs. He also demonstrates his talents for senior-citizen groups and has exhibited at galleries from Eureka to San Francisco. Folk-art collectors are on to his work. Sometimes one wonders how they can carry it away.

Chain-saw sculpture has become a popular form of entertainment at country fairs throughout the United States and Canada. Some of the carvers travel in house trailers, going from fair to fair, and their

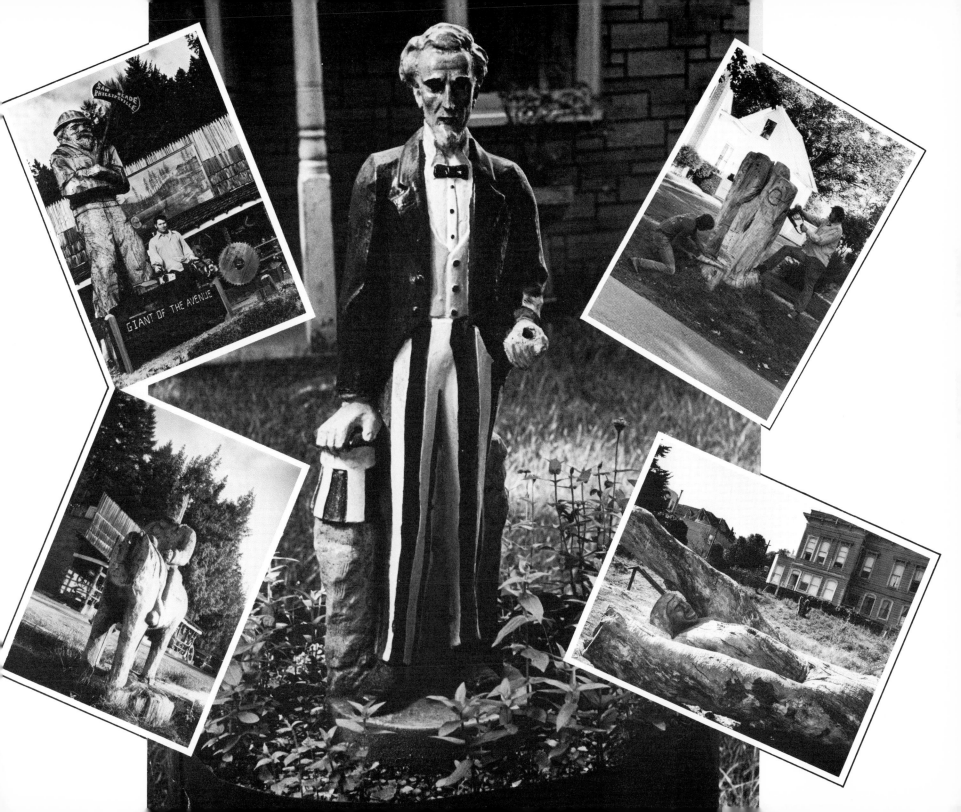

The PASSING SCENE

art is of indifferent quality. They have set patterns that they repeat endlessly without variation, selling the pieces to anyone who makes them an offer.

Then there is sculptor's art that is purely accidental.

The trees bordering the streets of Bristol, Vermont, are old; the elms, one by one, are succumbing to disease, and the aged maples are going too. Dying trees fall an easy prey to winter storms and are a danger to houses and people, and so in the fall the trees that are beyond saving are cut down by town employees. The custom is to stack the cut wood beside the stump, and if the property owners don't claim it, others are free to take it away to fuel their fires.

In the fall of 1975, Jeremy Perfect and Don Rivait, carpenters, and Steve Halnon, a printer by trade, were collecting wood for the stove that heats their cabin on the Lincoln Road. On Pleasant Street, in front of the Kingsland house, was a stack of wood piled beside the stump, which stood about 6 feet high with three short, very thick branch stubs. The three men had permission to take the piled wood, but looking at the stump of the tree, they felt that they owed it a debt of gratitude. A week later they returned with two chain saws, and after stripping off the bark, they held a conference. "At first we talked it over," said Jeremy. "The shape came to us when one of us—I can't remember which—looked at the stubby branches and thought it looked like wings. We thought of making it an angel, so we started sawing away, and then an owl started to shape up, so we stuck with that." Don and Jeremy did most of the chain-saw work, Steve and Jeremy most of the chisel work, and all were pleased with the results, including the townspeople. Mrs. Kingsland couldn't remember seeing the young men at work, but then, "When I looked out, there was an owl instead of the stump."

In San Francisco, on a vacant lot at Divasadero and Eddy streets, a felled eucalyptus tree has been carved into the figure of a man struggling to emerge from the tree. Two huge limbs like arms appear to confine him. His face is contorted with effort; his body, formed by the twisted central branch of the tree, seems to writhe eternal in pain and anguish.

112

No one remembers who made it, or why. "He seemed to be some kind of Oriental" is the only response. The trunk and limbs of the tree probably suggested man's urge to be free, and because it was there the sculptor set to work. It now serves as public sculpture to be admired by all.

This kind of art, created by the sculptor with no thought of recompense, is there for all to appreciate, simply because the material presented itself and the artist responded in a very direct way. It has a kind of purity in its conception, far removed as it is from the marketplace of art. But now the whole concept of outdoor art of this sort, as opposed to formally commissioned works for parks, plazas, and buildings, has become a movement; and while such works continue to appear spontaneously, there are also organizations devoted to producing outdoor art, either to beautify the environment or to deliver some important message.

OUTDOOR MURALS

In the ruined, gutted centers of large cities, life goes on—the life of the very poor, the people who work for the minimum wage or less, those on part-time employment, the unemployed, and those on welfare. They are the minorities, the "last hired, first fired." In these centers, where hope for a future seems to have been abandoned, a new art is growing out of the ruins, expressing the determination of these people to achieve a better life.

This art began as protests painted on the sides of fences and walls, expressing the grievances of the underprivileged and calling for action to help them achieve their modest goals. The more talented among the protest painters graphically depicted their struggles in bold but simple shapes and in brilliant colors, most often on the walls of public buildings such as schools, a local symbol of authority and government. The civil rights movement had brought with it an awareness on the part of minority groups that they could demand to be heard and to have their contributions recognized.

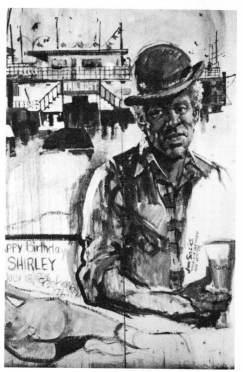

Opposite page A California freeway after the next earthquake. Painted by the Los Angeles Fine Arts Squad, on concrete-on-brick wall. Santa Monica Boulevard, Los Angeles, 1971.

The idea of the underprivileged speaking out, stating their grievances publicly and asserting their right to be heard, was a powerful one. As the idea took hold, organization became necessary. Empty stores were taken over; people formed workshops, sometimes with a trained artist-director in charge. Community support and funds were sought out; local students and adults contributed their talents to the cooperative project. Organizers with training and experience in neighborhood group work helped to determine how and where the art of protest could be used most effectively. A theme was selected and a site chosen that would reach the largest possible audience with its graphic message, usually the side of an empty building. Immediately, a community would be involved, and besides the message, color and life would be added to a drab neighborhood.

The first successful people's art movement in the United States is thought to have had its beginning in the 1960s on Chicago's South Side, a black community, under the guidance of black artists. The "Wall of Respect," a huge outdoor mural done under the leadership of William Walker, a pioneer in the mural activities, was intended to "further the struggle for an end to racism, for peace, justice, and human dignity." The outdoor mural movement that started in the 1960s attracted the attention of activist groups throughout the nation, which followed its lead.

The inspiration for the mural trend had its roots in the work of the WPA artists during the 1930s, whose murals, executed in paint, mosaic, and wood, appeared in post offices, schools, and other public buildings and are still to be seen. At that time, there was a major movement to bring art back to the people. It has been estimated that between 1933 and 1943, artists paid with government funds painted over 4,000 murals in public buildings. The time was the Great Depression, when millions were out of work. Art projects were created to make work for some of the unemployed, and the message was optimism and determination with Uncle Sam as the art patron. The projects led to a rebirth of the arts in America and also provided a training ground for artists.

Many of the WPA mural artists were influenced by the techniques, scale, and symbols employed by the Mexican mural movement, whose artists renounced easel painting as an expression of the aristocratic class. Their murals were intended to speak forcefully and directly to the largely illiterate workers and peasants of Mexico. During the 1930s three of the artists, David Siqueiros, Diego Rivera, and José Clemente Orozco, worked in the United States and fraternized with the socially conscious left-wing artists engaged on the federal mural projects. Their impact carried over to the work done by the American artists, and to some degree is to be found in current mural projects.

In addition, the poster artists of the 1960s had their effect on the colors, line, and use of symbolism found in community murals. However, the message was paramount; it was discussed at length before a design was decided upon, and drawings to scale were prepared before work began. Materials were donated or purchased at cost with money raised by local organizations, grants from foundations, or funds from the city. In 1973 the Public Art Workshop of Chicago issued the *Mural Manual*, written by Mark Rogovin, Marie Burton, and Holly Highfill and published by the Beacon Press of Boston. The *Manual* is a step-by-step illustrated instruction guide, covering all phases of "How to Paint Murals for the Classroom, Community Center, and Street Corner."

The successes of the Public Art Workshop in Chicago reached the attention of neighborhood groups throughout the country, and by 1973 outdoor murals appeared in many of the depressed communities in the larger cities. Among the first to follow Chicago's lead was New York's Cityarts Workshop, with a Children's Mural in 1968, and by 1976 twenty-four exterior and seven interior mural projects had been completed. Most are in Manhattan's Lower East Side, with ethnic and militant themes predominating.

Los Angeles and San Francisco during the 1960s had spontaneous but small movements that were of short duration, as had other cities. Efforts by small groups working with meager funds produced a few murals without sponsors, and usually without authorization by the property owners. In other instances, vacant properties offered perfect

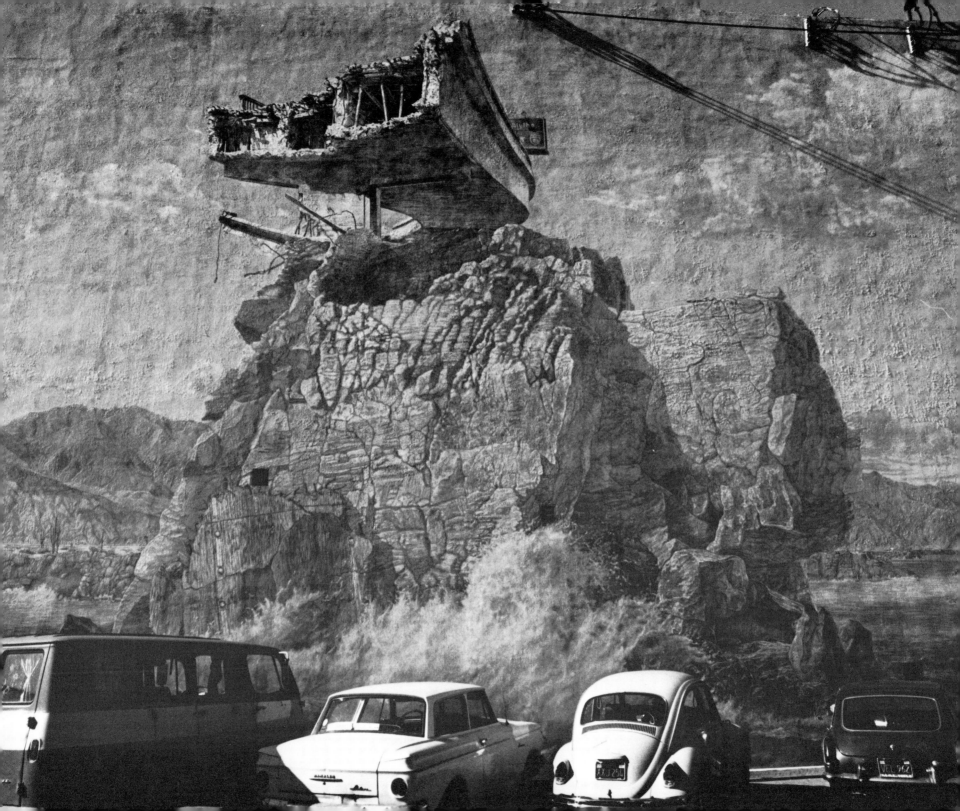

façades for the artists. By the 1970s organized art groups had appeared in many of America's urban areas. In Los Angeles, the Fine Arts Squad produced an apocalyptic vision on the side of a wall quite different in technique from the community-involved murals. Done by a few highly skilled artists instead of unskilled volunteers working under the direction of an artist, the work carries a powerful message for the cause of the environmentalist.

There need not always be a message for an artist to use the surface of a wall to express himself. The urge to display one's talents publicly can make itself felt through a simple exercise in perspective, as it does in the mural *15¢ Wash* at Brooks Avenue and Pacific Street in Venice, California. It remains unfinished because the artists, two UCLA students, ran out of materials. Only a few blocks away, in an area where few people walk and not many cars drive by, a garage door is decorated in the psychedelic style and signed "Sloan E." Self-expression seems to be the rule in Santa Monica, California; on a fence erected around the carousel building at the pier, artists and others have felt free to exercise their freedom of expression as well as their talents. The fence is decorated, not with obvious or symbolic messages, but with professional-looking illustrations. The central work, a portrait with the pier in the background done in monochrome, is signed "John Solie, 1976."

The impromptu nature of these fence paintings is matched by the folk-art quality of a wall painting in San Francisco at Eddy and Divisadero streets, just up the street from the bus stop. The mural, painted on concrete and wood siding, is titled *Waiting for the Bus*. The assorted people waiting in line may be attempts at actual portraits, identified by a number of signatures. At the extreme right of the wall, a dragon approaches; a conveniently placed outcropping of rock has been utilized as a three-dimensional front leg for the creature.

Five blocks away at 1309A Hayes Street, a New York brownstone-stoop scene is painted on a wall next to Norris' Golden Fry restaurant. A black woman wearing a bright yellow dress and hat stands out from the drab background. The painting, skillfully executed, is signed "V. Clarkston Peadee," and is clearly derived from Reginald Marsh's

High Yaller, painted in tempera in 1934. Peadee has reversed, widened, and color-heightened his rendering from Marsh's original to fit the working space.

In New York's SoHo district, once an area of commercial lofts and now taken over in part by artists who require space in the heart of the world's greatest art market, handsome designs have been painted here and there, high up on side walls of buildings. These represent an organized effort by a group called Citywalls, Inc., whose purpose is purely aesthetic, whose art carries no message but merely aims to please the eye.

The amount of outdoor art being produced clearly represents a trend—a conscious one on the part of members of workshop groups—a challenge to the sterility and lack of ornamentation in modern architecture. These murals are a constant surprise and reminder to the community and to public officials of the potential that resides within the walls.

But whether they worked as a group or alone, for a larger good or for their own personal gratification, these mural painters were all essentially social beings. Of a very different breed, needing only freedom to come and go whenever he chose, was an outdoor muralist who left his work on the walls of barns and other buildings in northern New England, a few years before the present "mural renaissance" got under way.

Dog Man

Up in the northeastern corner of Vermont, which is known as the "Northeast Kingdom," there is a mural painted on masonite on the side of the Irasburg General Store. It depicts a waterfall descending from twin peaks and cascading into a lake with a large leaping fish. The painting is signed "Dog Man, 1954."

Ken Johnson, who runs the store, has been there only six years. George Fortin, who had the store for thirty years up through the period when the mural was painted, sold it fifteen years ago; there

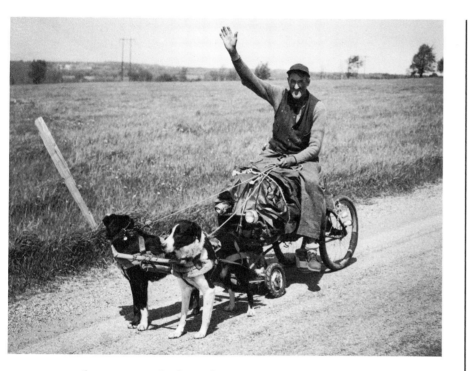

were two other owners before the present proprietor took over. All Ken Johnson knows about Dog Man is that he traveled on a sled on wheels, drawn by a team of dogs, that he was said to have come from the New Haven (Vermont) area, and that he had done other work in the vicinity of Irasburg: a painting on a barn, about a mile down the road. The mural on the side of the store had been repainted fairly recently by Muriel Liberty; she was paid $100 for the job. George Fortin, who could have told more about Dog Man, died a year or two ago.

The farm down the road, on Route 14 North, belongs to the Poultre family. "Sunny Acres—Home of the Black and White Holstein Cattle," the sign reads, its letters burnt into a board. The barn is large, white with red trim; the painting, which runs across one entire side, begins just above the ground-floor windows. A dark green area representing grass and trees sets off black-and-white cows; over the door and on a smaller scale are a red barn and the figure of a man with his dog.

His name was Norris Barton, and he was born about seventy-three years ago in Barton, Vermont—or maybe, according to another account, in Rutland. Mrs. Eva Rowland, formerly of Fairfax, just a few miles from Barton, remembers a *Maurice* Barton (she pronounces it Morris) who beginning in 1940 spent summers on her father-in-law's farm in Fairfax, living in the house with the family and working in the fields. He was a tremendous worker, she says. And she recalls how he would sit in a rocking chair, cutting out figures of horses and dogs from brown wrapping paper for her children. He painted a large picture, about 36 by 24 inches, of horses and a wagon loaded with hay, for her mother-in-law; it's gone now, she doesn't know where. He stayed there for many summers, till 1952. Winters he'd go south, to Florida he said, on his bicycle.

William Mallow remembers Norris Barton. In 1953, Mr. Mallow bought the store on Route 116 at South Hinesburg, and the following year he bought a diner across the road for his daughter. "One day a fellow came by on a bicycle, wanted to paint the diner. He had no references, just told about how many other places he had painted. He started on a Tuesday, finished that Friday. On the front of the diner, in about an eight by fourteen space, he painted a fawn surrounded by small trees, on the left side of the door in front, a doe and fawn and a pond. There was an elk fight on the north side. South side, mother bear and two cubs. He worked from a calendar with photos of scenes that I'd been saving."

Mallow gave him meals, but not lodging; he had no idea where he went at night. Barton had asked for $20 for each of the four panels, but people stopping by to watch the work in progress told him he wasn't being paid enough; Mallow ended up giving him $100 for the complete job.

"He liked kids very well. When he started painting, they'd all gather round. He liked wine, too; he'd paint awhile, then lie on the grass and

drink awhile." Barton came through again, with his dogs, once a year for about three or four years. Mallow doesn't know what became of him. The store was sold in 1976 when Mallow retired. As to the diner, it became a house. It originally stood on open ground, but now there are trees and shrubs growing all around it; it takes a close inspection to see that nothing is left of Barton's work. It has all been painted over, except for possible vestiges of design on the roof.

Isabel and Winston Swain, of Highland Home Farm in the town of New Haven, have a painting signed "Norris M. Barton." It is of their farm, and Barton painted it in oils on plywood while seated on the ground across the road. "It's just the way the place looked then; now several of the buildings are gone. He did it in the late fifties. We paid him fifteen dollars for it." ("Five," said Mr. Swain.) "He was a very mild type of person. He had a bicycle, carried a lot of clothes with him. He wore a long overcoat. His last days weren't good." Mrs. Swain didn't elaborate on that.

The Hallock brothers, Donald and Kenneth, have a big farm over at Addison near the county fairgrounds, just a few miles from the Swains. They live in separate houses with their respective families, but they work the farm together. They knew Barton, called him Buck: "ole Buck." Never heard him called "Dog Man." But he had dogs, all right; unfriendly dogs, and everyone afraid of *him*. He always carried a handgun. People kept away from him pretty much. But, said Kenneth Hallock, "He could take a pair of tin shears and cut you out a dog, a cat, anything you want. He could look at something, a week later paint it. He painted two barns at Vergennes; they're both painted over now. And there was a deer painted on a barn. His work was on barns that burned down, or were torn down, or maybe on some the paint just washed off. He lived in an old shack up back here for one winter. He'd come back every year."

"Till when?"

"Till about two or three years ago," Donald Hallock said. "But then, time goes so fast, it's probably more like ten or fifteen years ago. And now it's time to start loading hay into the barn."

A wagon had just come in from the fields, and Donald went off with-

out another word. Kenneth looked as if he might have had more to say, but thought better of it.

A picturesque character if ever there was one, Barton attracted the attention of the press—the *Burlington Free Press*, that is—toward the end of the fifties, when at least five articles appeared, all accompanied by photographs. A wet snowstorm struck Vermont on January 28, 1958, a "winter wonderland" sort of snow that brought out the photographers and also Norris M. Barton, fifty-five, of Bristol, shown with sled and two-dog team. "Barton says the dogs are Labrador huskies and can draw 400 pounds," said the caption.

On Thursday, May 27, of the same year, Barton was sighted traveling Route 2A at Williston. Seated in a small homemade cart on a large canvas pack tied with rope, he was being pulled by a pair of medium-sized black-and-white dogs. In the pack, he said, were a tent, blankets, food for himself and the dogs, tools, and extra bicycle wheels. Barton said that the "Labrador huskies" were a cross between Labrador retriever and timber wolf: "When I tent down at night they'd take the hand off a man that came around looking for trouble." At the time he was on the way back from the Canadian border, where he had been refused entrance because of quarantine regulations. He said that he painted pictures and signs and cut out silhouettes for a living. "I can make a silhouette of pretty near anything. And I'm the only man you ever saw who can take a pencil in each hand and draw a picture of George Washington and Abraham Lincoln at the same time."

By November of that year, Barton had added another dog to his team. Reining up at Shelburne on his way to St. Albans for an interview by a representative of the *Free Press,* he described himself as "a first-rate painter of the naturalist school." He said he picked up

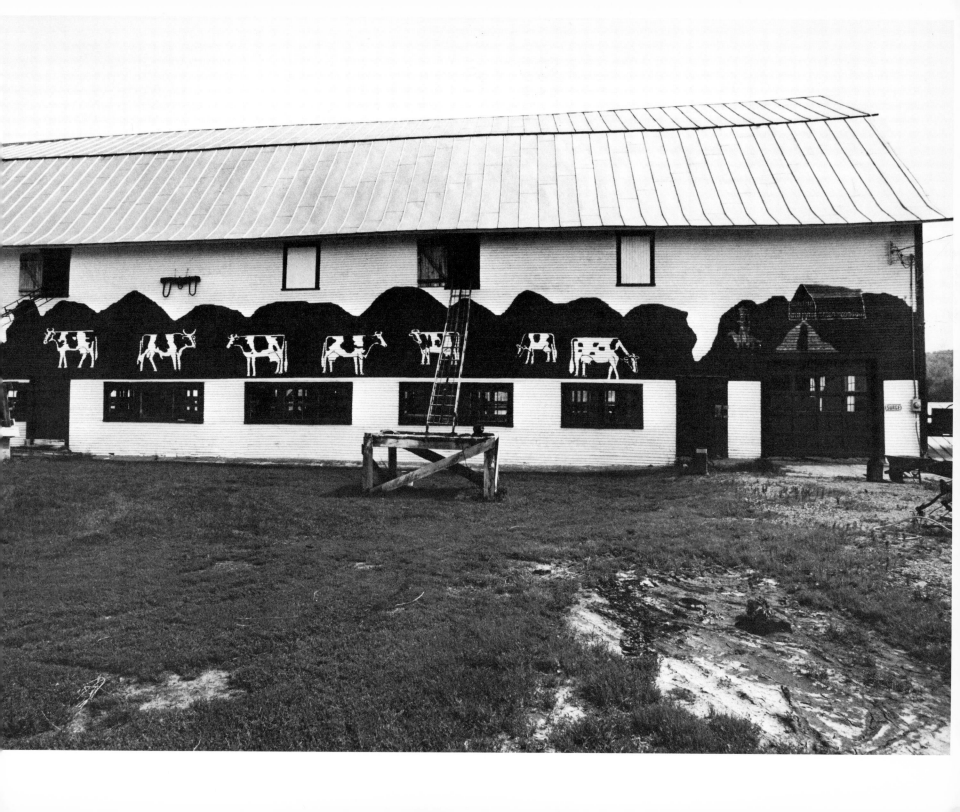

Below, right Detail of backdrop
painted by Charles W. Henry,
ca. 1908. Congregational Church,
Sudbury, Vt.

spare jobs as he traveled from town to town, to pay for his room, board, and traveling expenses. By now he was also charging a fee of 50 cents to pose for photographs. He had just completed a mural on a living-room wall in Charlotte, "for room and board." He said he also did sculpture, carving cement blocks. The subjects were wild life, sometimes people.

Barton was in the news once more in April 1959 after having spent a night at the Alpha Epsilon Pi fraternity house in Burlington, while his dogs were housed in the garage. "He has visited every state in the Union by dog sled or cart during the past 14 years except Hawaii, and 'plans to get there somehow,'" reported the *Free Press*. By then he had a four-dog team, and in May he added a fifth dog, called Spot. In the photographs the dogs look friendly and good-natured, and so does Norris M. Barton, who in all these accounts is referred to as coming from Bristol, Vermont. But no one in Bristol will acknowledge that he was there for very long. "A week or two," they'll say, or "Off and on one summer." And no one seems to know what became of him.

But a man who may have been Norris Barton is remembered in Lincoln, just eight miles from Bristol. Eddie Lafayette, who helps his father farm, recalled: "About eight or ten years ago there was a man called Bicycle Pete, stayed at the Crams. Bicycle Pete could draw like you wouldn't believe. And he painted a deer and white birch on an upstairs wall in the house where the Crams lived, Garland's house by the bridge. He'd say to us kids, 'What do you want me to draw?' Did some dappled gray Percherons. He painted Gene Le Beau's store in Vergennes, the inside. And there's a barn over in Marshfield with horses painted on it. Maybe he did that."

Nora Cram said her mother used to take in boarders when they lived in Lincoln; she took in Bicycle Pete, and he paid what he could. Her mother was like that, she said; she knew what it was like to be poor. He had a beard, was very heavy. And he was old—sixty or seventy. That is, he *looked* old. She couldn't remember his real name.

"Could it have been Norris Barton?"

"Yes, that was it, Norris Barton." She believed that Bicycle Pete, or

Norris Barton, was drowned in the southwest corner of the state several years after he moved on, away from Lincoln. However, investigation has not borne this out. He would seem to have simply vanished. The painting of the deer and the white birch in the house where the Crams used to live vanished too, either papered or painted over, and on Halloween 1977 the house itself, by then tenantless, was burned to the ground.

SCENES BEHIND THE SCENES

Pre-cinema America went to the theater. The big cities had their own repertory companies. New plays with guest stars had long runs in New York City. Road companies went out on tour and played the hundreds of theaters throughout the country; by 1900 there were nearly five hundred such companies on the road. But there were many towns too small to afford a visiting road company.

Throughout the United States, there were small troupes composed of family members who performed in out-of-the-way areas never reached by the larger companies. In the early years of this century, the Henry Family Players—father, mother, two sons, and two daughters—were very much a part of the theatrical scene in northern Vermont and northeastern New York State, where they delighted capacity audiences in town halls, granges, and church auditoriums. Their last performance took place in the year 1916. Although there are few people around today who saw their plays, the legend of the Henry Family remains as part of the folklore of these towns and villages. A visible legacy is still to be seen in such towns as Huntington and Sudbury, Vermont, where sets of scenery, still in position on the stages, attract attention to this day. Other towns also had scenery once, painted by the talented Charles W. Henry, leader and father of the troupe.

Charles Henry was born in 1850 in Guilford, Vermont, of puritanical parents to whom any form of artistic expression was suspect and the theater absolute anathema. As a boy, he was always drawing and

painting, in spite of his parents' disapproval and though he never received any art lessons. Upon his graduation from high school, his father apprenticed him to a machinist in Florence, Massachusetts, near Northampton, and after serving his time he became a very good machinist. After hours he joined up with the Northampton Dramatic Club, where he met Martha Fiske, lovely and talented and eighteen years old. They were shortly married and in time had seven children, of whom only four survived.

Poor health freed Charles Henry from the hated machine shop. From then on, in one form or another, he and his family were in the entertainment business. For a short while he was manager of the opera house in Bellows Falls, Vermont, and later played alto horn for the Manchester, New Hampshire, city band. Self-taught in music as he was in art, he also learned to play the violin, bass, banjo, and guitar. Soon his boys were learning to play the flute and violin, while the older sister developed a lovely soprano voice. In 1897 Grace, the youngest member of the family, was born, and shortly after, Charles was advised by his doctor that a cure for his asthma required a move to Franconia in the White Mountains of New Hampshire.

Franconia was then a fashionable summer resort with inspiring views of the mountains. Charles Henry set to work painting souvenir plates with scenes of Echo Lake, the Old Man of the Mountain, and other local wonders, which he sold to the shops and also peddled from hotel to hotel, selling to the ladies in the rocking chairs on the verandas.

"One time," said Grace Henry Hanna, "my father loaded a wagon with his painted plates, and drove over to Sugar Hill with an old horse. (He always hated horses.) In the circular driveway in front of the hotel, the horse slipped and fell, the wagon tipped over, and all the painted plates were smashed to bits. The ladies on the porch all ran down, one crying, 'Henry, are you hurt?' 'Oh, no, madam,' said my father grandly. 'That's the way we always turn around.'"

Fortunately, there were other sources of income. Charles Henry also painted shop signs and those on buildings. He formed a little company of players and charged admission. The boys from time to time played in the summer hotels; during the winters they were in school. But an idea was taking shape in the minds of Charles and Martha Henry, a plan which was to utilize all their talents and provide a career for the entire family, including Baby Grace, over a period of almost twenty years. In 1902, they became the Henry Family Sextet.

"That fall," noted Grace Henry Hanna, "Ma became the advance agent, and got us placed—in Vermont, mostly. We would appear under the auspices of the local grange, church, Oddfellows, Eastern Star. They would board us, pay expenses. We charged ten, twenty, thirty cents admission. My grandparents thought my parents had gone crazy."

But the townspeople everywhere accepted them, and friendships developed. However, they never associated with other groups of actors. "We always boarded in nice places, never in hotels because of the liquor." Martha Henry didn't want her children exposed to rough language and behavior, and besides, many of the towns were too small to boast a hotel.

At first they did minstrel shows, then such popular favorites as *Uncle Tom's Cabin* (with Grace as Little Eva), *Ten Nights in a Barroom*, *East Lynne*, and *Rip Van Winkle*. Later they presented plays written especially for the group by Charles W. Henry. One of these was *Darkness and Daylight*, which after a time was, as their playbill noted, "rewritten and revised, new scenes and characters added, making it one of the most beautiful and realistic pictures of New England home life ever presented. . . . Also, A GREAT STEAMBOAT SCENE!"

Summer was an all-too-short season when no one had time for playgoing, so it was during these months that the family, living in a rented cottage on the shores of Lake Champlain at North Ferrisburg, rehearsed the plays to be given in the fall. Martha Henry sewed costumes and also stitched together the long strips of fabric which her husband then sized and painted. They always carried a set of scenery with them on the road, but many of the towns wanted scenery of their own, and in most cases this was necessary, as few stages were of the same dimensions. Charles Henry then set to work painting the

scenery to order.

The scenery designed by Charles Henry was technically of the simplest sort, the kind in common use in the eighteenth and early nineteenth centuries. First of all, there was the stage curtain, which in a first-class theater would generally be a double curtain of some rich-looking stuff, hanging in ample folds; this was pulled back from either side to reveal the stage set. The Henry curtain was a simple drop of heavy woven cotton, hanging in front of the stage but painted in imitation of intricate draperies caught back with ropes to reveal a romantic or bucolic scene, all painted on the same surface. This front curtain and a series of backdrops were hung from the stage ceiling, supported by ropes that ran through pulleys and were lashed in position on cleats on the walls of the wings. As the front curtain was raised, one of the backdrops would come into view. Here too all was illusion: doors, windows, fireplaces—all painted on the fabric. Entrances and exits would be made from the wings or from the stage doors right and left.

The small-town halls had to serve many purposes: town meetings, church suppers, weddings, family reunions, all were held in the same hall. At Sudbury, Vermont, the Congregational church, painted white, with a square Gothic steeple, stands high on the village green. The meeting hall, with its stage, is on the ground floor, the church above. Henry's scenery is still in place and used on occasion. The drop curtain is a grand study in gathered draperies, gold tassels, and fringe, drawn back to disclose a lake, mountains, and in the left foreground, a noble stag. On the reverse side of the curtain, the fabric is marked "Lockheed Mills Fine Brown 40."

Behind the curtain is a backdrop painted with a street scene, drawn in meticulous perspective; the buildings are of rosy red brick. To the rear of this drop is an interior scene of a simple, poor cottage, painted with great economy, and finally, there is a seascape. A set of flats, rectangular wooden frames covered with canvas, three on either side of the stage, are painted on one side to match the interior, which may have been used for *Rip Van Winkle* and *Uncle Tom's Cabin* alike. "He could make one of those little halls look like a theater," says Charles

Henry's daughter. "He could paint a set of scenery in a week."

Henry's painted scenes were often applauded for their own merit before the performers took the stage. This was not unusual audience behavior toward the end of the nineteenth century. Even in sophisticated New York, audiences would applaud an elaborately painted drop curtain when it was revealed by the raising of the asbestos curtain shortly before the beginning of the performance, as was recalled by Frank Weitenkampf, then a cub reporter for the *New York Times.*

The former Modern Woodmen of America hall, now the town hall, in Huntington, Vermont, has a splendid set of Henry-painted scenery, which took him six weeks to complete. The presence of the front drop turns the hall immediately into a theater. It is painted with curtains of a rich red, fringed in gold and gathered back with gold tasseled ropes; behind these are other draperies, framing a landscape with mountains, a bridge, and a carriage drawn by a team of horses. There are three additional backdrops: a city scene, an interior, and a landscape. The last is part of the back wall; the others were taken down when an acoustical tile ceiling was installed and have never been replaced.

At Monkton Boro, Vermont, when the roof of the old town hall fell in, the Henry curtains were irreparably damaged, as were other sets elsewhere. The hall at Huntington Lower Village was vandalized and one curtain destroyed. Other surviving Henry curtains are sure to be found, if searched for, in Vermont and in New York State.

The Henrys played in various Vermont towns—Ferrisburg, Shelburne, Salisbury, Richmond, and far to the northeast, St. Johnsbury and Lunenburg, as well as in Alstead, New Hampshire. In the last four years of the group's existence, they crossed over to New York State, giving performances in Plattsburg and Chazy. "In the winter we traveled by sleigh," Mrs. Hanna recalled, "with robes over us and heated stones to keep our feet warm. It took all day to go twenty miles." When they began performing in New York State, the Henrys would cross frozen Lake Champlain by sleigh. In the later years, though, they acquired a winter home, a large comfortable house on Mount Philo Road in North Ferrisburg, where they would stay during

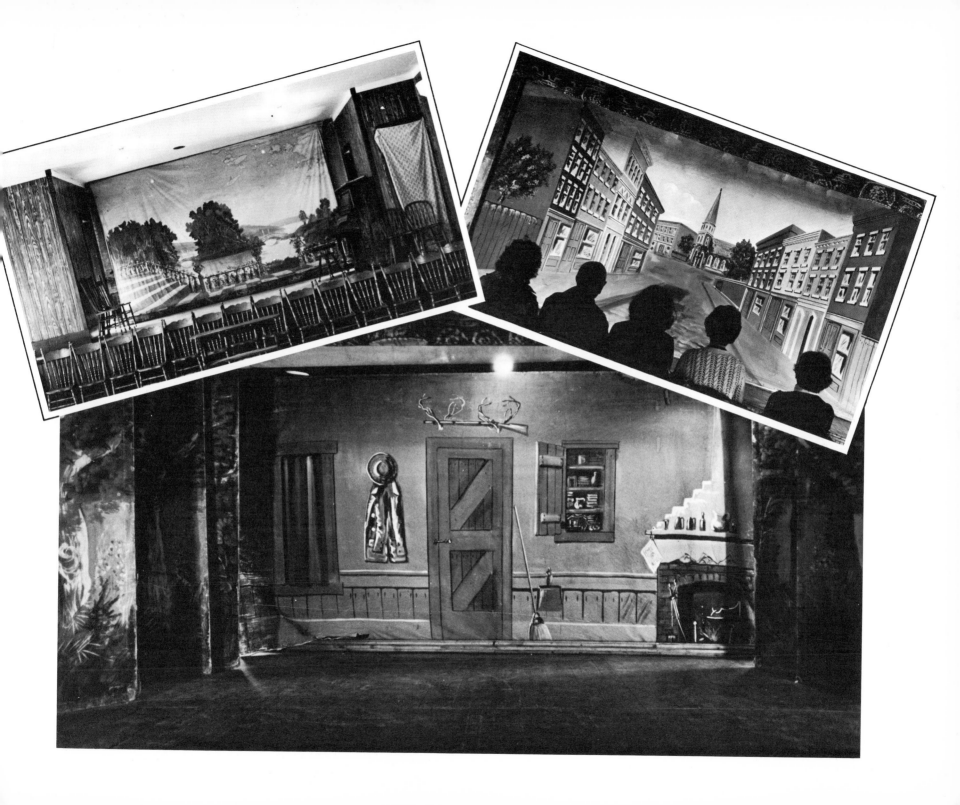

Top Graffiti on subway car in station, Broadway-Seventh Avenue IRT, New York, 1978. Artist's nickname in huge letters.

Center Subway-car graffiti make subway station a kinetic gallery.

Bottom A new trend in subway graffiti: the human figure and other forms enter the underground-art circuit.

Small photo, opposite page Graffiti with matching interior.

the worst of the winter weather.

"One of the company's most popular attractions was my father's 'painting act.' At the end of a play, while my sister and I sang, my father would paint a beautiful picture." One of the songs Grace sang was "My Old Village Home," while Charles Henry deftly sketched the village home. The great wonder was that both song and picture would be completed at exactly the same time. And if the audience happened to overhear a *sotto voce* "Slow down, I'm not through yet," they loved that too. Once when they were playing Chazy, New York, Henry was doing humorous drawings when a heckler in the audience began calling out what he imagined were witticisms. He turned up for every performance that week; finally, on Saturday night, he made the mistake of asking Henry to do his portrait. This Henry agreed to do if the heckler would stand up on his seat, in full view. The artist began with the feet of the subject, slowly working up to the head; when at last he stepped aside to reveal the finished drawing, it had the head of a jackass. This brought down the house, and the heckler crawled away.

After the final curtain the Henry Family would form a band and play for dancing. It was always a good evening's entertainment, and Grace Henry Hanna remembers it all as having been wonderful fun, even though group photographs show the family members as serious and unsmiling.

During World War I, the Henry Family gave their last performance. Charles W. Henry, never in robust health, died in 1918 at the age of sixty-eight.

But at Sudbury, the scenery painted by Henry is still used for high school plays. Two of the Huntington backdrops are being restored at the University of Vermont, and a Bicentennial project in many of the towns, the compilation of individual town histories, has brought about a renewed interest in the work of Charles W. Henry.

124

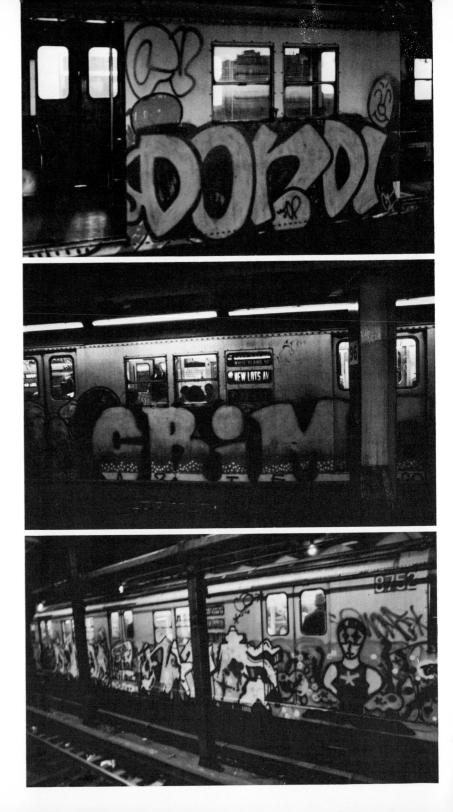

The Passing Scene

GRAFFITI

The trysting tree, scarred with twin hearts pierced by arrows and bearing the lovers' initials, all carved into the trunk by penknife, is a primitive testament to the art of graffiti. Man's instinct to leave an enduring mark comes in part from his awareness of mortality; the kings and pharaohs could have monuments and tombs erected to their memory, but the shepherd, wanderer, and common man could leave their marks only on rocks, trees, and the walls of caves.

During World War II, Kilroy appeared wherever American troops did. This cartoon character was always drawn peeping over a fence, only the top half of his head and his long drooping nose showing, along with the caption "Kilroy was here." Adopted by civilians, Kilroy turned up everywhere and offended no one but the property owners, who could easily erase the chalk lines. But since the introduction of the spray can and the felt-tip pen, any surface becomes a target for the spray-and-run graffito artist.

The common man today, in protest against the kings of industry, the kingmakers, and the Establishment, has discovered the supreme outlet for his defiance of the slings and arrows of his outrageous fortune: graffiti. In the 1960s spray-can graffiti began appearing on building walls, on fences surrounding construction sites, on marble, granite, and bronze monuments in large urban areas. The craze spread rapidly across the nation, and soon graffiti were to be found on rocks and bridge abutments even in the most rural areas. This is defacement on a grand scale and must be considered an "art" better left unrecognized. For now the initials, unlike those once carved into tree trunks, have taken on huge, bloated forms, outlined in felt-tip pen and filled in with spray-can paint of every hue. Most resemble the fat, round overlapping letters found in cartoons; a few, influenced by psychedelic art, are more creative.

While responsible citizens deplore this work as vandalism, there is a certain division of opinion regarding one aspect of spray-can art: the New York phenomenon of the decorated subway train. The interiors of the cars, dingy though they may have been, are not improved by the disturbing jumble of scrawled initials that often cover every available space. But the exteriors of the cars, the older ones especially, are considerably enlivened by the vivid designs. Often a single name in giant letters will appear on each car, and each car will display a distinctly different design from the one that precedes it. A train coming into a station or crossing a trestle is an arresting sight.

In the small hours of the morning, when the subway trains carry fewer cars and run at half-hour intervals instead of every five or ten minutes, the cars that are not in use are stored in vast yards in outlying parts of the city. Here a small maintenance crew works at cleaning them before they again enter service. An occasional guard checks the area, but it is not too difficult for youths bent on self-expression on a big scale to gain entrance. They have a few short hours when they can, with luck, work undisturbed; then the cars start moving out again, to fill morning rush-hour needs. But danger is always in attendance. The guards can make arrests, and one misstep can bring a fleeing graffitist in contact with the deadly third rail, which is always alive, even in the quiet midnight hours.

An effort has been made to channel these talents into less dangerous and more profitable forms of work. In the hope that the illegal activities might receive official approval, a workshop was formed for the development of designs for subway cars, and of other forms of art as well. In the spring of 1976, an exhibition was held at the Bank Street College of Education in Manhattan, where the subway designs and also easel paintings were shown. The show attracted a certain amount of interest from the press.

Subway art has not been legitimized, but the designs continue to appear. The fascination of leaving one's mark continues, and with each new subway car that pulls into a station, a new name or set of initials makes its appearance.

TIME & MONEY

CHAPTER 6

Like the tides, time and money have flowed in and out since time immemorial, and the embellishment of each has consumed the arts and skills, as well as the patience, of man and woman, boy and girl.

One of these skills, the fretwork embellishment of timepieces, such as clockcases and watch stands, and of other household objects was developed to the point where it became an art, and the enthusiasm for such work amounted to more than just a fancy passing of time. During the late 1870s and for about twenty-five years afterwards, fretwork, or perforated carving, was one of the most popular of the household arts. In 1875, George A. Sawyer described it in his *Fretwork Sawing and Wood Carving* as "an agreeable, useful and ornamental art to practice, and one that can be easily accomplished by either lady or gentleman," and added, "it has also the further advantage of being an employment for leisure moments, which is neither expensive, nor one that requires a special apartment, as it can be practised in any room, and upon an ordinary table, provided it be tolerably firm."

At an earlier period in America, especially near the end of the eighteenth and the beginning of the nineteenth century, fretwork was used in clockcases, particularly tall clocks, grandmothers' clocks, and the Massachusetts shelf clocks made by Simon and Aaron Willard of Boston, David Wood of Newburyport, and others. However, fretwork as popularly practiced in the 1870s and 1880s was not an adornment of a much larger work but the entire work itself, usually made up of smaller completed sections, stained, varnished, polished, and glued together to form the shape of the sample pattern.

Instruction manuals, catalogues, and monthly publications were issued with the newest patterns, designs, tools, and sources of materials. One of the most popular was *The Fret Sawyers Monthly and Home Decorator*, published in 1880 by Adams and Bishop in New York City, which carried a column called "Notes for Boys."

The tools were inexpensive, took up little room, caused little disturbance, and were easily obtainable. The simple scroll saw, with a variety of blades from the very fine to the heavier and coarser ones used for roughing work, was the most common tool. The fret-cutting and boring machine, operated by a foot treadle like the early sewing machines, was available at the price of $2 for a simple one with saw, made by A. H. Shipman of Rochester, New York, and of $14 for a more elaborate one made in England. However, hand scroll saw, clamps, awls, drills, wood files, and sandpaper were sufficient for the simpler design and for the novice. For the more advanced scroll sawyer, carving and fret-cutting benches were offered as well as several styles and sizes of chisels, gouges, oilstones and elaborate fret-cutting and boring machines. Patterns ranged from the simplest to advanced and elaborate designs.

The woods, too, were easily obtained. The most desirable for fret sawing was black walnut, sawed not more than ¼ inch thick and planed smooth on both sides. Its color and excellent grain were suitable for "all household adornments." In 1880 black walnut ¼ inch thick cost 6 to 10 cents a square foot. Another favorite was white holly, though it was not so easily obtained by rural households. When newly cut this wood had a light creamy tint, almost white, and the grain was nearly as fine and close as ivory, an excellent contrast when used with darker woods such as rosewood and black walnut. Its main disadvantage was that it tended to discolor, especially in rooms where gas was burned; to preserve its whiteness, a coat of shellac was prescribed. Another disadvantage of holly was its tendency to warp and split. Cherry and mahogany were considered among the finest woods for fret sawing. Maple was sometimes used, but it was hard to work. Red cedar and satinwood were recommended. Spanish cedar, best known as "cigar-box" wood, was one of the cheapest and most desirable for fretwork.

While wood carving even in its simplest forms was considered work cut out for men, the one exception was fretwork. According to George A. Sawyer, "The best seen examples were at the rooms of the Sorrento Wood-Carving Company in Boston, where the walls were hung with the most beautiful work, all done, we were told, by the ladies of the establishment." Sorrento wood carving was one of the more advanced forms of fretwork. As its name implies, it originated in Italy, where fine inlay work and the most delicate and intricate

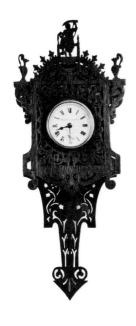
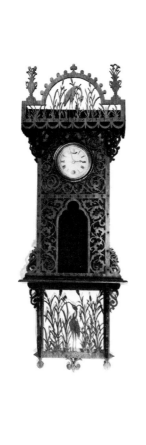
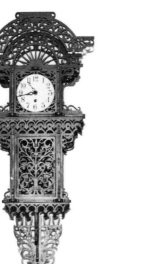

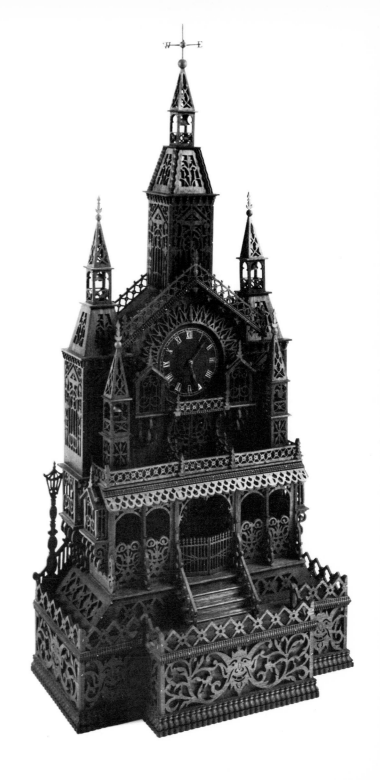

designs were executed with high precision and great talent. Firms in Boston and Cleveland employed women skilled in Sorrento work and sold this work to other companies, which offered it as a premium in advertisements in popular magazines and farm journals.

One of the most popular fretwork objects was the clockcase. A. H. Pomeroy of Hartford, Connecticut, ran a series of advertisements featuring fretwork clockcase patterns, which came with complete instructions and step-by-step procedures for the final assembly of all the parts, the gluing, staining, and varnishing. One such pattern, in the shape of a cottage, was offered for 15 cents. Around the cottage was a fence and an arbor, and the clock itself was in the center of the second story. Supplies were furnished by firms in New York, Detroit, Chicago, and Hartford; most of the clock movements, dials, and hands could be obtained for less than a dollar from several firms in Connecticut, the center of clockmaking in the United States.

Firms such as A. H. Pomeroy used completed fretwork clock samples made by professionals as illustrations in their advertisements. Work of this caliber offered a challenge to both amateurs and the more advanced fretwork carvers. Among the samples illustrated were cathedrals, castles, palaces, and mansions, embellished with towers, turrets, and belfries, and other architectural fancies. Clockcases in cathedral patterns came in various sizes, from 18 to 42 inches in height. The taller cases were made to rest on fretwork or on platforms of solid wood, mantel-size cases were shallow enough to sit on shelves, and still others were made to be hung on walls. The wall-hung cases were less ambitious works, usually made by novices.

One example is the work of Alvin J. Gibbs, who as a ten-year-old boy in 1878 carved and completed a clockcase that required a good deal of patience, skill, and time. This clock has been handed down to his son, James W. Gibbs, now a noted clock authority, an author, and a former officer of the National Association of Watch and Clock Collectors. The carving of Father Time, the two urns at the top, and the figural motifs like those used in mourning pictures are well done and compare favorably with the vases and flowers executed on a clockcase by an obviously mature and experienced carver. These

130

fretwork timepieces must be handled with care. Their lightness should be a reminder that the wood is thin, although strong, and that the whole was assembled out of little sections held together with animal glue, ornamental hinges, catches, corner braces, or locks.

The beginner was given the simplest of patterns and was encouraged by illustrated examples showing the results produced by other novices. Sometimes designs were taken from engravings in books and periodicals, producing odd but interesting effects, such as the one-winged angel that seems to be skipping rope with what appears to be a grapevine. Cabinet and writing-desk patterns, elaborate pedestals, and ornate alphabets were for the more advanced and experienced fret carvers. Patterns for these came in books from which tracings could be made and transferred to the wood in ink or pencil; "to avoid the risk of sawing out a part of the design that should be left in, it is advisable to adopt the simple method of making a few rough strokes, with a pen or pencil over the parts which are to be removed.... The designs thus obtained are pasted or glued to the piece of wood about to be operated upon." The same manual also suggested: "The Fretwork about to be carved, should be fastened to a piece of soft waste wood, somewhat larger than the Fretwork, in the manner already described, and the wood held to the table by the holdfast. This method supports each tender leaf or stem whilst it is being carved, which otherwise would not admit of the operation of carving, from its fragile nature. The grain of wood must be observed, not merely as to whether the carver is cutting across or along the grain, but whether up or down (as in planing), so that the chips may come out clean, instead of tearing deeper than is wished. In case the tool does not cut clean, cut from an opposite direction or sideways."

The art of fretwork did not die out as did the parlor arts and pastimes of the last quarter of the nineteenth century. In 1905, the T. B. Rayl Company of Detroit was still offering the Rogers scroll saws, Star scroll saws, and Companion lathes and saws, as well as pantagraphs and catalogues showing designs in miniature and other sundry items for fret-saw work. This information was supplied us by the

Woodcraft Supply Corporation of Woburn, Massachusetts, which informed us on January 17, 1977, that their new spring supplement will include a fretwork set—a drill clamp and a wooden apparatus for holding the drill, as well as a large fretwork fixture in a workbench vise. In 1940 the Craftsman Wood Service Company of Chicago issued pages of "Scroll and Fret Work Patterns—Full Size": pattern No. 200 for a "Grandfather Clock," 26⅞ by 13 by 4¾ inches, cost 45 cents. This pattern was executed by James Shawn of Pharr, Texas, shortly after that time.

CAST-IRON CLOCKS

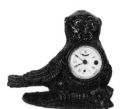

The lightness and airiness of the fretwork clocks, each individually made, contrasts with the solidity and weightiness of the fancy iron clocks that were mass-produced and were a product of the cast-iron era in America. In the late 1840s cast-iron architecture was introduced by its inventor-designer-engineer—and former clockmaker—James Bogardus of Catskill and New York City. His patents for constructing prefabricated iron buildings of mass-produced parts became an American architectural innovation. By 1858 prefabricated buildings were being erected in all the larger American cities, many from the same molds. Small foundries had been turning out stoves, utensils, and other items for periods before this, but the cast-iron building fronts stirred the imagination of inventors, designers, and manufacturers.

Connecticut had an abundance of ironworks before the Revolutionary War, as great ore deposits were found at Salisbury earlier in the century. The foundries in this state were numerous, as were the clock factories that produced, first, the wooden-works clock movements, then the brass-movement shelf and tall clocks. It was therefore natural that products from both sources were combined to emerge as a readily marketable commodity, the iron-cased novelty clock.

In 1857 Pietro Cinquini, an inventor-designer of West Meriden, Connecticut, applied for and was granted design patents for three iron clockcases. The first patent, No. 916, granted July 14, was for an iron figure dressed in the style of the Revolutionary period, wearing a tricorn hat and buckled shoes, with the clock placed in the center of the body. The second patent, No. 935, was granted August 25 for a triangular clock with a small basket of fruit as the finial. Tendrils and bunches hung over the sides, the dial, and the circular window that revealed the pendulum. Patent No. 946, granted October 6, was for a figure of Saint Nicholas with toys stuffed in the pockets of his cloak and others under his arms; here, too, the clock was in the center of the figure. This Santa was unlike the popular version later created by Thomas Nast; the artist-designer either forgot the mustache, or perhaps influenced by the fashions of the time, omitted it and the bushy brows. The costume suggested one of the Elizabethan period, and the pedestal was an unornamented circular base. Until recently it was believed that the Saint Nicholas clock had never been produced. However, a clock was discovered in the collection of Mr. and Mrs. Frank G. Whitson of Baltimore that is practically identical to the designer's patent drawing.

There was one novel addition to these and other figural clocks that were to follow: the eyes of the figures were made to move as though winking or blinking. The eyes were activated by the movement of the balance wheel and verge, which had a wire attached to the eyes suspended on a pivot inside the head.

The patents granted were then assigned by Cinquini to a firm but three years in business—Bradley and Hubbard of Meriden, Connecticut. Production began in 1857, and by 1858 the "winker" clocks were put on the market. Bradley and Hubbard manufactured art metal goods with a foundry capable of turning out volumes of these and other fancy metal-cased clocks with thirty-hour brass movements. These were purchased from the Seth Thomas Clock Company of Plymouth Hollow (later renamed Thomaston) and the Waterbury Clock Company, established on March 27, 1857, as a branch of Benedict and Burnham of Waterbury, Connecticut. A catalogue issued in 1875 by the Waterbury Clock Company listed four styles of "winkers" under the category of "Fancy Iron Clocks": Continental, Topsy, Sambo, and Organ Grinder, each 16 to 17 inches tall, and

Left to right Six "winker" or blinking-eye 30-hour cast-iron clocks made by Bradley & Hubbard Co., Meriden, Conn.

Saint Nicholas, 17″ h. designed and patented by Pietro Cinquini, West Meriden, Conn., Oct 6, 1857. Whitson Collection.

Gambrinus (named for the inventor of lager beer). 15″ h. Ca. 1867. Whitson Collection.

Organ grinder and monkey blinking-eye clock. 17½″ h. Ca. 1867.

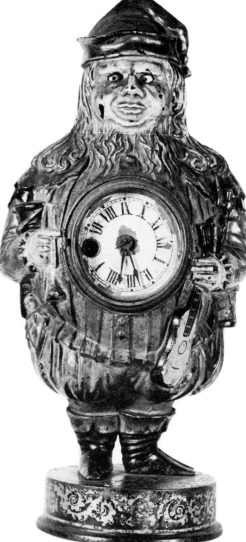
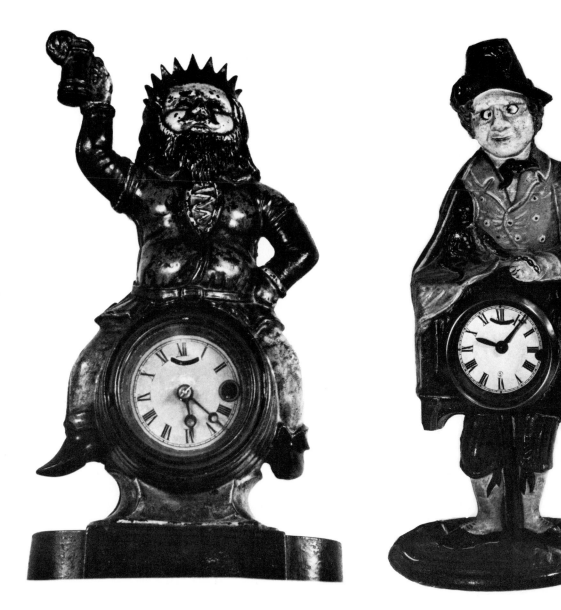

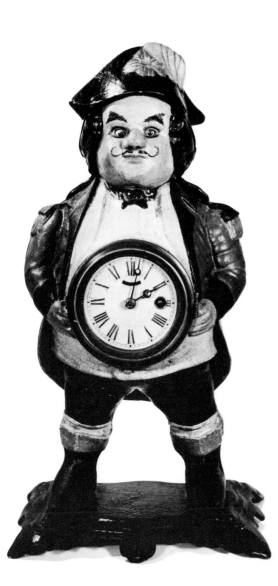

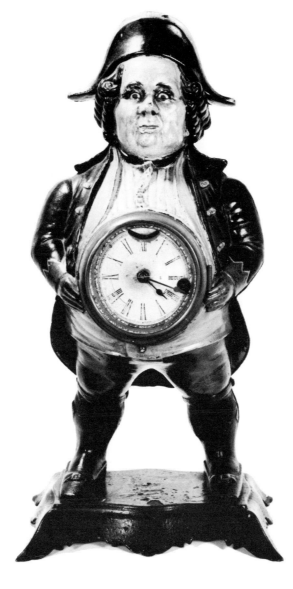

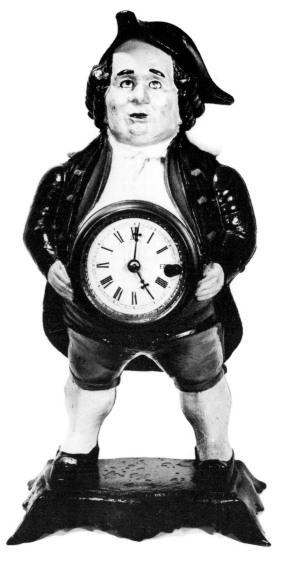

Toby or Continental in uniform, cockade on hat. 16½″ h. Ca. 1859. Gibbs Collection.

Toby or Continental (standard). 16½″ h. Designed and patented by Pietro Cinquini, July 14, 1857. Gibbs Collection.

Toby or Continental with tricom hat, a variation. Patented July 14, 1857. Gibbs Collection.

each priced at $5.75.

In addition to these winkers, there were two variations of the Continental, also called "Toby": one with a tricorn hat and the other in a military uniform with cockade on his hat and a variation in the base. There were also the Sitting Dog, Reclining Dog, Owl, Lion, and Gambrinus (named for the inventor of lager beer). Variations also appeared in the colors, as these were all hand-painted at the factory by women who were paid by the piece. The castings came in from three to five sections, and none were as complicated or precise as those required by the mechanical toy banks, also made of cast iron, which were to appear ten years later.

The firm of Bradley and Hubbard was started in 1854 by Walter Hubbard in partnership with his brother-in-law, Nathaniel Lyman Bradley, in Meriden, Connecticut, manufacturing cast-metal ornamental household items such as clocks, vase tables, mirror frames, sewing birds, andirons, sconces, lamps, and chandeliers. In 1875 the firm was incorporated under the name of Bradley and Hubbard Manufacturing Company, with Walter Hubbard as president, Nathaniel L. Bradley as treasurer, and brother Clarence P. Bradley and Charles F. Linsley as officers.

Walter Hubbard was born September 23, 1828, in Middletown, Connecticut, a descendant of George Hubbard, who arrived from England in 1633 and was one of the original settlers of Middletown in 1650. The Hubbards resided in the area for 250 years and are noted for their role in the Revolutionary War. Walter Hubbard was reared on a farm, was educated in public schools, and attended Chase Preparatory School in Middletown. At eighteen years of age he found employment as a clerk in a Meriden store, and in 1851 he opened a dry-goods and clothing store in Meriden, which he operated successfully until 1860. In 1852 he married Abby Ann, daughter of Levi Bradley of Cheshire, Connecticut. His wife died a short while after their marriage, and Hubbard never remarried, devoting all his time

to business enterprises. He became president of the Meriden Gas Light Company, the Meriden Electric Light Company, and the Trust and Safe Deposit Company, and held interests and directorships in other banks and businesses. He is best remembered as the builder of the Winthrop Hotel, one of the finest in New England in its time.

The clockmaking experience came from another member of the firm, Nathaniel L. Bradley, also a gifted businessman. Daniel Bradley, his grandfather, was a Vermont farmer who was driven from his home by the destructive advance of the British during the Revolution and eventually settled in Cheshire, Connecticut. Levi Bradley, Nathaniel's father, had the reputation of having enormous energy and the best farm in the entire region. Born in Cheshire in 1829, Nat Bradley had his early schooling in Cheshire and attended the old Meriden Academy. He left school, however, at the early age of fifteen and took a job as a clerk for E. B. M. Hughes, a hardware merchant in New Haven. After a year there, his father called him back to help on the farm, where he remained until he was twenty-one.

Nat Bradley's ambition led him away from the farm to embark on a business venture in Southington, Connecticut, where he became one of the stockholders. His business was the making of clocks. After six months in the factory he was offered a contract for making three hundred clocks a day and gladly accepted it. Because there was overproduction at the factory during this time, Bradley was sent to New York, Philadelphia, Baltimore, and Washington, D.C., to sell off the surplus stock, and succeeded so well that his orders taxed the factory to its full capacity. For his reward he was made head salesman and a director of the firm. He remained here until 1854, when he went into partnership with Walter Hubbard.

The firm of Bradley and Hubbard continued for many years making novelty art goods. In 1940, the Charles Parker Company, once famous for its manufacture of the Springfield rifle under the name of Parker Brothers in West Meriden, Connecticut, purchased the Bradley and Hubbard Manufacturing Company, by then best known for the Rayo lamp, made by them for the Standard Oil Company.

Prior to 1880, the United States Patent Office required a model of every invention for which an application was submitted. Exemptions were made for design patents, for which only detailed drawings were required. These were granted for only seven years, with renewals accepted upon application and the payment of a fee. No design-patent renewals are recorded for the winkers, which would indicate that, like most novelties, they had had a very short span of public interest and acceptance.

The year 1857 was an economic disaster from which the American economy was slow to recover, and within five years the country was at war. The Connecticut foundries became engaged in the production of war materials, and did not resume production of fancy iron-cased clocks until 1866. Winkers appeared again in more than one catalogue during the 1870s. New lines were constantly being produced by Bradley and Hubbard, as well as by N. Muller's Sons with castings by D. Buchner and Company of New York City. The styles were numerous enough to fill pages and pages of clock catalogues.

As happens with other novelties, these clocks were discarded when damaged or when their works needed costly repairs. Today such figural novelty clocks have become quite rare. Like the mechanical toy banks of which they are believed to be the forerunners, winkers are now sought after by collectors, who have renamed them "blinking-eye clocks." It is their art which is of interest to us.

MECHANICAL TOY BANKS

An old saying has it that "Thrift is the best way of thriving," and during the last quarter of the nineteenth century, one could buy for a dollar or so a toy that was not only amusing but encouraged thrift. By the insertion of a coin, it could be put through rapid and sometimes violent motions as its several moving parts were activated by pressure on a lever. This toy was the mechanical bank, which made its first appearance in 1869.

Like the blinking-eye clocks, these banks were mass-produced in cast iron, but in far greater numbers, believed to have been in the

hundreds of thousands. The inventors, designers, and makers of these banks outnumbered those who made the fancy cast-metal-cased clocks, and their manufacture continued through the first quarter of the twentieth century.

The ingenuity of the inventor-designers in devising these small mechanisms was indeed remarkable, and the survival of so many of the banks is a testimony to the workmanship of their Yankee craftsmen. The shapes and colors of these toys are pleasing and interesting. But what pleased the purchaser most of all was that the simple insertion of a coin was doubly rewarded by the enactment of a scene and by the accumulation of small wealth.

The inventor-designer was usually an artist, sculptor, or model maker—or all of these at once, like Charles A. Bailey—and his work reflected the social, political, economic, and athletic interests of his day and also its myths, follies, and prejudices. Scenes from fairy tales, opera and stage, amusement parks, and everyday life all served as inspiration for new designs. Competition among designers was keen, requiring them to spend hours making sketches and rough models, which had to go through many stages before they were acceptable for manufacture. The entire operation, from the design stage to the master pattern from which all others were made, demanded the constant personal involvement of the designer. Furthermore, his work was not regarded as art by his fellow artists, many of whom fled to Europe to study in the ateliers of Italy and France. Their sculpture, finished in clay and cast in plaster, was nearly always cut in marble or enlarged to be cast in bronze by others. Yet the mechanical-bank designer's art reached a far greater public, gave more joy, and today is more cherished than the marmorean and plaster busts gathering dust in warehouses.

Hall's Excelsior bank has often been referred to as the first of the cast-iron banks. The patent was granted to John Hall of Watertown, Massachusetts, on December 21, 1869. Hall's Race Course bank, patented August 15, 1871, combined iron and tin, represented by the two stamped horses and riders. It was manufactured by the J. and E. Stevens Company in Cromwell, Connecticut, who sold it as "The Toy

of the Period" and also noted that it was "strong, compact, simple, and pleasing." The talent and art of the inventor-designer can be appreciated by a study of the original carved-wood pattern of the base plate, with the date of patent, the floral decorations, and the wooden groom and gate. The inventor usually made as his first study a rough sketch of the entire bank, then sketches of the various parts from front and back, and a silhouette. These drawings, which saved much time and labor, were used in the next step, the making of the sample in wax, plaster, and wood.

The artistry of the mechanical banks' creators is again evident in the various stages in the very popular William Tell bank, designed by Russel Frisbie and patented on June 23, 1896. When a coin is placed on the end of Tell's crossbow, the trigger is drawn back, and as Tell's foot is depressed, the coin is shot into the opening in the tower, at the same time striking the apple from his son's head. Fortunately, Frisbie's original carved-wood pattern of the tower has survived, as have the lead models, parts of the bronze master patterns, and the sand molds with the production heads of William Tell, showing the progression from designer's pattern to unpainted production piece.

Another inventor–designer–model maker was James H. Bowen of Philadelphia, who invented the Creedmore bank in 1877. That year an international shooting match was held at Creedmore, Long Island, as a sequel to the Centennial Exposition, attracting participants from Europe and journalists from all over the United States. The event inspired Bowen to create this bank, in which a penny placed in the marksman's gun is shot into the tree, ringing the bell. Bowen also invented other banks such as the Bull Dog, Owl, Kicking Mule, Cat and Mouse, Baseball, Two Frogs, and Football.

A first-hand report from design to foundry stage exists in an interview granted to a reporter of the *Philadelphia Times* in 1885 by James H. Bowen himself:

"The Creedmore bank was the first I made. . . . That was followed by the Kicking Mule, the Bull Dog, and others. I am now at work upon a more complicated toy bank; the first bronze casting has just come in. We are now chasing it and filing down all the rough edges, and mak-

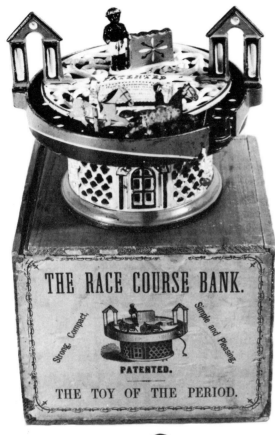

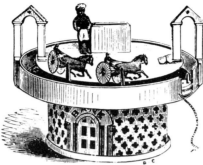

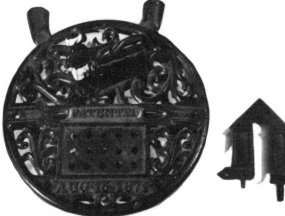

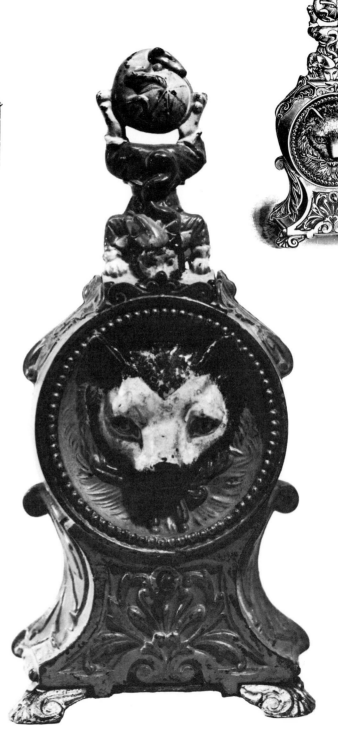

Top left Race Course bank with original box. Cast iron and tin, painted. John Hall, Watertown, Conn., designer and inventor, Aug. 15, 1871. Mosler Collection.

Bottom Original carved wood patterns for base and gate of Race Course bank. Designed and carved by John Hall. Mosler Collection.

Center top Contemporary engraving for promotional sales of Hall's Race Course bank.

Right Cat and Mouse bank. Cast iron, painted. James H. Bowen, Philadelphia, designer and inventor. Mosler Collection.

Far right Small engraving used for advertising Cat and Mouse bank.

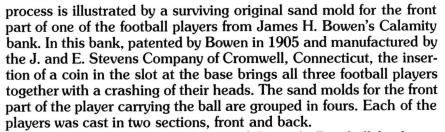

Opposite page Lead pattern of Baseball bank or "Dark Town Battery." Designed and patented by James H. Bowen, Philadelphia, Jan. 17, 1888. Mosler Collection.

ing all the joints work easily. I first of all make a solid model of the figure in specially prepared wax. From this I take a plaster of paris mold in two halves. Then I make two hollow models of the figure in wax from these molds. The next thing is to separate from the complete models the parts which are intended to be movable. Before me I have the left forearm and hand of a monkey, holding up a piece of coconut shell, the thumb of the right hand, the lower jaw, the eyes, and tail which, when the toy is complete, will act in conjunction with a spring on the inside. These parts being removed, I have to make a fresh model in wax of every part, with an end or joint attached to them. They are then sent to the brass foundry to be cast in bronze. The whole figure has to be made complete and working in wax before it goes to the foundry. When they come back some of the pieces are very rough and need a great deal of filing and chasing to make them fit and move easily. You see, the model in bronze that I make is the foundation from which all the banks are eventually to be made, and unless my model works perfectly there will be no end of complaints when it goes eventually to the iron foundry, where the marketable toys are turned out. There are twenty pieces in this bank. A coin is placed between the thumb and fingers of a monkey's right hand. The thumb, you see, is kept in place by a spring strong enough to hold a coin the weight of half a dollar. When the tail is depressed the left hand raises the upper half of the coconut, the lower jaw falls down, the eyes go up, the right thumb is drawn back and releases the coin, which falls through a slit in the coconut. . . ."

Before the mechanical bank was ready for the foundry, the many stages described in the Bowen interview were necessary, and each had to be prepared in the exacting manner he specified. The shapes had to be simple, yet interesting, especially those that had an action to perform. There could be no rough edges, so that in the sand-casting process, the casting would free itself smoothly from the mold without disturbing the form and be ready for the next pouring of the liquid metal. In this way a perfect shape was produced.

The casting was done in multiples with the same mold shape repeated within the same frame or half of the "flask." This multiple casting process is illustrated by a surviving original sand mold for the front part of one of the football players from James H. Bowen's Calamity bank. In this bank, patented by Bowen in 1905 and manufactured by the J. and E. Stevens Company of Cromwell, Connecticut, the insertion of a coin in the slot at the base brings all three football players together with a crashing of their heads. The sand molds for the front part of the player carrying the ball are grouped in fours. Each of the players was cast in two sections, front and back.

Some figures, such as the batter of Bowen's Baseball bank, required seven separate castings—front and back, and the arms and head in sections. Bowen patented this bank—also known as the Dark Town Battery, as the casting imprint reads—and received his patent on January 17, 1888. This bank too was made by the J. and E. Stevens Company, and its lead pattern survives in the collection of Edwin H. Mosler, Jr. The action of this bank is one of the most exacting, to the bewilderment and astonishment of the viewer, who is likely to ask that it be repeated in order to be believed. A coin is placed in the hand of the pitcher, which is drawn back. When a lever is pressed, the coin is speedily pitched, the batter swings the bat and misses, as the catcher gloves the coin, which falls into the interior and out of sight.

The foundry operation depended on keeping costs to the barest minimum, on the low cost of materials and of labor, and on the reuse of excess iron. The foundry was not the place for the worker with a weak back. James Shawn, an old foundry hand in a related industry, tells it like it was:

"My experience in a foundry?—well, in my day at the work it was something better to be forgotten, since it was the day a man worked hard and long hours. You started the day by cutting your sand with a shovel and tempering it with water and mixing it well till when you picked up a handful and compressed it, it would hold together between your thumb and forefinger, also leave your fingerprints in it. Well mixed and tempered this way, you were ready to start work.

"The workbench was on wheels and your sandpile was in a long row, sometimes about fifty feet long. Your bench sat astride this, and you

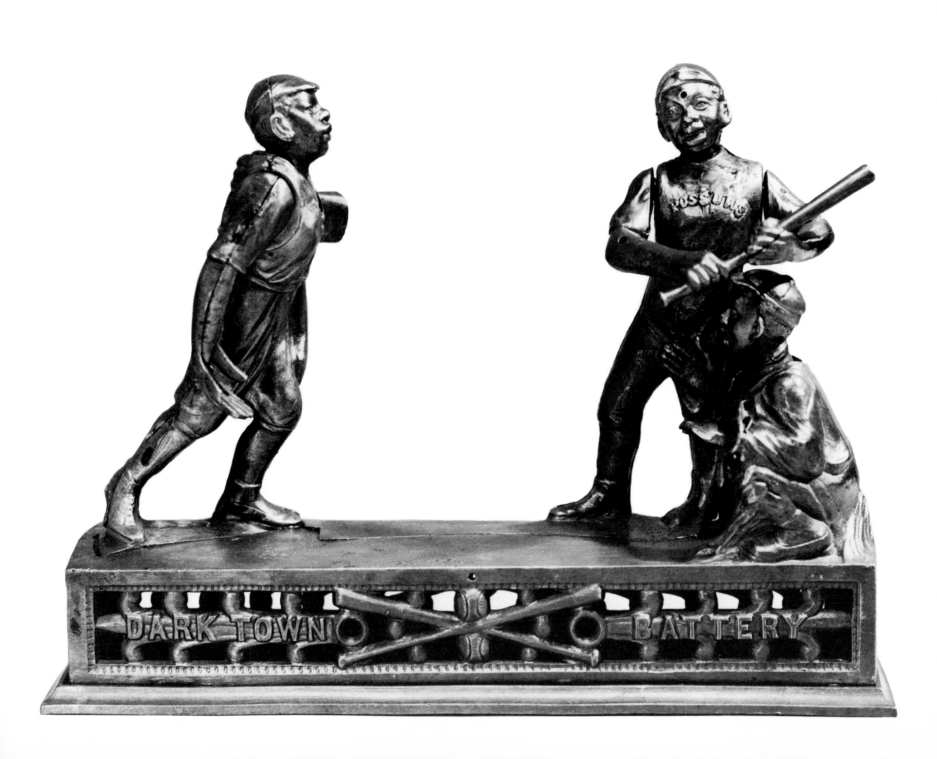

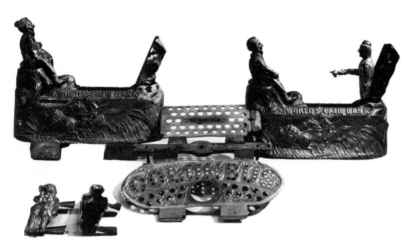

used your sand up as you pushed your bench back over it and rammed up your molds. The ramming up of the pattern was done in a two-piece flask with a top and bottom—the top was the 'cope' and the bottom was the 'drag.' The pattern was rammed up in this assembly, then the halves were separated and the pattern taken out. You then closed the mold, which would weigh from fifty to a hundred pounds, then set it down gently behind you on a nice level place you had prepared on the floor. Now you were expected to do this from fifty to a hundred times according to the size of the castings to be made. All this was far from all you had to do to the mold.

"After this work was done, you still had to pour them all full of molten metal. The heat was started about two in the afternoon, and about four to six in the evening, you would be ready to pour. We seldom got away before six or seven in the evening. . . . Boy, when you got through you were ready for no poolroom or dance hall. Dog-tired and dirty as hell, and after a year or two of this I looked around me and saw old men at the age of forty, so I packed up and got the heck out of there. Still, I do not regret the experience, since it was part of life and I have used it at different times."

Another stage in the manufacture of the bank was demonstrated by the completed production bank; then the base plates at the bottom of the bank, the interior parts, and the sides were assembled as they

came from the molds without removal of the lags at the bottom, and the front and back of the figures, still with the gates from the pouring of the molten iron. The next step was to remove the lags, gates, and other excess iron, close up the holes, attach the arms, finish the surface, and paint. As in the production of the "winker" clocks, the painting was the work of women and girls who were paid by the piece, while the finishing touches such as striping and fine brushwork were done by specialists.

Of all the inventor-designers of mechanical toy banks, none made a more lasting, more significant, or greater contribution to this art than Charles A. Bailey. He was born September 16, 1848, in Cobalt, Connecticut, ten miles southeast of Cromwell, where the future production of his creative efforts would be carried out. His early education and training are obscure, but leanings toward the creative and industrial arts were manifested in Cobalt, where he maintained a shop and where, as the town directories indicate, he remained from about 1875 until 1882, designing toys and making dies, molds, and patterns. At the age of thirty-two, Bailey had felt sufficiently secure to take a bride, and five years later he moved his effects to Middletown, Connecticut, a much larger and industrialized center.

Bailey's shop on Main Street in Middletown was a combination of studio, art establishment, and factory; the commercial register listed him as a "Designer Die and Model maker, Patterns made to Order." Bailey had been making toy designs for the J. and E. Stevens Company in Cromwell and on December 21, 1887, he sold and assigned his rights to the Bad Accident bank to them. His letterhead on which the agreement was signed reads:

<div align="center">

Chas. A. Bailey
DESIGNER * and * SCULPTOR
Dies, Moulds and Patterns to Order.
Portraits and Busts in Bronze and Plaster A Specialty.

</div>

Bailey evidently thought himself primarily a designer and sculptor. It would be most interesting to discover a signed portrait bust that would reveal the true scope of his talents.

Working from Middletown, Bailey continued to supply the Stevens Company with designs and patterns. In 1898, the Columbian Exposition in Chicago furnished many designers with the theme to create all kinds of souvenirs, appliances, and toys. On October 10, 1893, the United States Patent Office granted him a patent for the World's Fair bank. For the four-hundredth anniversary of the landing of Columbus on the North American continent, Bailey chose the theme of an Indian offering the peace pipe to Columbus. The action is not too complicated; upon insertion of a coin, the lever is pressed and the ground seems to open up, an Indian appears offering the peace pipe, and the right arm of Columbus is raised in a gesture of acceptance.

Shortly before Bailey applied for the World's Fair bank patent, he began full-time employment in the J. and E. Stevens Company, where he produced many banks from design to production stage. In 1916, he retired to open his own shop, designing toys and novelties and making molds and models for the trade. He continued working for himself for the next ten years. On Saint Valentine's Day, 1926, America's most prolific and perhaps most talented toy designer died.

The J. and E. Stevens Company was organized in 1843 by the brothers John and Elisha Stevens for the production of axes, hammers, hooks, and building hardware. They began to manufacture toys after the Civil War and continued for over half a century until 1928, when the cost of labor and of iron and other materials made the production of the iron bank unprofitable and it was discontinued.

There were designers other than Bailey who supplied Stevens with ideas for banks and assigned their patents to them—Russel Frisbie, designer of the William Tell bank, was one—and there were other factories that made banks. One such firm was the Shepard Hardware Company in Buffalo, New York. Some of the banks they produced were designed and patented by Charles Shepard and Peter Adams, Jr.: the Speaking Dog, the Humpty Dumpty, the Uncle Sam, and the Punch and Judy.

Time has run by, but money is still put into these banks, not so that the small sums will amass into small wealth, but for the joy and amazement of watching them come to life once more.

142

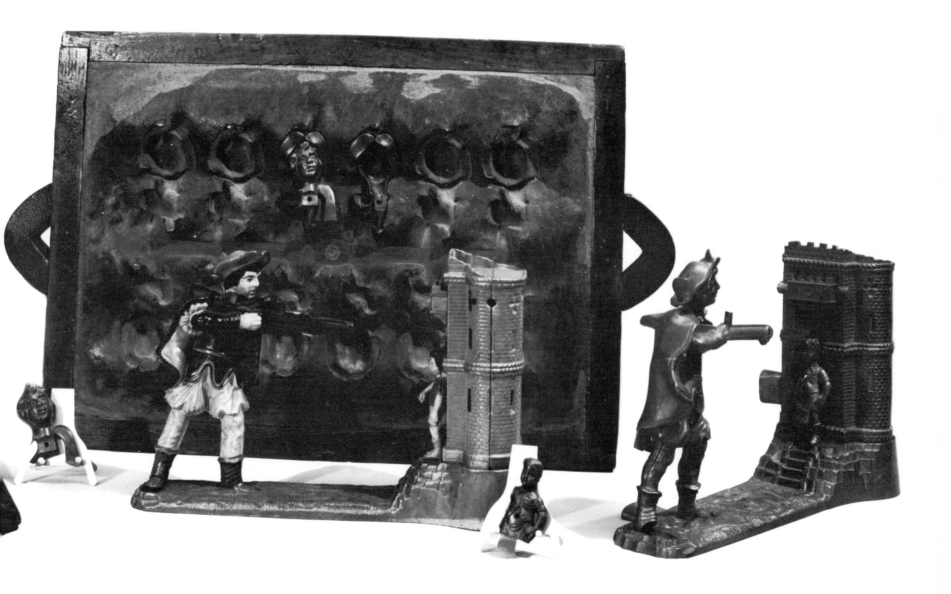

Indeed, woman's work is never done. Should the daily tasks and seasonal chores be completed, there is always fancywork to keep the fingers busy, and should inspiration or imagination be lacking, there are always the women's magazines, replete with ideas and with instructions for carrying them out.

The journals that cater specifically to women and their interests, and in turn become a profound influence on their life-style and ways of thinking, had their beginnings in the 1830s and 1840s. Though the publishers were male, it was women who wrote and presumably tested the instructions for making wall pockets, lambrequins, brackets, etuis, fern stands, picture frames, and other necessities of civilized life from such improbable decorative materials as pine cones, mosses, sea shells, acorns, twigs, and seeds, as well as more conventional leather, beads, wool, and feathers.

These early "how-to" articles were usually accompanied by delightful engravings illustrating the finished product, together with simple diagrams showing step-by-step procedures. Studying the engravings, which after all were an artist's concept of the subject, you might wonder whether anyone ever succeeded in carrying out any of these designs. However, a surprising number of works, encased in shadow boxes or under glass domes, remain for us to admire, often in remarkably good condition, too, and looking very much like the engravings that seem so fanciful. Good examples as well as near failures may be seen in county historical societies and period houses; they even turn up from time to time at country auctions.

We are all familiar with the needlework arts: embroidery, knitting, and crocheting have never really gone out of fashion. Their popularity has always been due in some part to the ease with which they could be picked up and then set aside, as well as carried from place to place, requiring a minimum of concentration. The arts we are dealing with here called for more of a commitment of time and space, and of energy, too. They came of the need, once the bare essentials of existence had been gained, of having something more. The rich were becoming richer with remarkable rapidity; mansions were being filled with art objects from Europe and the Orient; the cluttered look was all the rage. For the many without money, there was always do-it-yourself. The women's magazines, besides publishing plans for Downing-style cottages, were beginning to print instructions for making all manner of delightful space-clutter. Art-supply stores in such cities as Philadelphia and Boston furnished patterns and directions as well as materials, and presently found themselves also publishing volumes of instructions, with frequent revised editions, in response to popular demand.

The sheer variety of things that could be ornamented and embellished astonishes us; there appears to have been an insatiable appetite for new designs and materials. Nature is the motif that runs through most of the designs: flowers, leaves, vines, tendrils, and fruit were rendered in as lifelike a manner as the medium would allow. And nature supplied many of the basic raw materials for the designs, though glues and varnishes, brushes, paints, and wire had to be purchased from the art dealer. The objects to be ornamented — the picture frames, small tables, brackets, and so on — were generally made to order by a carpenter, perhaps a husband or brother.

Many of the crafts were meant to be imitations of more expensive materials, out of reach of the average person. One of the most striking of these was leatherwork. In her *Art Recreations*, Mme. Levina Urbino wrote: "When well and tastefully done, leatherwork resembles rich carving in wood. . . . Select a soft sheepskin, rather thick; cut from it flowers and leaves to suit your fancy." Cardboard patterns could be made from natural leaves, while diagrams for various flower forms were printed along with the text. "When you have a sufficient number cut from the leather, wet them in cold water and squeeze them dry, and pull them into shape, and form the leaves and flowers to your taste; while wet, put them into the oven to dry." (A *cool* oven, surely!) The leaves were to be veined with a pointed instrument and bent and molded before the drying process. To continue: "Make a solution of vinegar and Venetian red, and dip them into it. When perfectly dry, dip them in thin black varnish. When dry, they will have the color of rosewood." As a final step, the leather leaves and flowers were dipped in a thin solution of shellac and then put on

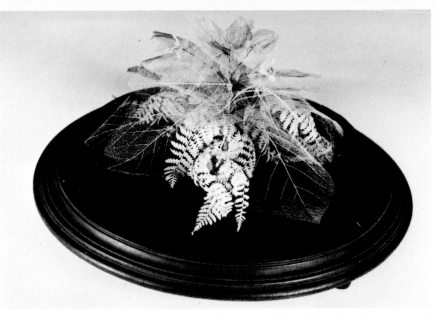

a board to dry in the sun, as drying by a fire would make them sticky. Stems were made of strips of leather, dampened and rolled with the hand upon the table or over a wire. Grapes, very handsome in this type of work, were made by tying bits of cotton or wadding, peas, or marbles into the leather with strong thread; they were then stained and wired into clusters. The frame, or whatever was to be decorated, was also stained with Venetian red and vinegar and varnished with black varnish; the leaves and flowers were nailed on, and the completed work was painted with a solution of shellac dissolved in alcohol and finally varnished with the best copal varnish. Leather leaves combined with real acorns could be entwined with ivy to decorate a simple wall bracket. Convolvulus, or morning-glory, made a graceful border, and roses and passion flowers were also popular. The articles that could be decorated by this method included clocks, mirror frames, cornices, reading stands, and even tables. The results could be very handsome; surviving examples of leatherwork do in fact suggest ornately carved wood.

Much simpler to do was "Oriental" work, or tinsel painting. This was reverse painting on glass, the design done in transparent washes of oil or japan color, with a backing of metal foil showing through, "giving the appearance of much more costly mother-of-pearl inlay." A basket, vase, or wreath of flowers was the usual subject; the background was filled in with flat opaque paint, white, ivory, or black, so that only the subject itself acquired the shimmering, mother-of-pearl look. Frequently the tinsel paintings were worked from printed designs, which could be purchased from dealers in artists' supplies. The all-original, homemade design can usually be recognized, however, by its comparative crudity and an engaging lack of symmetry.

In "Japanese" work, actual leaves, grasses and fronds of fern were used to decorate wooden boxes or sectional screens. After being pressed and dried between the pages of heavy volumes, the leaves and grasses were first arranged in a design on thin white paper and then transferred to a smooth wooden surface, with glue to hold them in place. Japanner's size was used to fill in the spaces until the surface was even; the whole then was lacquered or highly varnished. A box

described in Miss Florence Hartley's *Ladies' Handbook of Fancy and Ornamental Work* was decorated in Japanese style with leaves, ferns, grasses, and butterflies. Instructions for capturing and preparing the last were also to be found in the journals of the period. With or without butterflies, Japanese work was very charming. Wooden objects decorated in this fashion would seem to have had a long life expectancy, yet they are rarely seen today.

Dried leaves and flowers made bouquets that would last under glass for a few winters. Far more fragile and delicate-seeming were phantom or skeleton leaves, for which instructions were given in *Household Elegancies*, by Mrs. C. S. Jones. These were prepared by an extremely tedious, messy, and long-drawn-out procedure that involved soaking the leaves in a tub or pan of water, covered by a pane of glass, in the open air and full sunlight until they were sufficiently decayed. In about two weeks the membranes of some of them would have become soft and pulpy enough to be removed easily. Mrs. Jones, describing the process, pulled no punches: "The odor of decaying vegetable matter is most unpleasant, and the leaves themselves are absolutely so disgusting in their filthy sliminess, that were it not for the exquisite results to be accomplished by persevering... one would determine at once to 'have done with it.'" The leaves were cleaned of all pulp, leaving nothing but the skeletons, which were then bleached in chloride of lime and dried. Last came the pleasant part of the operation: arranging the gossamer things and covering them with a glass dome. Though extremely rare, there are phantom-leaf arrangements which have survived to this day. This is scarcely the sort of fancywork that we associate with the Victorian era, and it

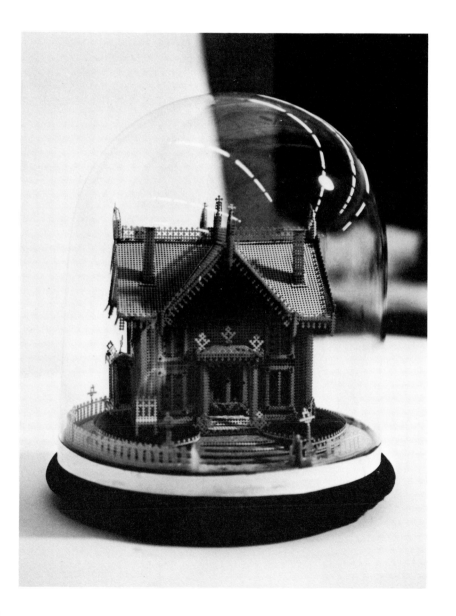

would be impossible to guess how many women undertook this disagreeable task in order to have something lovely as a reward for their efforts.

Other arts achieved their effects with far less trouble, though it was necessary to purchase the materials. Potichomanie, or potichomania, which first appeared in Paris, was described by Mathilda Marian Pullan as the art of "converting very ordinary glass vases into imitations of Etruscan, Dresden or Chinese jars, as beautiful as the originals, at a tenth part of the cost." Mrs. Pullan, an eminent British authority on ladies' fancywork who moved to America in the mid-1850s, said that the art bid fair "to contribute more to the decoration of our drawing-rooms and boudoirs, at small expense and with very little labor, than any art that has made its appearance for the last half century."

For this work, besides the inexpensive glass vases, sheets of specially designed engravings were to be purchased, colored or uncolored, in a variety of subjects: birds, plants, dragons, and figures *à la chinoise*, medallions and other subjects intended for Sèvres, figures in dull red outlined in black destined for Etruscan jars. Also needed were long-handled paintbrushes, dissolved gums, oil paints, and varnish. The designs were cut out carefully, gummed on the right side, and placed in position on the inside of the glass. When they were all in place, the entire inside surface of the vase was given a coating of gum, then a coat of varnish, and finally a coat of oil paint in white or any color desired. For a perfectly smooth finish, the oil paint could be poured in and the vase turned until the entire inner surface was coated.

Apparently the fad for this sort of work did actually reach the proportions of a mania, but the manic phase seems to have subsided fairly soon. For in 1876 William Dean Howells wrote of "certain large glass vases, ornamented by the polite art of potichomanie," which he had seen in a secondhand shop in South Boston and which suggested to him faded rose petals and the faded hopes of maiden ladies of a time gone by.

Godey's Lady's Book from time to time printed instructions for

149

Opposite page Illustrations from *Art Recreations*, by Mme. Levina Urbino, 1859.

Top left Amateur taxidermist with stuffed birds. Do-it-yourself taxidermy was one of the art recreations for leisure moments.

Bottom left "Oriental work," or tinsel painting, usually framed to be hung on a wall, was sometimes used for table tops.

Top right Potichomanie, the art of decorating glass vases with cut-out pictures, imitated Dresden or Sèvres porcelain.

Bottom right Mirror frame, table, clock and bracket, all in leatherwork.

making small glass boxes and baskets, the earliest appearing in 1832. A "cotton box," hexagonal in shape, was described in *Godey's* for March 1855. The glass pieces were to be cut by a glazier, or you could do it yourself with a glazier's diamond. Each piece was to be decorated in potichomanie, then bound in satin ribbon, after which the pieces could be sewn together to form a box.

A version of potichomanie which certainly lacked the elegance of Sèvres porcelain, but still gave quite an interesting effect, was the glass vessel lined with cigar bands, usually placed so close together that there was no open space between them to be enameled.

Another related mania, that for transferring colored designs specially created for the purpose from paper to metal, wood, or human skin, has continued in popularity over the years since its importation into this country in 1862. Decalcomanias, or decals, as they are called nowadays, were used first as playthings, later for decorating buggies, sewing machines, and other articles, and are still used on furniture. The play type used to be sold in dingy little candy stores along with the gaudy penny candies—watermelon slices, jawbreakers, fried eggs, "chicken dinner" or candy corn, and ropes of licorice—and no doubt they still are. Generally worn on the back of the hand or on the knee, they were juvenile tattoos, instant and painless and—fortunately—easily washed off. They recently made the fashion scene when stylish patterns were made for the blue-jeans crowd and for the models posing in cowboy cigarette ads.

Stained glass, an aspect of the Gothic Revival style in architecture and decoration, was all the rage in the latter part of the nineteenth century. Skylights, doorlights, and windows on staircases and in entrance halls were often done in stained glass; it was also used for lampshades. Real stained-glass windows could be made by following the instructions given by Mrs. Jones in *Household Elegancies*: "Appropriate colors can be obtained from any colored-glass establishment, where they can be cut as directed, or large pieces can be obtained and cut with a glazier's diamond." Directions for leading the glass followed.

Much more readily accomplished, however, was the new French method of simulating stained glass by affixing transparent pictures to plain glass, a process called diaphanie. The designs came in 16-by-20-inch sheets, printed in both ancient and modern styles, the subjects ranging from sacred figures to bouquets, birds, and butterflies. Borders, plain transparent colors, and ornaments were available to fill in the spaces between the picture and the edge of the glass.

Leaf transparencies or arrangements of pressed ferns, grasses, and autumn leaves between panes of window glass, bound with linen or muslin and then with ribbon, were another possibility for window decoration or for lampshades.

The oil lamps themselves always seem to have been purchased, but lampshades could be made in a variety of ways. One popular method was to make the shade of glazed cardboard with the design, whether flowers or fruit or a sailing ship, cut out in such a way that the cardboard remaining would hold together. The shade was lined with several thicknesses of tissue paper to soften the light shining through the cutouts. A much more elaborate shade could be made by covering a wire frame with silk or transparent paper (preferably rose-color). Then, "with gum, and, if necessary, by the needle, attach to the frame ordinary artificial flowers. Trailing vines produce a beautiful effect," suggested Miss Florence Hartley. The shades were "very handsome, and not at all difficult to do."

A great variety of natural materials could be made into decorative and possibly useful objects. It is easy to picture much of this work as being done by the young, after a visit to the seashore or the country. Collecting shells, pine cones, twigs, or moss now had a higher purpose. The mementos of a happy sojourn might take the form of a cone-work wall bracket or a shellwork hand mirror and so find a more or less permanent place in parlor or bedroom.

Moss work, charming as some of the examples might have been when first created, was one of the shorter-lived processes. Dried moss is especially fragile, and if unprotected by a glass cover, quickly collects dust; soon its charm is gone and the scruffy thing is consigned not to the attic but to the bonfire. Pretty moss baskets were made for flowers and fruit; moss wall brackets and picture frames

150

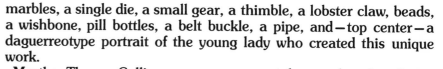

were probably less successful. But there are moss pictures and wreaths of moss and grasses that have survived under glass and even retained some of their original appeal.

A border of cherrystones could be glued to the outer and inner edges of a plain wood frame, apricot or plum stones placed at the corners, and the rest of the space filled in with red corn (unpopped popcorn). Various kinds of dried beans were used, as were rice and pearl barley. There was cone work, acorn work, and twig work. There was fish-scale work, and there was shellwork. Shells were doubtless the most popular material of all. They could be used to encrust a box, a plant stand, or an album cover; chains of them could be hung in swags from shelves or mantels. With their great variety of colors and sizes, shells could be made into fantastic bouquets, large ones under domes or tiny ones like porcelain. Shellwork is enjoying renewed popularity now, particularly in the Southern resort areas where quantities of shells are easily obtained.

Chenille, wool, feathers, and wax all were used to make bird and flower arrangements in the round, to be put under a glass dome, or floral wreaths for display in recessed frames. A very popular subject, frequently used for Easter cards, was the cross entwined with ivy or lilies; carried out in white wax, it had a kind of sepulchral elegance that evidently appealed strongly to the temperament of the period.

Victorian interiors were nothing if not eclectic, and there was no problem with assembling many different types of work—shell, twig, seed, and cone—in one room. But when it came to making picture frames, the frame was supposed to be in agreement with the subject it enclosed: coral, sea moss, or shells for a seascape, twigs for a woodland scene, and so forth. It would be difficult to find an appropriate work of art for the "variety" frame made by Martha Thayer Collins of Franklin County, Vermont, about 1898. Evidently she started out with shells and other small objects found on the beach, but then began to add other things collected on trips and visits, or those which simply had some sort of sentimental value. In addition to the shells, which form the basic pattern, the frame includes coins, buttons, a small round pocket mirror, a buttonhook, a miniature pitcher, keys, marbles, a single die, a small gear, a thimble, a lobster claw, beads, a wishbone, pill bottles, a belt buckle, a pipe, and—top center—a daguerreotype portrait of the young lady who created this unique work.

Martha Thayer Collins may or may not have taken her frame seriously, but examples of intentional humor in these arts are very rare. An exception is the pair of lobster figures for which Godey's gave instructions in 1867; they were "the greatest novelties in the fancy line that have ever been brought out." These droll creatures, intended to be used as match or toothpick holders, were to be "formed of portions of lobster shell and pieces of bright-colored velvets or silks. For [the female figure] take the left claw of the lobster, the head and two small claws [legs]. Care should be taken to keep the shells moist while working on them. . . . The lobster claw intended for the lady's head is securely fastened on a body formed of wire covered with rags or wadding. The feet are also made of wire worked over with orange wool, and the figure is then dressed to taste." The two small lobster legs formed the arms, and the open end of the lobster-claw head was to be covered by a velvet cap. The eyes were made from two large black beads. The actual head of the lobster was fastened, upside down, like a pack on the old lady's back; it was to be lined with green paper and finished with a ruching of ribbon. The old-gentleman figure "has for his head the right claw of the lobster, and his coat is formed of the lobster's tail, and his arms of the two small claws. The body and legs are arranged the same as for the other figure. The top of the head, intended for the matches or toothpicks, is lined with silver paper and bordered with a band of astrakan. The figure is then dressed as fancifully as possible."

The special humor of these figures lies in the fact that the lobster shell has been used to create figures of birds which are dressed as people. Since the pair were to be made from one lobster, and that a small one, no great expense was involved; besides, you could always eat the lobster. A charming set of lobster figures is to be found in the Margaret Woodbury Strong Museum in Rochester, New York. These were made purely as amusing ornaments and have been protected

Left A wall pocket for horticultural papers, described by Mrs. C. S. Jones in her *Household Elegancies*, 1875.

Top right "Oriental work" or tinsel painting of wreath and birds. 15⅜″ x 19″. Ca. 1850. Margaret Woodbury Strong Museum.

Bottom right Floral wreath made of tinted feathers. 14″ d. Ca. 1860. Margaret Woodbury Strong Museum.

over the years by glass domes. There are two individual musicians — a violinist and a banjo player — and a group of four cardplayers seated around a miniature card table. Every detail of these delightful figures has been beautifully worked out: the tiny spectacles on the great beaklike lobster-claw noses; the diminutive bottle, glass, and pipe resting on the little table beside the fiddler. These characters have been given lobster-shell legs; there is no suggestion that they are birds.

There is a kind of unconscious humor in the very brief chapter on do-it-yourself taxidermy by Mme Urbino. She launches into her instructions briskly: "Take out the entrails; remove the skin with the greatest possible care; rub over the whole interior with arsenic, (a deadly poison); put wires from the head to the legs to preserve the natural form; and stuff immediately with tow, wool, or the like." It would appear to be an art better left to the experts. The resultant stuffed bird, of course, was to be posed on a small branch, along with moss, dried leaves, and flowers, the whole to be protected under glass.

Some of the objects that lent themselves to decoration are rarely heard of today. Lambrequins somewhat resembled present-day valances, but they were used not only at the tops of windows but to ornament shelves, brackets, and mantels. They might be made of draped cloth ornamented with fringe, or of wood covered with paper or fabric and then embellished with designs in shells, pine cones, or any other materials that might strike the fancy of the home decorator.

Another article of that era which is not often heard of today is the wall pocket. "Probably no one article of modern invention and inge-

154

Lobster-shell figures, with feather hair, under glass domes. Ca. 1870. Margaret Woodbury Strong Museum.

Top left: Cardplayers. Miniature furniture made of wood, beautifully detailed. Base 13 ¾″ d.

Top right: Top-hatted banjo player, his face made from a lobster claw. Base 9 ¼″ d.

Bottom: Fiddler. Base 9 ¼″ d.

nuity has afforded greater satisfaction than wall-pockets," wrote Mrs. C. S. Jones in 1875. This may seem something of an overstatement, but in fact wall pockets were the work organizers, the space organizers of the period, besides which they were capable of being made into "really artistic house adornments." They could be attractive gifts, too. Hanging on the wall convenient to the location where their contents were to be used, they were often decorated in a way that bespoke their purpose. A wall pocket for horticultural papers was magazine-sized and decorated with English walnuts and pecans, leather leaves, colored engravings cut from flower and fruit catalogues. After all these materials were glued in place, the pocket was to be finished with Damar varnish and lined with marbled paper or velveteen. Wall pockets for the vestibule or entrance hall might take the shape of a box to hold visiting cards or a pouch to hold gloves, while in the bedroom a wall pocket for toilet articles was needed. In the kitchen several pockets would be handy; oilcloth and bed ticking were appropriate materials for these. Some of them were shaped like boxes suspended on the wall; others resembled partially opened portfolios, their front covers held in position by chains, cords, or ribbons; still others were pouch-shaped. All were decorated lavishly.

But fashions change; suddenly no one wanted these homemade elegancies any more. The acorns and barley seeds and pine cones were falling one by one from the picture frames; the mosses that covered the wall brackets had long since crumbled. The paper flowers on the lampshades were scorched, the feather flowers were fast fading, and the waxwork arrangements of fruit had melted out of shape. In parlors where these things were still kept on display out of sentiment, they were a source of embarrassment to the younger generation, eager to redecorate with machine-made art. The objects that had been made with so much pleasure and care were swept out, to make room for stylish manufactured art objects at prices everyone could now afford. And yet the urge to make things by hand from found materials has continued down the years; piggy banks made from bleach bottles and lamps from Popsicle sticks can be added to our list of homemade adornments.

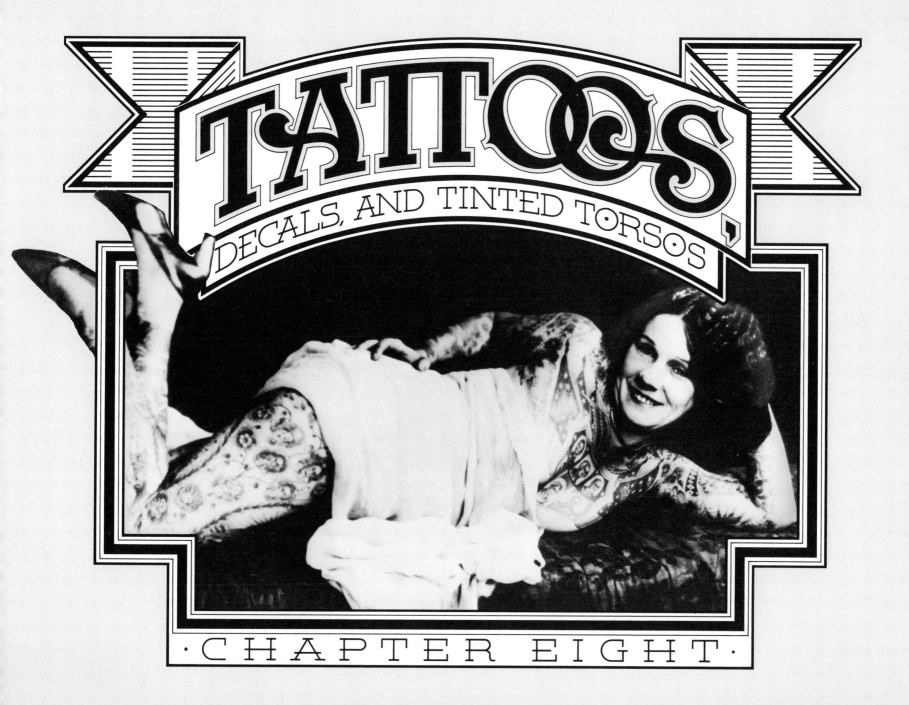

TATTOOS

DECALS, AND TINTED TORSOS

·CHAPTER EIGHT·

Preceding page Lady Viola, famous tattooed circus and dime-show lady. Tattooed by Frank Graff, Coney Island, 1930s. Six presidents on her chest, U.S. Capitol on her back, numerous movie stars on legs.

Below Detail of chest or back tattoo design popular with sailors over the past sixty years.

He had designs upon himself,
She had designs on him;
She loved to look at the picture book
He had on every limb.

—From a lyric by Harry B. Smith for The Idol's Eye, with music by Victor Herbert, produced at the Broadway Theatre, New York, on October 25, 1897.

"I've made more lasting impressions on people than any other artist," once quipped Spider Webb, probably the only tattoo artist in America with a master's degree in fine arts. The permanency of the tattooer's art is well stated in a commercially distributed sign: "All tattooing guaranteed for ninety-nine years."

That tattooing is an art was recognized in 1971 by the Museum of American Folk Art in New York City with an exhibition that proved to be one of its most popular shows. Up to that point the art of tattooing had been in some disrepute, patronized mainly by sailors, soldiers, roustabouts, and drifters. However, a new interest was generated by the psychedelic art and the peace movements, when both men and women requested peace signs, flowers, butterflies, and signs of the Zodiac to be tattooed on all parts of their anatomy. The museum showing, the first of its kind, received nation-wide publicity and gave an aura of respectability to the art. Since then new styles and techniques have raised the standards for the art and its artists.

The museum exhibition for the first time recognized tattoo for the art that it is: folk art with roots as deep and an expression as full as any other. Tattoo artists have always felt that their work deserved more acceptance as an art and that it was discredited because of the nature of the medium. But if the medium is put aside, it is easy to see the craft, the fancy, the individuality, and the art of the practitioner. Whatever one may think of tattooing itself, one must acknowledge that it is a true folk art.

Tattooing as the art of marking the human skin is quite ancient. One of the earliest known examples was discovered recently on the body of a Scythian chieftain found, frozen and perfectly preserved, in a tomb in Russia dating back to 2500 B.C. The earliest records of the use of the tattoo are Egyptian ones dating to 2000 B.C., and tattoo markings have been revealed on mummies. Libyan figures from the tomb of Set I, built in 1330 B.C., are tattooed symbols of the Egyptian goddess Neith which, in a simplified form, are still employed as tattoo designs in North Africa today. Tattooing existed in southwest China in 1100 B.C. In Japan it thrived in the middle of the first century A.D., but has also been traced to its origin in the sixth century B.C. It is now thought that from Japan it was taken to the South Sea Islands, where today one still sees the most intricate and delicate patterns in the raised skin of the natives.

The word "tattoo" is derived from the Tahitian *tatau*, "to mark," and was first used by the French navigator Bougainville in his *Voyage autour du monde, 1766–69*, published in Paris in 1771. The form "tattow" first appeared in *Captain Cook's First Voyage*, published in July 1796.

The practice of tattooing among the American Indians is believed to go back a thousand or more years. The aborigines had figures of their totem animals tattooed on their bodies as a family identification. When the French explorer Bossu came upon the Quapaw Indians in the 1770s in the area now known as Arkansas, they greeted him with a great feast and a ceremony in which they tattooed his thigh with the sign of a roebuck, thus guaranteeing him safe passage among all their allies. When the Puritans arrived in America, they frowned upon tattooing, as they did upon any marking of the skin, and considered the Indians children of the devil. Taking their text from Leviticus 19:28—"Ye shall not make any cuttings in your flesh for the dead, nor print any marks upon you"—Christian missionaries discouraged the redmen from the practice. Their influence did much to eliminate the tattoo from Indian ritual, and by 1870 the Indians regarded anyone with a tattoo on his body with superstition. The presence of a tattoo was supposed to prevent them from attacking, which encouraged many a traveler to the West to have himself tattooed prior to his journey.

Tattooing was unusual among whites in America, although Ameri-

can sailors who visited foreign shores frequently returned with such markings. The first white man to exhibit his tattoos professionally was James F. O'Connell, who toured the Eastern United States in 1837 with a cast of characters, enacting his shipwreck on one of the Caroline Islands, his rescue by astonished natives, their introduction to firearms, his marriage to a native woman, and the tattoo ritual that attended his becoming a chief. After successful appearances in Boston, Buffalo, and other cities, O'Connell was taken under the management of circus Impresario Dan Rice for several years. In 1853 "The Pacific Adventurer" found time to put his story into a book, which was published that year by J. Merone and Company in New York.

The public exhibition of O'Connell, billed as "The Celebrated Tattoo Man," created much interest in tattoo. But in the mid-1870s George Constantine, a Greek from Albania, came under the management of P. T. Barnum, and it was his tour throughout the country that really introduced the art of tattoo to the Americans. Barnum billed him as "Prince Constantenus the Turk, the Living Picture Gallery." (The term has stuck; today most banners exhibiting tattooed men and women bear the legend "The Living Picture Gallery.")

Constantine's story—probably conceived and certainly embroidered upon by Barnum—contained all the elements of adventure with a band of robbers in "Chinese Tartary," a search for gold, apprehension, and punishment by tattoo inflicted over his entire face and body by six tattooers during a three-month period—a total of 388 designs. His upper torso contained two crowned sphinxes, two serpents, two swans, one horned owl, several elephants, tigers, monkeys, and other beasts of the jungle, slithering serpents separating peacocks: a veritable Noah's Ark, all harmoniously placed and proportioned. When Constantine later toured the world and was exhibited in Vienna, men of science studied his markings and pronounced them to be in "imitation of Doorga, the wife of Siva, the oldest demon god of India." The tattooing had evidently been done in Burma by the most talented of artists, ordered by Constantine, and for the purpose of exhibition.

Constantine's appearances throughout this country left their mark in more than the usual sense, as the desire to be tattooed caught on among young and old, men and women, of all classes. There were several tattooers practicing their art during the last quarter of the nineteenth century, but one, Martin Hildebrandt, claimed to have been the first professional tattoo artist in America, stating that he had been in constant practice since 1846, with an "atelier" on Oak Street between Oliver and James streets in New York. Hildebrandt's accounts of his activities during the Civil War included many stories of how he "marked thousands of sailors and soldiers," devoting his full time to this work.

Chatham Square, slightly north of Oliver and James streets, was the boundary between what was in 1886 called "Jewtown" to the east and Chinatown and Little Italy to the west, with cheap lodging houses on all sides. Jacob A. Riis, the reporter and social reformer, reported in *How the Other Half Lives*, published in 1890: "Appropriately enough, nearly one-fifth of all pawn-shops in the city and one-sixth of all the saloons are located here, while twenty-seven per cent of all the arrests on the police books have been credited to this district for the last two years." The area attracted the sailors whose ships docked along the wharfs of South Street a few blocks east, and also young men and women looking for adventure and excitement. The Bowery ran through this area, and the "Bowery girls" drew the young bloods from the upper-class brownstone neighborhood around Madison Square.

Chatham Square also attracted the tattooer and was to be the center for this art for nearly seventy-five consecutive years. In 1875 Samuel F. O'Reilly opened his tattoo shop at the corner of Chatham Square and the Bowery, and in spite of its surroundings it drew patrons from all walks of life. At about this time the electric tattoo needle was introduced, and for a while O'Reilly had the exclusive use of this tool, which he named the "tattaugraph." Prior to this, the process had been a long and painful one in which the skin was broken with sharp needles tipped with powdered charcoal, brick and coal dust, gunpowder, lampblack, and other vegetable and mineral dyes. With the electric needle, the process was much quicker and less

Tattooed undershirt. Artist, Lewis (Lew-the-Jew) Alberts, Chatham Square, New York, 1922.

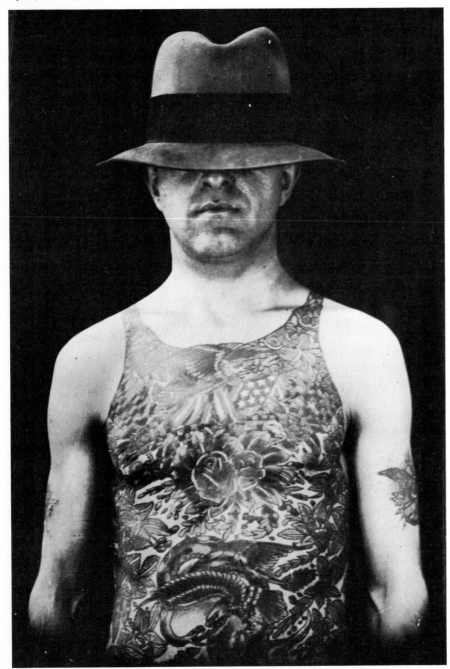

Tattooed undershirt. "When he laid down he slept on a bed of roses." Artist, Lewis (Lew-the-Jew) Alberts, wallpaper designer turned tattooer.

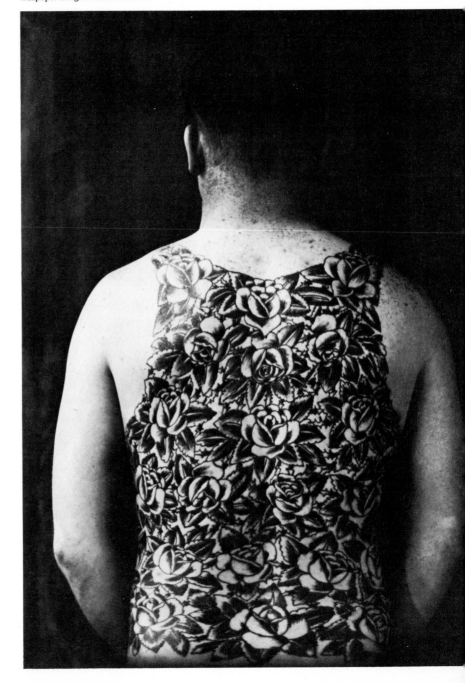

Princess Beatrice, circus and dime-show tattoo lady, with portrait of George Washington in oval frame on her chest.

Tattooed father, mother, and child, carnival and dime-show family, 1920s.

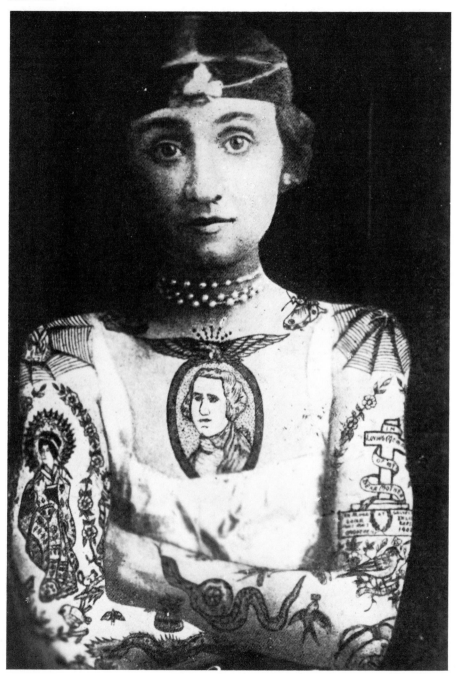

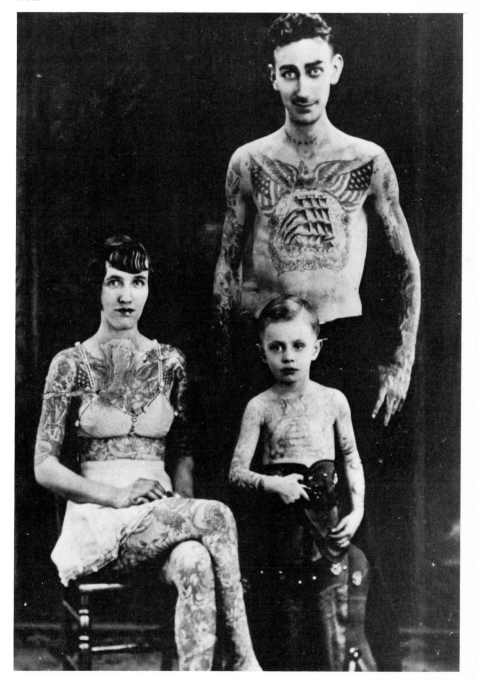

Right "Professor" Charles Wagner's Electric Tattoo Studio at 11 Chatham Square, New York, 1911. **Left to right:** Adam Ogent, Joe Van Hart, Charles Wagner, and Lewis Alberts.

painful, and tattooers, like dentists, displayed signs advertising their painless skills.

In the late nineteenth century an impetus was given to our native tattoo artists by the increased interest that developed in England, especially among royalty and men and women of society. Officers returning from tours of duty in Her Majesty's colonies in the Orient proudly displayed one or more tattoos as marks of distinction. Perhaps the greatest influence was the newspaper publicity that resulted in England and America when the two sons of the Prince of Wales were tattooed in the Orient, each with a dragon on one arm. (One son later became the king of England; the other, the duke of Clarence.) This episode and the publicity it received turned what was at first a fright into a fad, and it became fashionable for royalty and nobility to exhibit tattoo designs. Several of the most important monarchs in Europe journeyed to Japan to be decorated by the world-famous Hori Chyo; others patronized Tom Riley in London. Riley also traveled anywhere for a royal commission. Lady Randolph Churchill, the American-born mother of Sir Winston Churchill, engaged Riley on an American visit to do the first of her several tattoos, which he completed in London.

The tattoo fever caught on in America, and tattooers began to advertise in several publications. Most favored was the *Police Gazette*, published by Richard K. Fox at Franklin Square, a few blocks away from Chatham Square. This publication was to be found at most barbershops, pool rooms, and sporting clubs; its columns carried advertisements offering devices for "regaining lost manhood" and medicines guaranteed to cure all the social diseases. The tattooers' notices drew patrons and also competitors.

The art as practiced in America to this point was primitive and crude, to judge from the artists' renderings or samples, known as "flash," which have survived. Not a single tattoo artist in nineteenth-century America was known to have had any formal art training. The masters of design and technique with a tradition of long apprenticeship were the Japanese. Americans who returned from the Orient

162

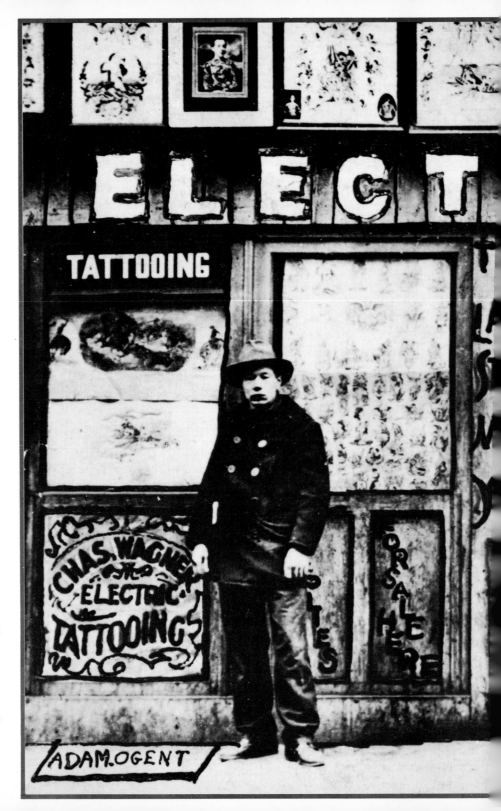

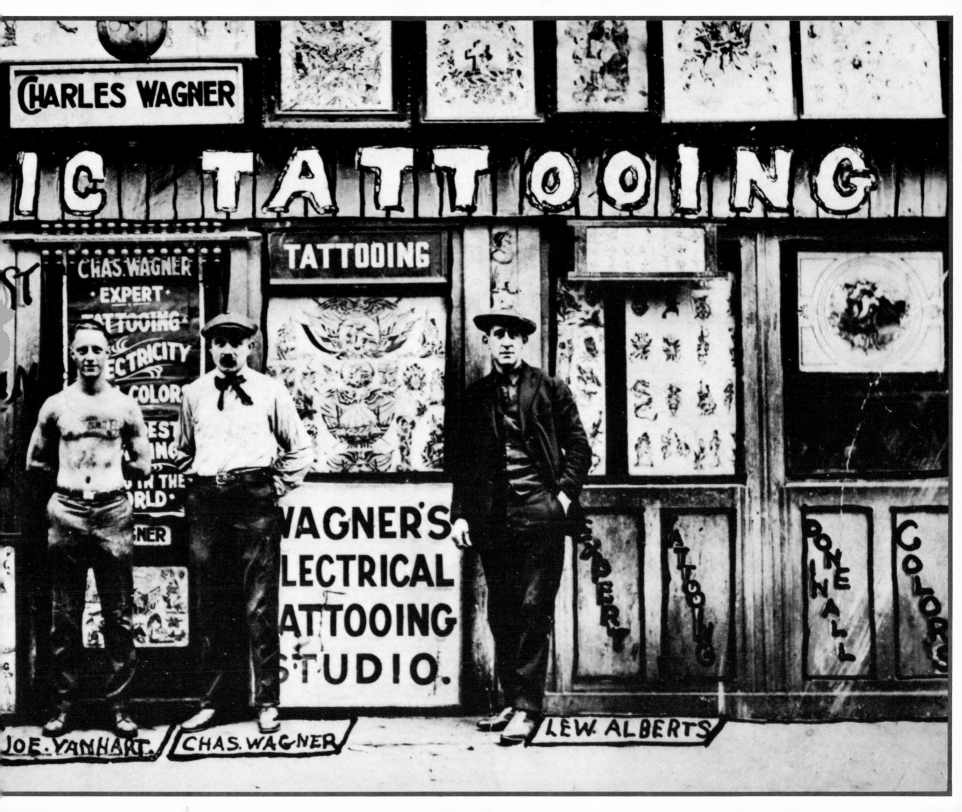

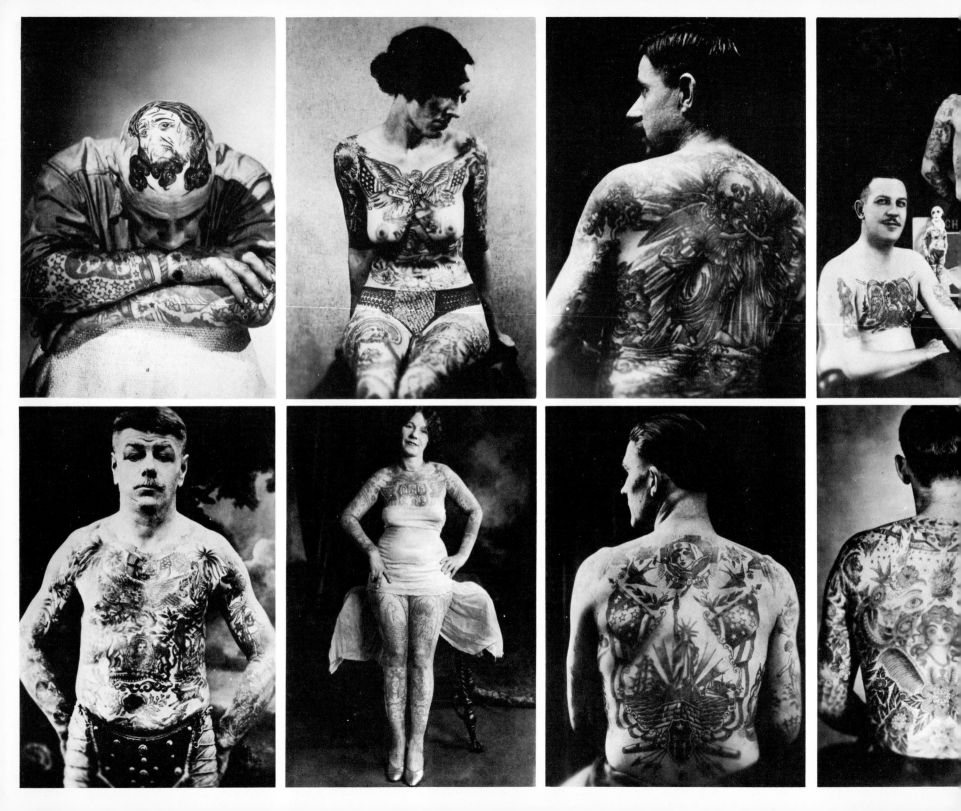

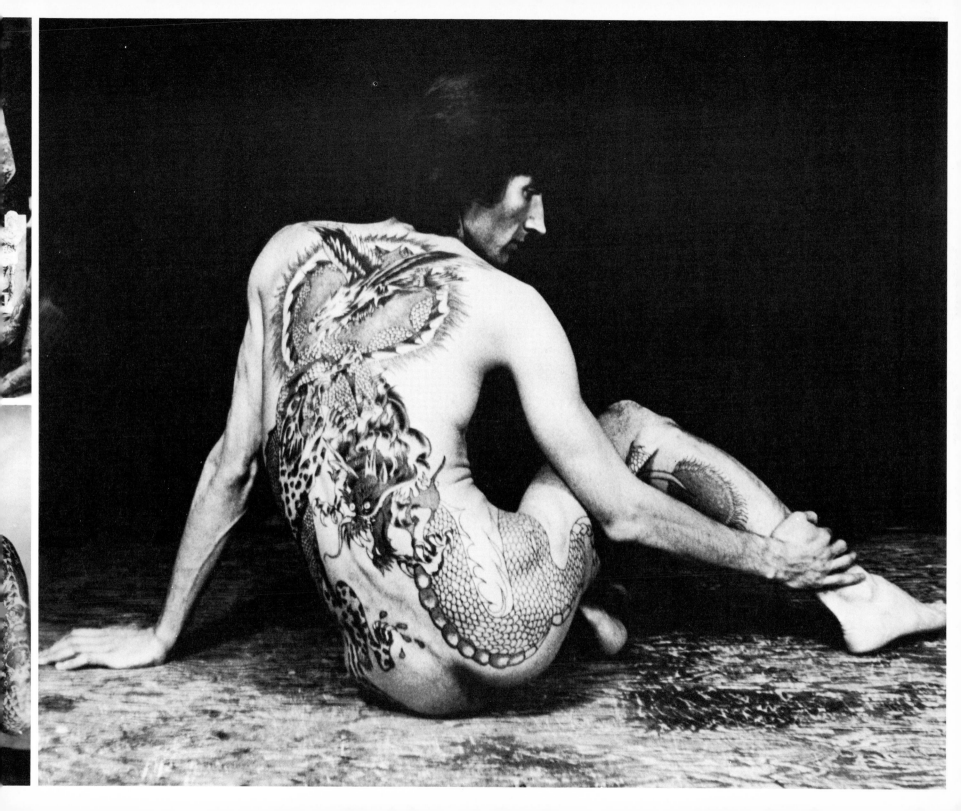

bearing the work of these masters prompted the *New York World* to report on August 29, 1897, that "Hori (tattooer) Chyo is the Shakespeare of tattooing because none other approaches him. . . . Even the prejudice against the barbaric and senseless adornment cannot disguise the fact that [Japanese] design is one of art, and is executed with rare skill." At one point two of the Japanese masters came to New York to practice their art under the auspices of Samuel F. O'Reilly. Although they stayed for a very brief time, their influence remained, and a proliferation of dragons, serpents, insects, and other Oriental designs found on kimonos became the fad. However, the rendition was still imperfect and even primitive.

Among those who came to Samuel F. O'Reilly to be taught the art of the tattoo were Ed Smith and Charles Wagner, two men whose names were foremost among tattoophiles for many years. Smith later established his shop in Boston, but Wagner remained in the Chatham Square area for almost half a century and in turn taught a large number of eager students.

Charles Wagner had progressed sufficiently to give himself the title of "Professor," which adorned his trade card and his shop sign. On April 19, 1904, Wagner filed with the United States Patent Office his invention of an improved electric tattooing needle and was granted patent No. 768.413. He began supplying the apparatus and other materials to tattooers all over the country.

About this time, a young man who had enlisted for service in the Spanish-American War, and who had put his talents to work on his fellow soldiers and sailors in the Philippines and on shipboard, became a professional tattoo artist and gravitated toward Chatham Square. Lewis Alberts, who lived in Newark, New Jersey, had been a designer of wallpaper before his enlistment, and is said to have been appalled by the tattoo designs and their renderings on the anatomy of his shipmates. He set to work to bring about a change.

There was also a change in Alberts' name: he became professionally known as "Lew-the-Jew." Albert Parry noted in his book *Tattoo* that Alberts "dedicated his nights to creating and drawing his designs. . . . To this day [1933] many tattoo-shops use them for at least fifty-

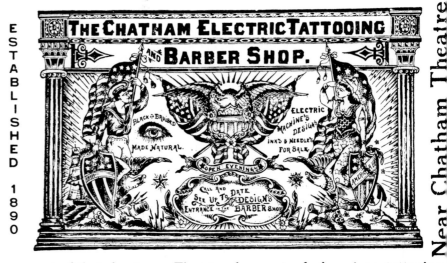

THE CHATHAM ELECTRIC TATTOOING AND BARBER SHOP.

percent of their business. That is why so much American tattooing looks like the walls of your grandmother's living room. Lew-the-Jew pre-eminently left his mark on the folk-art of America." Alberts remained for several years at Chatham Square, but then moved to Sands Street near the Brooklyn Navy Yard, where he remained during World War I. Later, his competition increased there, with Jack Redcloud at 139 Sands Street and Bill Donnelly and Jim Wilson all within a short distance of each other. During the 1920s, Donnelly left for England and Wilson for Panama. Alberts moved to his home base in Newark and eventually gave up the work entirely.

During the enlistment and draft for World War I, tattooers thrived, but after the war, business dropped considerably and the professionals had to seek other areas, usually along the coasts and waterways. Among the better known were "Red" Gibbons in San Antonio, Texas, then considered the best artist in the country, and by some, on a par with the Japanese masters; Lenora Platt, the most famous woman tattooer, based in Norfolk, Virginia; Bill Moore in Chicago; Louis Morgan in San Francisco; Gus Wagner in Los Angeles; "Dad" Liberty

in Boston; George Pennell in New Orleans; and "Old Dutch" in Chicago. In Manhattan, Chatham Square and the Bowery had their original tattoo artists and acquired several more from time to time: "Electric" Elmer Getchell, so called because of his early use of the electric needle; Harry V. Lawson, considered the "swankiest" of the masters, with his suite of rooms and his affectation of being a medical-arts practitioner; and Al Neville at 12 Bowery. Neville had much higher credentials than his fellow tattooers; he had attended the Birkenhead School of Art in England and had learned his tattoo techniques in Malabar, India, in 1904. Neville, a former Welsh soldier and boatbuilder, had come to America in 1918. His tattoo shop was part of the barbershop in the basement of 12 Bowery.

One of the more talented tattoo artists was Robert F. "Texas" Wicks. He is probably the last living of the old-time tattooers, although he gave up that form of art for another during the Depression. His tattooing career began in Coney Island during World War I:

"About that time (1916–17) I became interested in tattooing and within a year, I teamed up with Burt Thompson (a balloon jumper and tattoo artist whose studio was a good-size cabin cruiser). He worked the waterfronts of coastal cities. Anyhow, after several weeks together on Worth Street near Chatham Square, I was sent for by Charlie Wagner and I joined him at 11 Chatham Square, remaining there for over five years, in which time we tattooed each other. Charlie had a younger brother. His name was Steve. He was completely covered with Charlie's work and toured with the Barnum Show sometime between 1915 and 1918. . . . I saw him last in the early twenties when he was a house painter and lived with his wife and children somewhere in the Greenpoint section.

"[Charlie Wagner and I] when we worked together, we averaged between $8 and $10 an hour every single day, and that was in the late teens and early twenties. A lot of money in those days . . . that 5-by-8 corner was rented from Louis Alteresi, who owned the barbershop and was also a bail bondsman.

"Eventually I went out alone and had two studios. One on the Bowery and another on Canal Street. It was the latter place where I tattooed Dorothy Thompson and her lady companion, a Miss Harriman. The long-defunct *New York Graphic* ran a full-page photo of Jack Redcloud's bald pate on which I was tattooing 'Ecce Homo.' Eventually I gave up tattooing during the Depression, and I turned to show painting, and after having been successful at mural painting made a somewhat successful showing in the first three years of exhibiting outdoors in Greenwich Village."

The Depression years were hard on most tattooers. Prices were reduced, but even that did not help to increase business. Fred Thornton, now at Long Beach, California, remembers: "During the Depression, we all starved, but Wagner always had fifty cents in his pocket." Norfolk, Virginia, where most of the naval fleet was anchored, was probably the exception. August B. Coleman, one of the ablest tattoo artists of his day, never reduced his rates and was never idle. At the time of his death in 1973 at eighty-nine, he left an estate of nearly $340,000, accumulated through wise investment of his earnings, most of which he willed to charities. His tools, drawings, samples, and other professional equipment are now at the Mariners Museum at Newport News, Virginia.

World War II brought a new crop of eager customers as well as a new group of tattooers, amateur and professional—at times it was difficult to tell their work apart. During the Spanish-American War the slogan tattooed on a sinking battleship was "Remember the Maine"; now it was "Remember Pearl Harbor," and it was found on chests and backs and in smaller dimensions on forearms and biceps, in red, fleshtone, and blue. The old standbys from World War I were retraced and supplemented with tanks, anti-aircraft guns, planes, and submarines. But hearts, broken or in pairs with the name of a sweetheart, were still popular, as were the serpent with dagger and scroll which proclaimed "Death Before Dishonor," the "Rock of Ages," the flag and scroll with "Mother," and nudes wearing sailor hats.

At the end of World War II, veterans who had been in Guam, the Philippines, or Japan carried back on their limbs a superior form of the tattooer's art. Public opposition to the Korean and Vietnam wars which followed developed into the peace movement. Antiwar protes-

tors graphically stated their views on posters and billboards, and with peace symbols and flowers on their own skin. Graffiti developed into a highly visible art on walls, fences, sidewalks, and subway cars, a free outlet for group and individual expression. Music, with the aid of rock groups, eased the psychedelic art movement into a phenomenon unparalleled in growth in this century. Opposition to the Establishment took the form of student protests; many dropped out to embrace more primitive ways of living, seeking out the old crafts and arts as a way of survival. Never was there a more art-conscious America than in the decades that followed the wars in the Far East.

Tattoo, the art of the self-taught, and primitive artist, suddenly became attractive to well-educated, talented art-school graduates of both sexes. The application of their talents to this ancient form of human embellishment brought new life to a stagnating art, resulting in a combination of Oriental and psychedelic influences.

"The younger generation is a helluva lot better than the old-timers," admitted one seventy-year-old tattooer in Long Beach, California. "They couldn't draw a box with a ruler!" "Aren't you an artist?" he was asked. "Hell, no! I'm just a skin decorator." But he conceded that it was an old-timer, "Sailor" Jerry Collins, who died in 1972, who was the first to mix colors and to use a full-spectrum palette.

On the West and East coasts, the post-Vietnam generation of tattooers have been changing the image of the art and the artists by experimenting with designs and creating an entirely new portfolio of designs, symbols, and colors which reflect the trends in the arts of the past two decades. Foremost among these is Lyle Tuttle of San Francisco, who has gained for his art more respect and attention than any other tattoo artist. Tuttle's devotion to the history of the tattoo has resulted in his establishing the Tattoo Art Museum at 30 Seventh Avenue in San Francisco, which represents his years of collecting tattoo artifacts, tools, drawings, photographs, and original art from the masters of the past and present.

Don Ed Hardy, also of San Francisco, with a degree in fine arts, has the youth and talents to expand the art to unforeseen possibilities. Don Nolan of Seattle, Washington, has created new images and line-work in repeating patterns with exciting designs in color. Cliff Raven, located in Hollywood, California, is an expert in the Western-Oriental rendering; he has mastered the techniques of unusual color mixtures, which have become his trademark. Michael Malone, now working out of Honolulu, was an assistant to the exhibition directors in the history-making 1971 show "The Art of the Tattoo" at the Museum of American Folk Art in New York. At that time Malone brought attention to the new trend developing in the West.

In the East, New York, the birthplace and once the center of the tattooer's art, appears to be as sterile as the 1961 law that forbids its practice. But in spite of the ordinance, the underground practice is much in evidence, with ads appearing in community papers. In 1976, Spider Webb (Joseph Patrick O'Sullivan) decided to test the constitutionality of the decree by the New York State Appellate Division in its 1963 ruling, which had upset a previous decision by Justice Jacob Markowitz of the State Supreme Court ruling that the city's ban was illegal.

On August 4, 1976, Webb set up a portable battery-operated tattoo apparatus in front of the entrance to the Museum of Modern Art in New York and proceeded to tattoo his assistant, Shadow. The result was as expected: a large crowd gathered, among them the police. A summons was issued, and the first stage in the fight to upset the law was accomplished. "I'll take it to the Supreme Court if I have to go broke doing so," promised Webb.

Webb's studio in Mount Vernon, outside New York City's jurisdiction, attracts customers young and old who want a small or large tattoo from the master. Webb's tattoos are a reflection of his art training and his constant revision of his earlier designs. Should he win his campaign for "the right of an artist to make a living through the medium of his choice," he will indeed have made a lasting impression for generations to come.

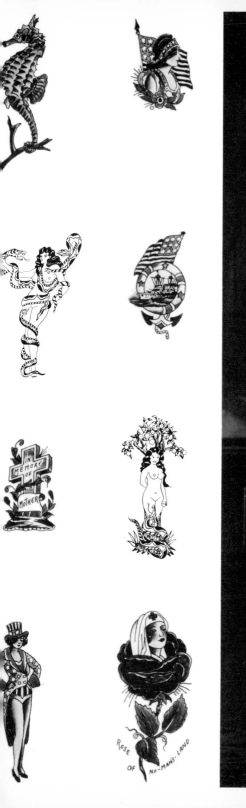
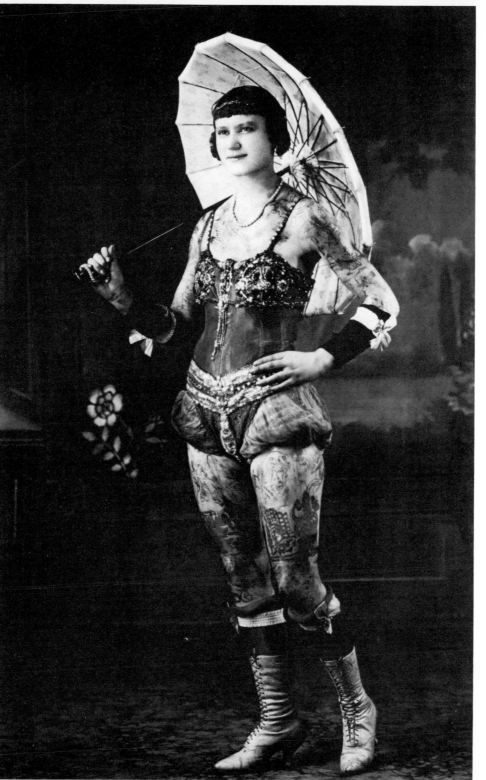

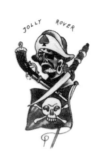

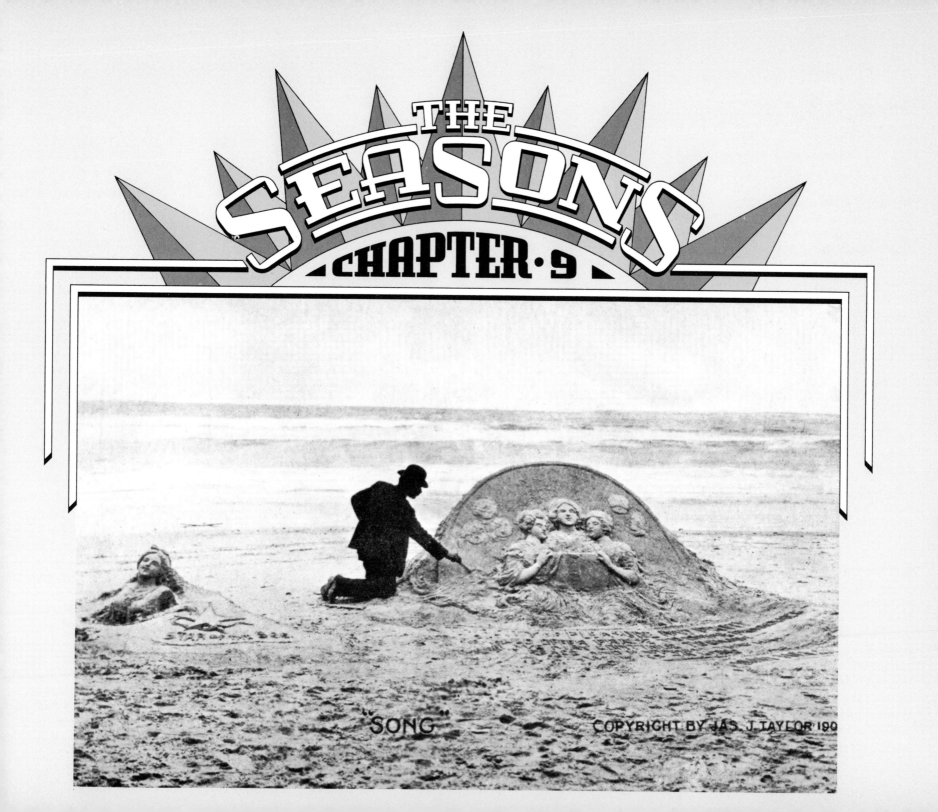

THE SEASONS

CHAPTER · 9

"SONG"

COPYRIGHT BY JAS. J. TAYLOR 190

The arts associated with the great seasonal festivals and celebrations are by nature ephemeral, yet they recur, year after year, a part of their fascination being the way in which old practices have been layered over with new ones. The arts of the seasons have the true folk quality; they are not the expression of people who think of themselves primarily as artists. They are rooted in humanity's earliest beginnings: in the plantings and harvests and celebrations of the turn of the year at the winter solstice. The anniversaries of great events and birthdays of great leaders are celebrated in the fashion of the season, as at Christmas and the Fourth of July.

WINTER

Of all the seasons, surely it is winter that arouses in us the deepest nostalgia for times gone by. Winter would seem to have been easier to cope with in the days when motive power was the horse. Dobbin was easy to start up on cold winter mornings, and he could be hitched to carriage or wagon or sleigh, depending on the weather. In those days there were winter sports in considerable variety, and many of them were participated in by groups: there were skating clubs, toboggan clubs, snowshoe clubs. Out of these organizations grew the great winter carnivals, with their ice palaces and snow and ice sculptures and their pageantry.

The first winter carnival on the American continent was held in Montreal in the winter of 1882–83. Its focal point was a palatial building constructed of blocks of ice. For the 1894 Quebec Winter Carnival, Louis Jobin, a Canadian sculptor and carver of show figures and religious works whose usual medium was wood, undertook the carving of a series of patriotic statues from ice; these included Samuel de Champlain, the Comte de Frontenac, Monsignor de Laval, and many other historical figures. "These transparent statues were a whole revelation," reported one viewer. "They resembled crystal, and shone with a thousand fires in the light." Jobin also created sculpture in colored snow. In Quebec he was known as the father of ice sculp-

ture. However, there was ice sculpture by anonymous artists at the first St. Paul Winter Carnival in Minnesota in 1886.

An outbreak of smallpox in Montreal in the winter of 1885–86 caused the abandonment of their carnival plans for that season, and lent impetus to St. Paul's preparations. Actually, the carnival had been conceived in early fall of that year, by business and civic leaders stung by reports of Eastern newspaper correspondents that Minnesota was a Siberia unfit for human habitation. Their aim was to show the world that St. Paul was no Siberia; that its climate was brisk, vigorous, and healthy, and that snow and ice were actual assets rather than liabilities. The group adopted the name "Saint Paul Ice Palace and Winter Carnival Association," and was able to secure the services of J. H. Hutchinson, the Montreal Ice Palace contractor.

The weather was uncooperative, the month of December being so warm that there was no ice to work with, but finally the building of the palace got under way, after elaborate cornerstone-laying ceremonies, and the winter carnival opened on February 1, 1886. *Harper's Weekly* described the edifice as "the largest and probably the most effectively designed ice palace the world has ever seen. The building covers an area of 160 x 150 feet, and stands, to the top of the central tower, 130 feet high." It was a "congeries of turrets and towers and bastions . . . standing on a piece of rising ground which dominates the city . . . equally conspicuous from both sides of the broad Mississippi." Illuminated within and without by electric lights, it was a dazzling sight. In addition there were six toboggan slides, curling and skating rinks, baseball on snowshoes, cutter races, and other winter sports events every night throughout the entire month of February. Examples of ice sculpture were to be found in various parts of the city.

The carnival was a success, and others followed. For the second carnival in 1887, the architects of the city competed for the winning ice-palace plan; there was a prize of $200. The palace was in the same location as the previous year's but it was more elaborate and costly. As in the first carnival, festivities were presided over by a king, Borealis Rex II. This time a rival, Fire King Coal, was introduced; as

172

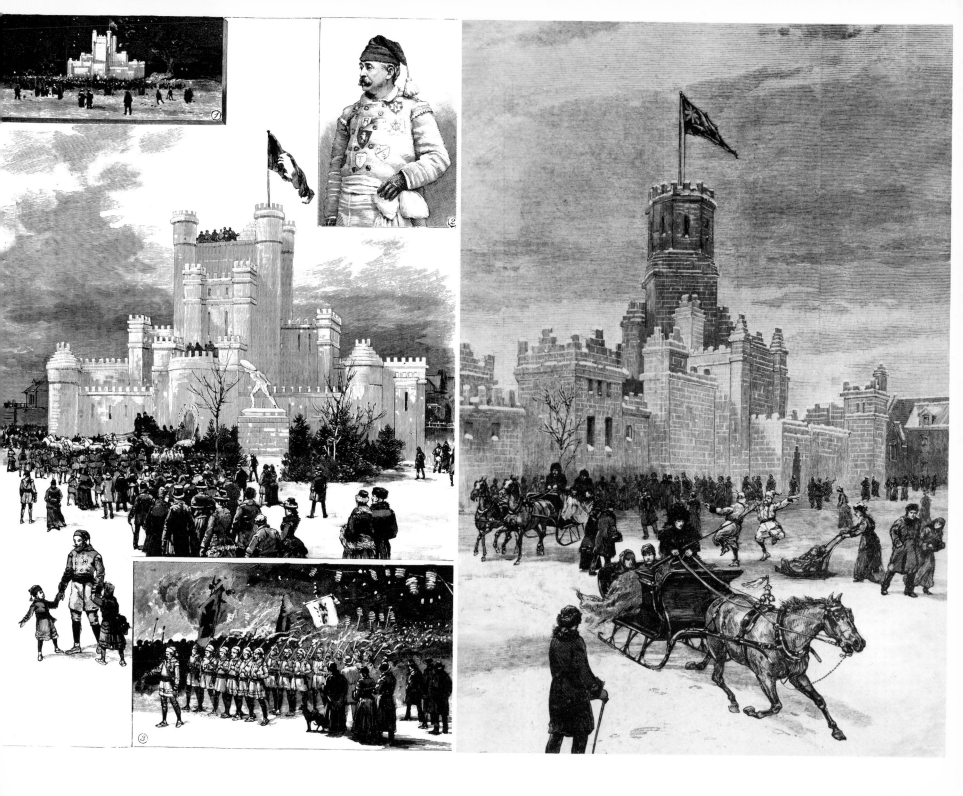

a climax to the whole celebration his forces stormed the palace. Again there was ice sculpture: a snowshoer, an imposing figure of heroic dimensions mounted on a 5-foot pedestal, was made entirely of glittering ice. Its location, in front of Kennedy and Chittenden, Importers of Fancy Groceries and Havana Cigars, suggests a tobacconist's figure. The ice palace of 1888, its crenellated towers ablaze with the recently invented electric lights, set off the large number of snow and ice sculptures dotting the winter landscape.

Warm weather and rain caused the cancellation of several successive carnivals, and then for a while the whole idea seems to have been abandoned. There were sporadic revivals interrupted by war and depression. Then in 1937 the St. Paul Winter Carnival was reinstated as an annual event, which has continued up to the present time. Held usually in late January or early February, it is still the city's major festival of the year. An ice show and ski-jumping championships, guest appearances of TV stars, and televising of the coronation ceremonies are modern additions to the traditional carnival, with its gleaming fairy-tale ice palace. And year after year when the snows come to Minnesota, snow and ice sculptures appear throughout the twin cities. Loring Park becomes a sculpture garden, with snow figures of a royal couple attended by page boys, a dog team driven by a man on a sled, a polar bear with two charming cubs... Sculptures in people's front yards, too: an old-fashioned shingle house almost overwhelmed by a gigantic though benevolent-looking dinosaur that seems to occupy every inch of available space. Skiers modeled in snow reappear every year, their actual skis and poles adding to their realism. But most spectacular are the sculptures carved from blocks of ice, glinting and flashing in the sun.

At northern colleges, too, winter carnivals with competition in sports and snow and ice sculpture have become a tradition. At Middlebury College in the foothills of the Green Mountains of Vermont, where winter carnivals have been held continuously since 1934, the last weekend in February is set aside for skiing events, the coronation of a king and queen, an ice show, ice hockey, and rounds of parties. Each year the students select a theme for the carnival which also

serves as the inspiration for the snow and ice sculpture, much of it created by dormitory or fraternity groups. If the theme happens to reflect some notable event of the period, the interpretation in snow or ice sculpture will usually be humorous or satirical. During the Kennedy administration, a Mount Rushmore-type snow mountain, lettered "Fohwahd—with vigah!" substituted John, Jackie, Bobby, and Ted for the four presidents. The oil crisis of early 1975 ignited the ire and imagination of the Middlebury campus, and the theme "The Arabian Nights" was selected, with results none too gentle or sympathetic toward the oil-producing nations.

Dartmouth College, in Hanover, New Hampshire, is Middlebury's traditional rival in winter sports. Here massive art is the goal, monumental ice figures that dwarf their creators. In the year 1940, "The Star Shooter," a work of colossal size notable for the boldness and vigor of its execution in ice, was the center-of-campus sculpture. An earlier work, reflecting the Art Deco period as well as the carnival spirit, was a pair of figures in low relief, white against blocks of black ice.

Many a small community in snow country has its own celebration. Lincoln, Vermont, in the Green Mountains just a few miles northeast of Middlebury, held a competition for snow sculpture as part of its '76 Winter Carnival. Members of the Lincoln Youth Fellowship created a Statue of Liberty noteworthy for its diadem of icicles, sparkling in the rays of the setting sun. Donald and Peter Brown were also inspired by the Bicentennial with their "Engine No. 76."

Quantities of snow and extended cold periods are required for the more elaborate snow and ice sculptures. Methods of work vary according to the medium. For ice sculpture the form is built up of blocks of ice, either cut from frozen river or lake or manufactured in block molds. This rough approximation is then carved into the final shape, water being used to smooth the surfaces. A chilly job indeed, but the results are dazzlingly beautiful. Snow sculpture may be built on armatures of wood, boxes, or pipe, or simply built up of the snow itself. Here, too, water may be added to make the dry snow adhere and to smooth the surfaces, but the finished sculpture will be opaque

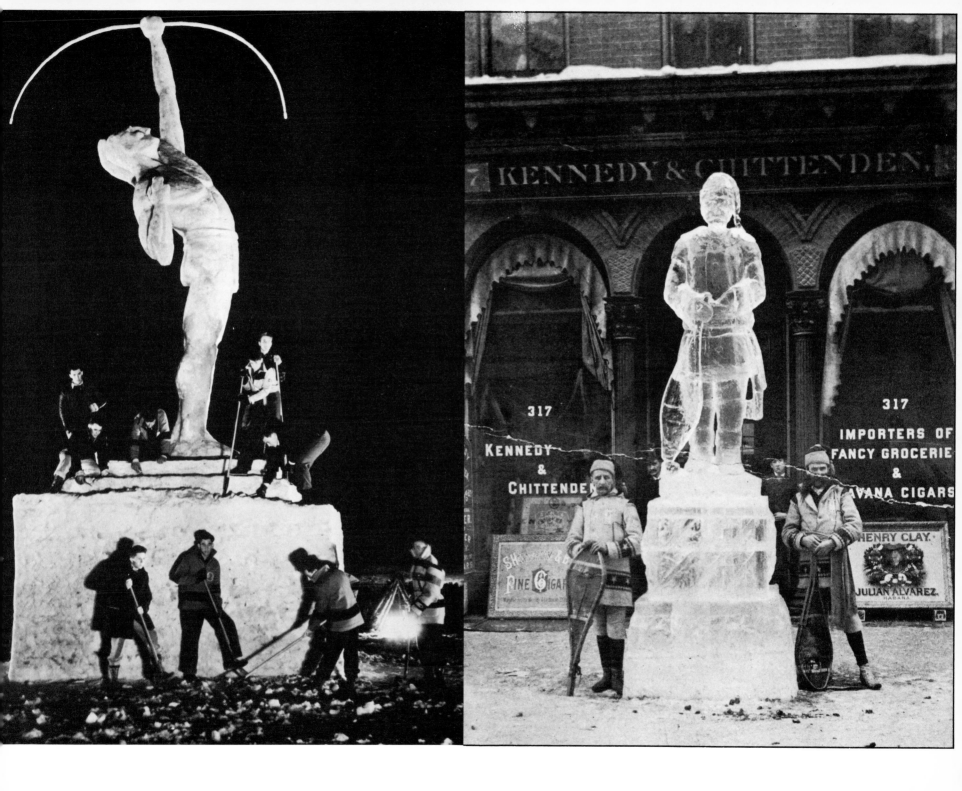

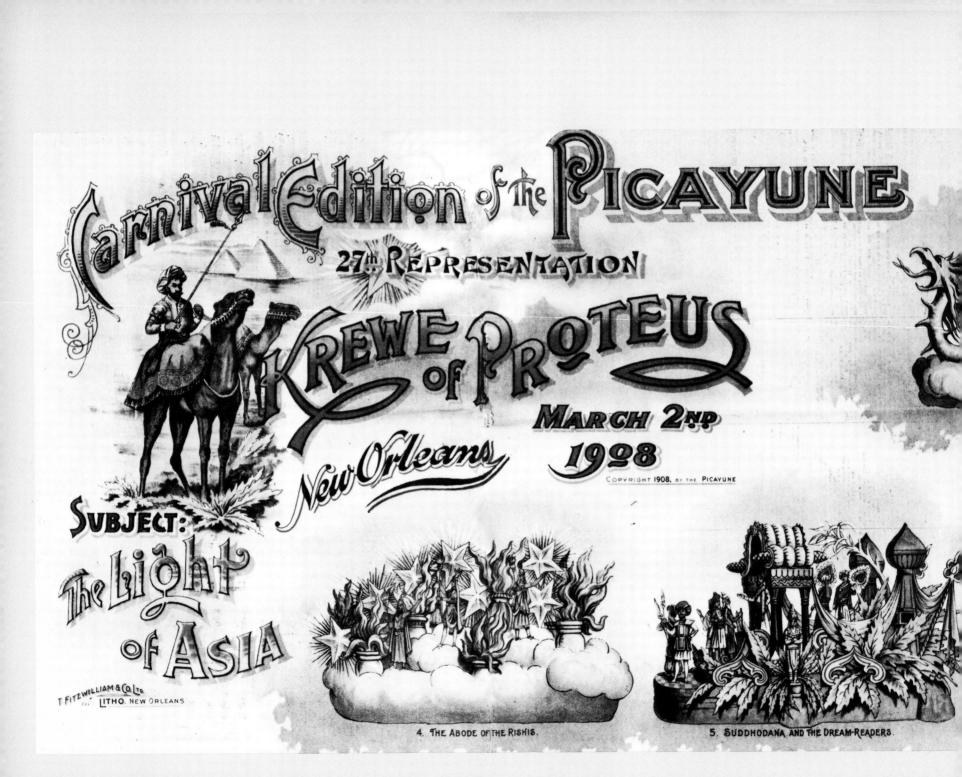

Carnival Edition of the Picayune

27th Representation

Krewe of Proteus

New Orleans

March 2nd 1908

Copyright 1908, by the Picayune

Subject: The Light of Asia

T. Fitzwilliam & Co. Ltd. Litho. New Orleans

4. The Abode of the Rishis.

5. Suddhodana and the Dream-Readers.

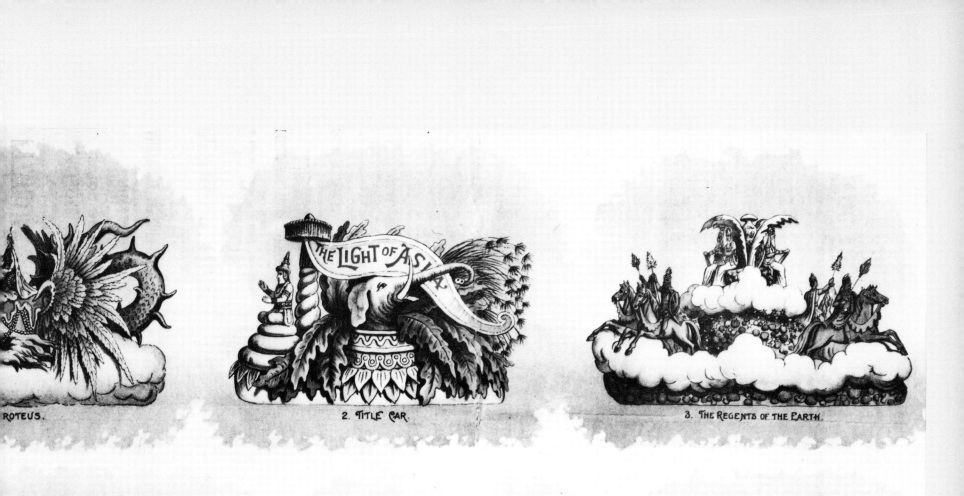

ROTEUS.

2. TITLE CAR.

3. THE REGENTS OF THE EARTH.

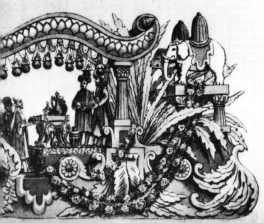

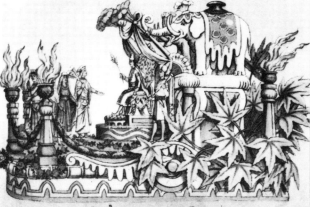

6. THE OFFERINGS OF THE MERCHANT-MEN.

7. THE HOMAGE OF THE HOLY ONES.

8. YASODHARA THE FAIR.

and marble-like, with only the surfaces showing, while ice sculpture reveals greenish depths and interior fires. Sometimes caterers use an ice figure that has been frozen in a mold—a swan or a leaping fish—as the centerpiece for a buffet table. Here the art is really that of the mold maker, and the design is repeated over and over again.

Every child knows how to make the giant snowballs that are the components of an old-fashioned snowman. A fresh fall of wet snow is needed, the kind that comes down in big fluffy flakes when the temperature is very close to the freezing point. This kind of snowfall is most common in the more southerly states; in the North it is the first snows of winter and the last ones of spring that are snowman material. The life of the snowman, accordingly, is usually a short one; he soon falls victim to a thaw.

Winter carnivals in the frozen Northland were that region's answer to Mardi Gras, the ancient tradition of celebration and indulgence before the restrictions of Lent. The date of Mardi Gras is determined by the Christian calendar, based on phases of the moon, and varies from year to year just as the date of Easter does. The early Church wisely endowed popular traditional pagan festivals with Christian significance; the ancient Roman Saturnalia became Mardi Gras.

Mardi Gras, or Carnival, is celebrated in the Catholic countries of Europe and in the southern parts of the United States, where it was introduced by Spanish and French settlers. The New Orleans Mardi Gras dates back to 1827. At first there was individual masking. Then in 1837 the first organized pageant was given, with all the participants masked. The early processions were held by day and were more humorous than magnificent. By the 1880s, the carnival processions were taking place at night, and the increasingly elaborate pageants, with a different theme each year, were the work of secret societies dedicated to providing as grand a spectacle as possible. The Krewe of Proteus, which made its first appearance on the Monday before Mardi Gras in 1882 with "A Dream of Egypt," had as its theme in 1908 "The Light of Asia."

According to an account in the New Orleans *Picayune*, these pageants, which required a complete new set of tableaux and costumes every year, kept a work force constantly employed, each Krewe having its own designers, carpenters, workers in papier-mâché, carvers, gilders, painters, and costumers. This work was carried on in utmost secrecy; even the locations of the shops were said to be secret, as was membership in the societies. From two days of revelry, the carnival had grown to a two-week celebration. By this time streets were strung with incandescent lights, adding to the illumination provided by Nubian torchbearers. The *Picayune* in 1908 noted the ease with which a Southern Negro "can be transformed by the mere addition of a crimson tunic into a servant of the Pharaohs, and a touch of picturesque antiquity links this Southern spectacle to the past."

In 1910 the Zulu King made his first appearance, a comic figure wearing a lard-can crown. By the 1940s he was clad in a royal costume of leopard skin and ermine and had a retinue of richly dressed attendants.

Purim, which commemorates the deliverance of the Jews of Persia in the fifth century B.C. from a plot to destroy them, was originally considered a minor Jewish holiday, but because it comes near carnival time, it has taken on some of the trappings of carnival. On March 14, 1865, a Purim ball was held at the Academy of Music in New York which was reported and illustrated in *Frank Leslie's Illustrated Newspaper*. The Town Gossip columnist of that paper wrote most enthusiastically of a "superb festival of splendor and beauty...at the Academy on Tuesday night." In true carnival spirit, costumes included

"deists, Plymouth brethren, and indeed all the most exclusive sects," Saint Nicholas, and Mary Queen of Scots, as well as someone got up as an oversized *dredel*, a four-sided top with Hebrew characters on each face, such as is spun in a game of chance.

For the rest, there is a succession of days in late winter and early spring, some of which are actual holidays, that are observed by the sending of cards, the purchase of small souvenirs, or the eating of cakes, cookies, and candies decorated in a special way.

The making of Valentines is no longer a widely observed custom. Time was when young men penned verses in their best calligraphy and young ladies assembled confections of colored paper and lace and cutout chromos. Later, Valentine kits could be purchased. They had cards with scenes and verses, which were to be embellished with paper lace, made to stand out from the card by means of folded cardboard hinges; the paper lace in turn was decorated with embossed stickers: bunches of violets or roses, faces of children or angels, doves, little lambs. Today, the complete card is selected in the shop and mailed, and that's that. And there are always candy and flowers.

For Lincoln's and Washington's birthdays there are miniature log cabins and hatchets and cherry trees, or chocolate-dipped cherries, and assorted party favors for those whose birthdays happen to fall during this season. Many of these have come from far-off places such as Germany—or more likely from Japan and Taiwan—and are American only in their design.

St. Patrick's Day follows, with shamrock pins, clay pipes, and emerald flags. Then comes Easter, with a flurry of chocolate bunnies and Easter eggs of all descriptions, including those charming ones that are open at one end with little scenes inside, and those painted on the outside with all the colors of the rainbow. There are molds for making candy bunnies and chicks and eggs. And there are cookie cutters in these popular shapes, and cake pans in the form of bunnies and lambs.

But these are mere symbols, a fantasy far removed from the actualities of the growing season. The sun is rising earlier every day, and the earth is beginning to respond.

SPRING

The earth is plowed and harrowed; the seed is planted. Then the scarecrow is made and placed on guard against the birds. This is done all over the world: in Japan the scarecrows wear the same wide flat straw hats as are worn by the field workers. In fact, in any country the scarecrow will usually be dressed in the farmer's cast-off clothing.

In America nowadays, the scarecrow is apt to be a set of pressed metal-foil pie pans strung on a line over the seeded rows, where they flash in the sun and clatter with every breeze. Old-time scarecrows are still made, though, mostly by small or part-time farmers and kitchen gardeners.

In 1976 a remarkable group of urban scarecrows made their appearance in the inner city of New Haven, Connecticut. That spring Maishe Dickman, a young man trained as an environmental engineer but with no gardening experience, had found himself planning a community garden project with the aid of a federal CETA (Comprehensive Educational and Training Act) grant under the aegis of the New Haven Arts Council. The garden site, a little under an acre of abandoned land now owned by the state, was a mass of rubble before bulldozing, plowing, addition of topsoil, and application of fertilizer. The site was divided into seventy-two garden plots, each 20 by 20 feet. Dr. David Hill, a soil scientist with the Connecticut Agricultural Extension Station and adviser to the project, worked two of these, Maishe Dickman had one, and all the others were planted by area families. These families were mainly black, mainly poverty-level people, and many had come from the rural South, where they had been in touch with the soil and with growing things. The gardens were a great success in many ways: they flourished and produced quantities of vegetables; they were a source of pride and gratification; they brought people into contact with one another.

As for the scarecrows, Maishe Dickman thought ten or so would probably be produced independently, but liking the idea and wanting to encourage it, he organized a scarecrow-building party one Saturday. This resulted in thirty-five to forty splendid scarecrows, each with a personality of its own. There were females as well as males, one carrying a baby scarecrow, and as befitted urban scarecrows, some wore platform shoes. Tina Davis, six years old, did a stylishly abstract figure, while her brother Kevin, aged thirteen, working with Mr. Dickman, created a fine seated scarecrow wearing a sugar-cane cutter's hat. And the entire Hunt family collaborated on the scarecrow for their corn patch.

As the season's abundant crops were being harvested, plans were already taking shape for the following year. In 1977, there were three gardens with a total of over 140 separate plots, with an average size of about 800 square feet, almost all of them being tended by entire families. The scarecrow-building competition was well publicized as a cultural event for the children and their parents, and there were about seventy entries, one of the most spectacular a 7½-foot female figure with an Afro wig and a scarlet dress.

Once again plans were made for many more gardens the following year, and as crops were harvested, visions of fields of scarecrows of all shapes and sizes would keep hopes alive until the following spring's planting and the summer's first crop.

SUMMER

Summer brings an increased tempo on the farm, and even the longest days are not long enough for all that needs to be done. In the cities, there is a slowing down of the pace; work progresses but in a more relaxed way, and everyone agrees that the city is really at its best when there aren't so many people around. Because everyone who possibly can does get away, if only for long weekends or even Sundays at the beach.

At Atlantic City there used to be great piers, amusement parks on stilts jutting out into the sea, the sound of the waves as they rushed through the piles adding to the excitement and the sense of something special. And there were other attractions besides sun and surf bathing. One of the most popular attractions was the sand sculptors at work on the beach.

In 1906, a visitor to Atlantic City out for an early morning stroll on the boardwalk might have seen a sand artist at work on one of his sculptures. With the aid of an assistant, he piled up a mound of sand close to the boardwalk and began modeling a horse's head, while his helper brought pails of sea water to keep the sand in workable condition. Already completed was a large recumbent lion with the shield of the United States, and beside it, an amusing miniature lion. A canvas, ready to receive the coins tossed down by appreciative onlookers, was spread out before the works of art; a small sign, "Remember the Worker," was a reminder that the artist depended on the generosity and appreciation of the gallery.

One of the early sand sculptors, James J. Taylor, wore a dark business suit and derby hat while practicing his art in the early 1900s. Postcard photographs reveal the work of an artist of great ability and sensitivity. "Cast Up by the Sea," the larger-than-life-size figure of a young mother, a faint smile on her face, lightly supporting the body of her infant child, might suggest the repose of sleep rather than death but for the presence of the sea just a few yards distant. The marvelously intricate draperies flow like rivulets from her body. She is a part of the seascape; only her creator seems out of place.

A popular subject in those early days was the automobile, still a novelty to most people. An open touring car with driver and passengers dressed in motoring fashions of the period was made of sand with the addition of such props as wheels, fenders, and steering wheel. Bas-reliefs, on the other hand, were made entirely of sand. They had a spontaneity lacking in later works, as though they were a part of the beach, almost as if shaped by the winds and tides—and it was these same forces that were their undoing. They might be covered against drenching, eroding rains; cracks might be repaired; but the high tides and winds of a northeast storm could devastate

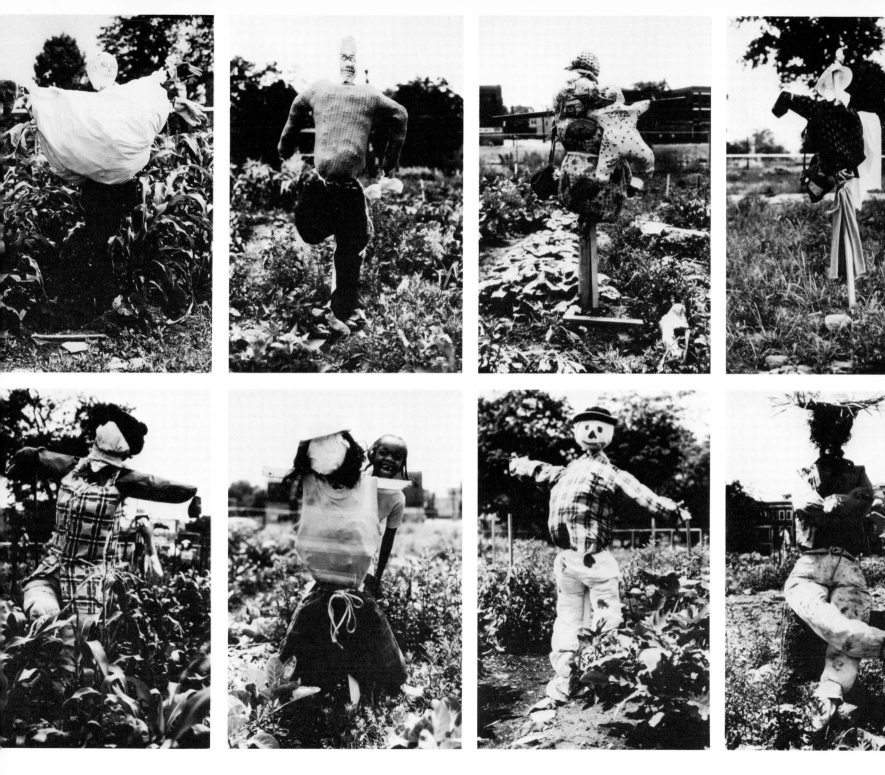

them. At best this was art for a season.

Philip McCord is considered to have been the first Atlantic City sand artist; he is known to have worked on the beach as early as 1897. In that same year, Dominick Spagnola, who became one of the best-known practitioners of the art, was born in Calabria, Italy; he was brought to this country by his family when he was four years old. The Spagnolas settled first in Chicago, but soon moved to Atlantic City, where Dominick watched the sand sculptors at work. One of them, he remembers, was James J. Taylor; he also recalls two one-armed men, one of them black, who worked on the beach when he was a boy.

Dominick began creating images in sand at an age when other children were still building sand castles. His first location was just off the boardwalk at Park Place, but he soon moved to a spot at Arkansas Avenue next to the Million Dollar Pier, where he was to remain until the hurricane of 1944, which destroyed the beach. There was one interruption—army service in World War I. He was discharged in 1919 and went back to sand sculpture, making it his life's work.

In time he evolved two types of sand art: quick sketches of passers-by, sand graffiti drawn with a stick, all line on a flat surface; and big elaborate showpieces that might take anywhere from a few days to two or three months to complete. These were often a combination of bas-relief and sculpture in the round, and subjects might be topical: a World War I battle, the first solo flight across the Atlantic, or a local event, particularly one of the conventions that were always taking place at Atlantic City. Frequently color was applied to the finished art.

Tony and Frank, two of Dominick's brothers, worked with him from time to time. Tony would clean up the area early each morning and carry water, helping to bank and pack the sand, which had to be constantly wetted down while the work was in progress. Frank helped with the sculpture. After wetting the sand to just the right degree of firmness and packing it very hard, they would sketch the outline of the subject, then build it up in relief. "Using our hands and a pointed stick, we would fashion the sculpture, and finish off the very fine

details with a nail file. Smooth areas would be worked with a paint brush, and always we would use sea water to make it firm," Dominick said in an interview with Jack E. Boucher for an article appearing in the 1965 yearbook of the Atlantic County Historical Society. An embankment as much as 20 feet in length would be constructed; the side facing the boardwalk would present a plane surface at an angle of perhaps 45 degrees to the horizontal. This would be divided by a wooden framework into a series of panels presenting a variety of subjects.

Among the outstanding sand sculptures made by Dominick Spagnola was a group dedicated to Captain John L. Young, owner of Young's Million Dollar Pier. Spagnola sculptured a fisherman hauling in his catch, and medallion busts of Captain Young and his son, John Jr. (Young, who lived in a house on the pier with the address No. 1 Atlantic Ocean, featured two daily net hauls of fish as a pier attraction.)

While not an original composition, Spagnola's "The Slave Merchant," done from a lithograph of the academic painting by Victor Giraud, was a technical *tour de force*. He undoubtedly had great ability. On a good day he would take in from $100 to $200, considerably more than many sculptors working in more permanent media might have earned in those days, but in the end he had nothing to show for it but a few postcards and snapshots.

Many people thought that the sculpture was done in concrete. In later years Spagnola confessed that the finished art was reinforced with a light solution of cement in water, but he insisted that the sculptures were done entirely in sand. They were not as ephemeral as the sand castles by the water's edge, which crumbled and washed away with the next high tide, but even if they survived a season's storms, they were destined to be pulled down and replaced with something new. And if his works had been made of solid concrete, they could not have endured the hurricane of September 14, 1944, when in a few short hours the seas swept away miles of boardwalk, a great pier, and countless tons of sand from the beach. An era had come to an end. In later years Dominick Spagnola earned a living of sorts by painting

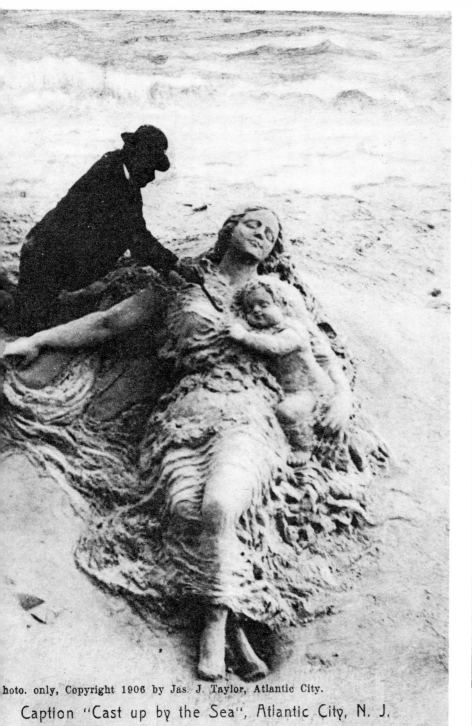

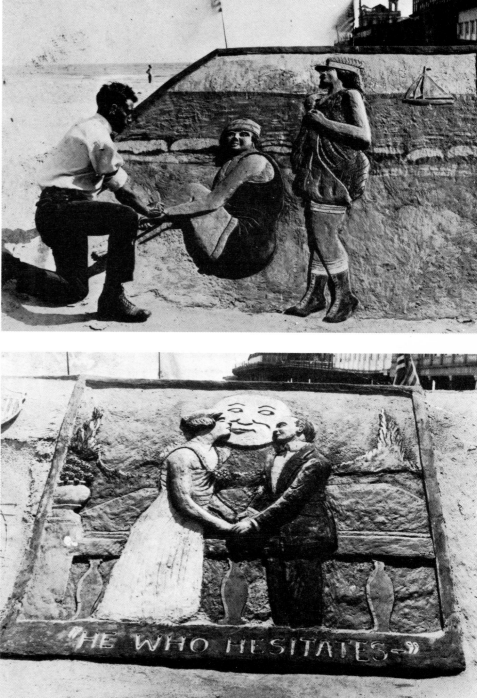

hoto. only, Copyright 1906 by Jas. J. Taylor, Atlantic City.

Caption "Cast up by the Sea", Atlantic City, N. J.

"HE WHO HESITATES—"

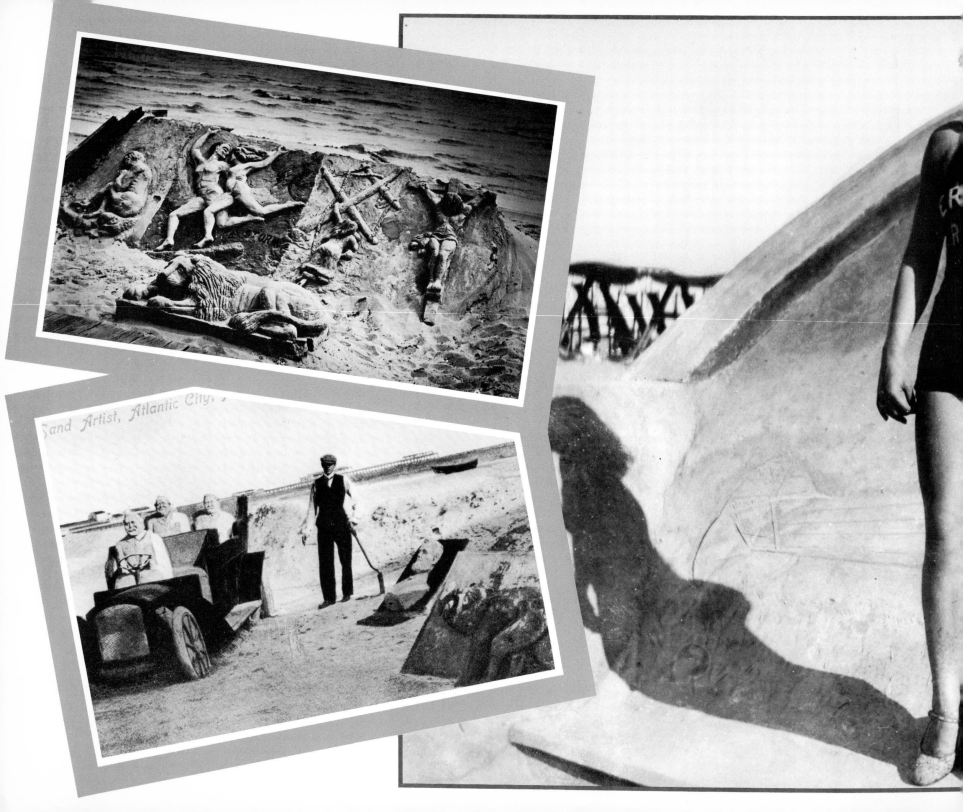

Sand Artist, Atlantic City,

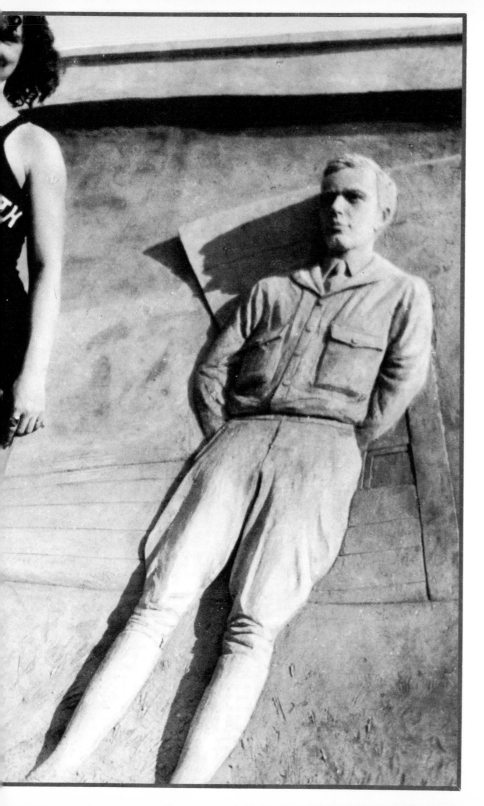

signs; he had a small shop on East Kansas Avenue until at last illness forced him to give it up. Spagnola died on April 2, 1977.

In the old days there were sand artists on the beach at Coney Island too. Among these was Marcus Charles Illions, the carver of flamboyant steeds for carousels. On his days off or on hot days, his shop being only a block from the beach and the Coney waves, he would dash into the surf. Then, instead of resting on the sand, he would by habit start doing sand sculpture. There were other sculptors too, but the beach was usually too crowded to allow space for sculpture instead of people.

Not too far from the beach, however, there were vacant sand lots that would permit the making of sand sculpture. A sculptor called Truax made sand figures there during World War II; for the war bond drive his central feature was a pair of American flags forming a V for Victory symbol with the legend "Buy War Bonds." But sand art never had a very big place in the beach scene at Coney Island. Perhaps the crowds who came to the seashore by subway were less inclined to part with their coins than the free-spending conventioneers of Atlantic City.

Wherever there was sand, there were inspired sculptors and artists. One hardly thinks of the beaches of the Great Lakes as likely places for sand sculpture, but the shores of Lake Erie at Sandusky, Ohio's amusement area at Cedar Point, did attract the sand artists. In 1890 one such artist, who has yet to be identified, was greatly impressed by Auguste Rodin's *Thinker* and Pierre-Auguste Cot's famous painting *The Storm*, both of which he re-created in sand. These were captured on film by an anonymous photographer, along with "The Shipwreck," "The Crucifixion," and the "Lion of Lucerne," all sculptured by that same artist.

The disappearance of formal sand sculptures from the beaches is mainly due to the greatly increased use of the beach by vacationers, who in earlier years had spent more of their time strolling on the boardwalk. Nowadays sand art is an amateur activity, encouraged by occasional contests at Margate and on Long Beach Island, both on the Jersey shore. The medium is always available, is easy to work with, and is free to all who visit the seashore and would like to try their hand with sand.

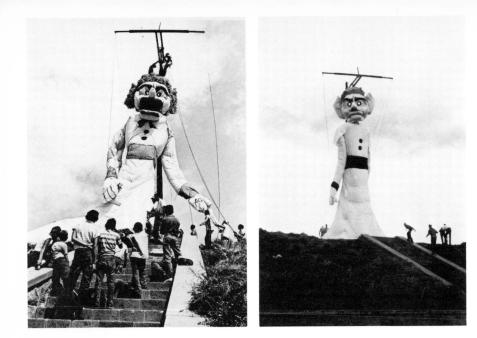

Zozobra

Santa Fe, the capital of New Mexico, is an ancient city, as cities go on this continent. The Pueblo Indians were the earliest settlers in the area. In 1609 the Spanish came: they were driven out by the Indians in the year 1680, but were able to return without bloodshed twelve years later, on September 14, 1692. In 1712 the day was declared a holiday, and the Fiesta de Santa Fe has been celebrated ever since, though in recent times the date has been moved to Labor Day weekend, the opening festivities taking place on the Friday night before. By the first quarter of this century, the fiesta had come to mean a rather dull historical pageant, and it was, curiously enough, a newcomer to Santa Fe, Will Shuster, who with his artist friends and with Dana Johnson, editor of the *New Mexican*, undertook to liven things up, first with a street dance and a comic parade and then with the brilliant inspiration of building an effigy of gloom and burning it, so that joy could reign at the carnival and throughout the following months. A possible source of inspiration was the Mexican Judas effigies, figures filled with fireworks which are suspended from branches of trees and burned during Holy Week.

The first Santa Fe Fiesta gloom figure, 18 feet tall, was built for the fiesta of 1926 and burned on a vacant lot near the fire station, with a few curious onlookers in attendance. By the following year the giant figure of gloom, in his second incarnation, had been given the Span-

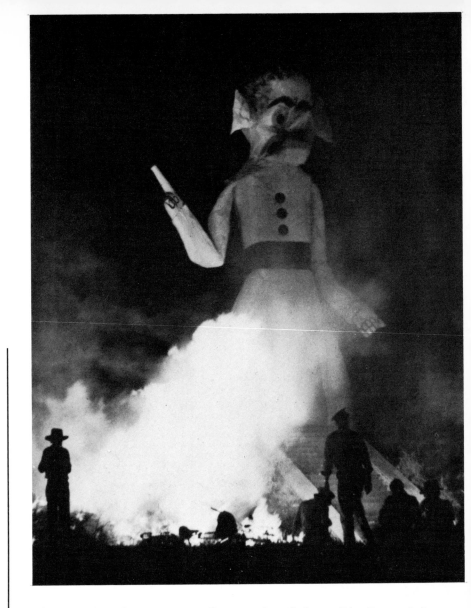

ish name Zozobra, meaning "anxiety" or "gloom," by Dana Johnson. The locale of the burning was moved to the hilltop in Fort Marcy Park, where there was ample room for throngs of spectators to view the proceedings.

Will Shuster, the creator of the gloom figures, was a young painter who had come to Santa Fe from the East in search of health. Born in Philadelphia in 1893, he served in World War I, saw action in France, and was gassed, his lungs being permanently damaged as a result. Back in Philadelphia, he resumed his interrupted art studies,

Opposite page, left to right
Zozobra, symbolic figure represent-
ing Gloom or Worry, is ritually
burned each year on the eve of the
Santa Fe Fiesta in New Mexico.

Zozobra 1954 in place atop hill in
Santa Fe's Fort Marcy Park.

Flames begin to mount around
Zozobra: it is the end of Gloom, and
people celebrate.

1959 model Zozobra being hoisted
into position by special machinery
to a height of 40' h.

This page, below Harvest figure
with pumpkin head, New Haven,
Vt., 1976.

but then on his doctor's advice moved to New Mexico in 1920. There in Santa Fe he became one of a group of young artists called Los Cincos Pintores (The Five Painters): in his work and in his being he became completely identified with the Southwest, his adopted home. In the desert climate he did regain health; the annual destruction of the figure of gloom must have had special meaning for him. At any rate, he dedicated a part of each year, for most of the remaining forty-three years of his life, to the creation of the Zozobra figure and to directing the ceremonies leading to its demise.

Every year, about a month in advance of the holiday, Shuster, assisted by friends, would set to work on a new, improved version of Old Man Gloom, incorporating what he had learned in previous years. Originally inert, tied to a stake where it submitted to its fiery fate without a whimper, Zozobra has developed into a giant puppet constructed of wood and chicken wire with shredded paper stuffing. The lower jaw is hinged, and the mouth and eyes are moved by ropes attached to pulleys, as are the arms. Gigantic ears stand out like sails on either side of the head, an enormous misshapen nose juts out from the face, and the eyes are round and black. Shredded paper tops off the head. Nowadays, color is added with a spray gun. The figure is always clad in a white muslin garment, clerical in appearance, with a wide black belt or sash, two or three large black buttons, and sometimes a black bow tie. The monster steadily increased in size—with the exception of the war years, when materials had to be conserved—until it topped off at a height of about 40 feet, a size imposed by its weight, by now about 1,500 pounds, and by the limitations of the work area, particularly the measurements of the door through which the head had to pass.

Shuster had built a 1-inch-scale working model to assist him, but before he could finally retire from active work in 1963, he had to draw up a complete set of plans, with all the dimensions, and a notebook full of working drawings. The Santa Fe Kiwanis Club, some of whose members had been helping Shuster all along, took over the responsibility for building the figure and directing the entire show, but he continued to act as adviser for several years more until illness

finally brought a halt to all activity. (Shuster died in February 1969.) The Zozobra personality had slowly evolved over the years, along with his size, but now his character has become more or less fixed, pinned down by diagrams and charts.

Every year on the Friday before Labor Day, the ceremony begins about dusk, by which time a huge crowd will have assembled. Zozobra's attendants, attired in white sheets, gather around to pay him homage. A gong is struck slowly, twelve times, and the figure's arms begin to move, his eyes to roll. A troop of boy scouts arrive on the scene, bearing torches with which they set fire to the piles of tumbleweeds around the base of the figure, causing Gloom's supporters to rush off into the crowd. The monstrous creature flaps his arms wildly and he utters terrifying cries and howls, his enormous mouth opening and closing, his eyes rolling frantically.

A fire spirit dressed in red springs forth from the flames, or so it seems, and begins dancing up and down the steps before Zozobra, finally seizing two torches and hurling them at the monster. Batteries of Roman candles and rockets go off overhead, and the entire figure is engulfed in flames. With the demise of Gloom all cares are gone, and the people of Santa Fe and their guests are free to enjoy the fiesta to the full.

In 1976 the height of Gloom was increased to 50 feet in honor of his fiftieth anniversary. By this time the ceremony of the destruction of Zozobra had become an inextricable part of the Fiesta of Santa Fe, now well into its third century.

HARVEST FESTIVALS

We happened to meet some country people celebrating their harvest-home: their last load of corn they crown with flowers, having besides, an image richly dressed, by which they perhaps signify Ceres. . . .
— Sixteenth-century account by a visitor to England, reported in Joseph Strutt, Sports and Pastimes of the People of England (1801)

Of all the seasonal celebrations, that of the harvest is perhaps

THE SEASONS

closest in spirit to the most ancient festivals. Unless there is a crop failure due to drought or other natural disasters, there is generally an abundance, which sets the mood for celebration. The finest specimens of vegetables—the biggest, the most perfect—are set aside for the county fair, where they are judged against others perhaps even more splendid. The design of these exhibits is a special art. Later in the season pumpkins, winter squash, and ears of corn are arranged on farmhouse porches. In the Northeast, harvest figures are made, rather resembling scarecrows but plumper and much jollier, their bodies formed of old clothes stuffed with dried leaves and corn husks and their heads made of pumpkins—close kin to the jack-o'-lanterns that appear all over the country on Halloween.

At Mitchell, South Dakota, the corn harvest is celebrated, as it has been for the past eighty-four years, by decorating with ears of corn a building known as the Corn Palace. But the idea of celebrating the harvest on such a scale originated in Sioux City, Iowa. The year 1887 was a year of drought throughout most of the United States, but there was sufficient rainfall in the middle part of the Missouri Valley to result in a record yield of corn in northwest Iowa. Sioux City, in the midst of those bountiful cornfields, was a young city whose population had increased fourfold in the past seven years. Bursting with pride and ambition, the city's business leaders met to discuss ways of celebrating this abundance. Their solution—to build a palace of corn and to do it in a few short weeks—was typical of these irrepressibly energetic people. The idea was seized upon with the greatest enthusiasm; it would seem that every Sioux Citian, as well as every farmer in the surrounding area, was eager to take part.

"Corn Is King" became the slogan; everyone was thinking corn: corn as an art form, corn as a subject for poetry and song. Feature writers looked into the origins of harvest festivals and wrote numerous stories on the subject.

A Sioux City architect, E. W. Loft, was given the job of drawing up plans for the palace. The preliminary sketches were for a palace of modest dimensions, at the corner of Jackson and Fifth streets, but the area was doubled and then extended again to 18,500 square feet.

The basic structure was of wood, in a Moorish Revival—or perhaps Neo-Byzantine—style: a central tower 100 feet high with a cupola, and smaller corner towers and minarets and windows that were definitely Moorish in shape. The roof was thatched with cornstalks, and every inch of the exterior was covered with corn and other grains in a rich variety of patterns, colors, and textures.

After the outside of the building was completed, the women of Sioux City were handed the task of decorating the interior. Calling themselves the Ladies' Decorative Association, they set to work with abundant natural materials and created murals, a large map of the United States (each state in a different color of grain), and a figure of Ceres standing at the top of a stairway made of golden corn.

The rest of the city received its share of decoration: the main streets had great illuminated arches, each with 250 gas jets in colored glass globes. Shopwindows had harvest scenes, storefronts were decorated with corn and pumpkins. The stupendous job of transforming the entire city into a celebration of corn was accomplished in time for the official opening of the Corn Palace Festival on October 3, just six weeks from the day when the idea was first conceived. The weather was fine, and there were throngs of visitors enjoying the daily parades, speeches, concerts, dances, and fireworks. Omaha, Winnebago, and Sioux Indians paraded in their native costumes. The festival lasted an entire week. It drew visitors from far and wide, including such prominent Eastern capitalists as Cornelius Vanderbilt and Chancey Depew of the New York Central Railroad. President and Mrs. Grover Cleveland, touring the West by special train, made a detour to visit the palace the day after the official closing, and seemed much impressed by what they saw.

The second Corn Palace the following year was bigger and also better designed, though lacking some of the fantastic quality of the previous year. John Ely Briggs wrote in *The Palimpsest*, October 1922, "The booths around the walls were the units of decoration.... Supporting pillars transformed with white corn into graceful columns of marble carried the eye upward...to a belt of inverted wheat sheaves at the base of the dome-like roof." The corn used for decora-

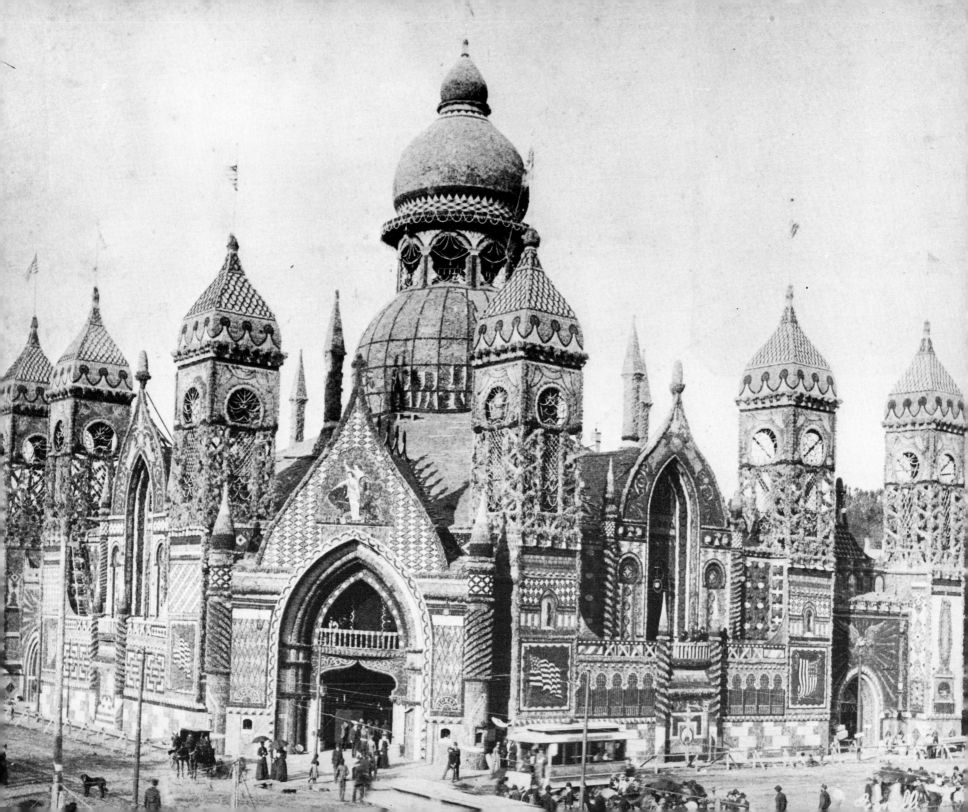

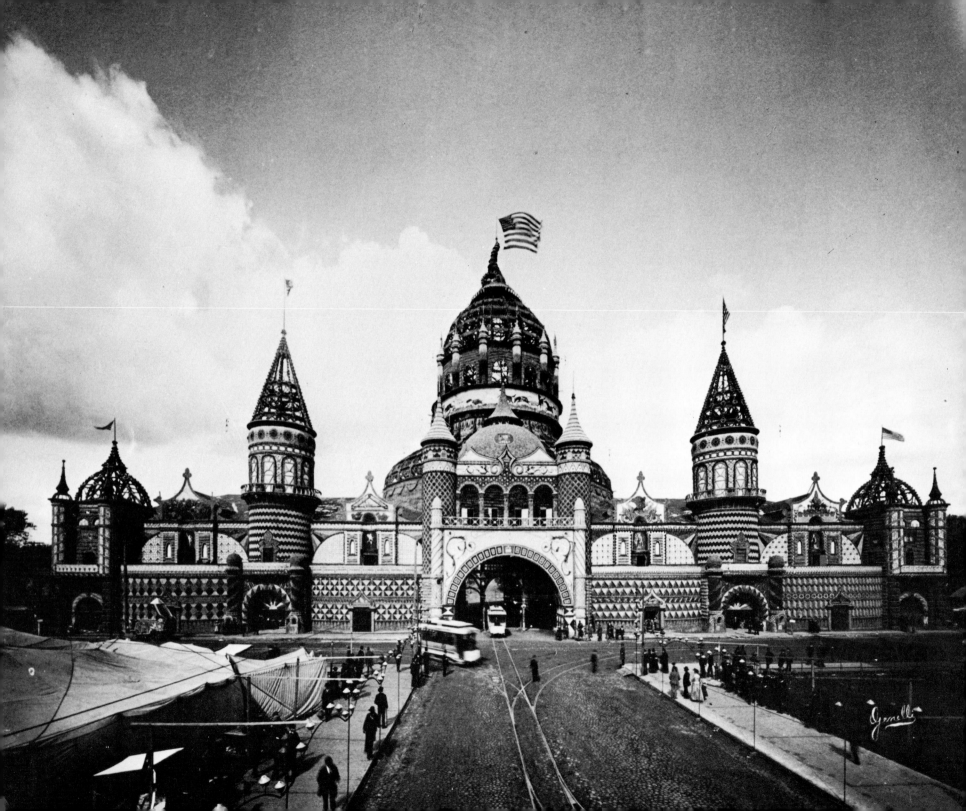

Left The fifth and last Sioux City Corn Palace, 1891, built over one of the main streets, with archway for traffic to pass under.

tion was of many colors; the ears were sawed in half lengthwise and then cut again; the pieces were nailed to the walls to make a rich variety of patterns. Attendance at this festival was more than double that of the previous year.

To make the third Corn Palace Festival an even more rousing success, a Corn Palace train, decorated with ears of corn and carrying 135 local boosters, made a tour of the East. Its stop in Washington, D.C., coincided with the inauguration of President Benjamin Harrison, who came aboard later to inspect the train. The *New York Times* of March 8, 1889, took note of the decorations: "The whole train is a marvel of beauty," the corn "blended and arranged so as to form magnificent specimens of rustic art."

The third Corn Palace had a 200-foot tower, higher than any of the surrounding church steeples. The interior designs, on which 269 women had worked, were said to surpass any previous efforts. The palace was opened on September 23. A bicycle tournament was held. As in other festivals, hundreds of Indians came in and paraded daily. The Blue Grass League from southwestern Iowa came in a train decorated with bluegrass.

The Corn Palace Festival had already become an established tradition. There seemed every reason to believe that it would continue, year after year, always bigger and better, incorporating the latest technical developments along the way. The closing of the fourth festival in 1890 was marred by a torrential rainstorm, but there was no question but that there would be another one the next year. In 1891 the fifth and, as it turned out, the last Corn Palace was erected, covering an entire city block, large enough to contain an auditorium in the east wing and an agricultural exhibit area in the west wing; in the center a huge archway over one of the city's main thoroughfares permitted traffic to move through. The designs decorating the walls, both inside and out, were most elaborate, as were the booths and displays.

Plans were being made for the sixth festival when Sioux City was hit by a catastrophic flood in the spring of 1892, and the festival was postponed to the following year. But there was never to be another Sioux City Corn Palace. In May 1893, a financial panic swept the entire country. The dream of constant growth, of things always becoming better and better, turned out to be—a dream.

The people who had so recently come as pioneers, who had known hardship and want, had suddenly found themselves with an overabundance, and they had expressed their gratitude in an extraordinary way. They were a young population with boundless energies and with a vision of ever-increasing prosperity. The flood and then the panic were sobering, maturing experiences; Sioux City would never again feel quite the same heady excitement.

The initial success of the Sioux City corn palaces had inspired a Blue Grass Palace, advertising southwestern Iowa to the world in 1889. It was successful enough so that a second, much larger one was undertaken the following year on the Creston fairgrounds facing the racetrack, as part of the annual state fair. The eighteen counties of the Blue Grass League took part, with displays including a life-size Newfoundland dog and a horse made of bluegrass, a sheep of oat and wheat heads, a straw man in a sleigh driving a corn horse. The building itself was covered with bluegrass, timothy, and other grasses. Displays of butter, cheese, all sorts of vegetables, fruits, and grains were attractively arranged. Livestock was exhibited, and there was horse racing. The Blue Grass Palace flourished for two more years, and then was no more.

Finally, it should be mentioned that there was a Coal Palace at Ottumwa. Built in 1890, and understandably lacking the charm of some of the other palaces, it had a unique feature: a miniature mine beneath the palace. A mule-drawn train of pit cars took the visitors through the corridors, where "rich veins of coal were visible, and several miners were at work with pick and drill," according to Carl Kreiner, writing in 1922. The building was redecorated the following year, but enthusiasm had waned. The Coal Palace too was torn down, and thus ended the palace-building era in late-nineteenth-century Iowa.

In 1892, the year that Sioux City was ravaged by floods, a group of young men in Mitchell, South Dakota, seized the initiative and built

the first Mitchell Corn Palace, which was frankly patterned after the Sioux City ventures. It was the site of Mitchell's first Corn Belt Exposition, planned to display the farm products of the state. Bristling with turrets, patterned in diagonal stripings and diamond and checkerboard effects, all worked in corn, grains, and grasses, it was a modest-sized structure, just 66 by 100 feet, in keeping with the size of the town itself, which then had 3,000 inhabitants. For the second exposition, the size of the palace was increased by two-thirds. In the years between 1894 and 1899 there was no celebration, because of the same depression that brought the Sioux City festivals to a halt.

Mitchell put on a festival in 1900, skipped 1901, then planned an all-out effort in 1902. The palace was remodeled and enlarged. A Colonel Rohe, who had had a part in decorating the Sioux City palaces, was engaged for this work, while the local women took over the decoration of the interior. In 1905 a new and larger building was erected; by then the Mitchell Corn Palace gave promise of becoming a permanent institution. The all-over geometric designs that had originally decorated the Corn Palace were gradually replaced by pictorial panels, still carried out in corn and grains.

The present building, actually the Mitchell Auditorium, dates from 1921. It is constructed of brick with wooden panels affixed, and like its predecessors is an Arabian Nights fantasy of domes and minarets. Every year it is redecorated with new designs by the people of Mitchell. From 1948 through 1971, the panels were designed by Oscar Howe, a Sioux Indian who overcame incredible handicaps to become a renowned artist and teacher. His panels often depicted his people and their culture; ecology was a frequent theme.

Decorative materials for the Corn Palace are restricted to the native corns, grains, and grasses of South Dakota, quantities of which are specially grown for the occasion. The artist develops the design and lays it out full-scale on roofing paper, which is then tacked to the panel. The trim around the panels, made of grasses and grains, is completed before the ears of corn, sawed in half lengthwise, are nailed in place. In order that the corn colors—red, brown, white, and blue, as well as many shades of yellow—should be as bright and fresh as possible, the work is completed only two or three days before the festival begins in late September. There is a full week of celebration; a gigantic carnival with rides and concessions surrounds the palace.

Formerly a bonanza for pigeons and squirrels once the crowds were gone, nowadays the grains are treated with a repellant and preservative to give them longer life. Even so, this too is art for a season.

CHRISTMAS AND THE WINTER SOLSTICE

A foreign student, remarking on the excesses of the American Christmas celebration, observed that we even have a special holiday a month ahead of Christmas to start off that frantic period of gift buying. He meant, of course, the day thousands of New Yorkers line the curbs of the parade route and millions across the land watch the Macy's Thanksgiving Day Parade on their television sets, and the day after, when shoppers converge on the stores to begin what is sometimes considered the most dreaded of all tasks: Christmas shopping.

It was not always so. The Sunday following Thanksgiving is the first Sunday of Advent on church calendars, and this was the time to begin preparations for Christmas, but of a quite different sort: the baking of Christmas foods, the cleaning and then the decorating of the house with evergreen boughs. Gifts, yes, but most often these were homemade, with a special person in mind. And at last, on the special eve, lighted candles were placed in the windows of the houses to light the Christ Child on his way. The beauty of this custom has been diminished as gaudy colored electric lights, often flashing on and off, have taken the place of candles.

In New Mexico, Christmas eve is still celebrated with the lovely custom of lighting farolitos and luminarias. The luminarias were once shepherds' bonfires, such as might have been used long ago by the shepherds in the Holy Land. In Spain the fires even predate the first Christmas, for in pre-Christian times the pagan peoples of Europe built huge bonfires on hills and mountaintops at the time of the winter

solstice. Today the luminarias, "little fires," made of piñon wood built up criss-cross on the ground, continue to be a tradition in the rural areas of New Mexico. The farolito is a lantern made of a paper bag partly filled with sand in which a candle is embedded. It shines with a soft warm light and is used by the thousands to outline adobe rooftops, garden walls and driveways, church walls and roofs, and the roofs of public buildings. Farolitos evolved, strangely enough, from the Chinese lanterns that came into use in the Philippines on festive occasions. The custom was brought to Mexico and then made its way northward. But the Chinese lanterns were costly when used in large numbers, and fragile too, and so the custom came about of making lanterns from plain paper bags, which add their glow to Christmas in Santa Fe.

Christmas is the time, too, when the Indians celebrate the winter solstice with chants and dances. In some of the pueblos it is possible to attend a midnight mass and then the Indian ceremony immediately after, just outside the church: the two cultures have blended.

Another celebration that coincides more or less with the solstice is Hanukkah, the Jewish Festival of Lights, or the Feast of the Maccabees. The lighting of the menorah, the candelabrum with nine branches for nine candles, takes place at sundown, one additional candle lighted each night of the festival. Unfortunately Hanukkah, like Christmas, has been overly brightened by electric lights and the fringe commercial aspects.

And now we come to the biggest and brightest—as well as the noisiest—of the demonstrations, fit for all seasons and celebrations, beginning and ending of all the festivals: the fireworks.

FIREWORKS

It is a generally accepted fact that gunpowder originated in Asia, probably in China; made into firecrackers and rockets, it was used there in celebrations, not warfare. It is said to have been a European—a Franciscan monk in Freiburg, Germany, in the fourteenth century—who adapt-

ed the invention to weaponry. After two hundred years or so, firearms made the journey back to the Orient.

In Europe, fireworks were used first as stage effects, then on their own at coronations, royal marriages, and state visits. When Anne Boleyn was conveyed by water from Greenwich to London for her coronation, her barge was accompanied by a galley in which there was "a great red dragon, continually moving and casting forth wildfire." Displays of fireworks diverted Queen Elizabeth when she visited Kenilworth Castle in 1575. Louis XV of France was another pyrotechnics enthusiast, and the formal gardens and parks of that period made glorious settings for the displays. Also in the eighteenth century, commercial manufacturers, notably the Brock and Mortram families in England, began to bring fireworks to the people, in public amusement parks in their own country and continental Europe.

Fireworks were exported from England to America while the United States were still colonies. They were a part of the first Independence Day celebration, on July 4, 1777, and quickly became one of the principal features of the Glorious Fourth. (Independence meant self-sufficiency in the production of this commodity as well as others.) It is not recorded who furnished the fireworks for the great celebration of the opening of the Erie Canal in New York on October 26, 1825, but it was probably an American firm. At the celebration that took place in front of New York's city hall on July 5, 1858, the fireworks were manufactured by Messrs. J. G. and I. Edge, a local company. "The grand finale was the 'Triumph of America,' a piece of the most gorgeous and elaborate character, which fully deserved the rapturous applause which it elicited," reported a journal of the period.

There are, basically, three kinds of fireworks: the hand-held varieties, such as Roman candles, flowerpots, and sparklers; the exhibition pieces, rocket types that shoot high in the air and then release showers of brilliant stars; and finally the set pieces, which are displayed at public exhibitions, often accompanied by music.

The Ives, Blakeslee and Williams Company of Bridgeport, Connecticut, in their 1893 catalogue, offered "fireworks for private and public display" along with iron, wood, and mechanical toys, cap pistols,

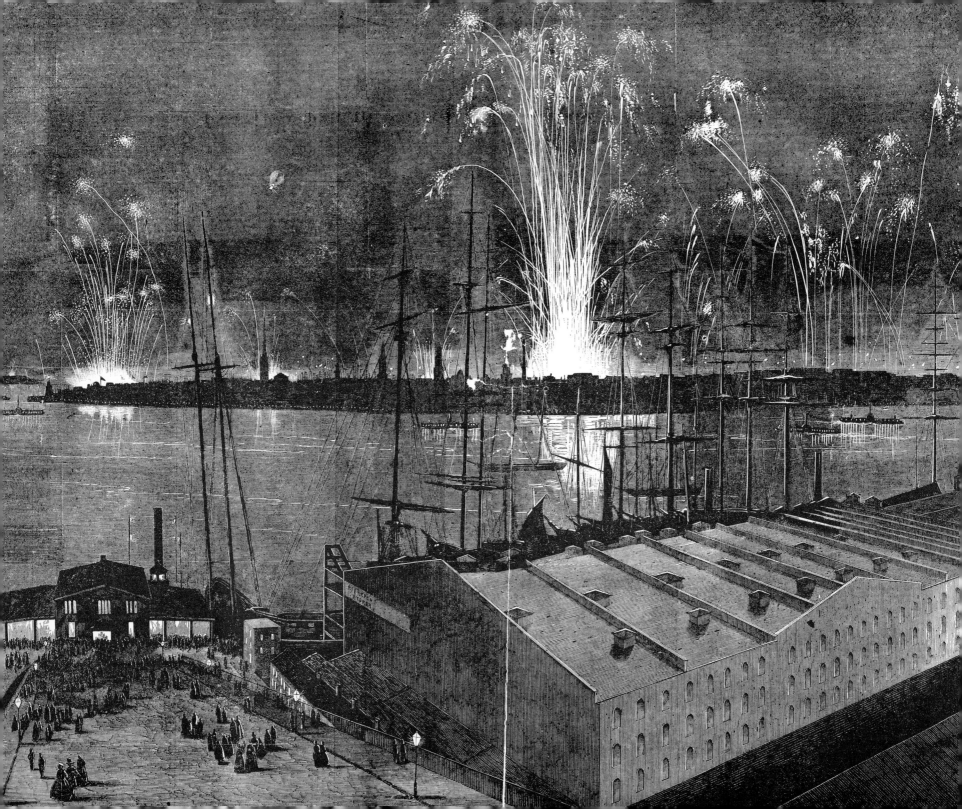

bombshells, and magic lanterns. Roman candles, containing assorted colored stars could be "safely fired from the hand." Flowerpots, also hand-held and "adapted for Ladies and Children," threw out brilliant flowers of variegated fire-drops. There were also "Tri-colored Union Candles," discharging red, white, and blue stars, and meteor candles, shooting stars that as they ascended left a trail of "brilliant scintillating Golden Fire." Larger skyrockets were set up on sticks, pointing skyward; pinwheels or Saxons were affixed to posts or trees; volcanoes and Vesuvius fountains, known to the trade as "gerbes," were set on the ground, where they gave forth showers of gold and silver sparks. Water fireworks were made to be used on lakes or streams or at the seashore ("CAUTION: after lighting, row away rapidly").

All of these small, inexpensive fireworks were sold retail for individual or family use. Generally the father or oldest brother would take charge of firing the larger pieces, while the children gyrated on lawn or sidewalk, making brilliant patterns of light with their sparklers, and older members of the family sat on the veranda or stoop watching the show. This annual celebration was deemed one of the inalienable rights of all good Americans; there was no nonsense about a "safe and sane Fourth" back in those days. The element of risk to life and limb simply added to the excitement of the occasion; to flirt with danger was an expression of patriotism. Even young children were allowed firecrackers—or got hold of them, anyway. There was never a Glorious Fourth without a casualty list. Although safety laws were proposed as far back as 1865, the first fireworks legislation was not passed until July 1908, in Cleveland, Ohio. The Cleveland law, more sweeping than many more recent ones, forbade the sale or possession of "any toy pistol, squib, rocket, cracker, Roman candle, or fire balloon or other . . . fireworks." The Cleveland Board of Public Service was authorized to give pyrotechnic displays when so directed by the Council. In 1929, the State of Michigan prohibited the use of fireworks by the general public. Today there is some sort of restrictive legislation in almost every part of the country.

The great public exhibitions, governed by fairly strict safety codes, were something quite different. These spectacles, growing in popularity as the nineteenth century progressed, were a feature at resorts, fairs, carnivals, and particularly celebrations marking important events, victories, and anniversaries.

For the Brocks and the Mortrams, the two pyrotechnist families who still dominated their field in England, America represented territory to be conquered, and they launched a pyrotechnic invasion of the New World, with James C. Pain representing the Mortram family interest and a seventh-generation Brock, Charles T., seeking advantage for his family's firm. The Brocks, who wisely left the Fourth of July business to American companies, were putting on displays of fireworks for important historical events in this country as early as 1858. In August of that year, Cyrus W. Field completed the first Atlantic cable, enabling Queen Victoria and President James Buchanan to exchange messages. In early September there was a grand show of fireworks staged by Brock, with the words "All Honor to Cyrus W. Field" prominently featured.

Charles T. Brock signed a contract for four displays at the Philadelphia Centennial Exposition, which were "on a scale never before approached in the Western Hemisphere." They attracted more than a quarter of a million spectators, and according to *Frank Leslie's Illustrated Newspaper,* "far surpassed anything of the kind seen in this country." Encouraged by this success, Brock built a factory at Sheepshead Bay near Coney Island in 1879, with the intention of establishing an entertainment resort along the lines of an English pleasure garden, where fireworks would be the main attraction. However, the project failed.

James C. Pain had already gained a foothold in America with a factory at Parkville, Long Island, now a part of Brooklyn. In the summer of 1878 he launched his first season at Manhattan Beach, inaugurating a series of pyrotechnic extravaganzas that would continue in popularity until the 1920s. An amphitheater, seating up to 10,000 spectators, sloped down to a lagoon, on the other side of which was a stage with the sets outlined in fireworks. The stage action, such as it was, was designed to lead up to an awesomely fiery climax: the eruption of Vesuvius, inundating Pompeii with mol-

ten lava, or the burning of Moscow or Sebastopol, accompanied by a large chorus singing the Russian national anthem of Czarist days. Similar entertainments were produced in Atlantic City, St. Louis, Louisville, Kentucky, and St. George, Staten Island.

It was Pain who got the contract for the Chicago World's Fair in 1892; Brock had to settle for the New York Columbian celebration. On October 10, 1892, a Niagara of fire was set off, reaching the entire length of the Brooklyn Bridge and pouring down to the river below. A display by Consolidated Fireworks of America was given the following evening.

For the resorts, amusement parks, and municipalities that wanted to run their own fireworks shows, there was a wide choice of subjects; special designs could be made to order by several manufacturers. "Niagara Falls" was usually kept in stock. In 1899 it could be bought for $6 the running foot, 10 feet being the minimum amount one could buy. "The Capitol at Washington," on a frame 85 feet wide by 45 feet high, was ordered on occasion by the government. When set ablaze, these pieces spread out, producing an effect three to twelve times their original size; some would burn as long as ten minutes.

To make any sort of design, strips of wood were nailed together for the framework, then lances—cardboard tubes of explosive compound about the size of a cigarette—were laid out to form the design and secured to the frame, with a continuous fuse running through them. The whole piece was then dressed up in gaily colored tissue paper. The giant display pieces were made up in sections, to be assembled at the site.

The golden age of fireworks, which began with the Centennial and continued up to America's entry into World War I, was a time of super-patriotism, of flag-waving, of boundless confidence in the American destiny. On the last Fourth of July of the nineteenth century, the people of the United States gave literal meaning to the expression "money to burn" by ordering $1 million worth of fireworks, twice the usual average spent at that time. The coincidence of the century's

turn with the victories in Cuba and the Philippines brought about such a mood of jubilation that orders poured in.

Several "fireworks farms" were located on Staten Island, New York, a prerequisite for the manufacture of fireworks being ample space between the buildings where the various processes were carried out, as well as a broad safety zone surrounding the whole operation. The Unexcelled Fireworks Company, founded in East New York in 1874, moved three years later to Graniteville on Staten Island and changed its name to Consolidated Fireworks Company of America; in 1911, it changed back to "Unexcelled." Pain's also moved their operation to Staten Island, at Dongan Hills. It was said that well over 60 percent of the fireworks displayed during the turn-of-the-century celebrations originated on these farms.

Each succeeding year brought with it occasions for fireworks: the Pan-American Exposition in Buffalo in 1901; the inauguration of Theodore Roosevelt and the Louisiana Purchase Exposition, both in 1905. The Hudson-Fulton Exposition in 1909 inspired some of the grandest displays, not only in New York but all along the Hudson River. In 1917 and 1918, Pain was manufacturing pyrotechnic signals for the War Department, and at the war's end, Pain's fireworks were a part of the celebration. There were several more years at Manhattan Beach, but audiences were dwindling, and the pyrotechnic drama became a thing of the past.

But fireworks, on their own without need of dramatic props, continue in popularity, at the end of a big day and evening at the fair or the amusement park. The rockets go streaking into the sky and burst into incredible blossoms of many-colored fire, hanging there for breathless moments before falling earthward in a shower of stars.

Fireworks are the most ephemeral of the visual arts. Like a musical performance, dance, or play, they continue to exist in the mind of the beholder, emblazoned there, not to be forgotten. The experience may be repeated but not held on to and examined carefully. The moment has passed, the celebration is over, until another time.

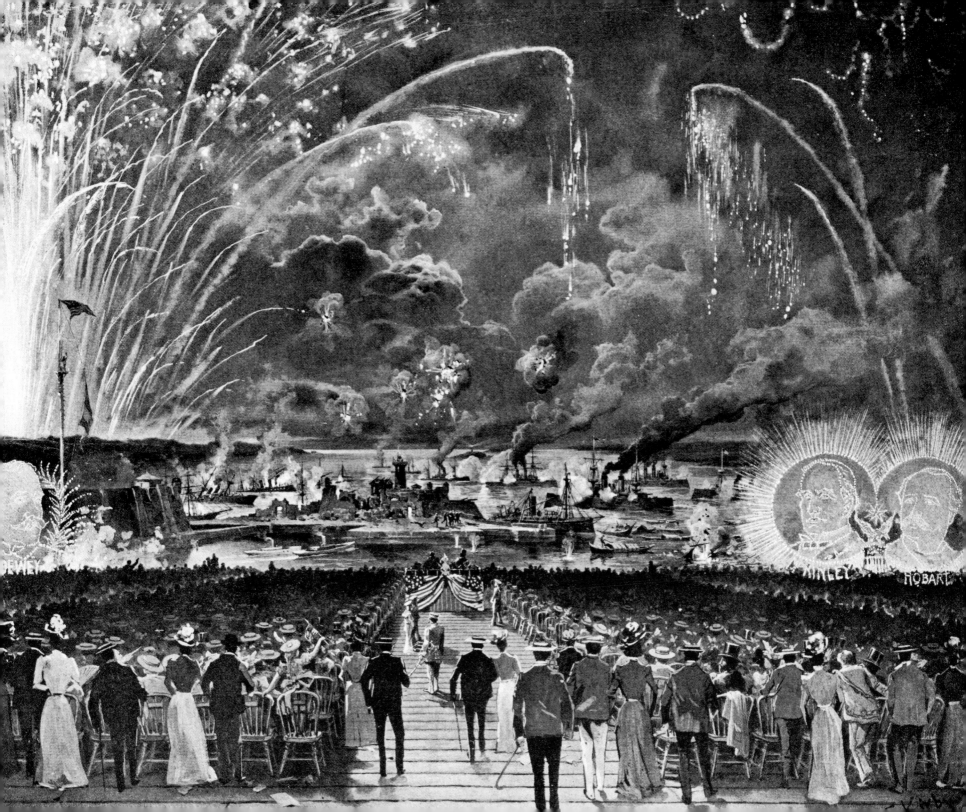

AMERICAN BANNER & SCENIC PAINTERS

BANNER PAINTERS

Brooklyn, N.Y.
Joseph Bruce
John Bulsterbaum
L. L. Graham
E. J. Hayden & Co.
Merrifield
Algernon W.
* Millard*
Millard & Bul-
* sterbaum*
August Wolfinger

Buffalo, N.Y.
Joseph Josephs

Chicago
Anderson
Chamberlain
H. C. Cummins
Davenport
Nieman Eisman
Fred G. Johnson
Lee & Tucker
Manuel's Studio

Columbus, Ohio
M. Armbruster &
* Sons*
Schell's Scenic
* Studio*

Kansas City, Mo.
Baker-Lockwood

New York
The New York
* Studios*

Providence, R.I.
Cad Hill

Sarasota, Fla.
Bill Nice

Tampa, Fla.
Sigler & Sons/
* Jack Cripe*
Bobby Wicks
Snap Wyatt

SCENIC PAINTERS

Chicago
O. Henry Tent &
* Awning Co.*
Sosman & Landis
* Co.*
Swift Studios
United States Tent
* and Awning Co.*

Columbus, Ohio
M. Armbruster &
* Sons*
Schell's Scenic
* Studio*

Dayton, Ohio
Bert L. Daily
* Scenic Studio*
* (advertising*
* drops for*
* theaters, motion*
* pictures, and*
* vaudeville*
* houses)*

St. Louis, Mo.
Dougherty Bros.
* Tent & Awning Co.*

Los Angeles, Cal.
Edwin H. Flagg

Memphis, Tenn.
Mahaffey Bros.
* Tent & Awning*
* Co.*

New York
*Henry E. Hoyt** *
* (Metropolitan*
* Opera, early*
* 1890s)*
T. J. Plaisted
Lafayette W.
* Seavey*
William Voegtlin

For the American
Opera Company,
1886
Homer Emens
Charles Graham
Caspard Meader
William Schaeffer

Omaha, Neb.
Enkeboll Art Co.
**Hoyt did a set of*
the pink ballroom
in the second act
of Erminie, with
an unusual color
for the interior and
big twisted col-
umns of the
Spanish type that
Stanford White
had in his private
collection. Hoyt
copyrighted the
painting.

BANNER-PAINTING SUBJECTS

African Dodger
Alligator
Armless and
* Legless Girl*
Athletic
Bathing Beauty
Big Steer
Camel-Mule
Cannibal
Chicago Fire
Chinese Dragon
Cigarette Fiend
Circus Front
Collins Entrapped,
* and a Trip*
* Through the*
* Wonder Caves of*
* Kentucky*
Dancing Girl
Diving Girl
Dog, Pony, and
* Monkey Show*
East India Prince
Educated Pony
Electric Lady
Fairy in the Well
Fat Beauty
Fire Queen
Flea Circus Front
* (4 pieces)*
Fortune Teller's
* Front*
Funny Monkey
* Circus*
Giant
Girl Show
Girl with a Thou-
* sand Eyes*
Glass Blowers
Grave Robbers
Handcuff
Happy Family
Hawaiian

Hippodrome
Human Bee Hive
Human Ostrich
Japanese Acrobat
Knife Rack
Lady Champion
* Bag Puncher*
Lady with Horse's
* Mane*
Lion Tamer
London Punch and
* Judy*
Magic and Punch
Magician—Lion
* Act*
Magician—Punch
* and Judy*
Malay Prince
Man-Eating
* Alligator*
Mammoth Snake
Mechanical
* Working World*
Mermaid
Midget
Midget and
* Giantess*
Mind Reader
Monkey
Monkey Merry-
* Go-Round*
Monkey Speed-
* way*
Moving Picture
* Front*
Musical Rats
Octopus or Devil
* Fish*
Oriental
Oriental Cooch
* Dancers*
Ossified Man
Palmist

Panama Canal
Penny Arcade
* Entrance*
Plantation
* Front*
Porcupine
Prize Fight
Sacred Monk
Sea Serpent
Seal
Skeleton Dude
Slim Jim and
* Happy Jack*
Small Horse
Snake
Snake Charmer
Snake Streamer
Spider Boy
Sword Walker
Tallest Man and
* Wife on Earth*
Tattooed Marvel
Three-Headed
* Woman*
Three-Legged
* Boy*
Tiny Elephant
Tormentors
Trained Wild
* Animal Front*
Tribe of Wahoos
* on the Island of*
* Haba Haba*
Ventriloquist
Ventriloquist and
* Magic*
White Slavery
Wild Girl
Wild Man
Wireless Tele-
* graphy*
World's Greatest
* Sheep*

BIBLIOGRAPHY

BOOKS

Adams, James Truslow. **Dictionary of American History**. New York: Charles Scribner's Sons, 1940.

Bellows, Ina Hayward. **Old Mechanical Banks**. Chicago: Lightner Publishing Corp., 1940.

Bemrose, E. W. **Fret Cutting and Perforated Carving**. London: Bemrose & Sons, 1869.

Boehm, Max and Fischel, Oskar. **Modes and Manners of the Nineteenth Century**. New York: E.P. Dutton & Co., 1909.

Brathwaite, David. **Fairground Architecture**. London: Hugh Evelyn, 1968.

Brock, Alan St. H. **A History of Fireworks**. London: George C. Harrap & Co., 1949.

Burchett, George, and Leighton, Peter. **Memoirs of a Tattooist**. New York: Crown Publishers, 1958.

Butler, Frank M. **The Book of the Boardwalk**. Atlantic City, N.J.: 1954 Association, 1952.

Campbell, Harry L. **Metal Castings**. New York: John Wiley & Sons, 1936.

Dawdy, Doris Ostrander. **Artists of the American West**. Chicago: The Swallow Press,

Eckhardt, George H. **United States Clock and Watch Patents**. New York: Privately Printed, 1960.

Ellis, Havelock. **The Criminal**. London: Walter Scott Publishing Co., 1914.

Field, June. **Collecting Georgian and Victorian Crafts**. New York: Charles Scribner's Sons, 1973.

Finley, Ruth E. **The Lady of Godey's: Sara Josepha Hale**. Philadelphia: J.B. Lippincott Co., 1931.

Fox, Charles Phillip. **Circus Parades**. Watkins Glen, N.Y.: Century House, 1953.

Fried, Frederick. **A Pictorial History of the Carousel**. New York: A. S. Barnes & Co., 1964.

————. **Artists in Wood**. New York: Clarkson N. Potter, 1970.

Gibson, Walter B. **The Bunco Book**. Holyoke, Mass.: Sidney H. Radner, 1946.

Gladstone, M. J. **A Carrot for a Nose**. New York: Charles Scribner's Sons, 1974.

Hartley, Florence. **The Ladies' Handbook of Fancy and Ornamental Work**. Philadelphia: J. W. Bradley, 1859.

Hertz, Louis H. **Mechanical Toy Banks**. Wethersfield, Conn.: Mark Haber & Co., 1947.

Hewitt, Barnard. **Theater, U.S.A.** New York: McGraw-Hill Book Co., 1959

Howells, William Dean. **Suburban Sketches**. Boston: James R. Osgood & Co., 1872.

Jones, Barbara. **The Unsophisticated Arts**. Rochester, Kent: Architectural Press, 1951.

Jones, Mrs. C. S. **Ladies' Fancy Work**. New York: Henry T. Williams, 1876.

————. **Household Elegancies: Suggestions in Household Art and Tasteful Home Decorations**. New York: Henry T. Williams, 1875.

Kane, Joseph Nathan. **Famous First Facts**. New York: H. T. Williams Co., 1950.

Kauffman, Henry J. **American Copper and Brass**. Camden, N.J.: Thomas Nelson & Sons, 1968.

Lancaster, Clay. **Architectural Follies in America: or Hammer, Saw-Tooth and Nail**. Rutland, Vt.: Charles E. Tuttle Co., 1960.

Landells, E., and Landells, Alice. **The Girl's Own Toy-Maker**. London: Griffith & Farran, 1860.

Lynes, Russell. **Domesticated Americans**. New York: Harper & Row Publishers, 1963.

McClinton, Katherine M. **Collecting American Victorian Antiques**. New York: Charles Scribner's Sons, 1966.

Morley, Henry. **Memoirs of Bartholomew Fair**. London: Chapman & Hall, 1859.

Morris, Lloyd. **Curtain Time**. New York: Random House, 1953.

Neal, Avon, and Parker, Ann. **Ephemeral Folk Figures**. New York: Clarkson N. Potter, 1969.

Ortega, Peter Ribera. **Christmas in Old Santa Fe**. Santa Fe: Piñon Publishing Co., 1961.

Parry, Albert. **Tattoo**. New York: Simon & Schuster, 1933.

Pilat, Oliver, and Ransom, Joe. **Sodom by the Sea**. Garden City, N.Y.: Garden City Publishing Co., 1941.

Pillsbury, Dorothy L. **Star over Adobe**. Albuquerque: University of New Mexico Press, 1963.

Pullan, Mrs. (Mathilda Marian). **The Lady's Manual of Fancy-Work**. New York: Dick & Fitzgerald, 1859.

Riis, Jacob A. **How the Other Half Lives**. New York: Charles Scribner's Sons, 1890.

Rogovin, Mark: Burton, Mary: and Highfill, Holly. **Mural Manual**. Boston: Beacon Press, 1973.

Sawyer, George A. **Fretwork Sawing and Wood Carving**. Boston: Lee & Shepard, 1875.

Scott-Steward, Dick. **Fairground Snaps**. London: Pleasant Pastures, 1974.

Sonn, Albert H. **Early American Wrought Iron**. New York: Charles Scribner's Sons, 1928.

Strutt, Joseph. **The Sports and Pastimes of the People of England**. London: Thomas Tegg, 1845 (first published London, 1801).

Urbino, Mme. Levina B. **Art Recreations**. Boston: J. S. Tilton & Co., 1859.

Webb, Spider. **Heavily Tattooed Men and Women**. New York: McGraw-Hill Book Co., 1976.

Weitenkampf, Frank. **Manhattan Kaleidoscope**. New York: Charles Scribner's Sons, 1947.

MAGAZINES

Annals of Iowa Schweider, Dorothy, and Swanson, Patricia. "The Sioux City Corn Palaces." Spring 1973.

Art Amateurs 1880–1890.

Better Homes and Gardens Bryant, Jean. "Paint Your Screen Door." June 1947.

Century Magazine 1884.

Fret Sawyer's Monthly & Home Decorator Vol. 11, no. 5, December 1880.

Godey's Ladies' Book 1832.

Harper's Magazine "Shooting Gallery at the Seashore." October 1878.

Illustrated London News "Shooting Galleries." August 11, 1855.

Life Magazine "World's Corniest Building." January 3, 1955.

The Magazine ANTIQUES "Victorian Window Embellishment." March 1940.

Motor Club News (Omaha, Neb.) "World's Corniest Festival." N.d.

New Mexico Magazine Hillerman, Tony. "Meet Dr. Frankenstein Shuster." August 1960.

Scientific American 1890–1912.

PUBLICATIONS AND PAPERS

Atlantic County Historical Society Yearbook Boucher, Jack E. "Atlantic City's Famed Sand Sculptors." October 1966.

Bulletin of the Musical Box Society International Fitch, Howard M. "Piano in a Pachyderm." Spring–Summer 1976.

Century of Meriden Meriden, Conn., 1906.

Charles Parker Company and the Bradley & Hubbard Division Charles Parker Co., Meriden, Conn., Republished 1976.

Cornbelt Exposition Corn Palace and the exhibits. Exposition Souvenir, Mitchell, S.D. 2nd ed. September 27–October 6, 1893.

Metropolitan Museum of Art Bulletin Fenton, Edward. "Fireworks." October 1954.

One Hundred and Fifty Years of Meriden City of Meriden, Conn., 1956.

Punch and Judy Lind, W. Murdoch. M. Witmark & Sons, New York, 1906.

The Billboard Cincinnati, Ohio. 1907–1932.

The Clarion Eff, Elaine. "The Painted Window Screens of Baltimore, Maryland." Museum of American Folk Art, New York, Spring 1976.

The Palimpsest Briggs, John Ely. "The Sioux City Corn Palaces." Kreiner, Carl B. "The Ottuma Coal Palace." Mahan, Bruce E. "The Blue Grass Palace." The State Historical Society of Iowa, December 1963.

The Sunstone Review and Press, Inc. Bond, Holly. "Zozobra."

United States Patent Office Reports, reviews, and gazettes.

World's Only Corn Palace Goin Co., Mitchell, S.D. 1974.

CATALOGUES

The American Clock Company 1869–1876 combined. National Association of Watch & Clock Collectors, Columbia, Pa., n.d.

A Catalogue of Designs Fretwork. A. H. Pomeroy, New York, 1879.

Coney Island Shooting Galleries Catalogues 3 to 8 incl. W. F. Mangels Co., Brooklyn, N.Y., 1905–1916.

Driver Brothers, Inc. Tents and banners. Chicago, 1926.

Emblem Signs and Copper Weather Vanes J. W. Fiske, Ornamental Iron & Zinc Work, New York, 1872.

Howard & Morse National Wire & Lantern Works, c. 1880. Metropolitan Museum of Art, Elisha Whittelsey Collection.

O. Henry Tent & Awning Co. Tents and banners. Chicago, 1925.

Park and Carnival Equipment H. C. Evans & Co., Chicago, 1929, 1932.

A Scene of Adornment The Margaret Woodbury Strong Museum, Rochester, N.Y., 1975. Edited by H. J. Swinney.

Scroll Sawings, Supplies The T. B. Rayl Co., Detroit, Mich., 1905.

United States Tent & Awning Co. Side-show and carnival banners and scenery. Chicago, c. 1911.

Wood Toys, Tin Toys, Games & Novelties Ives, Blakeslee & Williams Co., New York and Bridgeport, c. 1893.

NEWSPAPER ARTICLES

Addison Leader (Chicago) "Face Lift." October 23, 1974.

Baltimore Sun Bowie, Mary Clara. "Decorated Window Screens Regaining Vogue." August 1, 1926. Milspaugh, Martha. "Ancient Lineage of Those Window Scenes." September 7. 1947.

Brooklyn Daily Eagle Hochman, Bert. "Seaside Michelangelo Paints for the Millions." April 18, 1950.

Burlington Free Press "It Was a Winter Wonderland in Vermont." January 29, 1958. "Bristol 'Musher' Rejected at Canadian Line." May 23, 1958. "Roaming Artist 'Mushes' into Burlington." November 1, 1958. "Dog Sledder 'Joins' Fraternity." April 15, 1959. "Still 'Dogging' It." May 29, 1959.

Chicago Sun-Times Anderson, David. "Carny Painter Gives Freaks a Flashy Finish." September 17, 1973.

Meriden Morning Record "Death of Walter Hubbard After Five Hours Illness." August 25, 1911. "Hubbard Funeral Monday." August 26, 1911. "N. L. Bradley's Illness Fatal." March 14, 1915. "Bradley Funeral Attended by Many." March 17, 1915. "Clarence P. Bradley Dies Following Two-Year Illness." March 10, 1934.

Montreal Star Gatrill, Adrian J. "Hearts and (Ouch) Flowers." February 12, 1972.

Neighborhood Newspaper (Tampa) Lasky, Steve. "Tampa's Illustrated Man." January 6, 1977.

New Mexican (Santa Fe) "Firing Zozobra, 'Old Man Gloom,' Is Signal for Start of Merriment." August 31, 1967. Little, Linda. "Gloom to Go Up in Smoke." August 29, 1968. Cordtz, Kay. "Zozobra Gets Ready For Burning." September 1, 1976.

New York Post "And Right in Front of MOMA." August 5, 1976.

New York Times "Artist on Scaffold Resists Urge for Perspective." November 3, 1976. Taylor, Angela. "Some People Wore Just Their Tattoos." March 25, 1975.

San Francisco Chronicle Steger, Pat. "The Ageless Tattoo—Hidden or Flaunted." February 25, 1977.

San Francisco Sunday Examiner & Chronicle Hill, Annie. "The Most Colorful People." March 27, 1977.

Sunday News (New York) "Flea Circus." April 19, 1953.

Tampa Tribune Gerard, Eric. "Fading Art Displayed at Fair's Gaudy Midway." February 12, 1977.

TAPED AND ORAL INTERVIEWS

Frank Carretta, carousel carver

Salvatore Cernigliaro, carousel carver

John Eckhardt, screen painter

Mary Germond, town clerk, Sudbury, Vt.

Olga M. Hallock, town historian and author, Huntington, Vt.

Grace Henry Hanna, turn-of-the-century rural stage performer

Bertha Brown Hanson, historian, Starksboro, Vt.

Lee Landon, Vermont historian, Bristol, Vt.

Richard Oktavec, screen painter

Spider Webb, tattoo artist

CORRESPONDENCE

Melvin Byrd, chainsaw sculptor

Ruth Chrysam, screen painter

Fred G. Johnson, banner painter

Doug Ogden, sign painter

Benjamin Richardson, screen painter

Lyle Tuttle, tattoo artist

Robert F. Wicks, banner and show-front painter

Snap Wyatt, banner painter

INDEX

PHOTO CREDITS

**PERMISSIONS
ACKNOWLEDG-
MENTS**
Grateful
acknowledgment
is made to the
following for
permission to
reproduce
photographs on the
pages listed below:

Atlantic City Free
Public Library: 171,
180, 184
Ernst Beadle: 94
John Bernd: 92
Vahe and Bertha
Boyajian: 135; 137
center top, far rt.;
141 top
The Brooklyn
Museum, Dick S.
Ramsay and H.
Randolph Lever
Funds: 91
Buffalo and Erie
County Historical
Society, Buffalo,
N.Y.: 88
*The Burlington Free
Press*, Burlington,
Vt.: 117
Mel Byrd: 11, 111 top
and bot. lt. insets

Mrs. Marina Forrest
Cardona: 83,
84–85
Cedar Point, Inc.: 184
*Chicago Sun-Times:
Chicago Sun-
Times.*
Cityarts Workshop: 11
top row (far lt.), 112,
113
Dartmouth College
Archives: 175,
178
Harris Diamant: 87
2nd from rt.; 91
bot. row (far lt.)
Johnny Eck: 50–51
Robert Eckhardt: 108
C.P. Fox: 48–49
Franklin County
Historical Society,
St. Albans, Vt.:
152
James W. Gibbs: 129,
133, 134
James Gilmore:
70
Julie and Michael
Hall: 96
Mrs. Grace Henry
Hanna: 99
L.C. Hegerty
Collection: 11 top
row (2nd from lt.)
Heritage Plantation
of Sandwich, Mass.:
12, 86–87
Iowa State Historical
Department,
Division of
Historical Museum
and Archives: 189,
190
Evelyn Muller
Johnson: 19
Fred G. Johnson: 42;
43; 47 top lt., rt.;

52; 53; 54 top; 55; 56
Leo Kaplan: 91 top
(2nd from lt.)
The Kronen Gallery:
45 lt., rt. top; 67; 96
center
Frederick and Martha
Lapham: 11
Meriden Public
Library, Meriden,
Conn.: 134 2nd
from rt., rt.
The Metropolitan
Museum of Art,
The Elisha
Whittelsey
Collection, The
Elisha Whittelsey
Fund, 1958: 101 lt.
Colonel Michl: 84
Minnesota Historical
Society: 175
Edwin H. Mosler, Jr.,
Collection: 11 2nd
row (far lt.), 127,
137, 139, 140, 141,
142, 143
Museum of New
Mexico, Photo
Collections: 186
Museum of the City of
New York: 90 lt.
National Gallery of
Art, Index of
American Design:
86 far lt.
New-York Historical
Society, New York
City: 84 lt., 85
William A. Oktavec,
Jr.: 101
Old Clock Museum,
Pharr, Tex.: 129
bot. row
Ruth Pearson: 94
center
Patricia Ann Reed: 72,

73 top
Mrs. Charles Riebold:
60 lt.
James Shawn: 129
bot. row
Sanford and Patricia
Smith Collection:
91
Smithsonian
Institution, Van
Alstyne Collection:
87
Anthony Spagnola:
183, 184
Art Speltz: 41, 54 bot.
Staples and Charles
Ltd.: 75 center
Calista Sterling: 95
Margaret Woodbury
Strong Museum,
Rochester, N.Y.: 11;
12; 45 rt. col.
(center and bot.);
91; 129; 148; 149;
154; 155
The Sun, Baltimore:
86 2nd from lt.
Winston and Isabel
Swain: 118
Spider Webb Studios,
Ltd., Mt. Vernon,
N.Y.: 12, 157, 160,
164
Sandra Weiner: 111
center
The Western Reserve
Historical Society,
Cleveland, Ohio:
152
The Western Reserve
Historical Society,
Grace H. Stanley
Collection: 147
Frank G. and Frances
Whitson Collection:
12, 127 lt., 131, 132
David C. Wyatt: 58, 59

ABOUT THE AUTHORS

Frederick Fried, writer, lecturer, and museum consultant, is one of the country's foremost authorities on American folk art. A native of Brooklyn, New York, he acquired a fine-arts education during the 1920s and 1930s, with emphasis on sculpture. After serving with the Air Force in the South Pacific during World War II, he worked as art director in several fashion agencies. By 1961, Mr. Fried had become completely involved in American folk-art research. His first book, *A Pictorial History of the Carousel*, was published in 1964, followed by *Artists in Wood* and *New York Civic Sculpture*. Mr. Fried is a consultant to major museums and has served as guest curator for the Museum of American Folk Art.

Mary Hill Fried brings to this book her experience as artist, collector, and scholar. After her graduation from the Maryland Institute of Fine Arts and a year of study abroad, she worked in her native Baltimore and in New York as a fashion illustrator. During the war years she was a draftsman for a firm of naval architects.

After their marriage in 1949, the Frieds became active in landmark conservation, and soon started their trend-setting collections of three-dimensional folk art, architectural ornaments, timepieces, and the art and architecture of amusement parks. Their archives on these subjects are among the finest in the country.

In addition to their interest in folk art, the Frieds enjoy biking and growing flowers and vegetables on their Vermont farm. They have two children, Robert and Rachel.